flow

fl●w

The Psychology of Optimal Experience

MIHALY CSIKSZENTMIHALYI

HARPER**PERENNIAL** ● MODERN**CLASSICS**

NEW YORK ● LONDON ● TORONTO ● SYDNEY ● NEW DELHI ● AUCKLAND

HARPER**PERENNIAL** ● MODERN**CLASSICS**

A hardcover edition of this book was published in 1990 by Harper & Row.

P.S.™ is a trademark of HarperCollins Publishers.

HarperCollins books may be purchased for educational, business, or sales promotional use. For information, please e-mail the Special Markets Department at SPsales @harpercollins.com.

First Harper Perennial edition published 1991.
First Harper Perennial Modern Classics edition published 2008.

The Library of Congress has catalogued the hardcover edition as follows:

Csikszentmihalyi, Mihaly.
Flow : the psychology of optimal experience / Mihaly Csikszentmihalyi.— 1st ed.
 p. cm.
 ISBN 978-0-06-016253-5
 Includes bibliographical references.
 1. Happiness. 2. Attention. I. Title.
BF575.H27C85 1990
155.2—dc20 89-45645

ISBN 978-0-06-133920-2 (pbk.)

 15 RRD 20 19 18

For Isabella, and Mark and Christopher

CONTENTS

PREFACE

THIS BOOK SUMMARIZES, for a general audience, decades of research on the positive aspects of human experience—joy, creativity, the process of total involvement with life I call *flow*. To take this step is somewhat dangerous, because as soon as one strays from the stylized constraints of academic prose, it is easy to become careless or overly enthusiastic about such a topic. What follows, however, is not a popular book that gives insider tips about how to be happy. To do so would be impossible in any case, since a joyful life is an individual creation that cannot be copied from a recipe. This book tries instead to present general *principles*, along with concrete examples of how some people have used these principles, to transform boring and meaningless lives into ones full of enjoyment. There is no promise of easy short-cuts in these pages. But for readers who care about such things, there should be enough information to make possible the transition from theory to practice.

In order to make the book as direct and user-friendly as possible, I have avoided footnotes, references, and other tools scholars usually employ in their technical writing. I have tried to present the results of psychological research, and the ideas derived from the interpretation of such research, in a way that any educated reader can evaluate and apply to his or her own life, regardless of specialized background knowledge.

However, for those readers who are curious enough to pursue the scholarly sources on which my conclusions are based, I have included

extensive notes at the end of the volume. They are not keyed to specific references, but to the page number in the text where a given issue is discussed. For example, happiness is mentioned on the very first page. The reader interested in knowing what works I base my assertions on can turn to the notes section beginning on page 241 and, by looking under the reference to page 1, find a lead to Aristotle's view of happiness as well as to contemporary research on this topic, with the appropriate citations. The notes can be read as a second, highly compressed, and more technical shadow version of the original text.

At the beginning of any book, it is appropriate to acknowledge those who have influenced its development. In the present case this is impossible, since the list of names would have to be almost as long as the book itself. However, I owe special gratitude to a few people, whom I wish to take this opportunity to thank. First of all, Isabella, who as wife and friend has enriched my life for over twenty-five years, and whose editorial judgment has helped shape this work. Mark and Christopher, our sons, from whom I have learned perhaps as much as they have learned from me. Jacob Getzels, my once and future mentor. Among friends and colleagues I should like to single out Donald Campbell, Howard Gardner, Jean Hamilton, Philip Hefner, Hiroaki Imamura, David Kipper, Doug Kleiber, George Klein, Fausto Massimini, Elisabeth Noelle-Neumann, Jerome Singer, James Stigler, and Brian Sutton-Smith —all of whom, in one way or another, have been generous with their help, inspiration, or encouragement.

Of my former students and collaborators Ronald Graef, Robert Kubey, Reed Larson, Jean Nakamura, Kevin Rathunde, Rick Robinson, Ikuya Sato, Sam Whalen, and Maria Wong have made the greatest contributions to the research underlying the ideas developed in these pages. John Brockman and Richard P. Kot have given their skillful professional support to this project and have helped it along from start to finish. Last but not least, indispensable over the past decade has been the funding generously provided by the Spencer Foundation to collect and analyze the data. I am especially grateful to its former president, H. Thomas James, to its present one, Lawrence A. Cremin, and to Marion Faldet, vice-president of the foundation. Of course, none of those mentioned above are responsible for what might be unsound in the book— that is exclusively my own doing.

Chicago, March 1990

flow

HAPPINESS REVISITED

INTRODUCTION

TWENTY-THREE HUNDRED YEARS AGO Aristotle concluded that, more than anything else, men and women seek happiness. While happiness itself is sought for its own sake, every other goal—health, beauty, money, or power—is valued only because we expect that it will make us happy. Much has changed since Aristotle's time. Our understanding of the worlds of stars and of atoms has expanded beyond belief. The gods of the Greeks were like helpless children compared to humankind today and the powers we now wield. And yet on this most important issue very little has changed in the intervening centuries. We do not understand what happiness is any better than Aristotle did, and as for learning how to attain that blessed condition, one could argue that we have made no progress at all.

Despite the fact that we are now healthier and grow to be older, despite the fact that even the least affluent among us are surrounded by material luxuries undreamed of even a few decades ago (there were few bathrooms in the palace of the Sun King, chairs were rare even in the richest medieval houses, and no Roman emperor could turn on a TV set when he was bored), and regardless of all the stupendous scientific knowledge we can summon at will, people often end up feeling that their lives have been wasted, that instead of being filled with happiness their years were spent in anxiety and boredom.

Is this because it is the destiny of mankind to remain unfulfilled, each person always wanting more than he or she can have? Or is the pervasive malaise that often sours even our most precious moments the result of our seeking happiness in the wrong places? The intent of this book is to use some of the tools of modern psychology to explore this very ancient question: When do people feel most happy? If we can begin to find an answer to it, perhaps we shall eventually be able to order life so that happiness will play a larger part in it.

Twenty-five years before I began to write these lines, I made a discovery that took all the intervening time for me to realize I had made. To call it a "discovery" is perhaps misleading, for people have been aware of it since the dawn of time. Yet the word is appropriate, because even though my finding itself was well known, it had not been described or theoretically explained by the relevant branch of scholarship, which in this case happens to be psychology. So I spent the next quarter-century investigating this elusive phenomenon.

What I "discovered" was that happiness is not something that happens. It is not the result of good fortune or random chance. It is not something that money can buy or power command. It does not depend on outside events, but, rather, on how we interpret them. Happiness, in fact, is a condition that must be prepared for, cultivated, and defended privately by each person. People who learn to control inner experience will be able to determine the quality of their lives, which is as close as any of us can come to being happy.

Yet we cannot reach happiness by consciously searching for it. "Ask yourself whether you are happy," said J. S. Mill, "and you cease to be so." It is by being fully involved with every detail of our lives, whether good or bad, that we find happiness, not by trying to look for it directly. Viktor Frankl, the Austrian psychologist, summarized it beautifully in the preface to his book *Man's Search for Meaning*: "Don't aim at success—the more you aim at it and make it a target, the more you are going to miss it. For success, like happiness, cannot be pursued; it must ensue . . . as the unintended side-effect of one's personal dedication to a course greater than oneself."

So how can we reach this elusive goal that cannot be attained by a direct route? My studies of the past quarter-century have convinced me that there is a way. It is a circuitous path that begins with achieving control over the contents of our consciousness.

Our perceptions about our lives are the outcome of many forces that shape experience, each having an impact on whether we feel good or bad. Most of these forces are outside our control. There is not much we can do about our looks, our temperament, or our constitution. We

cannot decide—at least so far—how tall we will grow, how smart we will get. We can choose neither parents nor time of birth, and it is not in your power or mine to decide whether there will be a war or a depression. The instructions contained in our genes, the pull of gravity, the pollen in the air, the historical period into which we are born—these and innumerable other conditions determine what we see, how we feel, what we do. It is not surprising that we should believe that our fate is primarily ordained by outside agencies.

Yet we have all experienced times when, instead of being buffeted by anonymous forces, we do feel in control of our actions, masters of our own fate. On the rare occasions that it happens, we feel a sense of exhilaration, a deep sense of enjoyment that is long cherished and that becomes a landmark in memory for what life should be like.

This is what we mean by *optimal experience.* It is what the sailor holding a tight course feels when the wind whips through her hair, when the boat lunges through the waves like a colt—sails, hull, wind, and sea humming a harmony that vibrates in the sailor's veins. It is what a painter feels when the colors on the canvas begin to set up a magnetic tension with each other, and a new *thing,* a living form, takes shape in front of the astonished creator. Or it is the feeling a father has when his child for the first time responds to his smile. Such events do not occur only when the external conditions are favorable, however: people who have survived concentration camps or who have lived through near-fatal physical dangers often recall that in the midst of their ordeal they experienced extraordinarily rich epiphanies in response to such simple events as hearing the song of a bird in the forest, completing a hard task, or sharing a crust of bread with a friend.

Contrary to what we usually believe, moments like these, the best moments in our lives, are not the passive, receptive, relaxing times—although such experiences can also be enjoyable, if we have worked hard to attain them. The best moments usually occur when a person's body or mind is stretched to its limits in a voluntary effort to accomplish something difficult and worthwhile. Optimal experience is thus something that we *make* happen. For a child, it could be placing with trembling fingers the last block on a tower she has built, higher than any she has built so far; for a swimmer, it could be trying to beat his own record; for a violinist, mastering an intricate musical passage. For each person there are thousands of opportunities, challenges to expand ourselves.

Such experiences are not necessarily pleasant at the time they occur. The swimmer's muscles might have ached during his most memorable race, his lungs might have felt like exploding, and he might have been dizzy with fatigue—yet these could have been the best moments

of his life. Getting control of life is never easy, and sometimes it can be definitely painful. But in the long run optimal experiences add up to a sense of mastery—or perhaps better, a sense of *participation* in determining the content of life—that comes as close to what is usually meant by happiness as anything else we can conceivably imagine.

In the course of my studies I tried to understand as exactly as possible how people felt when they most enjoyed themselves, and why. My first studies involved a few hundred "experts"—artists, athletes, musicians, chess masters, and surgeons—in other words, people who seemed to spend their time in precisely those activities they preferred. From their accounts of what it felt like to do what they were doing, I developed a theory of optimal experience based on the concept of *flow*—the state in which people are so involved in an activity that nothing else seems to matter; the experience itself is so enjoyable that people will do it even at great cost, for the sheer sake of doing it.

With the help of this theoretical model my research team at the University of Chicago and, afterward, colleagues around the world interviewed thousands of individuals from many different walks of life. These studies suggested that optimal experiences were described in the same way by men and women, by young people and old, regardless of cultural differences. The flow experience was not just a peculiarity of affluent, industrialized elites. It was reported in essentially the same words by old women from Korea, by adults in Thailand and India, by teenagers in Tokyo, by Navajo shepherds, by farmers in the Italian Alps, and by workers on the assembly line in Chicago.

In the beginning our data consisted of interviews and questionnaires. To achieve greater precision we developed with time a new method for measuring the quality of subjective experience. This technique, called the Experience Sampling Method, involves asking people to wear an electronic paging device for a week and to write down how they feel and what they are thinking about whenever the pager signals. The pager is activated by a radio transmitter about eight times each day, at random intervals. At the end of the week, each respondent provides what amounts to a running record, a written film clip of his or her life, made up of selections from its representative moments. By now over a hundred thousand such cross sections of experience have been collected from different parts of the world. The conclusions of this volume are based on that body of data.

The study of flow I began at the University of Chicago has now spread worldwide. Researchers in Canada, Germany, Italy, Japan, and Australia have taken up its investigation. At present the most extensive collection of data outside of Chicago is at the Institute of Psychology of

the Medical School, the University of Milan, Italy. The concept of flow has been found useful by psychologists who study happiness, life satisfaction, and intrinsic motivation; by sociologists who see in it the opposite of anomie and alienation; by anthropologists who are interested in the phenomena of collective effervescence and rituals. Some have extended the implications of flow to attempts to understand the evolution of mankind, others to illuminate religious experience.

But flow is not just an academic subject. Only a few years after it was first published, the theory began to be applied to a variety of practical issues. Whenever the goal is to improve the quality of life, the flow theory can point the way. It has inspired the creation of experimental school curricula, the training of business executives, the design of leisure products and services. Flow is being used to generate ideas and practices in clinical psychotherapy, the rehabilitation of juvenile delinquents, the organization of activities in old people's homes, the design of museum exhibits, and occupational therapy with the handicapped. All this has happened within a dozen years after the first articles on flow appeared in scholarly journals, and the indications are that the impact of the theory is going to be even stronger in the years to come.

OVERVIEW

Although many articles and books on flow have been written for the specialist, this is the first time that the research on optimal experience is being presented to the general reader and its implications for individual lives discussed. But what follows is not going to be a "how-to" book. There are literally thousands of such volumes in print or on the remainder shelves of book-stores, explaining how to get rich, powerful, loved, or slim. Like cookbooks, they tell you how to accomplish a specific, limited goal on which few people actually follow through. Yet even if their advice were to work, what would be the result afterward in the unlikely event that one did turn into a slim, well-loved, powerful millionaire? Usually what happens is that the person finds himself back at square one, with a new list of wishes, just as dissatisfied as before. What would really satisfy people is not getting slim or rich, but feeling good about their lives. In the quest for happiness, partial solutions don't work.

However well-intentioned, books cannot give recipes for how to be happy. Because optimal experience depends on the ability to control what happens in consciousness moment by moment, each person has to achieve it on the basis of his own individual efforts and creativity. What a book can do, however, and what this one will try to accomplish,

is to present examples of how life can be made more enjoyable, ordered in the framework of a theory, for readers to reflect upon and from which they may then draw their own conclusions.

Rather than presenting a list of dos and don'ts, this book intends to be a voyage through the realms of the mind, charted with the tools of science. Like all adventures worth having it will not be an easy one. Without some intellectual effort, a commitment to reflect and think hard about your own experience, you will not gain much from what follows.

Flow will examine the process of achieving happiness through control over one's inner life. We shall begin by considering *how consciousness works, and how it is controlled* (chapter 2), because only if we understand the way subjective states are shaped can we master them. Everything we experience—joy or pain, interest or boredom—is represented in the mind as information. If we are able to control this information, we can decide what our lives will be like.

The optimal state of inner experience is one in which there is *order in consciousness.* This happens when psychic energy—or attention—is invested in realistic goals, and when skills match the opportunities for action. The pursuit of a goal brings order in awareness because a person must concentrate attention on the task at hand and momentarily forget everything else. These periods of struggling to overcome challenges are what people find to be the most enjoyable times of their lives (chapter 3). A person who has achieved control over psychic energy and has invested it in consciously chosen goals cannot help but grow into a more complex being. By stretching skills, by reaching toward higher challenges, such a person becomes an increasingly extraordinary individual.

To understand why some things we do are more enjoyable than others, we shall review the *conditions of the flow experience* (chapter 4). "Flow" is the way people describe their state of mind when consciousness is harmoniously ordered, and they want to pursue whatever they are doing for its own sake. In reviewing some of the activities that consistently produce flow—such as sports, games, art, and hobbies—it becomes easier to understand what makes people happy.

But one cannot rely solely on games and art to improve the quality of life. To achieve control over what happens in the mind, one can draw upon an almost infinite range of opportunities for enjoyment—for instance, through the use of *physical and sensory skills* ranging from athletics to music to Yoga (chapter 5), or through the development of *symbolic skills* such as poetry, philosophy, or mathematics (chapter 6).

Most people spend the largest part of their lives working and interacting with others, especially with members of their families. There-

fore it is crucial that one learn to *transform jobs into flow-producing activities* (chapter 7), and to think of ways of making *relations with parents, spouses, children, and friends more enjoyable* (chapter 8).

Many lives are disrupted by tragic accidents, and even the most fortunate are subjected to stresses of various kinds. Yet such blows do not necessarily diminish happiness. It is how people respond to stress that determines whether they will profit from misfortune or be miserable. Chapter 9 describes *ways in which people manage to enjoy life despite adversity.*

And, finally, the last step will be to describe how people manage *to join all experience into a meaningful pattern* (chapter 10). When that is accomplished, and a person feels in control of life and feels that it makes sense, there is nothing left to desire. The fact that one is not slim, rich, or powerful no longer matters. The tide of rising expectations is stilled; unfulfilled needs no longer trouble the mind. Even the most humdrum experiences become enjoyable.

Thus *Flow* will explore what is involved in reaching these aims. How is consciousness controlled? How is it ordered so as to make experience enjoyable? How is complexity achieved? And, last, how can meaning be created? The way to achieve these goals is relatively easy in theory, yet quite difficult in practice. The rules themselves are clear enough, and within everyone's reach. But many forces, both within ourselves and in the environment, stand in the way. It is a little like trying to lose weight: everyone knows what it takes, everyone wants to do it, yet it is next to impossible for so many. The stakes here are higher, however. It is not just a matter of losing a few extra pounds. It is a matter of losing the chance to have a life worth living.

Before describing how the optimal flow experience can be attained, it is necessary to review briefly some of the obstacles to fulfillment implicit in the human condition. In the old stories, before living happily ever after the hero had to confront fiery dragons and wicked warlocks in the course of a quest. This metaphor applies to the exploration of the psyche as well. I shall argue that the primary reason it is so difficult to achieve happiness centers on the fact that, contrary to the myths mankind has developed to reassure itself, the universe was not created to answer our needs. Frustration is deeply woven into the fabric of life. And whenever some of our needs *are* temporarily met, we immediately start wishing for more. This chronic dissatisfaction is the second obstacle that stands in the way of contentment.

To deal with these obstacles, every culture develops with time protective devices—religions, philosophies, arts, and comforts—that

help shield us from chaos. They help us believe that we are in control of what is happening and give reasons for being satisfied with our lot. But these shields are effective only for a while; after a few centuries, sometimes after only a few decades, a religion or belief wears out and no longer provides the spiritual sustenance it once did.

When people try to achieve happiness on their own, without the support of a faith, they usually seek to maximize pleasures that are either biologically programmed in their genes or are out as attractive by the society in which they live. Wealth, power, and sex become the chief goals that give direction to their strivings. But the quality of life cannot be improved this way. Only direct control of experience, the ability to derive moment-by-moment enjoyment from everything we do, can overcome the obstacles to fulfillment.

THE ROOTS OF DISCONTENT

The foremost reason that happiness is so hard to achieve is that the universe was not designed with the comfort of human beings in mind. It is almost immeasurably huge, and most of it is hostilely empty and cold. It is the setting for great violence, as when occasionally a star explodes, turning to ashes everything within billions of miles. The rare planet whose gravity field would not crush our bones is probably swimming in lethal gases. Even planet Earth, which can be so idyllic and picturesque, is not to be taken for granted. To survive on it men and women have had to struggle for millions of years against ice, fire, floods, wild animals, and invisible microorganisms that appear out of nowhere to snuff us out.

It seems that every time a pressing danger is avoided, a new and more sophisticated threat appears on the horizon. No sooner do we invent a new substance than its by-products start poisoning the environment. Throughout history, weapons that were designed to provide security have turned around and threatened to destroy their makers. As some diseases are curbed, new ones become virulent; and if, for a while, mortality is reduced, then overpopulation starts to haunt us. The four grim horsemen of the Apocalypse are never very far away. The earth may be our only home, but it is a home full of booby traps waiting to go off at any moment.

It is not that the universe is random in an abstract mathematical sense. The motions of the stars, the transformations of energy that occur in it might be predicted and explained well enough. But natural processes do not take human desires into account. They are deaf and blind

to our needs, and thus they are random in contrast with the order we attempt to establish through our goals. A meteorite on a collision course with New York City might be obeying all the laws of the universe, but it would still be a damn nuisance. The virus that attacks the cells of a Mozart is only doing what comes naturally, even though it inflicts a grave loss on humankind. "The universe is not hostile, nor yet is it friendly," in the words of J. H. Holmes. "It is simply indifferent."

Chaos is one of the oldest concepts in myth and religion. It is rather foreign to the physical and biological sciences, because in terms of their laws the events in the cosmos are perfectly reasonable. For instance, "chaos theory" in the sciences attempts to describe regularities in what appears to be utterly random. But chaos has a different meaning in psychology and the other human sciences, because if human goals and desires are taken as the starting point, there is irreconcilable disorder in the cosmos.

There is not much that we as individuals can do to change the way the universe runs. In our lifetime we exert little influence over the forces that interfere with our well-being. It is important to do as much as we can to prevent nuclear war, to abolish social injustice, to eradicate hunger and disease. But it is prudent not to expect that efforts to change external conditions will immediately improve the quality of our lives. As J. S. Mill wrote, "No great improvements in the lot of mankind are possible, until a great change takes place in the fundamental constitution of their modes of thought."

How we feel about ourselves, the joy we get from living, ultimately depend directly on how the mind filters and interprets everyday experiences. Whether we are happy depends on inner harmony, not on the controls we are able to exert over the great forces of the universe. Certainly we should keep on learning how to master the external environment, because our physical survival may depend on it. But such mastery is not going to add one jot to how good we as individuals feel, or reduce the chaos of the world as we experience it. To do that we must learn to achieve mastery over consciousness itself.

Each of us has a picture, however vague, of what we would like to accomplish before we die. How close we get to attaining this goal becomes the measure for the quality of our lives. If it remains beyond reach, we grow resentful or resigned; if it is at least in part achieved, we experience a sense of happiness and satisfaction.

For the majority of people on this earth, life goals are simple: to survive, to leave children who will in turn survive, and, if possible, to do so with a certain amount of comfort and dignity. In the *favelas*

spreading around South American cities, in the drought-stricken regions of Africa, among the millions of Asians who have to solve the problem of hunger day after day, there is not much else to hope for.

But as soon as these basic problems of survival are solved, merely having enough food and a comfortable shelter is no longer sufficient to make people content. New needs are felt, new desires arise. With affluence and power come escalating expectations, and as our level of wealth and comforts keeps increasing, the sense of well-being we hoped to achieve keeps receding into the distance. When Cyrus the Great had ten thousand cooks prepare new dishes for his table, the rest of Persia had barely enough to eat. These days every household in the "first world" has access to the recipes of the most diverse lands and can duplicate the feasts of past emperors. But does this make us more satisfied?

This paradox of rising expectations suggests that improving the quality of life might be an insurmountable task. In fact, there is no inherent problem in our desire to escalate our goals, as long as we enjoy the struggle along the way. The problem arises when people are so fixated on what they want to achieve that they cease to derive pleasure from the present. When that happens, they forfeit their chance of contentment.

Though the evidence suggests that most people are caught up on this frustrating treadmill of rising expectations, many individuals have found ways to escape it. These are people who, regardless of their material conditions, have been able to improve the quality of their lives, who are satisfied, and who have a way of making those around them also a bit more happy.

Such individuals lead vigorous lives, are open to a variety of experiences, keep on learning until the day they die, and have strong ties and commitments to other people and to the environment in which they live. They enjoy whatever they do, even if tedious or difficult; they are hardly ever bored, and they can take in stride anything that comes their way. Perhaps their greatest strength is that they are *in control of their lives.* We shall see later how they have managed to reach this state. But before we do so, we need to review some of the devices that have been developed over time as protection against the threat of chaos, and the reasons why such external defenses often do not work.

THE SHIELDS OF CULTURE

Over the course of human evolution, as each group of people became gradually aware of the enormity of its isolation in the cosmos and of the

precariousness of its hold on survival, it developed myths and beliefs to transform the random, crushing forces of the universe into manageable, or at least understandable, patterns. One of the major functions of every culture has been to shield its members from chaos, to reassure them of their importance and ultimate success. The Eskimo, the hunter of the Amazon basin, the Chinese, the Navajo, the Australian Aborigine, the New Yorker—all have taken for granted that they live at the center of the universe, and that they have a special dispensation that puts them on the fast track to the future. Without such trust in exclusive privileges, it would be difficult to face the odds of existence.

This is as it should be. But there are times when the feeling that one has found safety in the bosom of a friendly cosmos becomes dangerous. An unrealistic trust in the shields, in the cultural myths, can lead to equally extreme disillusion when they fail. This tends to happen whenever a culture has had a run of good luck and for a while seems indeed to have found a way of controlling the forces of nature. At that point it is logical for it to begin believing that it is a chosen people who need no longer fear any major setback. The Romans reached that juncture after several centuries of ruling the Mediterranean, the Chinese were confident of their immutable superiority before the Mongol conquest, and the Aztecs before the arrival of the Spaniards.

This cultural hubris, or overweening presumption about what we are entitled to from a universe that is basically insensitive to human needs, generally leads to trouble. The unwarranted sense of security sooner or later results in a rude awakening. When people start believing that progress is inevitable and life easy, they may quickly lose courage and determination in the face of the first signs of adversity. As they realize that what they had believed in is not entirely true, they abandon faith in everything else they have learned. Deprived of the customary supports that cultural values had given them, they flounder in a morass of anxiety and apathy.

Such symptoms of disillusion are not hard to observe around us now. The most obvious ones relate to the pervasive listlessness that affects so many lives. Genuinely happy individuals are few and far between. How many people do you know who enjoy what they are doing, who are reasonably satisfied with their lot, who do not regret the past and look to the future with genuine confidence? If Diogenes with his lantern twenty-three centuries ago had difficulty finding an honest man, today he would have perhaps an even more troublesome time finding a happy one.

This general malaise is not due directly to external causes. Unlike

so many other nations in the contemporary world, we can't blame our problems on a harsh environment, on widespread poverty, or on the oppression of a foreign occupying army. The roots of the discontent are internal, and each person must untangle them personally, with his or her own power. The shields that have worked in the past—the order that religion, patriotism, ethnic traditions, and habits instilled by social classes used to provide—are no longer effective for increasing numbers of people who feel exposed to the harsh winds of chaos.

The lack of inner order manifests itself in the subjective condition that some call ontological anxiety, or existential dread. Basically, it is a fear of being, a feeling that there is no meaning to life and that existence is not worth going on with. Nothing seems to make sense. In the last few generations, the specter of nuclear war has added an unprecedented threat to our hopes. There no longer seems to be any point to the historical strivings of humankind. We are just forgotten specks drifting in the void. With each passing year, the chaos of the physical universe becomes magnified in the minds of the multitude.

As people move through life, passing from the hopeful ignorance of youth into sobering adulthood, they sooner or later face an increasingly nagging question: "Is this all there is?" Childhood can be painful, adolescence confusing, but for most people, behind it all there is the expectation that after one grows up, things will get better. During the years of early adulthood the future still looks promising, the hope remains that one's goals will be realized. But inevitably the bathroom mirror shows the first white hairs, and confirms the fact that those extra pounds are not about to leave; inevitably eyesight begins to fail and mysterious pains begin to shoot through the body. Like waiters in a restaurant starting to place breakfast settings on the surrounding tables while one is still having dinner, these intimations of mortality plainly communicate the message: Your time is up, it's time to move on. When this happens, few people are ready. "Wait a minute, this can't be happening to me. I haven't even begun to live. Where's all that money I was supposed to have made? Where are all the good times I was going to have?"

A feeling of having been led on, of being cheated, is an understandable consequence of this realization. From the earliest years we have been conditioned to believe that a benign fate would provide for us. After all, everybody seemed to agree that we had the great fortune of living in the richest country that ever was, in the most scientifically advanced period of human history, surrounded by the most efficient technology, protected by the wisest Constitution. Therefore, it made sense to expect that we would have a richer, more meaningful life than

any earlier members of the human race. If our grandparents, living in that ridiculously primitive past, could be content, just imagine how happy we would be! Scientists told us this was so, it was preached from the pulpits of churches, and it was confirmed by thousands of TV commercials celebrating the good life. Yet despite all these assurances, sooner or later we wake up alone, sensing that there is no way this affluent, scientific, and sophisticated world is going to provide us with happiness.

As this realization slowly sets in, different people react to it differently. Some try to ignore it, and renew their efforts to acquire more of the things that were supposed to make life good—bigger cars and homes, more power on the job, a more glamorous life-style. They renew their efforts, determined still to achieve the satisfaction that up until then has eluded them. Sometimes this solution works, simply because one is so drawn into the competitive struggle that there is no time to realize that the goal has not come any nearer. But if a person does take the time out to reflect, the disillusionment returns: after each success it becomes clearer that money, power, status, and possessions do not, by themselves, necessarily add one iota to the quality of life.

Others decide to attack directly the threatening symptoms. If it is a body going to seed that rings the first alarm, they will go on diets, join health clubs, do aerobics, buy a Nautilus, or undergo plastic surgery. If the problem seems to be that nobody pays much attention, they buy books about how to get power or how to make friends, or they enroll in assertiveness training courses and have power lunches. After a while, however, it becomes obvious that these piecemeal solutions won't work either. No matter how much energy we devote to its care, the body will eventually give out. If we are learning to be more assertive, we might inadvertently alienate our friends. And if we devote too much time to cultivating new friends, we might threaten relationships with our spouse and family. There are just so many dams about to burst and so little time to tend to them all.

Daunted by the futility of trying to keep up with all the demands they cannot possibly meet, some will just surrender and retire gracefully into relative oblivion. Following Candide's advice, they will give up on the world and cultivate their little gardens. They might dabble in genteel forms of escape such as developing a harmless hobby or accumulating a collection of abstract paintings or porcelain figurines. Or they might lose themselves in alcohol or the dreamworld of drugs. While exotic pleasures and expensive recreations temporarily take the mind off the basic question "Is this all there is?" few claim to have ever found an answer that way.

Traditionally, the problem of existence has been most directly confronted through religion, and an increasing number of the disillusioned are turning back to it, choosing either one of the standard creeds or a more esoteric Eastern variety. But religions are only temporarily successful attempts to cope with the lack of meaning in life; they are not permanent answers. At some moments in history, they have explained convincingly what was wrong with human existence and have given credible answers. From the fourth to the eighth century of our era Christianity spread throughout Europe, Islam arose in the Middle East, and Buddhism conquered Asia. For hundreds of years these religions provided satisfying goals for people to spend their lives pursuing. But today it is more difficult to accept their worldviews as definitive. The form in which religions have presented their truths—myths, revelations, holy texts—no longer compels belief in an era of scientific rationality, even though the substance of the truths may have remained unchanged. A vital new religion may one day arise again. In the meantime, those who seek consolation in existing churches often pay for their peace of mind with a tacit agreement to ignore a great deal of what is known about the way the world works.

The evidence that none of these solutions is any longer very effective is irrefutable. In the heyday of its material splendor, our society is suffering from an astonishing variety of strange ills. The profits made from the widespread dependence on illicit drugs are enriching murderers and terrorists. It seems possible that in the near future we shall be ruled by an oligarchy of former drug dealers, who are rapidly gaining wealth and power at the expense of law-abiding citizens. And in our sexual lives, by shedding the shackles of "hypocritical" morality, we have unleashed destructive viruses upon one another.

The trends are often so disturbing that we tend to become jaded and tune out whenever we hear the latest statistics. But the ostrich's strategy for avoiding bad news is hardly productive; better to face facts and take care to avoid becoming one of the statistics. There are figures that may be reassuring to some: for instance, in the past thirty years, we have doubled our per-capita use of energy—most of it thanks to a fivefold increase in the use of electric utilities and appliances. Other trends, however, would reassure no one. In 1984, there were still thirty-four million people in the United States who lived below the poverty line (defined as a yearly income of $10,609 or less for a family of four), a number that has changed little in generations.

In the United States the per-capita frequency of violent crimes—murder, rape, robbery, assault—increased by well over 300 percent between 1960 and 1986. As recently as 1978 1,085,500 such crimes were

reported, and by 1986 the number had climbed to 1,488,140. The murder rate held steady at about 1,000 percent above that in other industrialized countries like Canada, Norway, or France. In roughly the same period, the rate of divorce rose by about 400 percent, from 31 per 1,000 married couples in 1950 to 121 in 1984. During those twenty-five years venereal disease more than tripled; in 1960 there were 259,000 cases of gonorrhea, by 1984 there were almost 900,000. We still have no clear idea what tragic price that latest scourge, the AIDS epidemic, will claim before it's over.

The three- to fourfold increase in social pathology over the last generation holds true in an astonishing number of areas. For instance, in 1955 there were 1,700,000 instances of clinical intervention involving mental patients across the country; by 1975 the number had climbed to 6,400,000. Perhaps not coincidentally, similar figures illustrate the increase in our national paranoia: during the decade from 1975 to 1985 the budget authorized to the Department of Defense climbed from $87.9 billion a year to $284.7 billion—more than a threefold increase. It is true that the budget of the Department of Education also tripled in the same period, but in 1985 this amounted to "only" $17.4 billion. At least as far as the allocation of resources is concerned, the sword is about sixteen times mightier than the pen.

The future does not look much rosier. Today's teenagers show the symptoms of the malaise that ails their elders, sometimes in an even more virulent form. Fewer young people now grow up in families where both parents are present to share the responsibilities involved in bringing up children. In 1960 only 1 in 10 adolescents was living in a one-parent family. By 1980 the proportion had doubled, and by 1990 it is expected to triple. In 1982 there were over 80,000 juveniles—average age, 15 years—committed to various jails. The statistics on drug use, venereal disease, disappearance from home, and unwed pregnancy are all grim, yet probably quite short of the mark. Between 1950 and 1980 teenage suicides increased by about 300 percent, especially among white young men from the more affluent classes. Of the 29,253 suicides reported in 1985, 1,339 were white boys in the 15–19 age range; four times fewer white girls of the same age killed themselves, and ten times fewer black boys (young blacks, however, more than catch up in the number of deaths from homicide). Last but not least, the level of knowledge in the population seems to be declining everywhere. For instance, the average math score on the SAT tests was 466 in 1967; in 1984 it was 426. A similar decrease has been noted in the verbal scores. And the dirgelike statistics could go on and on.

Why is it that, despite having achieved previously undreamed-of

miracles of progress, we seem more helpless in facing life than our less privileged ancestors were? The answer seems clear: while humankind collectively has increased its material powers a thousandfold, it has not advanced very far in terms of improving the content of experience.

RECLAIMING EXPERIENCE

There is no way out of this predicament except for an individual to take things in hand personally. If values and institutions no longer provide as supportive a framework as they once did, each person must use whatever tools are available to carve out a meaningful, enjoyable life. One of the most important tools in this quest is provided by psychology. Up to now the main contribution of this fledgling science has been to discover how past events shed light on present behavior. It has made us aware that adult irrationality is often the result of childhood frustrations. But there is another way that the discipline of psychology can be put to use. It is in helping answer the question: Given that we are who we are, with whatever hang-ups and repressions, what can we do to improve our future?

To overcome the anxieties and depressions of contemporary life, individuals must become independent of the social environment to the degree that they no longer respond exclusively in terms of its rewards and punishments. To achieve such autonomy, a person has to learn to provide rewards to herself. She has to develop the ability to find enjoyment and purpose regardless of external circumstances. This challenge is both easier and more difficult than it sounds: easier because the ability to do so is entirely within each person's hands; difficult because it requires a discipline and perseverance that are relatively rare in any era, and perhaps especially in the present. And before all else, achieving control over experience requires a drastic change in attitude about what is important and what is not.

We grow up believing that what counts most in our lives is that which will occur in the future. Parents teach children that if they learn good habits now, they will be better off as adults. Teachers assure pupils that the boring classes will benefit them later, when the students are going to be looking for jobs. The company vice president tells junior employees to have patience and work hard, because one of these days they will be promoted to the executive ranks. At the end of the long struggle for advancement, the golden years of retirement beckon. "We are always getting to live," as Ralph Waldo Emerson used to say, "but never living." Or as poor Frances learned in the children's story, it is always bread and jam tomorrow, never bread and jam today.

Of course this emphasis on the postponement of gratification is to a certain extent inevitable. As Freud and many others before and after him have noted, civilization is built on the repression of individual desires. It would be impossible to maintain any kind of social order, any complex division of labor, unless society's members were forced to take on the habits and skills that the culture required, whether the individuals liked it or not. Socialization, or the transformation of a human organism into a person who functions successfully within a particular social system, cannot be avoided. The essence of socialization is to make people dependent on social controls, to have them respond predictably to rewards and punishments. And the most effective form of socialization is achieved when people identify so thoroughly with the social order that they no longer can imagine themselves breaking any of its rules.

In making us work for its goals, society is assisted by some powerful allies: our biological needs and our genetic conditioning. All social controls, for instance, are ultimately based on a threat to the survival instinct. The people of an oppressed country obey their conquerors because they want to go on living. Until very recently, the laws of even the most civilized nations (such as Great Britain) were enforced by the threats of caning, whipping, mutilation, or death.

When they do not rely on pain, social systems use pleasure as the inducement to accept norms. The "good life" promised as a reward for a lifetime of work and adherence to laws is built on the cravings contained in our genetic programs. Practically every desire that has become part of human nature, from sexuality to aggression, from a longing for security to a receptivity to change, has been exploited as a source of social control by politicians, churches, corporations, and advertisers. To lure recruits into the Turkish armed forces, the sultans of the sixteenth century promised conscripts the rewards of raping women in the conquered territories; nowadays posters promise young men that if they join the army, they will "see the world."

It is important to realize that seeking pleasure is a reflex response built into our genes for the preservation of the species, not for the purpose of our own personal advantage. The pleasure we take in eating is an efficient way to ensure that the body will get the nourishment it needs. The pleasure of sexual intercourse is an equally practical method for the genes to program the body to reproduce and thereby to ensure the continuity of the genes. When a man is physically attracted to a woman, or vice versa, he usually imagines—assuming that he thinks about it at all—that this desire is an expression of his own individual interests, a result of his own intentions. In reality, more often than not his interest is simply being manipulated by the invisible genetic code,

following its own plans. As long as the attraction is a reflex based on purely physical reactions, the person's own conscious plans probably play only a minimal role. There is nothing wrong with following this genetic programming and relishing the resulting pleasures it provides, as long as we recognize them for what they are, and as long as we retain some control over them when it is necessary to pursue other goals, to which we might decide to assign priority.

The problem is that it has recently become fashionable to regard whatever we feel inside as the true voice of nature speaking. The only authority many people trust today is instinct. If something feels good, if it is natural and spontaneous, then it must be right. But when we follow the suggestions of genetic and social instructions without question we relinquish the control of consciousness and become helpless playthings of impersonal forces. The person who cannot resist food or alcohol, or whose mind is constantly focused on sex, is not free to direct his or her psychic energy.

The "liberated" view of human nature, which accepts and endorses every instinct or drive we happen to have simply because it's there, results in consequences that are quite reactionary. Much of contemporary "realism" turns out to be just a variation on good old-fashioned fatalism: people feel relieved of responsibility by recourse to the concept of "nature." By nature, however, we are born ignorant. Therefore should we not try to learn? Some people produce more than the usual amount of androgens and therefore become excessively aggressive. Does that mean they should freely express violence? We cannot deny the facts of nature, but we should certainly try to improve on them.

Submission to genetic programming can become quite dangerous, because it leaves us helpless. A person who cannot override genetic instructions when necessary is always vulnerable. Instead of deciding how to act in terms of personal goals, he has to surrender to the things that his body has been programmed (or misprogrammed) to do. One must particularly achieve control over instinctual drives to achieve a healthy independence of society, for as long as we respond predictably to what feels good and what feels bad, it is easy for others to exploit our preferences for their own ends.

A thoroughly socialized person is one who desires only the rewards that others around him have agreed he should long for—rewards often grafted onto genetically programmed desires. He may encounter thousands of potentially fulfilling experiences, but he fails to notice them because they are not the things he desires. What matters is not what he has now, but what he might obtain if he does as others want

him to do. Caught in the treadmill of social controls, that person keeps reaching for a prize that always dissolves in his hands. In a complex society, many powerful groups are involved in socializing, sometimes to seemingly contradictory goals. On the one hand, official institutions like schools, churches, and banks try to turn us into responsible citizens willing to work hard and save. On the other hand, we are constantly cajoled by merchants, manufacturers, and advertisers to spend our earnings on products that will produce the most profits for them. And, finally, the underground system of forbidden pleasures run by gamblers, pimps, and drug dealers, which is dialectically linked to the official institutions, promises its own rewards of easy dissipation—provided we pay. The messages are very different, but their outcome is essentially the same: they make us dependent on a social system that exploits our energies for its own purposes.

There is no question that to survive, and especially to survive in a complex society, it is necessary to work for external goals and to postpone immediate gratifications. But a person does not have to be turned into a puppet jerked about by social controls. The solution is to gradually become free of societal rewards and learn how to substitute for them rewards that are under one's own powers. This is not to say that we should abandon every goal endorsed by society; rather, it means that, in addition to or instead of the goals others use to bribe us with, we develop a set of our own.

The most important step in emancipating oneself from social controls is the ability to find rewards in the events of each moment. If a person learns to enjoy and find meaning in the ongoing stream of experience, in the process of living itself, the burden of social controls automatically falls from one's shoulders. Power returns to the person when rewards are no longer relegated to outside forces. It is no longer necessary to struggle for goals that always seem to recede into the future, to end each boring day with the hope that tomorrow, perhaps, something good will happen. Instead of forever straining for the tantalizing prize dangled just out of reach, one begins to harvest the genuine rewards of living. But it is not by abandoning ourselves to instinctual desires that we become free of social controls. We must also become independent from the dictates of the body, and learn to take charge of what happens in the mind. Pain and pleasure occur in consciousness and exist only there. As long as we obey the socially conditioned stimulus-response patterns that exploit our biological inclinations, we are controlled from the outside. To the extent that a glamorous ad makes us salivate for the product sold or that a frown from the boss spoils the day,

we are not free to determine the content of experience. Since what we experience *is* reality, as far as we are concerned, we can transform reality to the extent that we influence what happens in consciousness and thus free ourselves from the threats and blandishments of the outside world. "Men are not afraid of things, but of how they view them," said Epictetus a long time ago. And the great emperor Marcus Aurelius wrote: "If you are pained by external things, it is not they that disturb you, but your own judgment of them. And it is in your power to wipe out that judgment now."

PATHS OF LIBERATION

This simple truth—that the control of consciousness determines the quality of life—has been known for a long time; in fact, for as long as human records exist. The oracle's advice in ancient Delphi, "Know thyself," implied it. It was clearly recognized by Aristotle, whose notion of the "virtuous activity of the soul" in many ways prefigures the argument of this book, and it was developed by the Stoic philosophers in classical antiquity. The Christian monastic orders perfected various methods for learning how to channel thoughts and desires. Ignatius of Loyola rationalized them in his famous spiritual exercises. The last great attempt to free consciousness from the domination of impulses and social controls was psychoanalysis; as Freud pointed out, the two tyrants that fought for control over the mind were the id and the superego, the first a servant of the genes, the second a lackey of society—both representing the "Other." Opposed to them was the ego, which stood for the genuine needs of the self connected to its concrete environment.

 In the East techniques for achieving control over consciousness proliferated and achieved levels of enormous sophistication. Although quite different from one another in many respects, the yogi disciplines in India, the Taoist approach to life developed in China, and the Zen varieties of Buddhism all seek to free consciousness from the deterministic influences of outside forces—be they biological or social in nature. Thus, for instance, a yogi disciplines his mind to ignore pain that ordinary people would have no choice but to let into their awareness; similarly he can ignore the insistent claims of hunger or sexual arousal that most people would be helpless to resist. The same effect can be achieved in different ways, either through perfecting a severe mental discipline as in Yoga or through cultivating constant spontaneity as in Zen. But the intended result is identical: to free inner life from the threat of chaos, on the one hand, and from the rigid conditioning of biological

urges, on the other, and hence to become independent from the social controls that exploit both.

But if it is true that people have known for thousands of years what it takes to become free and in control of one's life, why haven't we made more progress in this direction? Why are we as helpless, or more so, than our ancestors were in facing the chaos that interferes with happiness? There are at least two good explanations for this failure. In the first place, the kind of knowledge—or wisdom—one needs for emancipating consciousness is not cumulative. It cannot be condensed into a formula; it cannot be memorized and then routinely applied. Like other complex forms of expertise, such as a mature political judgment or a refined aesthetic sense, it must be earned through trial-and-error experience by each individual, generation after generation. Control over consciousness is not simply a cognitive skill. At least as much as intelligence, it requires the commitment of emotions and will. It is not enough to *know* how to do it; one must *do* it, consistently, in the same way as athletes or musicians who must keep practicing what they know in theory. And this is never easy. Progress is relatively fast in fields that apply knowledge to the material world, such as physics or genetics. But it is painfully slow when knowledge is to be applied to modify our own habits and desires.

Second, the knowledge of how to control consciousness must be reformulated every time the cultural context changes. The wisdom of the mystics, of the Sufi, of the great yogis, or of the Zen masters might have been excellent in their own time—and might still be the best, if we lived in those times and in those cultures. But when transplanted to contemporary California those systems lose quite a bit of their original power. They contain elements that are specific to their original contexts, and when these accidental components are not distinguished from what is essential, the path to freedom gets overgrown by brambles of meaningless mumbo jumbo. Ritual form wins over substance, and the seeker is back where he started.

Control over consciousness cannot be institutionalized. As soon as it becomes part of a set of social rules and norms, it ceases to be effective in the way it was originally intended to be. Routinization, unfortunately, tends to take place very rapidly. Freud was still alive when his quest for liberating the ego from its oppressors was turned into a staid ideology and a rigidly regulated profession. Marx was even less fortunate: his attempts to free consciousness from the tyranny of economic exploitation were soon turned into a system of repression that would have boggled the poor founder's mind. And as Dostoevsky

among many others observed, if Christ had returned to preach his message of liberation in the Middle Ages, he would have been crucified again and again by the leaders of that very church whose worldly power was built on his name.

In each new epoch—perhaps every generation, or even every few years, if the conditions in which we live change that rapidly—it becomes necessary to rethink and reformulate what it takes to establish autonomy in consciousness. Early Christianity helped the masses free themselves from the power of the ossified imperial regime and from an ideology that could give meaning only to the lives of the rich and the powerful. The Reformation liberated great numbers of people from their political and ideological exploitation by the Roman Church. The *philosophes* and later the statesmen who drafted the American Constitution resisted the controls established by kings, popes, and aristocracy. When the inhuman conditions of factory labor became the most obvious obstacles to the workers' freedom to order their own experience, as they were in nineteenth-century industrial Europe, Marx's message turned out to be especially relevant. The much more subtle but equally coercive social controls of bourgeois Vienna made Freud's road to liberation pertinent to those whose minds had been warped by such conditions. The insights of the Gospels, of Martin Luther, of the framers of the Constitution, of Marx and Freud—just to mention a very few of those attempts that have been made in the West to increase happiness by enhancing freedom—will always be valid and useful, even though some of them have been perverted in their application. But they certainly do not exhaust either the problems or the solutions.

Given the recurring need to return to this central question of how to achieve mastery over one's life, what does the present state of knowledge say about it? How can it help a person learn to rid himself of anxieties and fears and thus become free of the controls of society, whose rewards he can now take or leave? As suggested before, the way is through control over consciousness, which in turn leads to control over the quality of experience. Any small gain in that direction will make life more rich, more enjoyable, more meaningful. Before starting to explore ways in which to improve the quality of experience, it will be useful to review briefly how consciousness works and what it actually means to have "experiences." Armed with this knowledge, one can more easily achieve personal liberation.

THE ANATOMY
OF CONSCIOUSNESS

AT CERTAIN TIMES in history cultures have taken it for granted that a
person wasn't fully human unless he or she learned to master thoughts
and feelings. In Confucian China, in ancient Sparta, in Republican
Rome, in the early Pilgrim settlements of New England, and among the
British upper classes of the Victorian era, people were held responsible
for keeping a tight rein on their emotions. Anyone who indulged in
self-pity, who let instinct rather than reflection dictate actions, forfeited
the right to be accepted as a member of the community. In other
historical periods, such as the one in which we are now living, the ability
to control oneself is not held in high esteem. People who attempt it are
thought to be faintly ridiculous, "uptight," or not quite "with it." But
whatever the dictates of fashion, it seems that those who take the trouble
to gain mastery over what happens in consciousness do live a happier
life.

 To achieve such mastery it is obviously important to understand
how consciousness works. In the present chapter, we shall take a step
in that direction. To begin with, and just to clear the air of any suspicion
that in talking about consciousness we are referring to some mysterious
process, we should recognize that, like every other dimension of human
behavior, it is the result of biological processes. It exists only because of
the incredibly complex architecture of our nervous system, which in
turn is built up according to instructions contained in the protein

molecules of our chromosomes. At the same time, we should also recognize that the way in which consciousness works is not entirely controlled by its biological programming—in many important respects that we shall review in the pages that follow, it is self-directed. In other words, consciousness has developed the ability to override its genetic instructions and to set its own independent course of action.

The function of consciousness is to represent information about what is happening outside and inside the organism in such a way that it can be evaluated and acted upon by the body. In this sense, it functions as a clearinghouse for sensations, perceptions, feelings, and ideas, establishing priorities among all the diverse information. Without consciousness we would still "know" what is going on, but we would have to react to it in a reflexive, instinctive way. With consciousness, we can deliberately weigh what the senses tell us, and respond accordingly. And we can also invent information that did not exist before: it is because we have consciousness that we can daydream, make up lies, and write beautiful poems and scientific theories.

Over the endless dark centuries of its evolution, the human nervous system has become so complex that it is now able to affect its own states, making it to a certain extent functionally independent of its genetic blueprint and of the objective environment. A person can make himself happy, or miserable, regardless of what is actually happening "outside," just by changing the contents of consciousness. We all know individuals who can transform hopeless situations into challenges to be overcome, just through the force of their personalities. This ability to persevere despite obstacles and setbacks is the quality people most admire in others, and justly so; it is probably the most important trait not only for succeeding in life, but for enjoying it as well.

To develop this trait, one must find ways to order consciousness so as to be in control of feelings and thoughts. It is best not to expect that shortcuts will do the trick. Some people have a tendency to become very mystical when talking about consciousness and expect it to accomplish miracles that at present it is not designed to perform. They would like to believe that anything is possible in what they think of as the spiritual realm. Other individuals claim the power to channel into past existences, to communicate with spiritual entities, and to perform uncanny feats of extrasensory perception. When not outright frauds, these accounts usually turn out to be self-delusions—lies that an overly receptive mind tells itself.

The remarkable accomplishments of Hindu fakirs and other practitioners of mental disciplines are often presented as examples of the

unlimited powers of the mind, and with more justification. But even many of these claims do not hold up under investigation, and the ones that do can be explained in terms of the extremely specialized training of a normal mind. After all, mystical explanations are not necessary to account for the performance of a great violinist, or a great athlete, even though most of us could not even begin to approach their powers. The yogi, similarly, is a virtuoso of the control of consciousness. Like all virtuosi, he must spend many years learning, and he must keep constantly in training. Being a specialist, he cannot afford the time or the mental energy to do anything other than fine-tune his skill at manipulating inner experiences. The skills the yogi gains are at the expense of the more mundane abilities that other people learn to develop and take for granted. What an individual yogi can do is amazing—but so is what a plumber can do, or a good mechanic.

Perhaps in time we shall discover hidden powers of the mind that will allow it to make the sort of quantum leaps that now we can only dream about. There is no reason to rule out the possibility that eventually we shall be able to bend spoons with brain waves. But at this point, when there are so many more mundane but no less urgent tasks to accomplish, it seems a waste of time to lust for powers beyond our reach when consciousness, with all its limitations, could be employed so much more effectively. Although in its present state it cannot do what some people would wish it to do, the mind has enormous untapped potential that we desperately need to learn how to use.

Because no branch of science deals with consciousness directly, there is no single accepted description of how it works. Many disciplines touch on it and thus provide peripheral accounts. Neuroscience, neuroanatomy, cognitive science, artificial intelligence, psychoanalysis, and phenomenology are some of the most directly relevant fields to choose from; however, trying to summarize their findings would result in an account similar to the descriptions the blind men gave of the elephant: each different, and each unrelated to the others. No doubt we shall continue to learn important things about consciousness from these disciplines, but in the meantime we are left with the task of providing a model that is grounded in fact, yet expressed simply enough so that anyone can make use of it.

Although it sounds like indecipherable academic jargon, the most concise description of the approach I believe to be the clearest way to examine the main facets of what happens in the mind, in a way that can be useful in the actual practice of everyday life, is "a phenomenological model of consciousness based on information theory." This representa-

tion of consciousness is *phenomenological* in that it deals directly with events—phenomena—as we experience and interpret them, rather than focusing on the anatomical structures, neurochemical processes, or unconscious purposes that make these events possible. Of course, it is understood that whatever happens in the mind is the result of electrochemical changes in the central nervous system, as laid down over millions of years by biological evolution. But phenomenology assumes that a mental event can be best understood if we look at it directly as it was experienced, rather than through the specialized optics of a particular discipline. Yet in contrast to pure phenomenology, which intentionally excludes any other theory or science from its method, the model we will explore here adopts principles from *information theory* as being relevant for understanding what happens in consciousness. These principles include knowledge about how sensory data are processed, stored, and used—the dynamics of attention and memory.

With this framework in mind, what, then, does it mean to be conscious? It simply means that certain specific *conscious events* (sensations, feelings, thoughts, intentions) are occurring, and that we are able to direct their course. In contrast, when we are dreaming, some of the same events are present, yet we are not conscious because we cannot control them. For instance, I may dream of having received news of a relative's being involved in an accident, and I may feel very upset. I might think, "I wish I could be of help." Despite the fact that I perceive, feel, think, and form intentions in the dream, I cannot act on these processes (by making provisions for checking out the truthfulness of the news, for example) and hence, I am not conscious. In dreams we are locked into a single scenario we cannot change at will. The events that constitute consciousness—the "things" we see, feel, think, and desire—are information that we can manipulate and use. Thus we might think of consciousness as *intentionally ordered information.*

This dry definition, accurate as it is, does not fully suggest the importance of what it conveys. Since for us outside events do not exist unless we are aware of them, consciousness corresponds to subjectively experienced reality. While everything we feel, smell, hear, or remember is potentially a candidate for entering consciousness, the experiences that actually do become part of it are much fewer than those left out. Thus, while consciousness is a mirror that reflects what our senses tell us about what happens both outside our bodies and within the nervous system, it reflects those changes selectively, actively shaping events, imposing on them a reality of its own. The reflection consciousness provides is what we call *our* life: the sum of all we have heard, seen, felt,

hoped, and suffered from birth to death. Although we believe that there are "things" outside consciousness, we have direct evidence only of those that find a place in it.

As the central clearinghouse in which varied events processed by different senses can be represented and compared, consciousness can contain a famine in Africa, the smell of a rose, the performance of the Dow Jones, and a plan to stop at the store to buy some bread all at the same time. But that does not mean that its content is a shapeless jumble.

We may call *intentions* the force that keeps information in consciousness ordered. Intentions arise in consciousness whenever a person is aware of desiring something or wanting to accomplish something. Intentions are also bits of information, shaped either by biological needs or by internalized social goals. They act as magnetic fields, moving attention toward some objects and away from others, keeping our mind focused on some stimuli in preference to others. We often call the manifestation of intentionality by other names, such as instinct, need, drive, or desire. But these are all explanatory terms, telling us why people behave in certain ways. Intention is a more neutral and descriptive term; it doesn't say *why* a person wants to do a certain thing, but simply states *that* he does.

For instance, whenever blood sugar level drops below a critical point, we start feeling uneasy: we might feel irritable and sweaty, and get stomach cramps. Because of genetically programmed instructions to restore the level of sugar in the blood, we might start thinking about food. We will look for food until we eat and are no longer hungry. In this instance we could say that it was the hunger drive that organized the content of consciousness, forcing us to focus attention on food. But this is already an interpretation of the facts—no doubt chemically accurate, but phenomenologically irrelevant. The hungry person is not aware of the level of sugar in his bloodstream; he knows only that there is a bit of information in his consciousness that he has learned to identify as "hunger."

Once the person is aware that he is hungry, he might very well form the intention of obtaining some food. If he does so, his behavior will be the same as if he were simply obeying a need or drive. But alternatively, he could disregard the pangs of hunger entirely. He might have some stronger and opposite intentions, such as losing weight, or wanting to save money, or fasting for religious reasons. Sometimes, as in the case of political protesters who wish to starve themselves to death, the intention of making an ideological statement might override genetic instructions, resulting in voluntary death.

The intentions we either inherit or acquire are organized in hierarchies of goals, which specify the order of precedence among them. For the protester, achieving a given political reform may be more important than anything else, life included. That one goal takes precedence over all others. Most people, however, adopt "sensible" goals based on the needs of their body—to live a long and healthy life, to have sex, to be well fed and comfortable—or on the desires implanted by the social system—to be good, to work hard, to spend as much as possible, to live up to others' expectations. But there are enough exceptions in every culture to show that goals are quite flexible. Individuals who depart from the norms—heroes, saints, sages, artists, and poets, as well as madmen and criminals—look for different things in life than most others do. The existence of people like these shows that consciousness can be ordered in terms of different goals and intentions. Each of us has this freedom to control our subjective reality.

THE LIMITS OF CONSCIOUSNESS

If it were possible to expand indefinitely what consciousness is able to encompass, one of the most fundamental dreams of humankind would come true. It would be almost as good as being immortal or omnipotent—in short, godlike. We could think everything, feel everything, do everything, scan through so much information that we could fill up every fraction of a second with a rich tapestry of experiences. In the space of a lifetime we could go through a million, or—why not?—through an infinite number of lives.

Unfortunately, the nervous system has definite limits on how much information it can process at any given time. There are just so many "events" that can appear in consciousness and be recognized and handled appropriately before they begin to crowd each other out. Walking across a room while chewing gum at the same time is not too difficult, even though some statesmen have been alleged to be unable to do it; but, in fact, there is not that much more that can be done concurrently. Thoughts have to follow each other, or they get jumbled. While we are thinking about a problem we cannot truly experience either happiness or sadness. We cannot run, sing, and balance the checkbook simultaneously, because each one of these activities exhausts most of our capacity for attention.

At this point in our scientific knowledge we are on the verge of being able to estimate how much information the central nervous system is capable of processing. It seems we can manage at most seven bits of

information—such as differentiated sounds, or visual stimuli, or recognizable nuances of emotion or thought—at any one time, and that the shortest time it takes to discriminate between one set of bits and another is about 1/18 of a second. By using these figures one concludes that it is possible to process at most 126 bits of information per second, or 7,560 per minute, or almost half a million per hour. Over a lifetime of seventy years, and counting sixteen hours of waking time each day, this amounts to about 185 billion bits of information. It is out of this total that everything in our life must come—every thought, memory, feeling, or action. It seems like a huge amount, but in reality it does not go that far.

The limitation of consciousness is demonstrated by the fact that to understand what another person is saying we must process 40 bits of information each second. If we assume the upper limit of our capacity to be 126 bits per second, it follows that to understand what three people are saying simultaneously is theoretically possible, but only by managing to keep out of consciousness every other thought or sensation. We couldn't, for instance, be aware of the speakers' expressions, nor could we wonder about why they are saying what they are saying, or notice what they are wearing.

Of course, these figures are only suggestive at this point in our knowledge of the way the mind works. It could be argued justifiably that they either underestimate or overestimate the capacity of the mind to process information. The optimists claim that through the course of evolution the nervous system has become adept at "chunking" bits of information so that processing capacity is constantly expanded. Simple functions like adding a column of numbers or driving a car grow to be automated, leaving the mind free to deal with more data. We also learn how to compress and streamline information through symbolic means—language, math, abstract concepts, and stylized narratives. Each biblical parable, for instance, tries to encode the hard-won experience of many individuals over unknown eons of time. Consciousness, the optimists argue, is an "open system"; in effect, it is infinitely expandable, and there is no need to take its limitations into account.

But the ability to compress stimuli does not help as much as one might expect. The requirements of life still dictate that we spend about 8 percent of waking time eating, and almost the same amount taking care of personal bodily needs such as washing, dressing, shaving, and going to the bathroom. These two activities alone take up 15 percent of consciousness, and while engaged in them we can't do much else that requires serious concentration. But even when there is nothing else

pressing occupying their minds, most people fall far below the peak capacity for processing information. In the roughly one-third of the day that is free of obligations, in their precious "leisure" time, most people in fact seem to use their minds as little as possible. The largest part of free time—almost half of it for American adults—is spent in front of the television set. The plots and characters of the popular shows are so repetitive that although watching TV requires the processing of visual images, very little else in the way of memory, thinking, or volition is required. Not surprisingly, people report some of the lowest levels of concentration, use of skills, clarity of thought, and feelings of potency when watching television. The other leisure activities people usually do at home are only a little more demanding. Reading most newspapers and magazines, talking to other people, and gazing out the window also involve processing very little new information, and thus require little concentration.

So the 185 billion events to be enjoyed over our mortal days might be either an overestimate or an underestimate. If we consider the amount of data the brain could theoretically process, the number might be too low; but if we look at how people actually use their minds, it is definitely much too high. In any case, an individual can experience only so much. Therefore, the information we allow into consciousness becomes extremely important; it is, in fact, what determines the content and the quality of life.

ATTENTION AS PSYCHIC ENERGY

Information enters consciousness either because we intend to focus attention on it or as a result of attentional habits based on biological or social instructions. For instance, driving down the highway, we pass hundreds of cars without actually being aware of them. Their shape and color might register for a fraction of a second, and then they are immediately forgotten. But occasionally we notice a particular vehicle, perhaps because it is swerving unsteadily between lanes, or because it is moving very slowly, or because of its unusual appearance. The image of the unusual car enters the focus of consciousness, and we become aware of it. In the mind the visual information about the car (e.g., "it is swerving") gets related to information about other errant cars stored in memory, to determine into which category the present instance fits. Is this an inexperienced driver, a drunken driver, a momentarily distracted but competent driver? As soon as the event is matched to an already known class of events, it is identified. Now it must be evaluated: Is this

something to worry about? If the answer is yes, then we must decide on an appropriate course of action: Should we speed up, slow down, change lanes, stop and alert the highway patrol?

All these complex mental operations must be completed in a few seconds, sometimes in a fraction of a second. While forming such a judgment seems to be a lightning-fast reaction, it does take place in real time. And it does not happen automatically: there is a distinct process that makes such reactions possible, a process called *attention*. It is attention that selects the relevant bits of information from the potential millions of bits available. It takes attention to retrieve the appropriate references from memory, to evaluate the event, and then to choose the right thing to do.

Despite its great powers, attention cannot step beyond the limits already described. It cannot notice or hold in focus more information than can be processed simultaneously. Retrieving information from memory storage and bringing it into the focus of awareness, comparing information, evaluating, deciding—all make demands on the mind's limited processing capacity. For example, the driver who notices the swerving car will have to stop talking on his cellular phone if he wants to avoid an accident.

Some people learn to use this priceless resource efficiently, while others waste it. The mark of a person who is in control of consciousness is the ability to focus attention at will, to be oblivious to distractions, to concentrate for as long as it takes to achieve a goal, and not longer. And the person who can do this usually enjoys the normal course of everyday life.

Two very different individuals come to mind to illustrate how attention can be used to order consciousness in the service of one's goals. The first is E., a European woman who is one of the best-known and powerful women in her country. A scholar of international reputation, she has at the same time built up a thriving business that employs hundreds of people and has been on the cutting edge of its field for a generation. E. travels constantly to political, business, and professional meetings, moving among her several residences around the world. If there is a concert in the town where she is staying, E. will probably be in the audience; at the first free moment she will be at the museum or library. And while she is in a meeting, her chauffeur, instead of just standing around and waiting, will be expected to visit the local art gallery or museum; for on the way home, his employer will want to discuss what he thought of its paintings.

Not one minute of E.'s life is wasted. Usually she is writing, solving

problems, reading one of the five newspapers or the earmarked sections of books on her daily schedule—or just asking questions, watching curiously what is going on, and planning her next task. Very little of her time is spent on the routine functions of life. Chatting or socializing out of mere politeness is done graciously, but avoided whenever possible. Each day, however, she devotes some time to recharging her mind, by such simple means as standing still for fifteen minutes on the lakeshore, facing the sun with eyes closed. Or she may take her hounds for a walk in the meadows on the hill outside town. E. is so much in control of her attentional processes that she can disconnect her consciousness at will and fall asleep for a refreshing nap whenever she has a moment free.

E.'s life has not been easy. Her family became impoverished after World War I, and she herself lost everything, including her freedom, during World War II. Several decades ago she had a chronic disease her doctors were sure was fatal. But she recovered everything, including her health, by disciplining her attention and refusing to diffuse it on unproductive thoughts or activities. At this point she radiates a pure glow of energy. And despite past hardships and the intensity of her present life, she seems to relish thoroughly every minute of it.

The second person who comes to mind is in many ways the opposite of E., the only similarity being the same unbending sharpness of attention. R. is a slight, at first sight unprepossessing man. Shy, modest to the point of self-effacement, he would be easy to forget immediately after a short meeting. Although he is known to only a few, his reputation among them is very great. He is master of an arcane branch of scholarship, and at the same time the author of exquisite verse translated into many languages. Every time one speaks to him, the image of a deep well full of energy comes to mind. As he talks, his eyes take in everything; every sentence he hears is analyzed three or four different ways even before the speaker has finished saying it. Things that most people take for granted puzzle him; and until he figures them out in an original yet perfectly appropriate way, he will not let them be.

Yet despite this constant effort of focused intelligence, R. gives the impression of restfulness, of calm serenity. He always seems aware of the tiniest ripples of activity in his surroundings. But R. does not notice things in order to change them or judge them. He is content to register reality, to understand, and then, perhaps, to express his understanding. R. is not going to make the immediate impact on society that E. has. But his consciousness is just as ordered and complex; his attention is stretched as far as it can go, interacting with the world around him. And like E., he seems to enjoy his life intensely.

Each person allocates his or her limited attention either by focusing it intentionally like a beam of energy—as do E. and R. in the previous examples—or by diffusing it in desultory, random movements. The shape and content of life depend on how attention has been used. Entirely different realities will emerge depending on how it is invested. The names we use to describe personality traits—such as *extrovert, high achiever,* or *paranoid*—refer to the specific patterns people have used to structure their attention. At the same party, the extrovert will seek out and enjoy interactions with others, the high achiever will look for useful business contacts, and the paranoid will be on guard for signs of danger he must avoid. Attention can be invested in innumerable ways, ways that can make life either rich or miserable.

The flexibility of attentional structures is even more obvious when they are compared across cultures or occupational classes. Eskimo hunters are trained to discriminate between dozens of types of snow, and are always aware of the direction and speed of the wind. Traditional Melanesian sailors can be taken blindfolded to any point of the ocean within a radius of several hundred miles from their island home and, if allowed to float for a few minutes in the sea, are able to recognize the spot by the feel of the currents on their bodies. A musician structures her attention so as to focus on nuances of sound that ordinary people are not aware of, a stockbroker focuses on tiny changes in the market that others do not register, a good clinical diagnostician has an uncanny eye for symptoms—because they have trained their attention to process signals that otherwise would pass unnoticed.

Because attention determines what will or will not appear in consciousness, and because it is also required to make any other mental events—such as remembering, thinking, feeling, and making decisions—happen there, it is useful to think of it as *psychic energy.* Attention is like energy in that without it no work can be done, and in doing work it is dissipated. We create ourselves by how we invest this energy. Memories, thoughts, and feelings are all shaped by how we use it. And it is an energy under our control, to do with as we please; hence, attention is our most important tool in the task of improving the quality of experience.

ENTER THE SELF

But what do those first-person pronouns refer to in the lines above, those *we*s and *our*s that are supposed to control attention? Where is the *I,* the entity that decides what to do with the psychic energy generated

by the nervous system? Where does the captain of the ship, the master of the soul, reside?

As soon as we consider these questions for even a short while, we realize that the *I*, or the *self* as we shall refer to it from now on, is also one of the contents of consciousness. It is one that never strays very far from the focus of attention. Of course my own self exists solely in my own consciousness; in that of others who know me there will be versions of it, most of them probably unrecognizable likenesses of the "original"—myself as I see me.

The self is no ordinary piece of information, however. In fact, it contains everything else that has passed through consciousness: all the memories, actions, desires, pleasures, and pains are included in it. And more than anything else, the self represents the hierarchy of goals that we have built up, bit by bit, over the years. The self of the political activist may become indistinguishable from his ideology, the self of the banker may become wrapped up in his investments. Of course, ordinarily we do not think of our self in this way. At any given time, we are usually aware of only a tiny part of it, as when we become conscious of how we look, of what impression we are making, or of what we really would like to do if we could. We most often associate our self with our body, though sometimes we extend its boundaries to identify it with a car, house, or family. Yet however much we are aware of it, the self is in many ways the most important element of consciousness, for it represents symbolically all of consciousness's other contents, as well as the pattern of their interrelations.

The patient reader who has followed the argument so far might detect at this point a faint trace of circularity. If attention, or psychic energy, is directed by the self, and if the self is the sum of the contents of consciousness and the structure of its goals, and if the contents of consciousness and the goals are the result of different ways of investing attention, then we have a system that is going round and round, with no clear causes or effects. At one point we are saying that the self directs attention, at another, that attention determines the self. In fact, both these statements are true: consciousness is not a strictly linear system, but one in which circular causality obtains. Attention shapes the self, and is in turn shaped by it.

An example of this type of causality is the experience of Sam Browning, one of the adolescents we have followed in our longitudinal research studies. Sam went to Bermuda for a Christmas holiday with his father when he was fifteen. At the time, he had no idea of what he wanted to do with his life; his self was relatively unformed, without an

identity of its own. Sam had no clearly differentiated goals; he wanted exactly what other boys his age are supposed to want, either because of their genetic programs or because of what the social environment told them to want—in other words, he thought vaguely of going to college, then later finding some kind of well-paying job, getting married, and living somewhere in the suburbs. In Bermuda, Sam's father took him on an excursion to a coral barrier, and they dove underwater to explore the reef. Sam couldn't believe his eyes. He found the mysterious, beautifully dangerous environment so enchanting that he decided to become more familiar with it. He ended up taking a number of biology courses in high school, and is now in the process of becoming a marine scientist.

In Sam's case an accidental event imposed itself on his consciousness: the challenging beauty of life in the ocean. He had not planned to have this experience; it was not the result of his self or his goals having directed attention to it. But once he became aware of what went on undersea, Sam *liked* it—the experience resonated with previous things he had enjoyed doing, with feelings he had about nature and beauty, with priorities about what was important that he had established over the years. He felt the experience was something good, something worth seeking out again. Thus he built this accidental event into a structure of goals—to learn more about the ocean, to take courses, to go on to college and graduate school, to find a job as a marine biologist—which became a central element of his self. From then on, his goals directed Sam's attention to focus more and more closely on the ocean and on its life, thereby closing the circle of causality. At first attention helped to shape his self, when he noticed the beauties of the underwater world he had been exposed to by accident; later, as he intentionally sought knowledge in marine biology, his self began to shape his attention. There is nothing very unusual about Sam's case, of course; most people develop their attentional structures in similar ways.

At this point, almost all the components needed to understand how consciousness can be controlled are in place. We have seen that experience depends on the way we invest psychic energy—on the structure of attention. This, in turn, is related to goals and intentions. These processes are connected to each other by the self, or the dynamic mental representation we have of the entire system of our goals. These are the pieces that must be maneuvered if we wish to improve things. Of course, existence can also be improved by outside events, like winning a million dollars in the lottery, marrying the right man or woman, or helping to change an unjust social system. But even these marvelous events must take their place in consciousness, and be connected in positive ways to

our self, before they can affect the quality of life.

The structure of consciousness is beginning to emerge, but so far we have a rather static picture, one that has sketched out the various elements, but not the processes through which they interact. We need now consider what follows whenever attention brings a new bit of information into awareness. Only then will we be ready to get a thorough sense of how experience can be controlled, and hence changed for the better.

DISORDER IN CONSCIOUSNESS: PSYCHIC ENTROPY

One of the main forces that affects consciousness adversely is psychic disorder—that is, information that conflicts with existing intentions, or distracts us from carrying them out. We give this condition many names, depending on how we experience it: pain, fear, rage, anxiety, or jealousy. All these varieties of disorder force attention to be diverted to undesirable objects, leaving us no longer free to use it according to our preferences. Psychic energy becomes unwieldy and ineffective.

Consciousness can become disordered in many ways. For instance, in a factory that produces audiovisual equipment, Julio Martinez—one of the people we studied with the Experience Sampling Method—is feeling listless on his job. As the movie projectors pass in front of him on the assembly line, he is distracted and can hardly keep up the rhythm of moves necessary for soldering the connections that are his responsibility. Usually he can do his part of the job with time to spare and then relax for a while to exchange a few jokes before the next unit stops at his station. But today he is struggling, and occasionally he slows down the entire line. When the man at the next station kids him about it, Julio snaps back irritably. From morning to quitting time tension keeps building, and it spills over to his relationship with his co-workers.

Julio's problem is simple, almost trivial, but it has been weighing heavily on his mind. One evening a few days earlier he noticed on arriving home from work that one of his tires was quite low. Next morning the rim of the wheel was almost touching the ground. Julio would not receive his paycheck till the end of the following week, and he was certain he would not have enough money until then to have the tire patched up, let alone buy a new one. Credit was something he had not yet learned to use. The factory was out in the suburbs, about twenty miles from where he lived, and he simply had to reach it by 8:00 A.M. The only solution Julio could think of was to drive gingerly to the service

station in the morning, fill the tire with air, and then drive to work as quickly as possible. After work the tire was low again, so he inflated it at a gas station near the factory and drove home.

On the morning in question, he had been doing this for three days, hoping the procedure would work until the next paycheck. But today, by the time he made it to the factory, he could hardly steer the car because the wheel with the bum tire was so flat. All through the day he worried: "Will I make it home tonight? How will I get to work tomorrow morning?" These questions kept intruding in his mind, disrupting concentration on his work and throwing a pall on his moods.

Julio is a good example of what happens when the internal order of the self is disrupted. The basic pattern is always the same: some information that conflicts with an individual's goals appears in consciousness. Depending on how central that goal is to the self and on how severe the threat to it is, some amount of attention will have to be mobilized to eliminate the danger, leaving less attention free to deal with other matters. For Julio, holding a job was a goal of very high priority. If he were to lose it, all his other goals would be compromised; therefore keeping it was essential to maintain the order of his self. The flat tire was jeopardizing the job, and consequently it absorbed a great deal of his psychic energy.

Whenever information disrupts consciousness by threatening its goals we have a condition of inner disorder, or *psychic entropy*, a disorganization of the self that impairs its effectiveness. Prolonged experiences of this kind can weaken the self to the point that it is no longer able to invest attention and pursue its goals.

Julio's problem was relatively mild and transient. A more chronic example of psychic entropy is the case of Jim Harris, a greatly talented high school sophomore who was in one of our surveys. Alone at home on a Wednesday afternoon, he was standing in front of the mirror in the bedroom his parents used to share. On the box at his feet, a tape of the Grateful Dead was playing, as it had been almost without interruption for the past week. Jim was trying on one of his father's favorite garments, a heavy green chamois shirt his father had worn whenever the two had gone camping together. Passing his hand over the warm fabric, Jim remembered the cozy feeling of being snuggled up to his dad in the smoky tent, while the loons were laughing across the lake. In his right hand, Jim was holding a pair of large sewing scissors. The sleeves were too long for him, and he was wondering if he dared to trim them. Dad would be furious . . . or would he even notice? A few hours later, Jim was lying in his bed. On the nightstand beside him was a bottle of

aspirin, now empty, although there had been seventy tablets in it just a while before.

Jim's parents had separated a year earlier, and now they were getting a divorce. During the week while he was in school, Jim lived with his mother. Friday evenings he packed up to go and stay in his father's new apartment in the suburbs. One of the problems with this arrangement was that he was never able to be with his friends: during the week they were all too busy, and on weekends Jim was stranded in foreign territory where he knew nobody. He spent his free time on the phone, trying to make connections with his friends. Or he listened to tapes that he felt echoed the solitude gnawing inside him. But the worst thing, Jim felt, was that his parents were constantly battling for his loyalty. They kept making snide remarks about each other, trying to make Jim feel guilty if he showed any interest or love toward one in the presence of the other. "Help!" he scribbled in his diary a few days before his attempted suicide. "I don't want to hate my Mom, I don't want to hate my Dad. I wish they stopped doing this to me."

Luckily that evening Jim's sister noticed the empty bottle of aspirin and called her mother, and Jim ended up in the hospital, where his stomach was pumped and he was set back on his feet in a few days. Thousands of kids his age are not that fortunate.

The flat tire that threw Julio into a temporary panic and the divorce that almost killed Jim don't act directly as physical causes producing a physical effect—as, for instance, one billiard ball hitting another and making it carom in a predictable direction. The outside event appears in consciousness purely as information, without necessarily having a positive or negative value attached to it. It is the self that interprets that raw information in the context of its own interests, and determines whether it is harmful or not. For instance, if Julio had had more money or some credit, his problem would have been perfectly innocuous. If in the past he had invested more psychic energy in making friends on the job, the flat tire would not have created panic, because he could have always asked one of his co-workers to give him a ride for a few days. And if he had had a stronger sense of self-confidence, the temporary setback would not have affected him as much because he would have trusted his ability to overcome it eventually. Similarly, if Jim had been more independent, the divorce would not have affected him as deeply. But at his age his goals must have still been bound up too closely with those of his mother and father, so that the split between them also split his sense of self. Had he had closer friends or a longer record of goals successfully achieved, his self would have had the strength to maintain its integrity.

He was lucky that after the breakdown his parents realized the predicament and sought help for themselves and their son, reestablishing a stable enough relationship with Jim to allow him to go on with the task of building a sturdy self.

Every piece of information we process gets evaluated for its bearing on the self. Does it threaten our goals, does it support them, or is it neutral? News of the fall of the stock market will upset the banker, but it might reinforce the sense of self of the political activist. A new piece of information will either create disorder in consciousness, by getting us all worked up to face the threat, or it will reinforce our goals, thereby freeing up psychic energy.

ORDER IN CONSCIOUSNESS: FLOW

The opposite state from the condition of psychic entropy is optimal experience. When the information that keeps coming into awareness is congruent with goals, psychic energy flows effortlessly. There is no need to worry, no reason to question one's adequacy. But whenever one does stop to think about oneself, the evidence is encouraging: "You are doing all right." The positive feedback strengthens the self, and more attention is freed to deal with the outer and the inner environment.

Another one of our respondents, a worker named Rico Medellin, gets this feeling quite often on his job. He works in the same factory as Julio, a little further up on the assembly line. The task he has to perform on each unit that passes in front of his station should take forty-three seconds to perform—the same exact operation almost six hundred times in a working day. Most people would grow tired of such work very soon. But Rico has been at this job for over five years, and he still enjoys it. The reason is that he approaches his task in the same way an Olympic athlete approaches his event: How can I beat my record? Like the runner who trains for years to shave a few seconds off his best performance on the track, Rico has trained himself to better his time on the assembly line. With the painstaking care of a surgeon, he has worked out a private routine for how to use his tools, how to do his moves. After five years, his best average for a day has been twenty-eight seconds per unit. In part he tries to improve his performance to earn a bonus and the respect of his supervisors. But most often he does not even let on to others that he is ahead and lets his success pass unnoticed. It is enough to know that he can do it, because when he is working at top performance the experience is so enthralling that it is almost painful for him to slow down. "It's better than anything else," Rico says. "It's a whole lot better

than watching TV." Rico knows that very soon he will reach the limit beyond which he will no longer be able to improve his performance at his job. So twice a week he takes evening courses in electronics. When he has his diploma he will seek a more complex job, one that presumably he will confront with the same enthusiasm he has shown so far.

For Pam Davis it is much easier to achieve this harmonious, effortless state when she works. As a young lawyer in a small partnership, she is fortunate to be involved in complex, challenging cases. She spends hours in the library, chasing down references and outlining possible courses of action for the senior partners of the firm to follow. Often her concentration is so intense that she forgets to have lunch, and by the time she realizes that she is hungry it is dark outside. While she is immersed in her job every piece of information fits: even when she is temporarily frustrated, she knows what causes the frustration, and she believes that eventually the obstacle can be overcome.

These examples illustrate what we mean by optimal experience. They are situations in which attention can be freely invested to achieve a person's goals, because there is no disorder to straighten out, no threat for the self to defend against. We have called this state the *flow experience*, because this is the term many of the people we interviewed had used in their descriptions of how it felt to be in top form: "It was like floating," "I was carried on by the flow." It is the opposite of psychic entropy—in fact, it is sometimes called *negentropy*—and those who attain it develop a stronger, more confident self, because more of their psychic energy has been invested successfully in goals they themselves had chosen to pursue.

When a person is able to organize his or her consciousness so as to experience flow as often as possible, the quality of life is inevitably going to improve, because, as in the case of Rico and Pam, even the usually boring routines of work become purposeful and enjoyable. In flow we are in control of our psychic energy, and everything we do adds order to consciousness. One of our respondents, a well-known West Coast rock climber, explains concisely the tie between the avocation that gives him a profound sense of flow and the rest of his life: "It's exhilarating to come closer and closer to self-discipline. You make your body go and everything hurts; then you look back in awe at the self, at what you've done, it just blows your mind. It leads to ecstasy, to self-fulfillment. If you win these battles enough, that battle against yourself, at least for a moment, it becomes easier to win the battles in the world."

The "battle" is not really *against* the self, but against the entropy that brings disorder to consciousness. It is really a battle *for* the self; it

is a struggle for establishing control over attention. The struggle does not necessarily have to be physical, as in the case of the climber. But anyone who has experienced flow knows that the deep enjoyment it provides requires an equal degree of disciplined concentration.

COMPLEXITY AND THE GROWTH OF THE SELF

Following a flow experience, the organization of the self is more *complex* than it had been before. It is by becoming increasingly complex that the self might be said to grow. Complexity is the result of two broad psychological processes: *differentiation* and *integration*. Differentiation implies a movement toward uniqueness, toward separating oneself from others. Integration refers to its opposite: a union with other people, with ideas and entities beyond the self. A complex self is one that succeeds in combining these opposite tendencies.

The self becomes more differentiated as a result of flow because overcoming a challenge inevitably leaves a person feeling more capable, more skilled. As the rock climber said, "You look back in awe at the self, at what you've done, it just blows your mind." After each episode of flow a person becomes more of a unique individual, less predictable, possessed of rarer skills.

Complexity is often thought to have a negative meaning, synonymous with difficulty and confusion. That may be true, but only if we equate it with differentiation alone. Yet complexity also involves a second dimension—the integration of autonomous parts. A complex engine, for instance, not only has many separate components, each performing a different function, but also demonstrates a high sensitivity because each of the components is in touch with all the others. Without integration, a differentiated system would be a confusing mess.

Flow helps to integrate the self because in that state of deep concentration consciousness is unusually well ordered. Thoughts, intentions, feelings, and all the senses are focused on the same goal. Experience is in harmony. And when the flow episode is over, one feels more "together" than before, not only internally but also with respect to other people and to the world in general. In the words of the climber whom we quoted earlier: "[There's] no place that more draws the best from human beings . . . [than] a mountaineering situation. Nobody hassles you to put your mind and body under tremendous stress to get to the top. . . . Your comrades are there, but you all feel the same way anyway, you're all in it together. Who can you trust more in the twen-

tieth century than these people? People after the same self-discipline as yourself, following the deeper commitment. . . . A bond like that with other people is in itself an ecstasy."

A self that is only differentiated—not integrated—may attain great individual accomplishments, but risks being mired in self-centered egotism. By the same token, a person whose self is based exclusively on integration will be connected and secure, but lack autonomous individuality. Only when a person invests equal amounts of psychic energy in these two processes and avoids both selfishness and conformity is the self likely to reflect complexity.

The self becomes complex as a result of experiencing flow. Paradoxically, it is when we act freely, for the sake of the action itself rather than for ulterior motives, that we learn to become more than what we were. When we choose a goal and invest ourselves in it to the limits of our concentration, whatever we do will be enjoyable. And once we have tasted this joy, we will redouble our efforts to taste it again. This is the way the self grows. It is the way Rico was able to draw so much out of his ostensibly boring job on the assembly line, or R. from his poetry. It is the way E. overcame her disease to become an influential scholar and a powerful executive. Flow is important both because it makes the present instant more enjoyable, and because it builds the self-confidence that allows us to develop skills and make significant contributions to humankind.

The rest of this volume will explore more thoroughly what we know about optimal experiences: how they feel and under what conditions they occur. Even though there is no easy shortcut to flow, it is possible, if one understands how it works, to transform life—to create more harmony in it and to liberate the psychic energy that otherwise would be wasted in boredom or worry.

ENJOYMENT AND
THE QUALITY OF LIFE

THERE ARE TWO MAIN STRATEGIES we can adopt to improve the quality of life. The first is to try making external conditions match our goals. The second is to change how we experience external conditions to make them fit our goals better. For instance, feeling secure is an important component of happiness. The sense of security can be improved by buying a gun, installing strong locks on the front door, moving to a safer neighborhood, exerting political pressure on city hall for more police protection, or helping the community to become more conscious of the importance of civil order. All these different responses are aimed at bringing conditions in the environment more in line with our goals. The other method by which we can feel more secure involves modifying what we mean by security. If one does not expect perfect safety, recognizes that risks are inevitable, and succeeds in enjoying a less than ideally predictable world, the threat of insecurity will not have as great a chance of marring happiness.

Neither of these strategies is effective when used alone. Changing external conditions might seem to work at first, but if a person is not in control of his consciousness, the old fears or desires will soon return, reviving previous anxieties. One cannot create a complete sense of inner security even by buying one's own Caribbean island and surrounding it with armed bodyguards and attack dogs.

The myth of King Midas well illustrates the point that controlling

external conditions does not necessarily improve existence. Like most people, King Midas supposed that if he were to become immensely rich, his happiness would be assured. So he made a pact with the gods, who after much haggling granted his wish that everything he touched would turn into gold. King Midas thought he had made an absolutely first-rate deal. Nothing was to prevent him now from becoming the richest, and therefore the happiest, man in the world. But we know how the story ends: Midas soon came to regret his bargain because the food in his mouth and the wine on his palate turned to gold before he could swallow them, and so he died surrounded by golden plates and golden cups.

The old fable continues to echo down the centuries. The waiting rooms of psychiatrists are filled with rich and successful patients who, in their forties or fifties, suddenly wake up to the fact that a plush suburban home, expensive cars, and even an Ivy League education are not enough to bring peace of mind. Yet people keep hoping that changing the external conditions of their lives will provide a solution. If only they could earn more money, be in better physical shape, or have a more understanding partner, they would really have it made. Even though we recognize that material success may not bring happiness, we engage in an endless struggle to reach external goals, expecting that they will improve life.

Wealth, status, and power have become in our culture all too powerful *symbols* of happiness. When we see people who are rich, famous, or good-looking, we tend to assume that their lives are rewarding, even though all the evidence might point to their being miserable. And we assume that if only we could acquire some of those same symbols, we would be much happier.

If we do actually succeed in becoming richer, or more powerful, we believe, at least for a time, that life as a whole has improved. But symbols can be deceptive: they have a tendency to distract from the reality they are supposed to represent. And the reality is that the quality of life does not depend directly on what others think of us or on what we own. The bottom line is, rather, how we feel about ourselves and about what happens to us. To improve life one must improve the quality of experience.

This is not to say that money, physical fitness, or fame are irrelevant to happiness. They can be genuine blessings, but only if they help to make us feel better. Otherwise they are at best neutral, at worst obstacles to a rewarding life. Research on happiness and life satisfaction suggests that in general there is a mild correlation between wealth and well-being. People in economically more affluent countries (including the

United States) tend to rate themselves as being on the whole more happy than people in less affluent countries. Ed Diener, a researcher from the University of Illinois, found that very wealthy persons report being happy on the average 77 percent of the time, while persons of average wealth say they are happy only 62 percent of the time. This difference, while statistically significant, is not very large, especially considering that the "very wealthy" group was selected from a list of the four hundred richest Americans. It is also interesting to note that not one respondent in Diener's study believed that money by itself guaranteed happiness. The majority agreed with the statement, "Money can increase or decrease happiness, depending on how it is used." In an earlier study, Norman Bradburn found that the highest-income group reported being happy about 25 percent more often than the lowest. Again, the difference was present, but it was not very large. In a comprehensive survey entitled *The Quality of American Life* published a decade ago, the authors report that a person's financial situation is one of the least important factors affecting overall satisfaction with life.

Given these observations, instead of worrying about how to make a million dollars or how to win friends and influence people, it seems more beneficial to find out how everyday life *can* be made more harmonious and more satisfying, and thus achieve by a direct route what cannot be reached through the pursuit of symbolic goals.

PLEASURE AND ENJOYMENT

When considering the kind of experience that makes life better, most people first think that happiness consists in experiencing pleasure: good food, good sex, all the comforts that money can buy. We imagine the satisfaction of traveling to exotic places or being surrounded by interesting company and expensive gadgets. If we cannot afford those goals that slick commercials and colorful ads keep reminding us to pursue, then we are happy to settle for a quiet evening in front of the television set with a glass of liquor close by.

Pleasure is a feeling of contentment that one achieves whenever information in consciousness says that expectations set by biological programs or by social conditioning have been met. The taste of food when we are hungry is pleasant because it reduces a physiological imbalance. Resting in the evening while passively absorbing information from the media, with alcohol or drugs to dull the mind overexcited by the demands of work, is pleasantly relaxing. Traveling to Acapulco is pleasant because the stimulating novelty restores our palate jaded by the

repetitive routines of everyday life, and because we know that this is how the "beautiful people" also spend their time.

Pleasure is an important component of the quality of life, but by itself it does not bring happiness. Sleep, rest, food, and sex provide restorative *homeostatic* experiences that return consciousness to order after the needs of the body intrude and cause psychic entropy to occur. But they do not produce psychological growth. They do not add complexity to the self. Pleasure helps to maintain order, but by itself cannot create new order in consciousness.

When people ponder further about what makes their lives rewarding, they tend to move beyond pleasant memories and begin to remember other events, other experiences that overlap with pleasurable ones but fall into a category that deserves a separate name: *enjoyment.* Enjoyable events occur when a person has not only met some prior expectation or satisfied a need or a desire but also gone beyond what he or she has been programmed to do and achieved something unexpected, perhaps something even unimagined before.

Enjoyment is characterized by this forward movement: by a sense of novelty, of accomplishment. Playing a close game of tennis that stretches one's ability is enjoyable, as is reading a book that reveals things in a new light, as is having a conversation that leads us to express ideas we didn't know we had. Closing a contested business deal, or any piece of work well done, is enjoyable. None of these experiences may be particularly pleasurable at the time they are taking place, but afterward we think back on them and say, "That really was fun" and wish they would happen again. After an enjoyable event we know that we have changed, that our self has grown: in some respect, we have become more complex as a result of it.

Experiences that give pleasure can also give enjoyment, but the two sensations are quite different. For instance, everybody takes pleasure in eating. To enjoy food, however, is more difficult. A gourmet enjoys eating, as does anyone who pays enough attention to a meal so as to discriminate the various sensations provided by it. As this example suggests, we can experience pleasure without any investment of psychic energy, whereas enjoyment happens only as a result of unusual investments of attention. A person can feel pleasure without any effort, if the appropriate centers in his brain are electrically stimulated, or as a result of the chemical stimulation of drugs. But it is impossible to enjoy a tennis game, a book, or a conversation unless attention is fully concentrated on the activity.

It is for this reason that pleasure is so evanescent, and that the self

does not grow as a consequence of pleasurable experiences. Complexity requires investing psychic energy in goals that are new, that are relatively challenging. It is easy to see this process in children: During the first few years of life every child is a little "learning machine" trying out new movements, new words daily. The rapt concentration on the child's face as she learns each new skill is a good indication of what enjoyment is about. And each instance of enjoyable learning adds to the complexity of the child's developing self.

Unfortunately, this natural connection between growth and enjoyment tends to disappear with time. Perhaps because "learning" becomes an external imposition when schooling starts, the excitement of mastering new skills gradually wears out. It becomes all too easy to settle down within the narrow boundaries of the self developed in adolescence. But if one gets to be too complacent, feeling that psychic energy invested in new directions is wasted unless there is a good chance of reaping extrinsic rewards for it, one may end up no longer enjoying life, and pleasure becomes the only source of positive experience.

On the other hand many individuals continue to go to great lengths to preserve enjoyment in whatever they do. I used to know an old man in one of the decrepit suburbs of Naples who made a precarious living out of a ramshackle antique store his family had owned for generations. One morning a prosperous-looking American lady walked into the store, and after looking around for a while, asked the price of a pair of baroque wooden *putti*, those chubby little cherubs so dear to Neapolitan craftsmen of a few centuries ago, and to their contemporary imitators. Signor Orsini, the owner, quoted an exorbitant price. The woman took out her folder of traveler's checks, ready to pay for the dubious artifacts. I held my breath, glad for the unexpected windfall about to reach my friend. But I didn't know Signor Orsini well enough. He turned purple and with barely contained agitation escorted the customer out of the store: "No, no, *signora*, I am sorry but I cannot sell you those angels." To the flabbergasted woman he kept repeating, "I cannot make business with you. You understand?" After the tourist finally left, he calmed down and explained: "If I were starving, I would have taken her money. But since I am not, why should I make a deal that isn't any fun? I enjoy the clash of wits involved in bargaining, when two persons try to outdo each other with ruses and with eloquence. She didn't even flinch. She didn't know any better. She didn't pay me the respect of assuming that I was going to try to take advantage of her. If I had sold those pieces to that woman at that ridiculous price, I would have felt cheated." Few people, in southern Italy or elsewhere, have this strange

attitude toward business transactions. But then I suspect that they don't enjoy their work as much as Signor Orsini did, either.

Without enjoyment life can be endured, and it can even be pleasant. But it can be so only precariously, depending on luck and the cooperation of the external environment. To gain personal control over the quality of experience, however, one needs to learn how to build enjoyment into what happens day in, day out.

The rest of this chapter provides an overview of what makes experience enjoyable. This description is based on long interviews, questionnaires, and other data collected over a dozen years from several thousand respondents. Initially we interviewed only people who spent a great amount of time and effort in activities that were difficult, yet provided no obvious rewards, such as money or prestige: rock climbers, composers of music, chess players, amateur athletes. Our later studies included interviews with ordinary people, leading ordinary existences; we asked them to describe how it felt when their lives were at their fullest, when what they did was most enjoyable. These people included urban Americans—surgeons, professors, clerical and assembly-line workers, young mothers, retired people, and teenagers. They also included respondents from Korea, Japan, Thailand, Australia, various European cultures, and a Navajo reservation. On the basis of these interviews we can now describe what makes an experience enjoyable, and thus provide examples that all of us can use to enhance the quality of life.

THE ELEMENTS OF ENJOYMENT

The first surprise we encountered in our study was how similarly very different activities were described when they were going especially well. Apparently the way a long-distance swimmer felt when crossing the English Channel was almost identical to the way a chess player felt during a tournament or a climber progressing up a difficult rock face. All these feelings were shared, in important respects, by subjects ranging from musicians composing a new quartet to teenagers from the ghetto involved in a championship basketball game.

The second surprise was that, regardless of culture, stage of modernization, social class, age, or gender, the respondents described enjoyment in very much the same way. *What* they did to experience enjoyment varied enormously—the elderly Koreans liked to meditate, the teenage Japanese liked to swarm around in motorcycle gangs—but they described *how* it felt when they enjoyed themselves in almost identical

terms. Moreover, the *reasons* the activity was enjoyed shared many more similarities than differences. In sum, optimal experience, and the psychological conditions that make it possible, seem to be the same the world over.

As our studies have suggested, the phenomenology of enjoyment has eight major components. When people reflect on how it feels when their experience is most positive, they mention at least one, and often all, of the following. First, the experience usually occurs when we confront tasks we have a chance of completing. Second, we must be able to concentrate on what we are doing. Third and fourth, the concentration is usually possible because the task undertaken has clear goals and provides immediate feedback. Fifth, one acts with a deep but effortless involvement that removes from awareness the worries and frustrations of everyday life. Sixth, enjoyable experiences allow people to exercise a sense of control over their actions. Seventh, concern for the self disappears, yet paradoxically the sense of self emerges stronger after the flow experience is over. Finally, the sense of the duration of time is altered; hours pass by in minutes, and minutes can stretch out to seem like hours. The combination of all these elements causes a sense of deep enjoyment that is so rewarding people feel that expending a great deal of energy is worthwhile simply to be able to feel it.

We shall take a closer look at each of these elements so that we may better understand what makes enjoyable activities so gratifying. With this knowledge, it is possible to achieve control of consciousness and turn even the most humdrum moments of everyday lives into events that help the self grow.

A Challenging Activity That Requires Skills

Sometimes a person reports having an experience of extreme joy, a feeling of ecstasy for no apparent good reason: a bar of haunting music may trigger it, or a wonderful view, or even less—just a spontaneous sense of well-being. But by far the overwhelming proportion of optimal experiences are reported to occur within sequences of activities that are goal-directed and bounded by rules—activities that require the investment of psychic energy, and that could not be done without the appropriate skills. Why this should be so will become clear as we go along; at this point it is sufficient to note that this seems to be universally the case.

It is important to clarify at the outset that an "activity" need not be active in the physical sense, and the "skill" necessary to engage in it need not be a physical skill. For instance, one of the most frequently mentioned enjoyable activities the world over is reading. Reading is an

activity because it requires the concentration of attention and has a goal, and to do it one must know the rules of written language. The skills involved in reading include not only literacy but also the ability to translate words into images, to empathize with fictional characters, to recognize historical and cultural contexts, to anticipate turns of the plot, to criticize and evaluate the author's style, and so on. In this broader sense, any capacity to manipulate symbolic information is a "skill," such as the skill of the mathematician to shape quantitative relationships in his head, or the skill of the musician in combining musical notes.

Another universally enjoyable activity is being with other people. Socializing might at first sight appear to be an exception to the statement that one needs to use skills to enjoy an activity, for it does not seem that gossiping or joking around with another person requires particular abilities. But of course, it does; as so many shy people know, if a person feels self-conscious, he or she will dread establishing informal contacts, and avoid company whenever possible.

Any activity contains a bundle of opportunities for action, or "challenges," that require appropriate skills to realize. For those who don't have the right skills, the activity is not challenging; it is simply meaningless. Setting up a chessboard gets the juices of a chess player flowing, but leaves cold anyone who does not know the rules of the game. To most people, the sheer wall of El Capitan in Yosemite valley is just a huge chunk of featureless rock. But to the climber it is an arena offering an endlessly complex symphony of mental and physical challenges.

One simple way to find challenges is to enter a competitive situation. Hence the great appeal of all games and sports that pit a person or team against another. In many ways, competition is a quick way of developing complexity: "He who wrestles with us," wrote Edmund Burke, "strengthens our nerves, and sharpens our skill. Our antagonist is our helper." The challenges of competition can be stimulating and enjoyable. But when beating the opponent takes precedence in the mind over performing as well as possible, enjoyment tends to disappear. Competition is enjoyable only when it is a means to perfect one's skills; when it becomes an end in itself, it ceases to be fun.

But challenges are by no means confined to competitive or to physical activities. They are necessary to provide enjoyment even in situations where one would not expect them to be relevant. For example, here is a quote from one of our studies, of a statement made by an art expert describing the enjoyment he takes in looking at a painting, something most people would regard as an immediate, intuitive process:

"A lot of pieces that you deal with are very straightforward . . . and you don't find anything exciting about them, you know, but there are other pieces that have some sort of challenge. . . . those are the pieces that stay in your mind, that are the most interesting." In other words, even the passive enjoyment one gets from looking at a painting or sculpture depends on the challenges that the work of art contains.

Activities that provide enjoyment are often those that have been designed for this very purpose. Games, sports, and artistic and literary forms were developed over the centuries for the express purpose of enriching life with enjoyable experiences. But it would be a mistake to assume that only art and leisure can provide optimal experiences. In a healthy culture, productive work and the necessary routines of everyday life are also satisfying. In fact, one purpose of this book is to explore ways in which even routine details can be transformed into personally meaningful games that provide optimal experiences. Mowing the lawn or waiting in a dentist's office can become enjoyable provided one restructures the activity by providing goals, rules, and the other elements of enjoyment to be reviewed below.

Heinz Maier-Leibnitz, the famous German experimental physicist and a descendant of the eighteenth-century philosopher and mathematician, provides an intriguing example of how one can take control of a boring situation and turn it into a mildly enjoyable one. Professor Maier-Leibnitz suffers from an occupational handicap common to academicians: having to sit through endless, often boring conferences. To alleviate this burden he invented a private activity that provides just enough challenges for him not to be completely bored during a dull lecture, but is so automated that it leaves enough attention free so that if something interesting is being said, it will register in his awareness.

What he does is this: Whenever a speaker begins to get tedious, he starts to tap his right thumb once, then the third finger of the right hand, then the index, then the fourth finger, then the third finger again, then the little finger of the right hand. Then he moves to the left hand and taps the little finger, the middle finger, the fourth finger, the index, and the middle finger again, and ends with the thumb of the left hand. Then the right hand reverses the sequence of fingering, followed by the reverse of the left hand's sequence. It turns out that by introducing full and half stops at regular intervals, there are 888 combinations one can move through without repeating the same pattern. By interspersing pauses among the taps at regular intervals, the pattern acquires an almost musical harmony, and in fact it is easily represented on a musical staff.

After inventing this innocent game, Professor Maier-Leibnitz found an interesting use for it: as a way of measuring the length of trains of thought. The pattern of 888 taps, repeated three times, provides a set of 2,664 taps that, with practice, takes almost exactly twelve minutes to perform. As soon as he starts tapping, by shifting attention to his fingers, Professor Maier-Leibnitz can tell exactly at what point he is in the sequence. So suppose that a thought concerning one of his physics experiments appears in his consciousness while he is tapping during a boring lecture. He immediately shifts attention to his fingers, and registers the fact that he is at the 300th tap of the second series; then in the same split second he returns to the train of thought about the experiment. At a certain point the thought is completed, and he has figured out the problem. How long did it take him to solve the problem? By shifting attention back to his fingers, he notices that he is about to finish the second series—the thought process has taken approximately two and a quarter minutes to play itself out.

Few people bother inventing quite such ingenious and complex diversions to improve the quality of their experiences. But all of us have more modest versions of the same. Everybody develops routines to fill in the boring gaps of the day, or to bring experience back on an even keel when anxiety threatens. Some people are compulsive doodlers, others chew on things or smoke, smooth their hair, hum a tune, or engage in more esoteric private rituals that have the same purpose: to impose order in consciousness through the performance of patterned action. These are the "microflow" activities that help us negotiate the doldrums of the day. But how enjoyable an activity is depends ultimately on its complexity. The small automatic games woven into the fabric of everyday life help reduce boredom, but add little to the positive quality of experience. For that one needs to face more demanding challenges, and use higher-level skills.

In all the activities people in our study reported engaging in, enjoyment comes at a very specific point: whenever the opportunities for action perceived by the individual are equal to his or her capabilities. Playing tennis, for instance, is not enjoyable if the two opponents are mismatched. The less skilled player will feel anxious, and the better player will feel bored. The same is true of every other activity: a piece of music that is too simple relative to one's listening skills will be boring, while music that is too complex will be frustrating. Enjoyment appears at the boundary between boredom and anxiety, when the challenges are just balanced with the person's capacity to act.

The golden ratio between challenges and skills does not only hold

true for human activities. Whenever I took our hunting dog, Hussar, for a walk in the open fields he liked to play a very simple game—the prototype of the most culturally widespread game of human children, escape and pursuit. He would run circles around me at top speed, with his tongue hanging out and his eyes warily watching every move I made, daring me to catch him. Occasionally I would take a lunge, and if I was lucky I got to touch him. Now the interesting part is that whenever I was tired, and moved halfheartedly, Hussar would run much tighter circles, making it relatively easy for me to catch him; on the other hand, if I was in good shape and willing to extend myself, he would enlarge the diameter of his circle. In this way, the difficulty of the game was kept constant. With an uncanny sense for the fine balancing of challenges and skills, he would make sure that the game would yield the maximum of enjoyment for us both.

The Merging of Action and Awareness

When all a person's relevant skills are needed to cope with the challenges of a situation, that person's attention is completely absorbed by the activity. There is no excess psychic energy left over to process any information but what the activity offers. All the attention is concentrated on the relevant stimuli.

As a result, one of the most universal and distinctive features of optimal experience takes place: people become so involved in what they are doing that the activity becomes spontaneous, almost automatic; they stop being aware of themselves as separate from the actions they are performing.

A dancer describes how it feels when a performance is going well: "Your concentration is very complete. Your mind isn't wandering, you are not thinking of something else; you are totally involved in what you are doing. . . . Your energy is flowing very smoothly. You feel relaxed, comfortable, and energetic."

A rock climber explains how it feels when he is scaling a mountain: "You are so involved in what you are doing [that] you aren't thinking of yourself as separate from the immediate activity. . . . You don't see yourself as separate from what you are doing."

A mother who enjoys the time spent with her small daughter: "Her reading is the one thing that she's really into, and we read together. She reads to me, and I read to her, and that's a time when I sort of lose touch with the rest of the world, I'm totally absorbed in what I'm doing."

A chess player tells of playing in a tournament: ". . . the concentra-

tion is like breathing—you never think of it. The roof could fall in and, if it missed you, you would be unaware of it."

It is for this reason that we called the optimal experience "flow." The short and simple word describes well the sense of seemingly effortless movement. The following words from a poet and rock climber apply to all the thousands of interviews collected by us and by others over the years: "The mystique of rock climbing is climbing; you get to the top of a rock glad it's over but really wish it would go on forever. The justification of climbing is climbing, like the justification of poetry is writing; you don't conquer anything except things in yourself. . . . The act of writing justifies poetry. Climbing is the same: recognizing that you are a flow. The purpose of the flow is to keep on flowing, not looking for a peak or utopia but staying in the flow. It is not a moving up but a continuous flowing; you move up to keep the flow going. There is no possible reason for climbing except the climbing itself; it is a self-communication."

Although the flow experience appears to be effortless, it is far from being so. It often requires strenuous physical exertion, or highly disciplined mental activity. It does not happen without the application of skilled performance. Any lapse in concentration will erase it. And yet while it lasts consciousness works smoothly, action follows action seamlessly. In normal life, we keep interrupting what we do with doubts and questions. "Why am I doing this? Should I perhaps be doing something else?" Repeatedly we question the necessity of our actions, and evaluate critically the reasons for carrying them out. But in flow there is no need to reflect, because the action carries us forward as if by magic.

Clear Goals and Feedback

The reason it is possible to achieve such complete involvement in a flow experience is that goals are usually clear, and feedback immediate. A tennis player always knows what she has to do: return the ball into the opponent's court. And each time she hits the ball she knows whether she has done well or not. The chess player's goals are equally obvious: to mate the opponent's king before his own is mated. With each move, he can calculate whether he has come closer to this objective. The climber inching up a vertical wall of rock has a very simple goal in mind: to complete the climb without falling. Every second, hour after hour, he receives information that he is meeting that basic goal.

Of course, if one chooses a trivial goal, success in it does not provide enjoyment. If I set as my goal to remain alive while sitting on the living-room sofa, I also could spend days knowing that I was achiev-

ing it, just as the rock climber does. But this realization would not make me particularly happy, whereas the climber's knowledge brings exhilaration to his dangerous ascent.

Certain activities require a very long time to accomplish, yet the components of goals and feedback are still extremely important to them. One example was given by a sixty-two-year-old woman living in the Italian Alps, who said her most enjoyable experiences were taking care of the cows and tending the orchard: "I find special satisfaction in caring for the plants: I like to see them grow day by day. It is very beautiful." Although it involves a period of patient waiting, seeing the plants one has cared for grow provides a powerful feedback even in the urban apartments of American cities.

Another example is solo ocean cruising, in which a person alone might sail for weeks in a small boat without seeing land. Jim Macbeth, who did a study of flow in ocean cruising, comments on the excitement a sailor feels when, after days of anxiously scanning the empty reaches of water, he discerns the outline of the island he had been aiming for as it starts to rise over the horizon. One of the legendary cruisers describes this sensation as follows: "I . . . experienced a sense of satisfaction coupled with some astonishment that my observations of the very distant sun from an unsteady platform and the use of some simple tables . . . enable[d] a small island to be found with certainty after an ocean crossing." And another: "Each time, I feel the same mixture of astonishment, love, and pride as this new land is born which seems to have been created for me and by me."

The goals of an activity are not always as clear as those of tennis, and the feedback is often more ambiguous than the simple "I am not falling" information processed by the climber. A composer of music, for instance, may know that he wishes to write a song, or a flute concerto, but other than that, his goals are usually quite vague. And how does he know whether the notes he is writing down are "right" or "wrong"? The same situation holds true for the artist painting a picture, and for all activities that are creative or open-ended in nature. But these are all exceptions that prove the rule: unless a person learns to set goals and to recognize and gauge feedback in such activities, she will not enjoy them.

In some creative activities, where goals are not clearly set in advance, a person must develop a strong personal sense of what she intends to do. The artist might not have a visual image of what the finished painting should look like, but when the picture has progressed to a certain point, she should know whether this is what she wanted to

achieve or not. And a painter who enjoys painting must have internalized criteria for "good" or "bad" so that after each brush stroke she can say: "Yes, this works; no, this doesn't." Without such internal guidelines, it is impossible to experience flow.

Sometimes the goals and the rules governing an activity are invented, or negotiated on the spot. For example, teenagers enjoy impromptu interactions in which they try to "gross each other out," or tell tall stories, or make fun of their teachers. The goal of such sessions emerges by trial and error, and is rarely made explicit; often it remains below the participants' level of awareness. Yet it is clear that these activities develop their own rules and that those who take part have a clear idea of what constitutes a successful "move," and of who is doing well. In many ways this is the pattern of a good jazz band, or any improvisational group. Scholars or debaters obtain similar satisfaction when the "moves" in their arguments mesh smoothly, and produce the desired result.

What constitutes feedback varies considerably in different activities. Some people are indifferent to things that others cannot get enough of. For instance, surgeons who love doing operations claim that they wouldn't switch to internal medicine even if they were paid ten times as much as they are for doing surgery, because an internist never knows exactly how well he is doing. In an operation, on the other hand, the status of the patient is almost always clear: as long as there is no blood in the incision, for example, a specific procedure has been successful. When the diseased organ is cut out, the surgeon's task is accomplished; after that there is the suture that gives a gratifying sense of closure to the activity. And the surgeon's disdain for psychiatry is even greater than that for internal medicine: to hear surgeons talk, the psychiatrist might spend ten years with a patient without knowing whether the cure is helping him.

Yet the psychiatrist who enjoys his trade is also receiving constant feedback: the way the patient holds himself, the expression on his face, the hesitation in his voice, the content of the material he brings up in the therapeutic hour—all these bits of information are important clues the psychiatrist uses to monitor the progress of the therapy. The difference between a surgeon and a psychiatrist is that the former considers blood and excision the only feedback worth attending to, whereas the latter considers the signals reflecting a patient's state of mind to be significant information. The surgeon judges the psychiatrist to be soft because he is interested in such ephemeral goals; the psychiatrist thinks the surgeon crude for his concentration on mechanics.

The *kind* of feedback we work toward is in and of itself often unimportant: What difference does it make if I hit the tennis ball between the white lines, if I immobilize the enemy king on the chessboard, or if I notice a glimmer of understanding in my patient's eyes at the end of the therapeutic hour? What makes this information valuable is the symbolic message it contains: that I have succeeded in my goal. Such knowledge creates order in consciousness, and strengthens the structure of the self.

Almost any kind of feedback can be enjoyable, provided it is logically related to a goal in which one has invested psychic energy. If I were to set myself up to balance a walking stick on my nose, then the sight of the stick wobbling upright above my face would provide a brief enjoyable interlude. But each of us is temperamentally sensitive to a certain range of information that we learn to value more than most other people do, and it is likely that we will consider feedback involving that information to be more relevant than others might.

For instance, some people are born with exceptional sensitivity to sound. They can discriminate among different tones and pitches, and recognize and remember combinations of sounds better than the general population. It is likely that such individuals will be attracted to playing with sounds; they will learn to control and shape auditory information. For them the most important feedback will consist in being able to combine sounds, to produce or reproduce rhythms and melodies. Composers, singers, performers, conductors, and music critics will develop from among them. In contrast, some are genetically predisposed to be unusually sensitive to other people, and they will learn to pay attention to the signals they send out. The feedback they will be looking for is the expression of human emotion. Some people have fragile selves that need constant reassurance, and for them the only information that counts is winning in a competitive situation. Others have invested so much in being liked that the only feedback they take into account is approval and admiration.

A good illustration of the importance of feedback is contained in the responses of a group of blind religious women interviewed by Professor Fausto Massimini's team of psychologists in Milan, Italy. Like the other respondents in our studies, they were asked to describe the most enjoyable experiences in their lives. For these women, many of whom had been sightless since birth, the most frequently mentioned flow experiences were the result of reading books in Braille, praying, doing handicrafts like knitting and binding books, and helping each other in case of sickness or other need. Of the over six hundred people inter-

viewed by the Italian team, these blind women stressed more than anyone else the importance of receiving clear feedback as a condition for enjoying whatever they were doing. Unable to see what was going on around them, they needed to know even more than sighted people whether what they were trying to accomplish was actually coming to pass.

Concentration on the Task at Hand

One of the most frequently mentioned dimensions of the flow experience is that, while it lasts, one is able to forget all the unpleasant aspects of life. This feature of flow is an important by-product of the fact that enjoyable activities require a complete focusing of attention on the task at hand—thus leaving no room in the mind for irrelevant information.

In normal everyday existence, we are the prey of thoughts and worries intruding unwanted in consciousness. Because most jobs, and home life in general, lack the pressing demands of flow experiences, concentration is rarely so intense that preoccupations and anxieties can be automatically ruled out. Consequently the ordinary state of mind involves unexpected and frequent episodes of entropy interfering with the smooth run of psychic energy. This is one reason why flow improves the quality of experience: the clearly structured demands of the activity impose order, and exclude the interference of disorder in consciousness.

A professor of physics who was an avid rock climber described his state of mind while climbing as follows: "It is as if my memory input has been cut off. All I can remember is the last thirty seconds, and all I can think ahead is the next five minutes." In fact, any activity that requires concentration has a similarly narrow window of time.

But it is not only the temporal focus that counts. What is even more significant is that only a very select range of information can be allowed into awareness. Therefore all the troubling thoughts that ordinarily keep passing through the mind are temporarily kept in abeyance. As a young basketball player explains: "The court—that's all that matters. . . . Sometimes out on the court I think of a problem, like fighting with my steady girl, and I think that's nothing compared to the game. You can think about a problem all day but as soon as you get in the game, the hell with it!" And another: "Kids my age, they think a lot . . . but when you are playing basketball, that's all there is on your mind—just basketball. . . . Everything seems to follow right along."

A mountaineer expands on the same theme: "When you're [climbing] you're not aware of other problematic life situations. It

becomes a world unto its own, significant only to itself. It's a concentration thing. Once you're into the situation, it's incredibly real, and you're very much in charge of it. It becomes your total world."

A similar sensation is reported by a dancer: "I get a feeling that I don't get anywhere else. . . . I have more confidence in myself than any other time. Maybe an effort to forget my problems. Dance is like therapy. If I am troubled about something, I leave it out of the door as I go in [the dance studio]."

On a larger time scale, ocean cruising provides an equivalent merciful oblivion: "But no matter how many little discomforts there may be at sea, one's real cares and worries seem to drop out of sight as the land slips behind the horizon. Once we were at sea there was no point in worrying, there was nothing we could do about our problems till we reached the next port. . . . Life was, for a while, stripped of its artificialities; [other problems] seemed quite unimportant compared with the state of the wind and the sea and the length of the day's run."

Edwin Moses, the great hurdler, has this to say in describing the concentration necessary for a race: "Your mind has to be absolutely clear. The fact that you have to cope with your opponent, jet lag, different foods, sleeping in hotels, and personal problems has to be erased from consciousness—as if they didn't exist."

Although Moses was talking about what it takes to win world-class sports events, he could have been describing the kind of concentration we achieve when we enjoy *any* activity. The concentration of the flow experience—together with clear goals and immediate feedback—provides order to consciousness, inducing the enjoyable condition of psychic negentropy.

The Paradox of Control

Enjoyment often occurs in games, sports, and other leisure activities that are distinct from ordinary life, where any number of bad things can happen. If a person loses a chess game or botches his hobby he need not worry; in "real" life, however, a person who mishandles a business deal may get fired, lose the mortgage on the house, and end up on public assistance. Thus the flow experience is typically described as involving a sense of control—or, more precisely, as lacking the sense of worry about losing control that is typical in many situations of normal life.

Here is how a dancer expresses this dimension of the flow experience: "A strong relaxation and calmness comes over me. I have no worries of failure. What a powerful and warm feeling it is! I want to expand, to hug the world. I feel enormous power to effect something of

grace and beauty." And a chess player: ". . . I have a general feeling of well-being, and that I am in complete control of my world."

What these respondents are actually describing is the *possibility*, rather than the *actuality*, of control. The ballet dancer may fall, break her leg, and never make the perfect turn, and the chess player may be defeated and never become a champion. But at least in principle, in the world of flow perfection is attainable.

This sense of control is also reported in enjoyable activities that involve serious risks, activities that to an outsider would seem to be much more potentially dangerous than the affairs of normal life. People who practice hang gliding, spelunking, rock climbing, race-car driving, deep-sea diving, and many similar sports for fun are purposefully placing themselves in situations that lack the safety nets of civilized life. Yet all these individuals report flow experiences in which a heightened sense of control plays an important part.

It is usual to explain the motivation of those who enjoy dangerous activities as some sort of pathological need: they are trying to exorcise a deep-seated fear, they are compensating, they are compulsively reenacting an Oedipal fixation, they are "sensation seekers." While such motives may be occasionally involved, what is most striking, when one actually speaks to specialists in risk, is how their enjoyment derives not from the danger itself, but from their ability to minimize it. So rather than a pathological thrill that comes from courting disaster, the positive emotion they enjoy is the perfectly healthy feeling of being able to control potentially dangerous forces.

The important thing to realize here is that activities that produce flow experiences, even the seemingly most risky ones, are so constructed as to allow the practitioner to develop sufficient skills to reduce the margin of error to as close to zero as possible. Rock climbers, for instance, recognize two sets of dangers: "objective" and "subjective" ones. The first kind are the unpredictable physical events that might confront a person on the mountain: a sudden storm, an avalanche, a falling rock, a drastic drop in temperature. One can prepare oneself against these threats, but they can never be completely foreseen. Subjective dangers are those that arise from the climber's lack of skill—including the inability to estimate correctly the difficulty of a climb in relation to one's ability.

The whole point of climbing is to avoid objective dangers as much as possible, and to eliminate subjective dangers entirely by rigorous discipline and sound preparation. As a result, climbers genuinely believe that climbing the Matterhorn is safer than crossing a street in Manhat-

tan, where the objective dangers—taxi drivers, bicycle messengers, buses, muggers—are far less predictable than those on the mountain, and where personal skills have less chance to ensure the pedestrian's safety.

As this example illustrates, what people enjoy is not the sense of *being* in control, but the sense of *exercising* control in difficult situations. It is not possible to experience a feeling of control unless one is willing to give up the safety of protective routines. Only when a doubtful outcome is at stake, and one is able to influence that outcome, can a person really know whether she is in control.

One type of activity seems to constitute an exception. Games of chance are enjoyable, yet by definition they are based on random outcomes presumably not affected by personal skills. The spin of a roulette wheel or the turn of a card in blackjack cannot be controlled by the player. In this case, at least, the sense of control must be irrelevant to the experience of enjoyment.

The "objective" conditions, however, happen to be deceptive, for it is actually the case that gamblers who enjoy games of hazard are subjectively convinced that their skills do play a major role in the outcome. In fact, they tend to stress the issue of control even more than practitioners of activities where skills obviously allow greater control. Poker players are convinced it is their ability, and not chance, that makes them win; if they lose they are much more inclined to credit bad luck, but even in defeat they are willing to look for a personal lapse to explain the outcome. Roulette players develop elaborate systems to predict the turn of the wheel. In general, players of games of chance often believe that they have the gift of seeing into the future, at least within the restricted set of goals and rules that defines their game. And this most ancient feeling of control—whose precursors include the rituals of divination so prevalent in every culture—is one of the greatest attractions the experience of gambling offers.

This sense of being in a world where entropy is suspended explains in part why flow-producing activities can become so addictive. Novelists have often written on the theme of chess as a metaphor for escape from reality. Vladimir Nabokov's short story "The Luchin Defense" describes a young chess genius so involved in the game that the rest of his life—his marriage, his friendships, his livelihood—is going by the boards. Luchin tries to cope with these problems, but he is unable to see them except in terms of chess situations. His wife is the White Queen, standing on the fifth square of the third file, threatened by the Black Bishop, who is Luchin's agent—and so forth. In trying to solve

his personal conflicts Luchin turns to chess strategy, and endeavors to invent the "Luchin defense," a set of moves that will make him invulnerable to outside attacks. As his relationships in real life disintegrate, Luchin has a series of hallucinations in which the important people around him become pieces on a huge chessboard, trying to immobilize him. Finally he has a vision of the perfect defense against his problems— and jumps out of the hotel window. Such stories about chess are not so farfetched; many champions, including the first and the last great American chess masters, Paul Morphy and Bobby Fischer, became so comfortable with the beautifully clear-cut and logically ordered world of chess that they turned their backs on the messy confusion of the "real" world.

The exhilaration gamblers feel in "figuring out" random chance is even more notorious. Early ethnographers have described North American Plains Indians so hypnotically involved in gambling with buffalo rib bones that losers would often leave the tepee without clothes in the dead of winter, having wagered away their weapons, horses, and wives as well. Almost any enjoyable activity can become addictive, in the sense that instead of being a conscious choice, it becomes a necessity that interferes with other activities. Surgeons, for instance, describe operations as being addictive, "like taking heroin."

When a person becomes so dependent on the ability to control an enjoyable activity that he cannot pay attention to anything else, then he loses the ultimate control: the freedom to determine the content of consciousness. Thus enjoyable activities that produce flow have a potentially negative aspect: while they are capable of improving the quality of existence by creating order in the mind, they can become addictive, at which point the self becomes captive of a certain kind of order, and is then unwilling to cope with the ambiguities of life.

The Loss of Self-Consciousness

We have seen earlier that when an activity is thoroughly engrossing, there is not enough attention left over to allow a person to consider either the past or the future, or any other temporarily irrelevant stimuli. One item that disappears from awareness deserves special mention, because in normal life we spend so much time thinking about it: our own self. Here is a climber describing this aspect of the experience: "It's a Zen feeling, like meditation or concentration. One thing you're after is the one-pointedness of mind. You can get your ego mixed up with climbing in all sorts of ways and it isn't necessarily enlightening. But when things become automatic, it's like an egoless thing, in a way.

Somehow the right thing is done without you ever thinking about it or doing anything at all. . . . It just happens. And yet you're more concentrated." Or, in the words of a famous long-distance ocean cruiser: "So one forgets oneself, one forgets everything, seeing only the play of the boat with the sea, the play of the sea around the boat, leaving aside everything not essential to that game. . . ."

The loss of the sense of a self separate from the world around it is sometimes accompanied by a feeling of union with the environment, whether it is the mountain, a team, or, in the case of this member of a Japanese motorcycle gang, the "run" of hundreds of cycles roaring down the streets of Kyoto: "I understand something, when all of our feelings get tuned up. When running, we are not in complete harmony at the start. But if the Run begins to go well, all of us, all of us feel for the others. How can I say this? . . . When our minds become one. At such a time, it's a real pleasure. . . . When all of us become one, I understand something. . . . All of a sudden I realize, 'Oh, we're one' and think, 'If we speed as fast as we can, it will become a real Run.' . . . When we realize that we become one flesh, it's supreme. When we get high on speed. At such a moment, it's really super."

This "becoming one flesh" so vividly described by the Japanese teenager is a very real feature of the flow experience. Persons report feeling it as concretely as they feel relief from hunger or from pain. It is a greatly rewarding experience, but as we shall see later on, one that presents its own dangers.

Preoccupation with the self consumes psychic energy because in everyday life we often feel threatened. Whenever we are threatened we need to bring the image we have of ourselves back into awareness, so we can find out whether or not the threat is serious, and how we should meet it. For instance, if walking down the street I notice some people turning back and looking at me with grins on their faces, the normal thing to do is immediately to start worrying: "Is there something wrong? Do I look funny? Is it the way I walk, or is my face smudged?" Hundreds of times every day we are reminded of the vulnerability of our self. And every time this happens psychic energy is lost trying to restore order to consciousness.

But in flow there is no room for self-scrutiny. Because enjoyable activities have clear goals, stable rules, and challenges well matched to skills, there is little opportunity for the self to be threatened. When a climber is making a difficult ascent, he is totally taken up in the mountaineering role. He is 100 percent a climber, or he would not survive. There is no way for anything or anybody to bring into question any

other aspect of his self. Whether his face is smudged makes absolutely no difference. The only possible threat is the one that comes from the mountain—but a good climber is well trained to face that threat, and does not need to bring the self into play in the process.

The absence of the self from consciousness does not mean that a person in flow has given up the control of his psychic energy, or that she is unaware of what happens in her body or in her mind. In fact the opposite is usually true. When people first learn about the flow experience they sometimes assume that lack of self-consciousness has something to do with a passive obliteration of the self, a "going with the flow" Southern California–style. But in fact the optimal experience involves a very active role for the self. A violinist must be extremely aware of every movement of her fingers, as well as of the sound entering her ears, and of the total form of the piece she is playing, both analytically, note by note, and holistically, in terms of its overall design. A good runner is usually aware of every relevant muscle in his body, of the rhythm of his breathing, as well as of the performance of his competitors within the overall strategy of the race. A chess player could not enjoy the game if he were unable to retrieve from his memory, at will, previous positions, past combinations.

So loss of self-consciousness does not involve a loss of self, and certainly not a loss of consciousness, but rather, only a loss of consciousness *of* the self. What slips below the threshold of awareness is the *concept* of self, the information we use to represent to ourselves who we are. And being able to forget temporarily who we are seems to be very enjoyable. When not preoccupied with our selves, we actually have a chance to expand the concept of who we are. Loss of self-consciousness can lead to self-transcendence, to a feeling that the boundaries of our being have been pushed forward.

This feeling is not just a fancy of the imagination, but is based on a concrete experience of close interaction with some Other, an interaction that produces a rare sense of unity with these usually foreign entities. During the long watches of the night the solitary sailor begins to feel that the boat is an extension of himself, moving to the same rhythms toward a common goal. The violinist, wrapped in the stream of sound she helps to create, feels as if she is part of the "harmony of the spheres." The climber, focusing all her attention on the small irregularities of the rock wall that will have to support her weight safely, speaks of the sense of kinship that develops between fingers and rock, between the frail body and the context of stone, sky, and wind. In a chess tournament, players whose attention has been riveted, for hours,

to the logical battle on the board claim that they feel as if they have been merged into a powerful "field of force" clashing with other forces in some nonmaterial dimension of existence. Surgeons say that during a difficult operation they have the sensation that the entire operating team is a single organism, moved by the same purpose; they describe it as a "ballet" in which the individual is subordinated to the group performance, and all involved share in a feeling of harmony and power.

One could treat these testimonials as poetic metaphors and leave them at that. But it is important to realize that they refer to experiences that are just as real as being hungry, or as concrete as bumping into a wall. There is nothing mysterious or mystical about them. When a person invests all her psychic energy into an interaction—whether it is with another person, a boat, a mountain, or a piece of music—she in effect becomes part of a system of action greater than what the individual self had been before. This system takes its form from the rules of the activity; its energy comes from the person's attention. But it is a real system—subjectively as real as being part of a family, a corporation, or a team—and the self that is part of it expands its boundaries and becomes more complex than what it had been.

This growth of the self occurs only if the interaction is an enjoyable one, that is, if it offers nontrivial opportunities for action and requires a constant perfection of skills. It is also possible to lose oneself in systems of action that demand nothing but faith and allegiance. Fundamentalist religions, mass movements, and extremist political parties also offer opportunities for self-transcendence that millions are eager to accept. They also provide a welcome extension of the boundaries of the self, a feeling that one is involved in something great and powerful. The true believer also becomes part of the system in concrete terms, because his psychic energy will be focused and shaped by the goals and rules of his belief. But the true believer is not really interacting with the belief system; he usually lets his psychic energy be absorbed by it. From this submission nothing new can come; consciousness may attain a welcome order, but it will be an order imposed rather than achieved. At best the self of the true believer resembles a crystal: strong and beautifully symmetrical, but very slow to grow.

There is one very important and at first apparently paradoxical relationship between losing the sense of self in a flow experience, and having it emerge stronger afterward. It almost seems that occasionally giving up self-consciousness is necessary for building a strong self-concept. Why this should be so is fairly clear. In flow a person is challenged to do her best, and must constantly improve her skills. At the time, she

doesn't have the opportunity to reflect on what this means in terms of the self—if she did allow herself to become self-conscious, the experience could not have been very deep. But afterward, when the activity is over and self-consciousness has a chance to resume, the self that the person reflects upon is not the same self that existed before the flow experience: it is now enriched by new skills and fresh achievements.

The Transformation of Time

One of the most common descriptions of optimal experience is that time no longer seems to pass the way it ordinarily does. The objective, external duration we measure with reference to outside events like night and day, or the orderly progression of clocks, is rendered irrelevant by the rhythms dictated by the activity. Often hours seem to pass by in minutes; in general, most people report that time seems to pass much faster. But occasionally the reverse occurs: Ballet dancers describe how a difficult turn that takes less than a second in real time stretches out for what seems like minutes: "Two things happen. One is that it seems to pass really fast in one sense. After it's passed, it seems to have passed really fast. I see that it's 1:00 in the morning, and I say: 'Aha, just a few minutes ago it was 8:00.' But then while I'm dancing . . . it seems like it's been much longer than maybe it really was." The safest generalization to make about this phenomenon is to say that during the flow experience the sense of time bears little relation to the passage of time as measured by the absolute convention of the clock.

But here, too, there are exceptions that prove the rule. An outstanding open-heart surgeon who derives a deep enjoyment from his work is well known for his ability to tell the exact time during an operation with only half a minute margin of error, without consulting a watch. But in his case timing is one of the essential challenges of the job: since he is called only to do a very small but extremely difficult part of the operation, he is usually involved in several operations simultaneously, and has to walk from one case to the next, making sure that he is not holding up his colleagues responsible for the preliminary phases. A similar skill is often found among practitioners of other activities where time is of the essence, for instance, runners and racers. In order to pace themselves precisely in a competition, they have to be very sensitive to the passage of seconds and minutes. In such cases the ability to keep track of time becomes one of the skills necessary to do well in the activity, and thus it contributes to, rather than detracts from, the enjoyment of the experience.

But most flow activities do not depend on clock time; like baseball,

they have their own pace, their own sequences of events marking transitions from one state to another without regard to equal intervals of duration. It is not clear whether this dimension of flow is just an epiphenomenon—a by-product of the intense concentration required for the activity at hand—or whether it is something that contributes in its own right to the positive quality of the experience. Although it seems likely that losing track of the clock is not one of the major elements of enjoyment, freedom from the tyranny of time does add to the exhilaration we feel during a state of complete involvement.

THE AUTOTELIC EXPERIENCE

The key element of an optimal experience is that it is an end in itself. Even if initially undertaken for other reasons, the activity that consumes us becomes intrinsically rewarding. Surgeons speak of their work: "It is so enjoyable that I would do it even if I didn't have to." Sailors say: "I am spending a lot of money and time on this boat, but it is worth it—nothing quite compares with the feeling I get when I am out sailing."

The term "autotelic" derives from two Greek words, *auto* meaning self, and *telos* meaning goal. It refers to a self-contained activity, one that is done not with the expectation of some future benefit, but simply because the doing itself is the reward. Playing the stock market in order to make money is not an autotelic experience; but playing it in order to prove one's skill at foretelling future trends is—even though the outcome in terms of dollars and cents is exactly the same. Teaching children in order to turn them into good citizens is not autotelic, whereas teaching them because one enjoys interacting with children is. What transpires in the two situations is ostensibly identical; what differs is that when the experience is autotelic, the person is paying attention to the activity for its own sake; when it is not, the attention is focused on its consequences.

Most things we do are neither purely autotelic nor purely exotelic (as we shall call activities done for external reasons only), but are a combination of the two. Surgeons usually enter into their long period of training because of exotelic expectations: to help people, to make money, to achieve prestige. If they are lucky, after a while they begin to enjoy their work, and then surgery becomes to a large extent also autotelic.

Some things we are initially forced to do against our will turn out in the course of time to be intrinsically rewarding. A friend of mine, with whom I worked in an office many years ago, had a great gift. Whenever

the work got to be particularly boring, he would look up with a glazed look in his half-closed eyes, and he would start to hum a piece of music—a Bach chorale, a Mozart concerto, a Beethoven symphony. But humming is a pitifully inadequate description of what he did. He reproduced the entire piece, imitating with his voice the principal instruments involved in the particular passage: now he wailed like a violin, now he crooned like a bassoon, now he blared like a baroque trumpet. We in the office listened entranced, and resumed work refreshed. What is curious is the way my friend had developed this gift. Since the age of three, he had been taken by his father to concerts of classical music. He remembers having been unspeakably bored, and occasionally falling asleep in the seat, to be awakened by a sharp slap. He grew to hate concerts, classical music, and presumably his father—but year after year he was forced to repeat this painful experience. Then one evening, when he was about seven years old, during the overture to a Mozart opera, he had what he described as an ecstatic insight: he suddenly discerned the melodic structure of the piece, and had an overwhelming sense of a new world opening up before him. It was the three years of painful listening that had prepared him for this epiphany, years during which his musical skills had developed, however unconsciously, and made it possible for him to understand the challenge Mozart had built into the music.

Of course he was lucky; many children never reach the point of recognizing the possibilities of the activity into which they are forced, and end up disliking it forever. How many children have come to hate classical music because their parents forced them to practice an instrument? Often children—and adults—need external incentives to take the first steps in an activity that requires a difficult restructuring of attention. Most enjoyable activities are not natural; they demand an effort that initially one is reluctant to make. But once the interaction starts to provide feedback to the person's skills, it usually begins to be intrinsically rewarding.

An autotelic experience is very different from the feelings we typically have in the course of life. So much of what we ordinarily do has no value in itself, and we do it only because we have to do it, or because we expect some future benefit from it. Many people feel that the time they spend at work is essentially wasted—they are alienated from it, and the psychic energy invested in the job does nothing to strengthen their self. For quite a few people free time is also wasted. Leisure provides a relaxing respite from work, but it generally consists of passively absorbing information, without using any skills or exploring new opportunities

for action. As a result life passes in a sequence of boring and anxious experiences over which a person has little control.

The autotelic experience, or flow, lifts the course of life to a different level. Alienation gives way to involvement, enjoyment replaces boredom, helplessness turns into a feeling of control, and psychic energy works to reinforce the sense of self, instead of being lost in the service of external goals. When experience is intrinsically rewarding life is justified in the present, instead of being held hostage to a hypothetical future gain.

But, as we have already seen in the section dealing with the sense of control, one must be aware of the potentially addictive power of flow. We should reconcile ourselves to the fact that nothing in the world is entirely positive; every power can be misused. Love may lead to cruelty, science can create destruction, technology unchecked produces pollution. Optimal experience is a form of energy, and energy can be used either to help or to destroy. Fire warms or burns; atomic energy can generate electricity or it can obliterate the world. Energy is power, but power is only a means. The goals to which it is applied can make life either richer or more painful.

The Marquis de Sade perfected the infliction of pain into a form of pleasure, and in fact, cruelty is a universal source of enjoyment for people who have not developed more sophisticated skills. Even in societies that are called "civilized" because they try to make life enjoyable without interfering with anyone's well-being, people are attracted to violence. Gladiatorial combat amused the Romans, Victorians paid money to see rats being torn up by terriers, Spaniards approach the killing of bulls with reverence, and boxing is a staple of our own culture.

Veterans from Vietnam or other wars sometimes speak with nostalgia about front-line action, describing it as a flow experience. When you sit in a trench next to a rocket launcher, life is focused very clearly: the goal is to destroy the enemy before he destroys you; good and bad become self-evident; the means of control are at hand; distractions are eliminated. Even if one hates war, the experience can be more exhilarating than anything encountered in civilian life.

Criminals often say things such as, "If you showed me something I can do that's as much fun as breaking into a house at night, and lifting the jewelry without waking anyone up, I would do it." Much of what we label juvenile delinquency—car theft, vandalism, rowdy behavior in general—is motivated by the same need to have flow experiences not available in ordinary life. As long as a significant segment of society has few opportunities to encounter meaningful challenges, and few chances

to develop the skills necessary to benefit from them, we must expect that violence and crime will attract those who cannot find their way to more complex autotelic experiences.

This issue becomes even more complicated when we reflect that respected scientific and technological activities, which later assume a highly ambiguous and perhaps even horrifying aspect, are originally very enjoyable. Robert Oppenheimer called his work on the atomic bomb a "sweet problem," and there is no question that the manufacture of nerve gas or the planning of Star Wars can be deeply engrossing to those involved in them.

The flow experience, like everything else, is not "good" in an absolute sense. It is good only in that it has the potential to make life more rich, intense, and meaningful; it is good because it increases the strength and complexity of the self. But whether the consequence of any particular instance of flow is good in a larger sense needs to be discussed and evaluated in terms of more inclusive social criteria. The same is true, however, of all human activities, whether science, religion, or politics. A particular religious belief may benefit a person or a group, but repress many others. Christianity helped to integrate the decaying ethnic communities of the Roman Empire, but it was instrumental in dissolving many cultures with which it later came into contact. A given scientific advance may be good for science and a few scientists, but bad for humanity as a whole. It is an illusion to believe that any solution is beneficial for all people and all times; no human achievement can be taken as the final word. Jefferson's uncomfortable dictum "Eternal vigilance is the price of liberty" applies outside the fields of politics as well; it means that we must constantly reevaluate what we do, lest habits and past wisdom blind us to new possibilities.

It would be senseless, however, to ignore a source of energy because it can be misused. If mankind had tried to ban fire because it could be used to burn things down, we would not have grown to be very different from the great apes. As Democritus said so simply many centuries ago: "Water can be both good and bad, useful and dangerous. To the danger, however, a remedy has been found: learning to swim." To swim in this case involves learning to distinguish the useful and the harmful forms of flow, and then making the most of the former while placing limits on the latter. The task is to learn how to enjoy everyday life without diminishing other people's chances to enjoy theirs.

THE CONDITIONS
OF FLOW

WE HAVE SEEN HOW PEOPLE DESCRIBE the common characteristics of optimal experience: a sense that one's skills are adequate to cope with the challenges at hand, in a goal-directed, rule-bound action system that provides clear clues as to how well one is performing. Concentration is so intense that there is no attention left over to think about anything irrelevant, or to worry about problems. Self-consciousness disappears, and the sense of time becomes distorted. An activity that produces such experiences is so gratifying that people are willing to do it for its own sake, with little concern for what they will get out of it, even when it is difficult, or dangerous.

But how do such experiences happen? Occasionally flow may occur by chance, because of a fortunate coincidence of external and internal conditions. For instance, friends may be having dinner together, and someone brings up a topic that involves everyone in the conversation. One by one they begin to make jokes and tell stories, and pretty soon all are having fun and feeling good about one another. While such events may happen spontaneously, it is much more likely that flow will result either from a structured activity, or from an individual's ability to make flow occur, or both.

Why is playing a game enjoyable, while the things we have to do every day—like working or sitting at home—are often so boring? And why is it that one person will experience joy even in a concentration

camp, while another gets the blahs while vacationing at a fancy resort? Answering these questions will make it easier to understand how experience can be shaped to improve the quality of life. This chapter will explore those particular activities that are likely to produce optimal experiences, and the personal traits that help people achieve flow easily.

FLOW ACTIVITIES

When describing optimal experience in this book, we have given as examples such activities as making music, rock climbing, dancing, sailing, chess, and so forth. What makes these activities conducive to flow is that they were *designed* to make optimal experience easier to achieve. They have rules that require the learning of skills, they set up goals, they provide feedback, they make control possible. They facilitate concentration and involvement by making the activity as distinct as possible from the so-called "paramount reality" of everyday existence. For example, in each sport participants dress up in eye-catching uniforms and enter special enclaves that set them apart temporarily from ordinary mortals. For the duration of the event, players and spectators cease to act in terms of common sense, and concentrate instead on the peculiar reality of the game.

Such *flow activities* have as their primary function the provision of enjoyable experiences. Play, art, pageantry, ritual, and sports are some examples. Because of the way they are constructed, they help participants and spectators achieve an ordered state of mind that is highly enjoyable.

Roger Caillois, the French psychological anthropologist, has divided the world's games (using that word in its broadest sense to include every form of pleasurable activity) into four broad classes, depending on the kind of experiences they provide. *Agon* includes games that have competition as their main feature, such as most sports and athletic events; *alea* is the class that includes all games of chance, from dice to bingo; *ilinx*, or vertigo, is the name he gives to activities that alter consciousness by scrambling ordinary perception, such as riding a merry-go-round or skydiving; and *mimicry* is the group of activities in which alternative realities are created, such as dance, theater, and the arts in general.

Using this scheme, it can be said that games offer opportunities to go beyond the boundaries of ordinary experience in four different ways. In agonistic games, the participant must stretch her skills to meet the challenge provided by the skills of the opponents. The roots of the

word "compete" are the Latin *con petire*, which meant "to seek together." What each person seeks is to actualize her potential, and this task is made easier when others force us to do our best. Of course, competition improves experience only as long as attention is focused primarily on the activity itself. If extrinsic goals—such as beating the opponent, wanting to impress an audience, or obtaining a big professional contract—are what one is concerned about, then competition is likely to become a distraction, rather than an incentive to focus consciousness on what is happening.

Aleatory games are enjoyable because they give the illusion of controlling the inscrutable future. The Plains Indians shuffled the marked rib bones of buffaloes to predict the outcome of the next hunt, the Chinese interpreted the pattern in which sticks fell, and the Ashanti of East Africa read the future in the way their sacrificed chickens died. Divination is a universal feature of culture, an attempt to break out of the constraints of the present and get a glimpse of what is going to happen. Games of chance draw on the same need. The buffalo ribs become dice, the sticks of the I Ching become playing cards, and the ritual of divination becomes gambling—a secular activity in which people try to outsmart each other or try to outguess fate.

Vertigo is the most direct way to alter consciousness. Small children love to turn around in circles until they are dizzy; the whirling dervishes in the Middle East go into states of ecstasy through the same means. Any activity that transforms the way we perceive reality is enjoyable, a fact that accounts for the attraction of "consciousness-expanding" drugs of all sorts, from magic mushrooms to alcohol to the current Pandora's box of hallucinogenic chemicals. But consciousness cannot be expanded; all we can do is shuffle its content, which gives us the impression of having broadened it somehow. The price of most artificially induced alterations, however, is that we lose control over that very consciousness we were supposed to expand.

Mimicry makes us feel as though we are more than what we actually are through fantasy, pretense, and disguise. Our ancestors, as they danced wearing the masks of their gods, felt a sense of powerful identification with the forces that ruled the universe. By dressing like a deer, the Yaqui Indian dancer felt at one with the spirit of the animal he impersonated. The singer who blends her voice in the harmony of a choir finds chills running down her spine as she feels at one with the beautiful sound she helps create. The little girl playing with her doll and her brother pretending to be a cowboy also stretch the limits of their ordinary experience, so that they become, temporarily, someone differ-

ent and more powerful—as well as learn the gender-typed adult roles of their society.

In our studies, we found that every flow activity, whether it involved competition, chance, or any other dimension of experience, had this in common: It provided a sense of discovery, a creative feeling of transporting the person into a new reality. It pushed the person to higher levels of performance, and led to previously undreamed-of states of consciousness. In short, it transformed the self by making it more complex. In this growth of the self lies the key to flow activities.

A simple diagram might help explain why this should be the case. Let us assume that the figure below represents a specific activity—for example, the game of tennis. The two theoretically most important dimensions of the experience, challenges and skills, are represented on the two axes of the diagram. The letter A represents Alex, a boy who is learning to play tennis. The diagram shows Alex at four different points in time. When he first starts playing (A_1), Alex has practically no skills, and the only challenge he faces is hitting the ball over the net. This is not a very difficult feat, but Alex is likely to enjoy it because the difficulty is just right for his rudimentary skills. So at this point he will probably be in flow. But he cannot stay there long. After a while, if he keeps practicing, his skills are bound to improve, and then he will grow

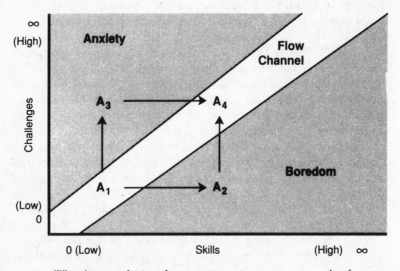

Why the complexity of consciousness increases as a result of flow experiences

bored just batting the ball over the net (A_2). Or it might happen that he meets a more practiced opponent, in which case he will realize that there are much harder challenges for him than just lobbing the ball—at that point, he will feel some anxiety (A_3) concerning his poor performance.

Neither boredom nor anxiety are positive experiences, so Alex will be motivated to return to the flow state. How is he to do it? Glancing again at the diagram, we see that if he is bored (A_2) and wishes to be in flow again, Alex has essentially only one choice: to increase the challenges he is facing. (He also has a second choice, which is to give up tennis altogether—in which case A would simply disappear from the diagram.) By setting himself a new and more difficult goal that matches his skills—for instance, to beat an opponent just a little more advanced than he is—Alex would be back in flow (A_4).

If Alex is anxious (A_3), the way back to flow requires that he increase his skills. Theoretically he could also reduce the challenges he is facing, and thus return to flow where he started (in A_1), but in practice it is difficult to ignore challenges once one is aware that they exist.

The diagram shows that both A_1 and A_4 represent situations in which Alex is in flow. Although both are equally enjoyable, the two states are quite different in that A_4 is a more *complex* experience than A_1. It is more complex because it involves greater challenges, and demands greater skills from the player.

But A_4, although complex and enjoyable, does not represent a stable situation, either. As Alex keeps playing, either he will become bored by the stale opportunities he finds at that level, or he will become anxious and frustrated by his relatively low ability. So the motivation to enjoy himself again will push him to get back into the flow channel, but now at a level of complexity even *higher* than A_4.

It is this dynamic feature that explains why flow activities lead to growth and discovery. One cannot enjoy doing the same thing at the same level for long. We grow either bored or frustrated; and then the desire to enjoy ourselves again pushes us to stretch our skills, or to discover new opportunities for using them.

It is important, however, not to fall into the mechanistic fallacy and expect that, just because a person is objectively involved in a flow activity, she will necessarily have the appropriate experience. It is not only the "real" challenges presented by the situation that count, but those that the person is aware of. It is not skills we actually have that determine how we feel, but the ones we think we have. One person may respond to the challenge of a mountain peak but remain indifferent to

the opportunity to learn to play a piece of music; the next person may jump at the chance to learn the music and ignore the mountain. How we feel at any given moment of a flow activity is strongly influenced by the objective conditions; but consciousness is still free to follow its own assessment of the case. The rules of games are intended to direct psychic energy in patterns that are enjoyable, but whether they do so or not is ultimately up to us. A professional athlete might be "playing" football without any of the elements of flow being present: he might be bored, self-conscious, concerned about the size of his contract rather than the game. And the opposite is even more likely—that a person will deeply enjoy activities that were intended for other purposes. To many people activities like working or raising children provide more flow than playing a game or painting a picture, because these individuals have learned to perceive opportunities in such mundane tasks that others do not see.

During the course of human evolution, every culture has developed activities designed primarily to improve the quality of experience. Even the least technologically advanced societies have some form of art, music, dance, and a variety of games that children and adults play. There are natives of New Guinea who spend more time looking in the jungle for the colorful feathers they use for decoration in their ritual dances than they spend looking for food. And this is by no means a rare example: art, play, and ritual probably occupy more time and energy in most cultures than work.

While these activities may serve other purposes as well, the fact that they provide enjoyment is the main reason they have survived. Humans began decorating caves at least thirty thousand years ago. These paintings surely had religious and practical significance. However, it is likely that the major raison d'être of art was the same in the Paleolithic era as it is now—namely, it was a source of flow for the painter and for the viewer.

In fact, flow and religion have been intimately connected from earliest times. Many of the optimal experiences of mankind have taken place in the context of religious rituals. Not only art but drama, music, and dance had their origins in what we now would call "religious" settings; that is, activities aimed at connecting people with supernatural powers and entities. The same is true of games. One of the earliest ball games, a form of basketball played by the Maya, was part of their religious celebrations, and so were the original Olympic games. This connection is not surprising, because what we call religion is actually the oldest and most ambitious attempt to create order in consciousness. It therefore makes sense that religious rituals would be a profound source of enjoyment.

In modern times art, play, and life in general have lost their supernatural moorings. The cosmic order that in the past helped interpret and give meaning to human history has broken down into disconnected fragments. Many ideologies are now competing to provide the best explanation for the way we behave: the law of supply and demand and the "invisible hand" regulating the free market seek to account for our rational economic choices; the law of class conflict that underlies historical materialism tries to explain our irrational political actions; the genetic competition on which sociobiology is based would explain why we help some people and exterminate others; behaviorism's law of effect offers to explain how we learn to repeat pleasurable acts, even when we are not aware of them. These are some of the modern "religions" rooted in the social sciences. None of them—with the partial exception of historical materialism, itself a dwindling creed—commands great popular support, and none has inspired the aesthetic visions or enjoyable rituals that previous models of cosmic order had spawned.

As contemporary flow activities are secularized, they are unlikely to link the actor with powerful meaning systems such as those the Olympic games or the Mayan ball games provided. Generally their content is purely hedonic: we expect them to improve how we feel, physically or mentally, but we do not expect them to connect us with the gods. Nevertheless, the steps we take to improve the quality of experience are very important for the culture as a whole. It has long been recognized that the productive activities of a society are a useful way of describing its character: thus we speak of hunting-gathering, pastoral, agricultural, and technological societies. But because flow activities are freely chosen and more intimately related to the sources of what is ultimately meaningful, they are perhaps more precise indicators of who we are.

FLOW AND CULTURE

A major element of the American experiment in democracy has been to make the pursuit of happiness a conscious political goal—indeed, a responsibility of the government. Although the Declaration of Independence may have been the first official political document to spell out this goal explicitly, it is probably true that no social system has ever survived long unless its people had some hope that their government would help them achieve happiness. Of course there have been many repressive cultures whose populace was willing to tolerate even extremely wretched rulers. If the slaves who built the Pyramids rarely revolted it was because compared to the alternatives they perceived, working as slaves for the

despotic Pharaohs offered a marginally more hopeful future.

Over the past few generations social scientists have grown extremely unwilling to make value judgments about cultures. Any comparison that is not strictly factual runs the risk of being interpreted as invidious. It is bad form to say that one culture's practice, or belief, or institution is in any sense better than another's. This is "cultural relativism," a stance anthropologists adopted in the early part of this century as a reaction against the overly smug and ethnocentric assumptions of the colonial Victorian era, when the Western industrial nations considered themselves to be the pinnacle of evolution, better in every respect than technologically less developed cultures. This naive confidence of our supremacy is long past. We might still object if a young Arab drives a truck of explosives into an embassy, blowing himself up in the process; but we can no longer feel morally superior in condemning his belief that Paradise has special sections reserved for self-immolating warriors. We have come to accept that our morality simply no longer has currency outside our own culture. According to this new dogma, it is inadmissible to apply one set of values to evaluate another. And since every evaluation across cultures must necessarily involve at least one set of values foreign to one of the cultures being evaluated, the very possibility of comparison is ruled out.

If we assume, however, that the desire to achieve optimal experience is the foremost goal of every human being, the difficulties of interpretation raised by cultural relativism become less severe. Each social system can then be evaluated in terms of how much psychic entropy it causes, measuring that disorder not with reference to the ideal order of one or another belief system, but with reference to the goals of the members of that society. A starting point would be to say that one society is "better" than another if a greater number of its people have access to experiences that are in line with their goals. A second essential criterion would specify that these experiences should lead to the growth of the self on an individual level, by allowing as many people as possible to develop increasingly complex skills.

It seems clear that cultures differ from one another in terms of the degree of the "pursuit of happiness" they make possible. The quality of life in some societies, in some historical periods, is distinctly better than in others. Toward the end of the eighteenth century, the average Englishman was probably much worse off than he had been earlier, or would be again a hundred years later. The evidence suggests that the Industrial Revolution not only shortened the life spans of members of several generations, but made them more nasty and brutish as well. It

is hard to imagine that weavers swallowed by the "Satanic mills" at five years of age, who worked seventy hours a week or more until they dropped dead from exhaustion, could feel that what they were getting out of life was what they wanted, regardless of the values and beliefs they shared.

To take another example, the culture of the Dobu islanders, as described by the anthropologist Reo Fortune, is one that encouraged constant fear of sorcery, mistrust among even the closest relatives, and vindictive behavior. Just going to the bathroom was a major problem, because it involved stepping out into the bush, where everybody expected to be attacked by bad magic when alone among the trees. The Dobuans didn't seem to "like" these characteristics so pervasive in their everyday experience, but they were unaware of alternatives. They were caught in a web of beliefs and practices that had evolved through time, and that made it very difficult for them to experience psychic harmony. Many ethnographic accounts suggest that built-in psychic entropy is more common in preliterate cultures than the myth of the "noble savage" would suggest. The Ik of Uganda, unable to cope with a deteriorating environment that no longer provides enough food for them to survive, have institutionalized selfishness beyond the wildest dreams of capitalism. The Yonomamo of Venezuela, like many other warrior tribes, worship violence more than our militaristic superpowers, and find nothing as enjoyable as a good bloody raid on a neighboring village. Laughing and smiling were almost unknown in the Nigerian tribe beset by sorcery and intrigue that Laura Bohannaw studied.

There is no evidence that any of these cultures *chose* to be selfish, violent, or fearful. Their behavior does not make them happier; on the contrary, it causes suffering. Such practices and beliefs, which interfere with happiness, are neither inevitable nor necessary; they evolved by chance, as a result of random responses to accidental conditions. But once they become part of the norms and habits of a culture, people assume that this is how things must be; they come to believe they have no other options.

Fortunately there are also many instances of cultures that, either by luck or by foresight, have succeeded in creating a context in which flow is relatively easy to achieve. For instance, the pygmies of the Ituri forest described by Colin Turnbull live in harmony with one another and their environment, filling their lives with useful and challenging activities. When they are not hunting or improving their villages they sing, dance, play musical instruments, or tell stories to each other. As in many so-called "primitive" cultures, every adult in this pygmy society

is expected to be a bit of an actor, singer, artist, and historian as well
as a skilled worker. Their culture would not be given a high rating in
terms of material achievement, but in terms of providing optimal experi-
ences their way of life seems to be extremely successful.

Another good example of how a culture can build flow into its
life-style is given by the Canadian ethnographer Richard Kool, describ-
ing one of the Indian tribes of British Columbia:

> The Shushwap region was and is considered by the Indian people to be
> a rich place: rich in salmon and game, rich in below-ground food re-
> sources such as tubers and roots—a plentiful land. In this region, the
> people would live in permanent village sites and exploit the environs for
> needed resources. They had elaborate technologies for very effectively
> using the resources of the environment, and perceived their lives as being
> good and rich. Yet, the elders said, at times the world became too
> predictable and the challenge began to go out of life. Without challenge,
> life had no meaning.
>
> So the elders, in their wisdom, would decide that the entire village
> should move, those moves occurring every 25 to 30 years. The entire
> population would move to a different part of the Shushwap land and
> there, they found challenge. There were new streams to figure out, new
> game trails to learn, new areas where the balsamroot would be plentiful.
> Now life would regain its meaning and be worth living. Everyone would
> feel rejuvenated and healthy. Incidentally, it also allowed exploited re-
> sources in one area to recover after years of harvesting. . . .

An interesting parallel is the Great Shrine at Isé, south of Kyoto,
in Japan. The Isé Shrine was built about fifteen hundred years ago on
one of a pair of adjacent fields. Every twenty years or so it has been taken
down from the field it has been standing on, and rebuilt on the next
one. By 1973 it had been reerected for the sixtieth time. (During the
fourteenth century conflict between competing emperors temporarily
interrupted the practice.)

The strategy adopted by the Shushwap and the monks of Isé
resembles one that several statesmen have only dreamed about accom-
plishing. For example, both Thomas Jefferson and Chairman Mao Ze-
dong believed that each generation needed to make its own revolution
for its members to stay actively involved in the political system ruling
their lives. In reality, few cultures have ever attained so good a fit
between the psychological needs of their people and the options availa-
ble for their lives. Most fall short, either by making survival too strenu-
ous a task, or by closing themselves off into rigid patterns that stifle the

opportunities for action by each succeeding generation.

Cultures are defensive constructions against chaos, designed to reduce the impact of randomness on experience. They are adaptive responses, just as feathers are for birds and fur is for mammals. Cultures prescribe norms, evolve goals, build beliefs that help us tackle the challenges of existence. In so doing they must rule out many alternative goals and beliefs, and thereby limit possibilities; but this channeling of attention to a limited set of goals and means is what allows effortless action within self-created boundaries.

It is in this respect that games provide a compelling analogy to cultures. Both consist of more or less arbitrary goals and rules that allow people to become involved in a process and act with a minimum of doubts and distractions. The difference is mainly one of scale. Cultures are all-embracing: they specify how a person should be born, how she should grow up, marry, have children, and die. Games fill out the interludes of the cultural script. They enhance action and concentration during "free time," when cultural instructions offer little guidance, and a person's attention threatens to wander into the uncharted realms of chaos.

When a culture succeeds in evolving a set of goals and rules so compelling and so well matched to the skills of the population that its members are able to experience flow with unusual frequency and intensity, the analogy between games and cultures is even closer. In such a case we can say that the culture as a whole becomes a "great game." Some of the classical civilizations may have succeeded in reaching this state. Athenian citizens, Romans who shaped their actions by *virtus,* Chinese intellectuals, or Indian Brahmins moved through life with intricate grace, and derived perhaps the same enjoyment from the challenging harmony of their actions as they would have from an extended dance. The Athenian *polis,* Roman law, the divinely grounded bureaucracy of China, and the all-encompassing spiritual order of India were successful and lasting examples of how culture can enhance flow—at least for those who were lucky enough to be among the principal players.

A culture that enhances flow is not necessarily "good" in any moral sense. The rules of Sparta seem needlessly cruel from the vantage point of the twentieth century, even though they were by all accounts successful in motivating those who abided by them. The joy of battle and the butchery that exhilarated the Tartar hordes or the Turkish Janissaries were legendary. It is certainly true that for great segments of the European population, confused by the dislocating economic and cultural shocks of the 1920s, the Nazi-fascist regime and ideology provided

an attractive game plan. It set simple goals, clarified feedback, and allowed a renewed involvement with life that many found to be a relief from prior anxieties and frustrations.

Similarly, while flow is a powerful motivator, it does not guarantee virtue in those who experience it. Other things being equal, a culture that provides flow might be seen as "better" than one that does not. But when a group of people embraces goals and norms that will enhance its enjoyment of life there is always the possibility that this will happen at the expense of someone else. The flow of the Athenian citizen was made possible by the slaves who worked his property, just as the elegant life-style of the Southern plantations in America rested on the labor of imported slaves.

We are still very far from being able to measure with any accuracy how much optimal experience different cultures make possible. According to a large-scale Gallup survey taken in 1976, 40 percent of North Americans said that they were "very happy," as opposed to 20 percent of Europeans, 18 percent of Africans, and only 7 percent of Far Eastern respondents. On the other hand, another survey conducted only two years earlier indicated that the personal happiness rating of U.S. citizens was about the same as that of Cubans and Egyptians, whose per-capita GNPs were respectively five and over ten times less than that of the Americans. West Germans and Nigerians came out with identical happiness ratings, despite an over fifteenfold difference in per-capita GNP. So far, these discrepancies only demonstrate that our instruments for measuring optimal experience are still very primitive. Yet the fact that differences do exist seems incontestable.

Despite ambiguous findings, all large-scale surveys agree that citizens of nations that are more affluent, better educated, and ruled by more stable governments report higher levels of happiness and satisfaction with life. Great Britain, Australia, New Zealand, and the Netherlands appear to be the happiest countries, and the United States, despite high rates of divorce, alcoholism, crime, and addictions, is not very far behind. This should not be surprising, given the amount of time and resources we spend on activities whose main purpose is to provide enjoyment. Average American adults work only about thirty hours a week (and spend an additional ten hours doing things irrelevant to their jobs while at the workplace, such as daydreaming or chatting with fellow workers). They spend a slightly smaller amount of time—on the order of twenty hours per week—involved in leisure activities: seven hours actively watching television, three hours reading, two in more active

pursuits like jogging, making music, or bowling, and seven hours in social activities such as going to parties, seeing movies, or entertaining family and friends. The remaining fifty to sixty hours that an American is awake each week are spent in maintenance activities like eating, traveling to and from work, shopping, cooking, washing up, and fixing things; or in unstructured free time, like sitting alone and staring into space.

Although average Americans have plenty of free time, and ample access to leisure activities, they do not, as a result, experience flow often. Potentiality does not imply actuality, and quantity does not translate into quality. For example, TV watching, the single most often pursued leisure activity in the United States today, leads to the flow condition very rarely. In fact, working people achieve the flow experience—deep concentration, high and balanced challenges and skills, a sense of control and satisfaction—about four times as often on their jobs, proportionately, as they do when they are watching television.

One of the most ironic paradoxes of our time is this great availability of leisure that somehow fails to be translated into enjoyment. Compared to people living only a few generations ago, we have enormously greater opportunities to have a good time, yet there is no indication that we actually enjoy life more than our ancestors did. Opportunities alone, however, are not enough. We also need the skills to make use of them. And we need to know how to control consciousness—a skill that most people have not learned to cultivate. Surrounded by an astounding panoply of recreational gadgets and leisure choices, most of us go on being bored and vaguely frustrated.

This fact brings us to the second condition that affects whether an optimal experience will occur or not: an individual's ability to restructure consciousness so as to make flow possible. Some people enjoy themselves wherever they are, while others stay bored even when confronted with the most dazzling prospects. So in addition to considering the external conditions, or the structure of flow activities, we need also to take into account the internal conditions that make flow possible.

THE AUTOTELIC PERSONALITY

It is not easy to transform ordinary experience into flow, but almost everyone can improve his or her ability to do so. While the remainder of this book will continue to explore the phenomenon of optimal experience, which in turn should help the reader to become more familiar with

it, we shall now consider another issue: whether all people have the same potential to control consciousness; and if not, what distinguishes those who do it easily from those who don't.

Some individuals might be constitutionally incapable of experiencing flow. Psychiatrists describe schizophrenics as suffering from *anhedonia*, which literally means "lack of pleasure." This symptom appears to be related to "stimulus overinclusion," which refers to the fact that schizophrenics are condemned to notice irrelevant stimuli, to process information whether they like it or not. The schizophrenic's tragic inability to keep things in or out of consciousness is vividly described by some patients: "Things just happen to me now, and I have no control over them. I don't seem to have the same say in things anymore. At times I can't even control what I think about." Or: "Things are coming in too fast. I lose my grip of it and get lost. I am attending to everything at once and as a result I do not really attend to anything."

Unable to concentrate, attending indiscriminately to everything, patients who suffer from this disease not surprisingly end up unable to enjoy themselves. But what causes stimulus overinclusion in the first place?

Part of the answer probably has to do with innate genetic causes. Some people are just temperamentally less able to concentrate their psychic energy than others. Among schoolchildren, a great variety of learning disabilities have been reclassified under the heading of "attentional disorders," because what they have in common is lack of control over attention. Although attentional disorders are likely to depend on chemical imbalances, it is also very likely that the quality of childhood experience will either exacerbate or alleviate their course. From our point of view, what is important to realize is that attentional disorders not only interfere with learning, but effectively rule out the possibility of experiencing flow as well. When a person cannot control psychic energy, neither learning nor true enjoyment is possible.

A less drastic obstacle to experiencing flow is excessive self-consciousness. A person who is constantly worried about how others will perceive her, who is afraid of creating the wrong impression, or of doing something inappropriate, is also condemned to permanent exclusion from enjoyment. So are people who are excessively self-centered. A self-centered individual is usually not self-conscious, but instead evaluates every bit of information only in terms of how it relates to her desires. For such a person everything is valueless in itself. A flower is not worth a second look unless it can be used; a man or a woman who cannot advance one's interests does not deserve further attention. Con-

sciousness is structured entirely in terms of its own ends, and nothing is allowed to exist in it that does not conform to those ends.

Although a self-conscious person is in many respects different from a self-centered one, neither is in enough control of psychic energy to enter easily into a flow experience. Both lack the attentional fluidity needed to relate to activities for their own sake; too much psychic energy is wrapped up in the self, and free attention is rigidly guided by its needs. Under these conditions it is difficult to become interested in intrinsic goals, to lose oneself in an activity that offers no rewards outside the interaction itself.

Attentional disorders and stimulus overinclusion prevent flow because psychic energy is too fluid and erratic. Excessive self-consciousness and self-centeredness prevent it for the opposite reason: attention is too rigid and tight. Neither extreme allows a person to control attention. Those who operate at these extremes cannot enjoy themselves, have a difficult time learning, and forfeit opportunities for the growth of the self. Paradoxically, a self-centered self cannot become more complex, because all the psychic energy at its disposal is invested in fulfilling its current goals, instead of learning about new ones.

The impediments to flow considered thus far are located within the individual himself. But there are also many powerful environmental obstacles to enjoyment. Some of these are natural, some social in origin. For instance, one would expect that people living in the incredibly harsh conditions of the arctic regions, or in the Kalahari desert, would have little opportunity to enjoy their lives. Yet even the most severe natural conditions cannot entirely eliminate flow. The Eskimos in their bleak, inhospitable lands learned to sing, dance, joke, carve beautiful objects, and create an elaborate mythology to give order and sense to their experiences. Possibly the snow dwellers and the sand dwellers who couldn't build enjoyment into their lives eventually gave up and died out. But the fact that some survived shows that nature alone cannot prevent flow from happening.

The social conditions that inhibit flow might be more difficult to overcome. One of the consequences of slavery, oppression, exploitation, and the destruction of cultural values is the elimination of enjoyment. When the now extinct natives of the Caribbean islands were put to work in the plantations of the conquering Spaniards, their lives became so painful and meaningless that they lost interest in survival, and eventually ceased reproducing. It is probable that many cultures disappeared in a similar fashion, because they were no longer able to provide the experience of enjoyment.

Two terms describing states of social pathology apply also to conditions that make flow difficult to experience: *anomie* and *alienation*. Anomie—literally, "lack of rules"—is the name the French sociologist Emile Durkheim gave to a condition in society in which the norms of behavior had become muddled. When it is no longer clear what is permitted and what is not, when it is uncertain what public opinion values, behavior becomes erratic and meaningless. People who depend on the rules of society to give order to their consciousness become anxious. Anomic situations might arise when the economy collapses, or when one culture is destroyed by another, but they can also come about when prosperity increases rapidly, and old values of thrift and hard work are no longer as relevant as they had been.

Alienation is in many ways the opposite: it is a condition in which people are constrained by the social system to act in ways that go against their goals. A worker who in order to feed himself and his family must perform the same meaningless task hundreds of times on an assembly line is likely to be alienated. In socialist countries one of the most irritating sources of alienation is the necessity to spend much of one's free time waiting in line for food, for clothing, for entertainment, or for endless bureaucratic clearances. When a society suffers from anomie, flow is made difficult because it is not clear what is worth investing psychic energy in; when it suffers from alienation the problem is that one cannot invest psychic energy in what is clearly desirable.

It is interesting to note that these two societal obstacles to flow, anomie and alienation, are functionally equivalent to the two personal pathologies, attentional disorders and self-centeredness. At both levels, the individual and the collective, what prevents flow from occurring is either the fragmentation of attentional processes (as in anomie and attentional disorders), or their excessive rigidity (as in alienation and self-centeredness). At the individual level anomie corresponds to anxiety, while alienation corresponds to boredom.

Neurophysiology and Flow

Just as some people are born with better muscular coordination, it is possible that there are individuals with a genetic advantage in controlling consciousness. Such people might be less prone to suffer from attentional disorders, and they may experience flow more easily.

Dr. Jean Hamilton's research with visual perception and cortical activation patterns lends support to such a claim. One set of her evidence is based on a test in which subjects had to look at an ambiguous figure (a Necker cube, or an Escher-type illustration that at one point

seems to be coming out of the plane of the paper toward the viewer and the next moment seems to recede behind the plane), and then perceptually "reverse" it—that is, see the figure that juts out of the surface as if it were sinking back, and vice versa. Dr. Hamilton found that students who reported less intrinsic motivation in daily life needed on the average to fix their eyes on more points before they could reverse the ambiguous figure, whereas students who on the whole found their lives more intrinsically rewarding needed to look at fewer points, or even only a single point, to reverse the same figure.

These findings suggest that people might vary in the number of external cues they need to accomplish the same mental task. Individuals who require a great deal of outside information to form representations of reality in consciousness may become more dependent on the external environment for using their minds. They would have less control over their thoughts, which in turn would make it more difficult for them to enjoy experience. By contrast, people who need only a few external cues to represent events in consciousness are more autonomous from the environment. They have a more flexible attention that allows them to restructure experience more easily, and therefore to achieve optimal experiences more frequently.

In another set of experiments, students who did and who did not report frequent flow experiences were asked to pay attention to flashes of lights or to tones in a laboratory. While the subjects were involved in this attentional task, their cortical activation in response to the stimuli was measured, and averaged separately for the visual and auditory conditions. (These are called "evoked potentials.") Dr. Hamilton's findings showed that subjects who reported only rarely experiencing flow behaved as expected: when responding to the flashing stimuli their activation went up significantly above their baseline level. But the results from subjects who reported flow frequently were very surprising: activation *decreased* when they were concentrating. Instead of requiring more effort, investment of attention actually seemed to decrease mental effort. A separate behavioral measure of attention confirmed that this group was also more accurate in a sustained attentional task.

The most likely explanation for this unusual finding seems to be that the group reporting more flow was able to reduce mental activity in every information channel but the one involved in concentrating on the flashing stimuli. This in turn suggests that people who can enjoy themselves in a variety of situations have the ability to screen out stimulation and to focus only on what they decide is relevant for the moment. While paying attention ordinarily involves an additional bur-

den of information processing above the usual baseline effort, for people who have learned to control consciousness focusing attention is relatively effortless, because they can shut off all mental processes but the relevant ones. It is this flexibility of attention, which contrasts so sharply with the helpless overinclusion of the schizophrenic, that may provide the neurological basis for the autotelic personality.

The neurological evidence does not, however, prove that some individuals have inherited a genetic advantage in controlling attention and therefore experiencing flow. The findings could be explained in terms of learning rather than inheritance. The association between the ability to concentrate and flow is clear; it will take further research to ascertain which one causes the other.

The Effects of the Family on the Autotelic Personality

A neurological advantage in processing information may not be the only key to explaining why some people have a good time waiting at a bus station while others are bored no matter how entertaining their environment is. Early childhood influences are also very likely factors in determining whether a person will or will not easily experience flow.

There is ample evidence to suggest that how parents interact with a child will have a lasting effect on the kind of person that child grows up to be. In one of our studies conducted at the University of Chicago, for example, Kevin Rathunde observed that teenagers who had certain types of relationship with their parents were significantly more happy, satisfied, and strong in most life situations than their peers who did not have such a relationship. The family context promoting optimal experience could be described as having five characteristics. The first one is *clarity*: the teenagers feel that they know what their parents expect from them—goals and feedback in the family interaction are unambiguous. The second is *centering*, or the children's perception that their parents are interested in what they are doing in the present, in their concrete feelings and experiences, rather than being preoccupied with whether they will be getting into a good college or obtaining a well-paying job. Next is the issue of *choice*: children feel that they have a variety of possibilities from which to choose, including that of breaking parental rules—as long as they are prepared to face the consequences. The fourth differentiating characteristic is *commitment*, or the trust that allows the child to feel comfortable enough to set aside the shield of his defenses, and become unselfconsciously involved in whatever he is interested in.

And finally there is *challenge*, or the parents' dedication to provide increasingly complex opportunities for action to their children.

The presence of these five conditions made possible what was called the "autotelic family context," because they provide an ideal training for enjoying life. The five characteristics clearly parallel the dimensions of the flow experience. Children who grow up in family situations that facilitate clarity of goals, feedback, feeling of control, concentration on the task at hand, intrinsic motivation, and challenge will generally have a better chance to order their lives so as to make flow possible.

Moreover, families that provide an autotelic context conserve a great deal of psychic energy for their individual members, thus making it possible to increase enjoyment all around. Children who know what they can and cannot do, who do not have to constantly argue about rules and controls, who are not worried about their parents' expectations for future success always hanging over their heads, are released from many of the attentional demands that more chaotic households generate. They are free to develop interests in activities that will expand their selves. In less well-ordered families a great deal of energy is expended in constant negotiations and strife, and in the children's attempts to protect their fragile selves from being overwhelmed by other people's goals.

Not surprisingly, the differences between teenagers whose families provided an autotelic context and those whose families did not were strongest when the children were at home with the family: here those from an autotelic context were much more happy, strong, cheerful, and satisfied than their less fortunate peers. But the differences were also present when the teenagers were alone studying, or in school: here, too, optimal experience was more accessible to children from autotelic families. Only when teenagers were with their friends did the differences disappear: with friends both groups felt equally positive, regardless of whether the families were autotelic or not.

It is likely that there are ways that parents behave with babies much earlier in life that will also predispose them to find enjoyment either with ease or with difficulty. On this issue, however, there are no long-term studies that trace the cause-and-effect relationships over time. It stands to reason, however, that a child who has been abused, or who has been often threatened with the withdrawal of parental love—and unfortunately we are becoming increasingly aware of what a disturbing proportion of children in our culture are so mistreated—will be so

worried about keeping his sense of self from coming apart as to have little energy left to pursue intrinsic rewards. Instead of seeking the complexity of enjoyment, an ill-treated child is likely to grow up into an adult who will be satisfied to obtain as much pleasure as possible from life.

THE PEOPLE OF FLOW

The traits that mark an autotelic personality are most clearly revealed by people who seem to enjoy situations that ordinary persons would find unbearable. Lost in Antarctica or confined to a prison cell, some individuals succeed in transforming their harrowing conditions into a manageable and even enjoyable struggle, whereas most others would succumb to the ordeal. Richard Logan, who has studied the accounts of many people in difficult situations, concludes that they survived by finding ways to turn the bleak objective conditions into subjectively controllable experience. They followed the blueprint of flow activities. First, they paid close attention to the most minute details of their environment, discovering in it hidden opportunities for action that matched what little they were capable of doing, given the circumstances. Then they set goals appropriate to their precarious situation, and closely monitored progress through the feedback they received. Whenever they reached their goal, they upped the ante, setting increasingly complex challenges for themselves.

Christopher Burney, a prisoner of the Nazis who had spent a long time in solitary confinement during World War II, gives a fairly typical example of this process:

> If the reach of experience is suddenly confined, and we are left with only a little food for thought or feeling, we are apt to take the few objects that offer themselves and ask a whole catalogue of often absurd questions about them. Does it work? How? Who made it and of what? And, in parallel, when and where did I last see something like it and what else does it remind me of? . . . So we set in train a wonderful flow of combinations and associations in our minds, the length and complexity of which soon obscures its humble starting-point. . . . My bed, for example, could be measured and roughly classified with school beds or army beds. . . . When I had done with the bed, which was too simple to intrigue me long, I felt the blankets, estimated their warmth, examined the precise mechanics of the window, the discomfort of the toilet . . . computed the length and breadth, the orientation and elevation of the cell [italics added].

Essentially the same ingenuity in finding opportunities for mental action and setting goals is reported by survivors of any solitary confinement, from diplomats captured by terrorists, to elderly ladies imprisoned by Chinese communists. Eva Zeisel, the ceramic designer who was imprisoned in Moscow's Lubyanka prison for over a year by Stalin's police, kept her sanity by figuring out how she would make a bra out of materials at hand, playing chess against herself in her head, holding imaginary conversations in French, doing gymnastics, and memorizing poems she composed. Alexander Solzhenitsyn describes how one of his fellow prisoners in the Lefortovo jail mapped the world on the floor of the cell, and then imagined himself traveling across Asia and Europe to America, covering a few kilometers each day. The same "game" was independently discovered by many prisoners; for instance Albert Speer, Hitler's favorite architect, sustained himself in Spandau prison for months by pretending he was taking a walking trip from Berlin to Jerusalem, in which his imagination provided all the events and sights along the way.

An acquaintance who worked in United States Air Force intelligence tells the story of a pilot who was imprisoned in North Vietnam for many years, and lost eighty pounds and much of his health in a jungle camp. When he was released, one of the first things he asked for was to play a game of golf. To the great astonishment of his fellow officers he played a superb game, despite his emaciated condition. To their inquiries he replied that every day of his imprisonment he imagined himself playing eighteen holes, carefully choosing his clubs and approach and systematically varying the course. This discipline not only helped preserve his sanity, but apparently also kept his physical skills well honed.

Tollas Tibor, a poet who spent several years in solitary confinement during the most repressive phases of the Hungarian communist regime, says that in the Visegrád jail, where hundreds of intellectuals were imprisoned, the inmates kept themselves occupied for more than a year by devising a poetry translation contest. First, they had to decide on the poem to translate. It took months to pass the nominations around from cell to cell, and several more months of ingenious secret messages before the votes were tallied. Finally it was agreed that Walt Whitman's O Captain! My Captain! was to be the poem to translate into Hungarian, partly because it was the one that most of the prisoners could recall from memory in the original English. Now began the serious work: everyone sat down to make his own version of the poem. Since no paper or writing tool was available, Tollas spread a film of soap on

the soles of his shoe, and carved the letters into it with a toothpick. When a line was learned by heart, he covered his shoe with a new coating of soap. As the various stanzas were written, they were memorized by the translator and passed on to the next cell. After a while, a dozen versions of the poem were circulating in the jail, and each was evaluated and voted on by all the inmates. After the Whitman translation was adjudicated, the prisoners went on to tackle a poem by Schiller.

When adversity threatens to paralyze us, we need to reassert control by finding a new direction in which to invest psychic energy, a direction that lies outside the reach of external forces. When every aspiration is frustrated, a person still must seek a meaningful goal around which to organize the self. Then, even though that person is objectively a slave, subjectively he is free. Solzhenitsyn describes very well how even the most degrading situation can be transformed into a flow experience: "Sometimes, when standing in a column of dejected prisoners, amidst the shouts of guards with machine guns, I felt such a rush of rhymes and images that I seemed to be wafted overhead. . . . At such moments I was both free and happy. . . . Some prisoners tried to escape by smashing through the barbed wire. For me there was no barbed wire. The head count of prisoners remained unchanged but I was actually away on a distant flight."

Not only prisoners report these strategies for wresting control back to their own consciousness. Explorers like Admiral Byrd, who once spent four cold and dark months by himself in a tiny hut near the South Pole, or Charles Lindbergh, facing hostile elements alone on his transatlantic flight, resorted to the same steps to keep the integrity of their selves. But what makes some people able to achieve this internal control, while most others are swept away by external hardships?

Richard Logan proposes an answer based on the writings of many survivors, including those of Viktor Frankl and Bruno Bettelheim, who have reflected on the sources of strength under extreme adversity. He concludes that the most important trait of survivors is a "nonself-conscious individualism," or a strongly directed purpose that is not self-seeking. People who have that quality are bent on doing their best in all circumstances, yet they are not concerned primarily with advancing their own interests. Because they are intrinsically motivated in their actions, they are not easily disturbed by external threats. With enough psychic energy free to observe and analyze their surroundings objectively, they have a better chance of discovering in them new opportunities for action. If we were to consider one trait a key element of the autotelic personality, this might be it. Narcissistic individuals, who are

mainly concerned with protecting their self, fall apart when the external conditions turn threatening. The ensuing panic prevents them from doing what they must do; their attention turns inward in an effort to restore order in consciousness, and not enough remains to negotiate outside reality.

Without interest in the world, a desire to be actively related to it, a person becomes isolated into himself. Bertrand Russell, one of the greatest philosophers of our century, described how he achieved personal happiness: "Gradually I learned to be indifferent to myself and my deficiencies; I came to center my attention increasingly upon external objects: the state of the world, various branches of knowledge, individuals for whom I felt affection." There could be no better short description of how to build for oneself an autotelic personality.

In part such a personality is a gift of biological inheritance and early upbringing. Some people are born with a more focused and flexible neurological endowment, or are fortunate to have had parents who promoted unselfconscious individuality. But it is an ability open to cultivation, a skill one can perfect through training and discipline. It is now time to explore further the ways this can be done.

THE BODY
IN FLOW

"A MAN POSSESSES NOTHING certainly save a brief loan of his own body," wrote J. B. Cabell, "yet the body of man is capable of much curious pleasure." When we are unhappy, depressed, or bored we have an easy remedy at hand: to use the body for all it is worth. Most people nowadays are aware of the importance of health and physical fitness. But the almost unlimited potential for enjoyment that the body offers often remains unexploited. Few learn to move with the grace of an acrobat, see with the fresh eye of an artist, feel the joy of an athlete who breaks his own record, taste with the subtlety of a connoisseur, or love with a skill that lifts sex into a form of art. Because these opportunities are easily within reach, the easiest step toward improving the quality of life consists in simply learning to control the body and its senses.

Scientists occasionally amuse themselves by trying to figure out how much a human body might be worth. Chemists have painstakingly added up the market value of skin, flesh, bone, hair, and the various minerals and trace elements contained in it, and have come up with the paltry sum of a few dollars. Other scientists have taken into account the sophisticated information processing and learning capacity of the mind-body system and have come to a very different conclusion: they calculate that to build such a sensitive machine would require an enormous sum, on the order of hundreds of millions of dollars.

Neither of these methods of assessing the body makes much sense.

Its worth does not derive from chemical ingredients, or from the neural wiring that makes information processing possible. What gives it a preciousness beyond reckoning is the fact that without it there would be no experiences, and therefore no record of life as we know it. Trying to attach a market value to the body and its processes is the same as attempting to put a price tag on life: By what scale can we establish its worth?

Everything the body can do is potentially enjoyable. Yet many people ignore this capacity, and use their physical equipment as little as possible, leaving its ability to provide flow unexploited. When left undeveloped, the senses give us chaotic information: an untrained body moves in random and clumsy ways, an insensitive eye presents ugly or uninteresting sights, the unmusical ear mainly hears jarring noises, the coarse palate knows only insipid tastes. If the functions of the body are left to atrophy, the quality of life becomes merely adequate, and for some even dismal. But if one takes control of what the body can do, and learns to impose order on physical sensations, entropy yields to a sense of enjoyable harmony in consciousness.

The human body is capable of hundreds of separate functions—seeing, hearing, touching, running, swimming, throwing, catching, climbing up mountains and climbing down caves, to name only a few—and to each of these there correspond flow experiences. In every culture, enjoyable activities have been invented to suit the potentialities of the body. When a normal physical function, like running, is performed in a socially designed, goal-directed setting with rules that offer challenges and require skills, it turns into a flow activity. Whether jogging alone, racing the clock, running against competition, or—like the Tarahumara Indians of Mexico, who race hundreds of miles in the mountains during certain festivals—adding an elaborate ritual dimension to the activity, the simple act of moving the body across space becomes a source of complex feedback that provides optimal experience and adds strength to the self. Each sensory organ, each motor function can be harnessed to the production of flow.

Before exploring further how physical activity contributes to optimal experience, it should be stressed that the body does not produce flow merely by its movements. The mind is always involved as well. To get enjoyment from swimming, for instance, one needs to cultivate a set of appropriate skills, which requires the concentration of attention. Without the relevant thoughts, motives, and feelings it would be impossible to achieve the discipline necessary to learn to swim well enough to enjoy it. Moreover, because enjoyment takes place in the mind of the

swimmer, flow cannot be a purely physical process: muscles and brain must be equally involved.

In the pages that follow we shall review some of the ways that the quality of experience can be improved through the refined use of bodily processes. These include physical activities like sports and dance, the cultivation of sexuality, and the various Eastern disciplines for controlling the mind through the training of the body. They also feature the discriminating use of the senses of sight, hearing, and taste. Each of these modalities offers an almost unlimited amount of enjoyment, but only to persons who work to develop the skills they require. To those who do not, the body remains indeed a lump of rather inexpensive flesh.

HIGHER, FASTER, STRONGER

The Latin motto of the modern Olympic games—*Altius, citius, fortius*—is a good, if incomplete summary of how the body can experience flow. It encompasses the rationale of all sports, which is to do something better than it has ever been done before. The purest form of athletics, and sports in general, is to break through the limitations of what the body can accomplish.

However unimportant an athletic goal may appear to the outsider, it becomes a serious affair when performed with the intent of demonstrating a perfection of skill. Throwing things, for instance, is a rather trivial ability; even small babies are quite good at it, as the toys surrounding any infant's crib testify. But how far a person can throw an object of a certain weight becomes a matter of legend. The Greeks invented the discus, and the great discus throwers of antiquity were immortalized by the best sculptors; the Swiss gathered on holidays in mountain meadows to see who could toss the trunk of a tree farthest; the Scots did the same with gigantic rocks. In baseball nowadays pitchers become rich and famous because they can throw balls with speed and precision, and basketball players because they can sink them into hoops. Some athletes throw javelins; others are bowlers, shot-putters, or hammer throwers; some throw boomerangs or cast fishing lines. Each of these variations on the basic capacity to throw offers almost unlimited opportunities for enjoyment.

Altius—higher—is the first word of the Olympic motto, and soaring above the ground is another universally recognized challenge. To break the bonds of gravity is one of the oldest dreams of mankind. The myth of Icarus, who had wings fashioned so he could reach the sun, has been long held to be a parable of the aims—noble and misguided at the

same time—of civilization itself. To jump higher, to climb the loftiest peaks, to fly far above the earth, are among the most enjoyable activities people can do. Yet some savants have recently invented a special psychic infirmity, the so-called "Icarus complex," to account for this desire to be released from the pull of gravity. Like all explanations that try to reduce enjoyment to a defensive ploy against repressed anxieties, this one misses the point. Of course, in some sense all purposeful action can be regarded as a defense against the threats of chaos. But in that respect it is more worthwhile to consider acts that bring enjoyment as signs of health, not of disease.

Flow experiences based on the use of physical skills do not occur only in the context of outstanding athletic feats. Olympians do not have an exclusive gift in finding enjoyment in pushing performance beyond existing boundaries. Every person, no matter how unfit he or she is, can rise a little higher, go a little faster, and grow to be a little stronger. The joy of surpassing the limits of the body is open to all.

Even the simplest physical act becomes enjoyable when it is transformed so as to produce flow. The essential steps in this process are: (a) to set an overall goal, and as many subgoals as are realistically feasible; (b) to find ways of measuring progress in terms of the goals chosen; (c) to keep concentrating on what one is doing, and to keep making finer and finer distinctions in the challenges involved in the activity; (d) to develop the skills necessary to interact with the opportunities available; and (e) to keep raising the stakes if the activity becomes boring.

A good example of this method is the act of walking, which is as simple a use of the body as one can imagine, yet which can become a complex flow activity, almost an art form. A great number of different goals might be set for a walk. For instance, the choice of the itinerary: where one wishes to go, and by what route. Within the overall route, one might select places to stop, or certain landmarks to see. Another goal may be to develop a personal style, a way to move the body easily and efficiently. An economy of motion that maximizes physical well-being is another obvious goal. For measuring progress, the feedback may include how fast and how easily the intended distance was covered; how many interesting sights one has seen; and how many new ideas or feelings were entertained along the way.

The challenges of the activity are what force us to concentrate. The challenges of a walk will vary greatly, depending on the environment. For those who live in large cities, flat sidewalks and right-angle layouts make the physical act of walking easy. Walking on a mountain trail is another thing altogether: for a skilled hiker each step presents

a different challenge to be resolved with a choice of the most efficient foothold that will give the best leverage, simultaneously taking into account the momentum and the center of gravity of the body and the various surfaces—dirt, rocks, roots, grass, branches—on which the foot can land. On a difficult trail an experienced hiker walks with economy of motion and lightness, and the constant adjustment of her steps to the terrain reveals a highly sophisticated process of selecting the best solution to a changing series of complex equations involving mass, velocity, and friction. Of course these calculations are usually automatic, and give the impression of being entirely intuitive, almost instinctive; but if the walker does not process the right information about the terrain, and fails to make the appropriate adjustments in her gait, she will stumble or will soon grow tired. So while this kind of walking might be entirely unselfconscious, it is in fact a highly intense activity that requires concentrated attention.

In the city the terrain itself is not challenging, but there are other opportunities for developing skills. The social stimulation of the crowds, the historical and architectural references of the urban milieu can add enormous variety to a walk. There are store windows to see, people to observe, patterns of human interaction to reflect on. Some walkers specialize in choosing the shortest routes, others the most interesting ones; some pride themselves in walking the same route with chronometric precision, others like to mix and match their itinerary. In winter some aim to walk as long as possible on the sunny stretches of the sidewalk, and to walk as much in the shade as possible in the summer. There are those who time their crossings exactly for when the traffic lights change to green. Of course these chances for enjoyment must be cultivated; they don't just happen automatically to those who do not control their itinerary. Unless one sets goals and develops skills, walking is just featureless drudgery.

Walking is the most trivial physical activity imaginable, yet it can be profoundly enjoyable if a person sets goals and takes control of the process. On the other hand, the hundreds of sophisticated forms of sport and body culture currently available—ranging from racquetball to Yoga, from bicycling to martial arts—may not be enjoyable at all if one approaches them with the attitude that one *must* take part in them because they are fashionable, or simply because they are good for one's health. Many people get caught up in a treadmill of physical activity over which they end up having little control, feeling duty bound to exercise but not having any fun doing it. They have made the usual mistake of confounding form and substance, and assume that concrete actions and

events are the only "reality" that determines what they experience. For such individuals, joining a fancy health club should be almost a guarantee that they will enjoy themselves. However, enjoyment, as we have seen, does not depend on *what* you do, but rather on *how* you do it.

In one of our studies we addressed the following question: Are people happier when they use more material resources in their leisure activities? Or are they happier when they invest more of themselves? We tried to answer these questions with the Experience Sampling Method (ESM), the procedure I developed at the University of Chicago to study the quality of experience. As described earlier, this method consists in giving people electronic pagers, or beepers, and a booklet of response sheets. A radio transmitter is programmed to send signals about eight times a day, at random intervals, for a week. Each time the pager signals, respondents fill out a page of the booklet, indicating where they are and what they are doing and with whom, and rating their state of mind on a variety of dimensions, such as a seven-point scale ranging from "very happy" to "very sad."

What we found was that when people were pursuing leisure activities that were expensive in terms of the outside resources required—activities that demanded expensive equipment, or electricity, or other forms of energy measured in BTUs, such as power boating, driving, or watching television—they were significantly *less* happy than when involved in inexpensive leisure. People were happiest when they were just talking to one another, when they gardened, knitted, or were involved in a hobby; all of these activities require few material resources, but they demand a relatively high investment of psychic energy. Leisure that uses up external resources, however, often requires less attention, and as a consequence it generally provides less memorable rewards.

THE JOYS OF MOVEMENT

Sports and fitness are not the only media of physical experience that use the body as a source of enjoyment, for in fact a broad range of activities rely on rhythmic or harmonious movements to generate flow. Among these dance is probably the oldest and the most significant, both for its universal appeal and because of its potential complexity. From the most isolated New Guinea tribe to the polished troupes of the Bolshoi Ballet, the response of the body to music is widely practiced as a way of improving the quality of experience.

Older people may consider dancing at clubs a bizarre and senseless ritual, but many teenagers find it an important source of enjoyment.

Here is how some of the dancers describe the sensation of moving on the floor: "Once I get into it, then I just float along, having fun, just feeling myself move around." "I get sort of a physical high from it. . . . I get very sweaty, very feverish or sort of ecstatic when everything is going really well." "You move about and try to express yourself in terms of those motions. That's where it's at. It's a body language kind of communicative medium, in a way. . . . When it's going good, I'm really expressing myself well in terms of the music and in terms of the people that are out there."

The enjoyment of dancing is often so intense that people will give up many other options for its sake. Here is a typical statement from one of the dancers interviewed by Professor Massimini's group in Milan, Italy: "From the very first I wanted to become a professional ballerina. It has been hard: little money, lots of traveling, and my mother always complains about my work. But love of the dance has always sustained me. It is now part of my life, a part of me that I could not live without." In this group of sixty professional dancers of marriageable age, only three were married, and only one had a child; pregnancy was seen as too great an interference with a career.

But just as with athletics, one certainly need not become a professional to enjoy controlling the expressive potentials of the body. Dilettante dancers can have just as much fun, without sacrificing every other goal for the sake of feeling themselves moving harmoniously.

And there are other forms of expression that use the body as an instrument: miming and acting, for instance. The popularity of charades as a parlor game is due to the fact that it allows people to shed for a time their customary identity, and act out different roles. Even the most silly and clumsy impersonation can provide an enjoyable relief from the limitations of everyday patterns of behavior, a glimpse into alternative modes of being.

SEX AS FLOW

When people think of enjoyment, usually one of the first things that comes to mind is sex. This is not surprising, because sexuality is certainly one of the most universally rewarding experiences, surpassed in its power to motivate perhaps only by the need to survive, to drink, and to eat. The urge to have sex is so powerful that it can drain psychic energy away from other necessary goals. Therefore every culture has to invest great efforts in rechanneling and restraining it, and many complex social institutions exist only in order to regulate this

urge. The saying that "love makes the world go round" is a polite reference to the fact that most of our deeds are impelled, either directly or indirectly, by sexual needs. We wash, dress, and comb our hair to be attractive, many of us go to work so as to afford keeping a partner and a household, we struggle for status and power in part so as to be admired and loved.

But is sex always enjoyable? By now the reader might be able to guess that the answer depends on what happens in the consciousness of those involved. The same sexual act can be experienced as painful, revolting, frightening, neutral, pleasant, pleasurable, enjoyable, or ecstatic—depending on how it is linked to a person's goals. A rape may not be distinguishable physically from a loving encounter, but their psychological effects are worlds apart.

It is safe to say that sexual stimulation in and of itself is generally pleasurable. That we are genetically programmed to derive pleasure from sexuality is evolution's rather clever way of guaranteeing that individuals will engage in activities likely to lead to procreation, thus ensuring the survival of the species. To take pleasure in sex one needs only to be healthy and willing; no special skills are required, and soon after the first experiences, few new physical challenges arise again. But like other pleasures, unless it is transformed into an enjoyable activity, sex easily becomes boring with time. It turns from a genuinely positive experience into either a meaningless ritual or an addictive dependence. Fortunately there are many ways to make sex enjoyable.

Eroticism is one form of cultivating sexuality that focuses on the development of physical skills. In a sense, eroticism is to sex as sport is to physical activity. The Kama Sutra and The Joy of Sex are two examples of manuals that aim to foster eroticism by providing suggestions and goals to help make sexual activity more varied, more interesting and challenging. Most cultures have elaborate systems of erotic training and performance, often overlaid with religious meanings. Early fertility rites, the Dionysian mysteries of Greece, and the recurring connection between prostitution and female priesthood are just a few forms of this phenomenon. It is as if in the early stages of religion, cultures coopted the obvious attraction of sexuality and used it as a basis on which to build more complex ideas and patterns of behavior.

But the real cultivation of sexuality begins only when psychological dimensions are added to the purely physical. According to historians, the art of love was a recent development in the West. With rare exceptions, there was very little romance in the sexual practices of the Greeks and the Romans. The wooing, the sharing of feelings between lovers, the

promises and the courtship rituals that now seem to be such indispensable attributes of intimate relations were only invented in the late Middle Ages by the troubadours who plied the castles of southern France, and then, as the "sweet new style," they were adopted by the affluent classes in the rest of Europe. Romance—the rituals of wooing first developed in the Romance region of southern France—provides an entire new range of challenges to lovers. For those who learn the skills necessary to meet them, it becomes not only pleasurable, but enjoyable as well.

A similar refinement of sexuality took place in other civilizations, and roughly in the same not-too-distant past. The Japanese created extremely sophisticated professionals of love, expecting their geishas to be accomplished musicians, dancers, actresses, as well as appreciative of poetry and art. Chinese and Indian courtesans and Turkish odalisques were equally skillful. Regrettably this professionalism, while developing the potential complexity of sex to great heights, did little to improve directly the quality of experience for most people. Historically, romance seems to have been restricted to youth and to those who had the time and the money to indulge in it; the vast majority in any culture appear to have had a very humdrum sex life. "Decent" people the world over do not spend too much energy on the task of sexual reproduction, or on the practices that have been built on it. Romance resembles sports in this respect as well: instead of doing it personally, most people are content to hear about it or watch a few experts perform it.

A third dimension of sexuality begins to emerge when in addition to physical pleasure and the enjoyment of a romantic relationship the lover feels genuine care for his partner. There are then new challenges one discovers: to enjoy the partner as a unique person, to understand her, and to help her fulfill her goals. With the emergence of this third dimension sexuality becomes a very complex process, one that can go on providing flow experiences all through life.

At first it is very easy to obtain pleasure from sex, and even to enjoy it. Any fool can fall in love when young. The first date, the first kiss, the first intercourse all present heady new challenges that keep the young person in flow for weeks on end. But for many this ecstatic state occurs only once; after the "first love" all later relationships are no longer as exciting. It is especially difficult to keep enjoying sex with the same partner over a period of years. It is probably true that humans, like the majority of mammalian species, are not monogamous by nature. It is impossible for partners not to grow bored unless they work to discover new challenges in each other's company, and learn appropriate skills for

enriching the relationship. Initially physical challenges alone are enough to sustain flow, but unless romance and genuine care also develop, the relationship will grow stale.

How to keep love fresh? The answer is the same as it is for any other activity. To be enjoyable, a relationship must become more complex. To become more complex, the partners must discover new potentialities in themselves and in each other. To discover these, they must invest attention in each other—so that they can learn what thoughts and feelings, what dreams reside in their partner's mind. This in itself is a never-ending process, a lifetime's task. After one begins to really know another person, then many joint adventures become possible: traveling together, reading the same books, raising children, making and realizing plans all become more enjoyable and more meaningful. The specific details are unimportant. Each person must find out which ones are relevant to his or her own situation. What is important is the general principle: that sexuality, like any other aspect of life, can be made enjoyable if we are willing to take control of it, and cultivate it in the direction of greater complexity.

THE ULTIMATE CONTROL: YOGA AND THE MARTIAL ARTS

When it comes to learning to control the body and its experiences, we are as children compared to the great Eastern civilizations. In many respects, what the West has accomplished in terms of harnessing material energy is matched by what India and the Far East have achieved in terms of direct control of consciousness. That neither of these approaches is, by itself, an ideal program for the conduct of life is shown by the fact that the Indian fascination with advanced techniques for self-control, at the expense of learning to cope with the material challenges of the physical environment, has conspired to let impotence and apathy spread over a great proportion of the population, defeated by scarcity of resources and by overcrowding. The Western mastery over material energy, on the other hand, runs the risk of turning everything it touches into a resource to be consumed as rapidly as possible, thus exhausting the environment. The perfect society would be able to strike a healthy balance between the spiritual and material worlds, but short of aiming for perfection, we can look toward Eastern religions for guidance in how to achieve control over consciousness.

Of the great Eastern methods for training the body, one of the oldest and most diffuse is the set of practices known as Hatha Yoga. It

is worth reviewing some of its highlights, because it corresponds in several areas to what we know about the psychology of flow, and therefore provides a useful model for anyone who wishes to be in better charge of psychic energy. Nothing quite like Hatha Yoga has ever been created in the West. The early monastic routines instituted by Saint Benedict and Saint Dominick and especially the "spiritual exercises" of Saint Ignatius of Loyola probably come the closest in offering a way to control attention by developing mental and physical routines; but even these fall far short of the rigorous discipline of Yoga.

In Sanskrit *Yoga* means "yoking," which refers to the method's goal of joining the individual with God, first by uniting the various parts of the body with one another, then making the body as a whole work together with consciousness as part of an ordered system. To achieve this aim, the basic text of Yoga, compiled by Patanjali about fifteen hundred years ago, prescribes eight stages of increasing skills. The first two stages of "ethical preparation" are intended to change a person's attitudes. We might say that they involve the "straightening out of consciousness"; they attempt to reduce psychic entropy as much as possible before the actual attempts at mental control begin. In practice, the first step, *yama*, requires that one achieve "restraint" from acts and thoughts that might harm others—falsehood, theft, lust, and avarice. The second step, *niyama*, involves "obedience," or the following of ordered routines in cleanliness, study, and obedience to God, all of which help to channel attention into predictable patterns, and hence make attention easier to control.

The next two stages involve physical preparation, or development of habits that will enable the practitioner—or yogin—to overcome the demands of the senses, and make it possible for him to concentrate without growing tired or distracted. The third stage consists in practicing various *asana*, ways of "sitting" or holding postures for long periods without succumbing to strain or fatigue. This is the stage of Yoga that we all know in the West, exemplified by a fellow in what looks like diapers standing on his head with his shanks behind his neck. The fourth stage is *pranayama*, or breath control, which aims to relax the body, and stabilizes the rhythm of breathing.

The fifth stage, the hinge between the preparatory exercises and the practice of Yoga proper, is called *pratyahara* ("withdrawal"). It involves learning to withdraw attention from outward objects by directing the input of the senses—thus becoming able to see, hear, and feel only what one wishes to admit into awareness. Already at this stage we see how close the goal of Yoga is to that of the flow activities described in

this volume—to achieve control over what happens in the mind.

Although the remaining three stages do not properly belong to the present chapter—they involve the control of consciousness through purely mental operations, rather than physical techniques—we shall discuss them here for the sake of continuity, and also because these mental practices are, after all, solidly based on the earlier physical ones. *Dharana*, or "holding on," is the ability to concentrate for long periods on a single stimulus, and thus is the mirror image of the earlier stage of *pratyahara*; first one learns to keep things out of the mind, then one learns to keep them in. Intense meditation, or *dhyana*, is the next step. Here one learns to forget the self in uninterrupted concentration that no longer needs the external stimuli of the preceding phase. Finally the yogin may achieve *samadhi*, the last stage of "self-collectedness," when the meditator and the object of meditation become as one. Those who have achieved it describe *samadhi* as the most joyful experience in their lives.

The similarities between Yoga and flow are extremely strong; in fact it makes sense to think of Yoga as a very thoroughly planned flow activity. Both try to achieve a joyous, self-forgetful involvement through concentration, which in turn is made possible by a discipline of the body. Some critics, however, prefer to stress the differences between flow and Yoga. Their main divergence is that, whereas flow attempts to fortify the self, the goal of Yoga and many other Eastern techniques is to abolish it. *Samadhi*, the last stage of Yoga, is only the threshold for entering Nirvana, where the individual self merges with the universal force like a river blending into the ocean. Therefore, it can be argued, Yoga and flow tend toward diametrically opposite outcomes.

But this opposition may be more superficial than real. After all, seven of the eight stages of Yoga involve building up increasingly higher levels of skill in controlling consciousness. *Samadhi* and the liberation that is supposed to follow it may not, in the end, be that significant—they may in one sense be regarded as the justification of the activity that takes place in the previous seven stages, just as the peak of the mountain is important only because it justifies climbing, which is the real goal of the enterprise. Another argument favoring the similarity of the two processes is that, even till the final stage of liberation, the yogin must maintain control over consciousness. He could not surrender his self unless he was, even at the very moment of surrender, in complete control of it. Giving up the self with its instincts, habits, and desires is so unnatural an act that only someone supremely in control can accomplish it.

Therefore it is not unreasonable to regard Yoga as one of the oldest and most systematic methods of producing the flow experience. The details of *how* the experience is produced are unique to Yoga, as they are unique to every other flow activity, from fly-fishing to racing a Formula One car. As the product of cultural forces that occurred only once in history, the way of Yoga bears the stamp of the time and place in which it was created. Whether Yoga is a "better" way to foster optimal experience than others cannot be decided on its own merits alone—one must consider the opportunity costs involved in the practice, and compare them with alternative options. Is the control that Yoga makes possible worth the investment of psychic energy that learning its discipline requires?

Another set of Eastern disciplines that have become popular recently in the West are the so-called "martial arts." There are many variations of these, and each year a new one seems to arrive. They include judo, jujitsu, kung fu, karate, tae kwon do, aikido, T'ai Chi ch'uan—all forms of unarmed combat that originated in China—and kendō (fencing), kyūdō (archery), and ninjutsu, which are more closely associated with Japan.

These martial arts were influenced by Taoism and by Zen Buddhism, and thus they also emphasize consciousness-controlling skills. Instead of focusing exclusively on physical performance, as Western martial arts do, the Eastern variety is directed toward improving the mental and spiritual state of the practitioner. The warrior strives to reach the point where he can act with lightning speed against opponents, without having to think or reason about the best defensive or offensive moves to make. Those who can perform it well claim that fighting becomes a joyous artistic performance, during which the everyday experience of duality between mind and body is transformed into a harmonious one-pointedness of mind. Here again, it seems appropriate to think of the martial arts as a specific form of flow.

FLOW THROUGH THE SENSES: THE JOYS OF SEEING

It is easy to accept the fact that sports, sex, and even Yoga can be enjoyable. But few people step beyond these physical activities to explore the almost unlimited capacities of the other organs of the body, even though any information that the nervous system can recognize lends itself to rich and varied flow experiences.

Seeing, for instance, is most often used simply as a distant sensing

system, to keep from stepping on the cat, or to find the car keys. Occasionally people stop to "feast their eyes" when a particularly gorgeous sight happens to appear in front of them, but they do not cultivate systematically the potential of their vision. Visual skills, however, can provide constant access to enjoyable experiences. Menander, the classical poet, well expressed the pleasure we can derive from just watching nature: "The sun that lights us all, the stars, the sea, the train of clouds, the spark of fire—if you live a hundred years or only a few, you can never see anything higher than them." The visual arts are one of the best training grounds for developing these skills. Here are some descriptions by people versed in the arts about the sensation of really being able to *see*. The first recalls an almost Zen-like encounter with a favorite painting, and emphasizes the sudden epiphany of order that seems to arise from seeing a work that embodies visual harmony: "There is that wonderful Cézanne 'Bathers' in the Philadelphia Museum . . . which . . . gives you in one glance that great sense of a scheme, not necessarily rational, but that things come together. . . . [That] is the way in which the work of art allows you to have a sudden appreciation of, an understanding of the world. That may mean your place in it, that may mean what bathers on the side of a river on a summer day are all about . . . that may mean the ability to suddenly let go of ourselves and understand our connection to the world. . . ."

Another viewer describes the unsettling physical dimension of the aesthetic flow experience, which resembles the shock a body feels when diving into a pool of cold water:

When I see works that come close to my heart, that I think are really fine, I have the strangest reaction: which is not always exhilarating, it is sort of like being hit in the stomach. Feeling a little nauseous. It's just this sort of completely overwhelming feeling, which then I have to grope my way out of, calm myself down, and try to approach it scientifically, not with all my antennae vulnerable, open. . . . What comes to you after looking at it calmly, after you've really digested every nuance and every little thread, is the total impact. When you encounter a very great work of art, you just know it and it thrills you in all your senses, not just visually, but sensually and intellectually.

Not only great works of art produce such intense flow experiences; for the trained eye, even the most mundane sights can be delightful. A man who lives in one of Chicago's suburbs, and takes the elevated train to work every morning, says:

On a day like this, or days when it's crystal clear, I just sit in the train and look over the roofs of the city, because it's so fascinating to see the city, to be above it, to be there but not be a part of it, to see these forms and these shapes, these marvelous old buildings, some of which are totally ruined, and, I mean, just the fascination of the thing, the curiosity of it. . . . I can come in and say, "Coming to work this morning was like coming through a Sheeler precisionist painting." Because he painted rooftops and things like that in a very crisp, clear style. . . . It often happens that someone who's totally wrapped up in a means of visual expression sees the world in those terms. Like a photographer looks at a sky and says, "This is a Kodachrome sky. Way to go, God. You're almost as good as Kodak."

Clearly, it takes training to be able to derive this degree of sensory delight from seeing. One must invest quite a bit of psychic energy in looking at beautiful sights and at good art before one can recognize the Sheeler-like quality of a roofscape. But this is true of all flow activities: without cultivating the necessary skills, one cannot expect to take true enjoyment in a pursuit. Compared to several other activities, however, seeing is immediately accessible (although some artists contend that many people have "tin eyes"), so it is a particular pity to let it rest undeveloped.

It might seem like a contradiction that, in the previous section, we have shown how Yoga can induce flow by training the eyes *not* to see, whereas we are now advocating the use of the eyes to make flow happen. This is a contradiction only for those who believe that what is significant is the behavior, rather than the experience to which it leads. It does not matter whether we see or we not-see, as long as we are in control of what is happening to us. The same person can meditate in the morning and shut out all sensory experience, and then look at a great work of art in the afternoon; either way he may be transformed by the same sense of exhilaration.

THE FLOW OF MUSIC

In every known culture, the ordering of sound in ways that please the ear has been used extensively to improve the quality of life. One of the most ancient and perhaps the most popular functions of music is to focus the listeners' attention on patterns appropriate to a desired mood. So there is music for dancing, for weddings, for funerals, for religious and for patriotic occasions; music that facilitates romance, and music

that helps soldiers march in orderly ranks.

When bad times befell the pygmies of the Ituri forest in Central Africa, they assumed that their misfortune was due to the fact that the benevolent forest, which usually provided for all their needs, had accidentally fallen asleep. At that point the leaders of the tribe would dig up the sacred horns buried underground, and blow on them for days and nights on end, in an attempt to wake up the forest, thus restoring the good times.

The way music is used in the Ituri forest is paradigmatic of its function everywhere. The horns may not have awakened the trees, but their familiar sound must have reassured the pygmies that help was on the way, and so they were able to confront the future with confidence. Most of the music that pours out of Walkmans and stereos nowadays answers a similar need. Teenagers, who swing from one threat to their fragile evolving personhood to another in quick succession throughout the day, especially depend on the soothing patterns of sound to restore order in their consciousness. But so do many adults. One policeman told us: "If after a day of making arrests and worrying about getting shot I could not turn on the radio in the car on my way home, I would probably go out of my mind."

Music, which is organized auditory information, helps organize the mind that attends to it, and therefore reduces psychic entropy, or the disorder we experience when random information interferes with goals. Listening to music wards off boredom and anxiety, and when seriously attended to, it can induce flow experiences.

Some people argue that technological advances have greatly improved the quality of life by making music so easily available. Transistor radios, laser disks, tape decks blare the latest music twenty-four hours a day in crystal-clear recordings. This continuous access to good music is supposed to make our lives much richer. But this kind of argument suffers from the usual confusion between behavior and experience. Listening to recorded music for days on end may or may not be more enjoyable than hearing an hour-long live concert that one had been looking forward to for weeks. It is not the *hearing* that improves life, it is the *listening*. We hear Muzak, but we rarely listen to it, and few could have ever been in flow as a result of it.

As with anything else, to enjoy music one must pay attention to it. To the extent that recording technology makes music too accessible, and therefore taken for granted, it can reduce our ability to derive enjoyment from it. Before the advent of sound recording, a live musical performance retained some of the awe that music engendered when it

was still entirely immersed in religious rituals. Even a village dance band, let alone a symphonic orchestra, was a visible reminder of the mysterious skill involved in producing harmonious sounds. One approached the event with heightened expectations, with the awareness that one had to pay close attention because the performance was unique and not to be repeated again.

The audiences at today's live performances, such as rock concerts, continue to partake in some degree in these ritual elements; there are few other occasions at which large numbers of people witness the same event together, think and feel the same things, and process the same information. Such joint participation produces in an audience the condition Emile Durkheim called "collective effervescence," or the sense that one belongs to a group with a concrete, real existence. This feeling, Durkheim believed, was at the roots of religious experience. The very conditions of live performance help focus attention on the music, and therefore make it more likely that flow will result at a concert than when one is listening to reproduced sound.

But to argue that live music is innately more enjoyable than recorded music would be just as invalid as arguing the opposite. Any sound can be be a source of enjoyment if attended to properly. In fact, as the Yaqui sorcerer taught the anthropologist Carlos Castaneda, even the intervals of silence between sounds, if listened to closely, can be exhilarating.

Many people have impressive record libraries, full of the most exquisite music ever produced, yet they fail to enjoy it. They listen a few times to their recording equipment, marveling at the clarity of the sound it produces, and then forget to listen again until it is time to purchase a more advanced system. Those who make the most of the potential for enjoyment inherent in music, on the other hand, have strategies for turning the experience into flow. They begin by setting aside specific hours for listening. When the time comes, they deepen concentration by dousing the lights, by sitting in a favorite chair, or by following some other ritual that will focus attention. They plan carefully the selection to be played, and formulate specific goals for the session to come.

Listening to music usually starts as a *sensory* experience. At this stage, one responds to the qualities of sound that induce the pleasant physical reactions that are genetically wired into our nervous system. We respond to certain chords that seem to have universal appeal, or to the plaintive cry of the flute, the rousing call of the trumpets. We are particularly sensitive to the rhythm of the drums or the bass, the beat on which rock music rests, and which some contend is supposed to

remind the listener of the mother's throbbing heart first heard in the womb.

The next level of challenge music presents is the *analogic* mode of listening. In this stage, one develops the skill to evoke feelings and images based on the patterns of sound. The mournful saxophone passage recalls the sense of awe one has when watching storm clouds build up over the prairie; the Tchaikovsky piece makes one visualize a sleigh driving through a snowbound forest, with its bells tinkling. Popular songs of course exploit the analogic mode to its fullest by cuing in the listener with lyrics that spell out what mood or what story the music is supposed to represent.

The most complex stage of music listening is the *analytic* one. In this mode attention shifts to the structural elements of music, instead of the sensory or narrative ones. Listening skills at this level involve the ability to recognize the order underlying the work, and the means by which the harmony was achieved. They include the ability to evaluate critically the performance and the acoustics; to compare the piece with earlier and later pieces of the same composer, or with the work of other composers writing at the same time; and to compare the orchestra, conductor, or band with their own earlier and later performances, or with the interpretations of others. Analytic listeners often compare various versions of the same blues song, or sit down to listen with an agenda that might typically be: "Let's see how von Karajan's 1975 recording of the second movement of the Seventh Symphony differs from his 1963 recording," or "I wonder if the brass section of the Chicago Symphony is really better than the Berlin brasses?" Having set such goals, a listener becomes an active experience that provides constant feedback (e.g., "von Karajan has slowed down," "the Berlin brasses are sharper but less mellow"). As one develops analytic listening skills, the opportunities to enjoy music increase geometrically.

So far we have considered only how flow arises from listening, but even greater rewards are open to those who learn to make music. The civilizing power of Apollo depended on his ability to play the lyre, Pan drove his audiences to frenzy with his pipes, and Orpheus with his music was able to restrain even death. These legends point to the connection between the ability to create harmony in sound and the more general and abstract harmony that underlies the kind of social order we call a civilization. Mindful of that connection, Plato believed that children should be taught music before anything else; in learning to pay attention to graceful rhythms and harmonies their whole consciousness would become ordered.

Our culture seems to have been placing a decreasing emphasis on exposing young children to musical skills. Whenever cuts are to be made in a school's budget, courses in music (as well as art and physical education) are the first to be eliminated. It is discouraging how these three basic skills, so important for improving the quality of life, are generally considered to be superfluous in the current educational climate. Deprived of serious exposure to music, children grow into teenagers who make up for their early deprivation by investing inordinate amounts of psychic energy into their own music. They form rock groups, buy tapes and records, and generally become captives of a subculture that does not offer many opportunities for making consciousness more complex.

Even when children *are* taught music, the usual problem often arises: too much emphasis is placed on how they perform, and too little on what they experience. Parents who push their children to excel at the violin are generally not interested in whether the children are actually enjoying the playing; they want the child to perform well enough to attract attention, to win prizes, and to end up on the stage of Carnegie Hall. By doing so, they succeed in perverting music into the opposite of what it was designed to be: they turn it into a source of psychic disorder. Parental expectations for musical *behavior* often create great stress, and sometimes a complete breakdown.

Lorin Hollander, who was a child prodigy at the piano and whose perfectionist father played first violin in Toscanini's orchestra, tells how he used to get lost in ecstasy when playing the piano alone, but how he used to quake in sheer terror when his demanding adult mentors were present. When he was a teenager the fingers of his hands froze during a concert recital, and he could not open his clawed hands for many years thereafter. Some subconscious mechanism below the threshold of his awareness had decided to spare him the constant pain of parental criticism. Now Hollander, recovered from the psychologically induced paralysis, spends much of his time helping other gifted young instrumentalists to enjoy music the way it is meant to be enjoyed.

Although playing an instrument is best learned when young, it is really never too late to start. Some music teachers specialize in adult and older students, and many a successful businessman decides to learn the piano after age fifty. Singing in a choir and playing in an amateur string ensemble are two of the most exhilarating ways to experience the blending of one's skills with those of others. Personal computers now come with sophisticated software that makes composition easy, and allows one to listen immediately to the orchestration. Learning to produce harmo-

nious sounds is not only enjoyable, but like the mastery of any complex skill, it also helps strengthen the self.

THE JOYS OF TASTING

Gioacchino Rossini, the composer of *William Tell* and many other operas, had a good grasp of the relationship between music and food: "What love is to the heart, appetite is to the stomach. The stomach is the conductor that leads and livens up the great orchestra of our emotions." If music modulates our feelings, so does food; and all the fine cuisines of the world are based on that knowledge. The musical metaphor is echoed by Heinz Maier-Leibnitz, the German physicist who has recently written several cookbooks: "The joy of cooking at home," he says, "compared to eating in one of the best restaurants, is like playing a string quartet in the living room as compared to a great concert."

For the first few hundred years of American history, food preparation was generally approached in a no-nonsense manner. Even as late as twenty-five years ago, the general attitude was that "feeding your face" was all right, but to make too much fuss about it was somehow decadent. In the past two decades, of course, the trend has reversed itself so sharply that earlier misgivings about gastronomic excesses seem almost to have been justified. Now we have "foodies" and wine freaks who take the pleasures of the palate as seriously as if they were rites in a brand-new religion. Gourmet journals proliferate, the frozen food sections of supermarkets bulge with esoteric culinary concoctions, and all sorts of chefs run popular shows on TV. Not so long ago, Italian or Greek cuisine was considered the height of exotic fare. Now one finds excellent Vietnamese, Moroccan, or Peruvian restaurants in parts of the country where a generation earlier one couldn't find anything but steak and potatoes for a radius of a hundred miles around. Of the many life-style changes that have taken place in the United States in the past few decades, few have been as startling as the turnabout concerning food.

Eating, like sex, is one of the basic pleasures built into our nervous system. The ESM studies done with electronic pagers have shown that even in our highly technological urban society, people still feel most happy and relaxed at mealtimes—although while at table they lack some of the other dimensions of the flow experience, such as high concentration, a sense of strength, and a feeling of self-esteem. But in every culture, the simple process of ingesting calories has been transformed with time into an art form that provides enjoyment as well as pleasure.

The preparation of food has developed in history according to the same principles as all other flow activities. First, people took advantage of the opportunities for action (in this case, the various edible substances in their environment), and as a result of attending carefully they were able to make finer and finer distinctions between the properties of foodstuffs. They discovered that salt preserves meats, that eggs are good for coating and binding, and that garlic, although harsh-tasting by itself, has medicinal properties and if used judiciously imparts subtle flavors to a variety of dishes. Once aware of these properties, people could experiment with them and then develop rules for putting together the various substances in the most pleasing combinations. These rules became the various cuisines; their variety provides a good illustration of the almost infinite range of flow experiences that can be evoked with a relatively limited number of edible ingredients.

Much of this culinary creativity was sparked by the jaded palates of princes. Referring to Cyrus the Great, who ruled Persia about twenty-five centuries ago, Xenophon writes with perhaps a touch of exaggeration: ". . . men travel over the whole earth in the service of the King of Persia, looking to find out what may be pleasant for him to drink; and ten thousand men are always contriving something nice for him to eat." But experimentation with food was by no means confined to the ruling classes. Peasant women in Eastern Europe, for instance, were not judged to be ready for marriage unless they had learned to cook a different soup for each day of the year.

In our culture, despite the recent spotlight on gourmet cuisine, many people still barely notice what they put in their mouths, thereby missing a potentially rich source of enjoyment. To transform the biological necessity of feeding into a flow experience, one must begin by paying attention to what one eats. It is astonishing—as well as discouraging—when guests swallow lovingly prepared food without any sign of having noticed its virtues. What a waste of rare experience is reflected in that insensitivity! Developing a discriminating palate, like any other skill, requires the investment of psychic energy. But the energy invested is returned many times over in a more complex experience. The individuals who really enjoy eating develop with time an interest in a particular cuisine, and get to know its history and its peculiarities. They learn to cook in that idiom, not just single dishes, but entire meals that reproduce the culinary ambience of the region. If they specialize in Middle Eastern food, they know how to make the best hummus, where to find the best tahini or the freshest eggplant. If their predilection includes the

foods of Venice, they learn what kind of sausage goes best with polenta, and what kind of shrimp is the best substitute for *scampi*.

Like all other sources of flow related to bodily skills—like sport, sex, and aesthetic visual experiences—the cultivation of taste only leads to enjoyment if one takes control of the activity. As long as one strives to become a gourmet or a connoisseur of wines because it is the "in" thing to do, striving to master an externally imposed challenge, then taste may easily turn sour. But a cultivated palate provides many opportunities for flow if one approaches eating—and cooking—in a spirit of adventure and curiosity, exploring the potentials of food for the sake of the experience rather than as a showcase for one's expertise.

The other danger in becoming involved with culinary delights—and here again the parallels with sex are obvious—is that they can become addictive. It is not by chance that gluttony and lechery were included among the seven deadly sins. The fathers of the Church well understood that infatuation with the pleasures of the flesh could easily drain psychic energy away from other goals. The Puritans' mistrust of enjoyment is grounded in the reasonable fear that given a taste of what they are genetically programmed to desire, people will want more of it, and will take time away from the necessary routines of everyday life in order to satisfy their craving.

But repression is not the way to virtue. When people restrain themselves out of fear, their lives are by necessity diminished. They become rigid and defensive, and their self stops growing. Only through freely chosen discipline can life be enjoyed, and still kept within the bounds of reason. If a person learns to control his instinctual desires, not because he *has* to, but because he *wants* to, he can enjoy himself without becoming addicted. A fanatical devotee of food is just as boring to himself and to others as the ascetic who refuses to indulge his taste. Between these two extremes, there is quite a bit of room for improving the quality of life.

In the metaphorical language of several religions, the body is called the "temple of God," or the "vessel of God," imagery to which even an atheist should be able to relate. The integrated cells and organs that make up the human organism are an instrument that allows us to get in touch with the rest of the universe. The body is like a probe full of sensitive devices that tries to obtain what information it can from the awesome reaches of space. It is through the body that we are related to one another and to the rest of the world. While this connection itself may be quite obvious, what we tend to forget is how enjoyable it can

be. Our physical apparatus has evolved so that whenever we use its sensing devices they produce a positive sensation, and the whole organism resonates in harmony.

To realize the body's potential for flow is relatively easy. It does not require special talents or great expenditures of money. Everyone can greatly improve the quality of life by exploring one or more previously ignored dimensions of physical abilities. Of course, it is difficult for any one person to reach high levels of complexity in more than one physical domain. The skills necessary to become good athletes, dancers, or connoisseurs of sights, sounds, or tastes are so demanding that one individual does not have enough psychic energy in his waking lifetime to master more than a few. But it is certainly possible to become a dilettante—in the finest sense of that word—in all these areas, in other words, to develop sufficient skills so as to find delight in what the body can do.

THE FLOW
OF THOUGHT

THE GOOD THINGS IN LIFE do not come only through the senses. Some of the most exhilarating experiences we undergo are generated inside the mind, triggered by information that challenges our ability to think, rather than from the use of sensory skills. As Sir Francis Bacon noted almost four hundred years ago, wonder—which is the seed of knowledge—is the reflection of the purest form of pleasure. Just as there are flow activities corresponding to every physical potential of the body, every mental operation is able to provide its own particular form of enjoyment.

Among the many intellectual pursuits available, reading is currently perhaps the most often mentioned flow activity around the world. Solving mental puzzles is one of the oldest forms of enjoyable activity, the precursor of philosophy and modern science. Some individuals have become so skilled at interpreting musical notation that they no longer need to listen to the actual notes to enjoy a piece of music, and prefer reading the score of a symphony to hearing it. The imaginary sounds dancing in their minds are more perfect than any actual performance could be. Similarly, people who spend much time with art come to appreciate increasingly the affective, historical, and cultural aspects of the work they are viewing, occasionally more than they enjoy its purely visual aspects. As one professional involved in the arts expressed it: "[Works of] art that I personally respond to . . . have behind them a

lot of conceptual, political, and intellectual activity. . . . The visual representations are really signposts to this beautiful machine that has been constructed, unique on the earth, and is not just a rehashing of visual elements, but is really a new thought machine that an artist, through visual means and combining his eyes with his perceptions, has created."

What this person sees in a painting is not just a picture, but a "thought machine" that includes the painter's emotions, hopes, and ideas—as well as the spirit of the culture and the historical period in which he lived. With careful attention, one can discern a similar mental dimension in physically enjoyable activities like athletics, food, or sex. We might say that making a distinction between flow activities that involve functions of the body and those that involve the mind is to some extent spurious, for all physical activities must involve a mental component if they are to be enjoyable. Athletes know well that to improve performance beyond a certain point they must learn to discipline their minds. And the intrinsic rewards they get include a lot more than just physical well-being: they experience a sense of personal accomplishment, and increased feelings of self-esteem. Conversely, most mental activities also rely on the physical dimension. Chess, for instance, is one of the most cerebral games there is; yet advanced chess players train by running and swimming because they are aware that if they are physically unfit they will not be able to sustain the long periods of mental concentration that chess tournaments require. In Yoga, the control of consciousness is prepared for by learning to control bodily processes, and the former blends seamlessly into the latter.

Thus, although flow always involves the use of muscle and nerve, on the one hand, and will, thought, and feelings on the other, it does make sense to differentiate a class of activities that are enjoyable because they order the mind directly, rather than through the mediation of bodily feelings. These activities are primarily *symbolic* in nature, in that they depend on natural languages, mathematics, or some other abstract notation system like a computer language to achieve their ordering effects in the mind. A symbolic system is like a game in that it provides a separate reality, a world of its own where one can perform actions that are permitted to occur in that world, but that would not make much sense anywhere else. In symbolic systems, the "action" is usually restricted to the mental manipulation of concepts.

To enjoy a mental activity, one must meet the same conditions that make physical activities enjoyable. There must be skill in a symbolic domain; there have to be rules, a goal, and a way of obtaining feedback.

One must be able to concentrate and interact with the opportunities at a level commensurate with one's skills.

In reality, to achieve such an ordered mental condition is not as easy as it sounds. Contrary to what we tend to assume, the normal state of the mind is chaos. Without training, and without an object in the external world that demands attention, people are unable to focus their thoughts for more than a few minutes at a time. It is relatively easy to concentrate when attention is structured by outside stimuli, such as when a movie is playing on the screen, or when while driving heavy traffic is encountered on the road. If one is reading an exciting book, the same thing occurs, but most readers still begin to lose concentration after a few pages, and their minds wander away from the plot. At that point, if they wish to continue reading, they must make an effort to force their attention back to the page.

We don't usually notice how little control we have over the mind, because habits channel psychic energy so well that thoughts seem to follow each other by themselves without a hitch. After sleeping we regain consciousness in the morning when the alarm rings, and then walk to the bathroom and brush our teeth. The social roles culture prescribes then take care of shaping our minds for us, and we generally place ourselves on automatic pilot till the end of the day, when it is time again to lose consciousness in sleep. But when we are left alone, with no demands on attention, the basic disorder of the mind reveals itself. With nothing to do, it begins to follow random patterns, usually stopping to consider something painful or disturbing. Unless a person knows how to give order to his or her thoughts, attention will be attracted to whatever is most problematic at the moment: it will focus on some real or imaginary pain, on recent grudges or long-term frustrations. Entropy is the normal state of consciousness—a condition that is neither useful nor enjoyable.

To avoid this condition, people are naturally eager to fill their minds with whatever information is readily available, as long as it distracts attention from turning inward and dwelling on negative feelings. This explains why such a huge proportion of time is invested in watching television, despite the fact that it is very rarely enjoyed. Compared to other sources of stimulation—like reading, talking to other people, or working on a hobby—TV can provide continuous and easily accessible information that will structure the viewer's attention, at a very low cost in terms of the psychic energy that needs to be invested. While people watch television, they need not fear that their drifting minds will force them to face disturbing personal problems. It is understandable

that, once one develops this strategy for overcoming psychic entropy, to give up the habit becomes almost impossible.

The better route for avoiding chaos in consciousness, of course, is through habits that give control over mental processes to the individual, rather than to some external source of stimulation, such as the programs of network TV. To acquire such habits requires practice, however, and the kind of goals and rules that are inherent in flow activities. For instance, one of the simplest ways to use the mind is daydreaming: playing out some sequence of events as mental images. But even this apparently easy way to order thought is beyond the range of many people. Jerome Singer, the Yale psychologist who has studied daydreaming and mental imagery more than perhaps any other scientist, has shown that daydreaming is a skill that many children never learn to use. Yet daydreaming not only helps create emotional order by compensating in imagination for unpleasant reality—as when a person can reduce frustration and aggression against someone who has caused injury by visualizing a situation in which the aggressor is punished—but it also allows children (and adults) to rehearse imaginary situations so that the best strategy for confronting them may be adopted, alternative options considered, unanticipated consequences discovered—all results that help increase the complexity of consciousness. And, of course, when used with skill, daydreaming can be very enjoyable.

In reviewing the conditions that help establish order in the mind, we shall first look at the extremely important role of memory, then at how words can be used to produce flow experiences. Next we shall consider three symbolic systems that are very enjoyable if one comes to know their rules: history, science, and philosophy. Many more fields of study could have been mentioned, but these three can serve as examples for the others. Each one of these mental "games" is accessible to anyone who wants to play them.

THE MOTHER OF SCIENCE

The Greeks personified memory as lady Mnemosyne. Mother of the nine Muses, she was believed to have given birth to all the arts and sciences. It is valid to consider memory the oldest mental skill, from which all others derive, for, if we weren't able to remember, we couldn't follow the rules that make other mental operations possible. Neither logic nor poetry could exist, and the rudiments of science would have to be rediscovered with each new generation. The primacy of memory is true first of all in terms of the history of the species. Before written

notation systems were developed, all learned information had to be transmitted from the memory of one person to that of another. And it is true also in terms of the history of each individual human being. A person who cannot remember is cut off from the knowledge of prior experiences, unable to build patterns of consciousness that bring order to the mind. As Buñuel has said, "Life without memory is no life at all. . . . our memory is our coherence, our reason, our feeling, even our action. Without it, we are nothing."

All forms of mental flow depend on memory, either directly or indirectly. History suggests that the oldest way of organizing information involved recalling one's ancestors, the line of descent that gave each person his or her identity as member of a tribe or a family. It is not by chance that the Old Testament, especially in the early books, contains so much genealogical information (e.g., Genesis 10: 26–29: "The descendants of Joktan were the people of Almodad, Sheleph, Hazarmaveth, Jerah, Hadoram, Uzal, Diklah, Obal, Abimael, Sheba, Ophir, Havilah, and Jobab. . . ."). Knowing one's origins, and to whom one was related, was an indispensable method for creating social order when no other basis for order existed. In preliterate cultures reciting lists of ancestors' names is a very important activity even today, and it is one in which the people who can do it take a great delight. Remembering is enjoyable because it entails fulfilling a goal and so brings order to consciousness. We all know the little spark of satisfaction that comes when we remember where we put the car keys, or any other object that has been temporarily misplaced. To remember a long list of elders, going back a dozen generations, is particularly enjoyable in that it satisfies the need to find a place in the ongoing stream of life. To recall one's ancestors places the recaller as a link in a chain that starts in the mythical past and extends into the unfathomable future. Even though in our culture lineage histories have lost all practical significance, people still enjoy thinking and talking about their roots.

It was not only their origins that our ancestors had to commit to memory, but all other facts bearing on their ability to control the environment. Lists of edible herbs and fruits, health tips, rules of behavior, patterns of inheritance, laws, geographical knowledge, rudiments of technology, and pearls of wisdom were all bundled into easily remembered sayings or verse. Before printing became readily available in the last few hundred years, much of human knowledge was condensed in forms similar to the "Alphabet Song" which puppets now sing on children's television shows such as "Sesame Street."

According to Johann Huizinga, the great Dutch cultural historian,

among the most important precursors of systematic knowledge were riddling games. In the most ancient cultures, the elders of the tribe would challenge each other to contests in which one person sang a text filled with hidden references, and the other person had to interpret the meaning encoded in the song. A competition between expert riddlers was often the most stimulating intellectual event the local community could witness. The forms of the riddle anticipated the rules of logic, and its content was used to transmit factual knowledge our ancestors needed to preserve. Some of the riddles were fairly simple and easy, like the following rhyme sung by ancient Welsh minstrels and translated by Lady Charlotte Guest:

> Discover what it is:
> The strong creature from before the Flood
> Without flesh, without bone,
> Without vein, without blood,
> Without head, without feet . . .
> In field, in forest . . .
> Without hand, without foot.
> It is also as wide
> As the surface of the earth,
> And it was not born,
> Nor was it seen . . .

The answer in this case is "the wind."

Other riddles that the druids and minstrels committed to memory were much longer and more complex, and contained important bits of secret lore disguised in cunning verses. Robert Graves, for instance, thought that the early wise men of Ireland and Wales stored their knowledge in poems that were easy to remember. Often they used elaborate secret codes, as when the names of trees stood for letters, and a list of trees spelled out words. Lines 67–70 of the *Battle of the Trees*, a strange, long poem sung by ancient Welsh minstrels:

> The alders in the front line
> Began the affray.
> Willow and rowan-tree
> were tardy in array.

encoded the letters F (which in the secret druidic alphabet was represented by the alder tree), S (willow), and L (rowan). In this fashion, the

few druids who knew how to use letters could sing a song ostensibly referring to a battle among the trees of the forest, which actually spelled out a message only initiates could interpret. Of course, the solution of riddles does not depend exclusively on memory; specialized knowledge and a great deal of imagination and problem-solving ability are also required. But without a good memory one could not be a good riddle master, nor could one become proficient at any other mental skill.

As far back as there are records of human intelligence, the most prized mental gift has been a well-cultivated memory. My grandfather at seventy could still recall passages from the three thousand lines of the *Iliad* he had to learn by heart in Greek to graduate from high school. Whenever he did so, a look of pride settled on his features, as his unfocused eyes ranged over the horizon. With each unfolding cadence, his mind returned to the years of his youth. The words evoked experiences he had had when he first learned them; remembering poetry was for him a form of time travel. For people in his generation, knowledge was still synonymous with memorization. Only in the past century, as written records have become less expensive and more easily available, has the importance of remembering dramatically declined. Nowadays a good memory is considered useless except for performing on some game shows or for playing Trivial Pursuit.

But for a person who has nothing to remember, life can become severely impoverished. This possibility was completely overlooked by educational reformers early in this century, who, armed with research results, proved that "rote learning" was not an efficient way to store and acquire information. As a result of their efforts, rote learning was phased out of the schools. The reformers would have had justification, if the point of remembering was simply to solve practical problems. But if control of consciousness is judged to be at least as important as the ability to get things done, then learning complex patterns of information by heart is by no means a waste of effort. A mind with some stable content to it is much richer than one without. It is a mistake to assume that creativity and rote learning are incompatible. Some of the most original scientists, for instance, have been known to have memorized music, poetry, or historical information extensively.

A person who can remember stories, poems, lyrics of songs, baseball statistics, chemical formulas, mathematical operations, historical dates, biblical passages, and wise quotations has many advantages over one who has not cultivated such a skill. The consciousness of such a person is independent of the order that may or may not be provided by the environment. She can always amuse herself, and find meaning in the

contents of her mind. While others need external stimulation—television, reading, conversation, or drugs—to keep their minds from drifting into chaos, the person whose memory is stocked with patterns of information is autonomous and self-contained. Additionally, such a person is also a much more cherished companion, because she can share the information in her mind, and thus help bring order into the consciousness of those with whom she interacts.

How can one find more value in memory? The most natural way to begin is to decide what subject one is really interested in—poetry, fine cuisine, the history of the Civil War, or baseball—and then start paying attention to key facts and figures in that chosen area. With a good grasp of the subject will come the knowledge of what is worth remembering and what is not. The important thing to recognize here is that you should not feel that you *have to* absorb a string of facts, that there is a right list you must memorize. If you decide what *you* would like to have in memory, the information will be under your control, and the whole process of learning by heart will become a pleasant task, instead of a chore imposed from outside. A Civil War buff need not feel compelled to know the sequence of dates of all major engagements; if, for instance, he is interested in the role of the artillery, then only those battles where cannons played an important part need concern him. Some people carry with them the texts of choice poems or quotations written on pieces of paper, to glance over whenever they feel bored or dispirited. It is amazing what a sense of control it gives to know that favorite facts or lyrics are always at hand. Once they are stored in memory, however, this feeling of ownership—or better, of *connectedness* with the content recalled—becomes even more intense.

Of course there is always a danger that the person who has mastered a domain of information will use it to become an overbearing bore. We all know people who cannot resist flaunting their memory. But this usually occurs when someone memorizes only in order to impress others. It is less likely that one will become a bore when one is intrinsically motivated—with a genuine interest in the material, and a desire to control consciousness, rather than in controlling the environment.

THE RULES OF THE GAMES OF THE MIND

Memory is not the only tool needed to give shape to what takes place in the mind. It is useless to remember facts unless they fit into patterns, unless one finds likenesses and regularities among them. The simplest ordering system is to give names to things; the words we invent trans-

form discrete events into universal categories. The power of the word is immense. In Genesis 1, God names day, night, sky, earth, sea, and all the living things immediately after He creates them, thereby completing the process of creation. The Gospel of John begins with: "Before the World was created, the Word already existed . . ."; and Heraclitus starts his now almost completely lost volume: "This Word (*Logos*) is from everlasting, yet men understand it as little after the first hearing of it as before. . . ." All these references suggest the importance of words in controlling experience. The building blocks of most symbol systems, words make abstract thinking possible and increase the mind's capacity to store the stimuli it has attended to. Without systems for ordering information, even the clearest memory will find consciousness in a state of chaos.

After names came numbers and concepts, and then the primary rules for combining them in predictable ways. By the sixth century B.C. Pythagoras and his students had embarked on the immense ordering task that attempted to find common numerical laws binding together astronomy, geometry, music, and arithmetic. Not surprisingly, their work was difficult to distinguish from religion, since it tried to accomplish similar goals: to find a way of expressing the structure of the universe. Two thousand years later, Kepler and then Newton were still on the same quest.

Theoretical thinking has never completely lost the imagistic, puzzlelike qualities of the earliest riddles. For example Archytas, the fourth-century-B.C. philosopher and commander-in-chief of the city-state of Tarentum (now in southern Italy), proved that the universe had no limits by asking himself: "Supposing that I came to the outer limits of the universe. If I now thrust out a stick, what would I find?" Archytas thought that the stick must have projected out into space. But in that case there was space beyond the limits of the universe, which meant that the universe had no bounds. If Archytas's reasoning appears primitive, it is useful to recall that the intellectual experiments Einstein used to clarify to himself how relativity worked, concerning clocks seen from trains moving at different speeds, were not that different.

Besides stories and riddles all civilizations gradually developed more systematic rules for combining information, in the form of geometric representations and formal proofs. With the help of such formulas it became possible to describe the movement of the stars, predict precisely seasonal cycles, and accurately map the earth. Abstract knowledge, and finally what we know as experimental science, grew out of these rules.

It is important to stress here a fact that is all too often lost sight of: philosophy and science were invented and flourished because thinking is pleasurable. If thinkers did not enjoy the sense of order that the use of syllogisms and numbers creates in consciousness, it is very unlikely that now we would have the disciplines of mathematics and physics.

This claim, however, flies in the face of most current theories of cultural development. Historians imbued with variants of the precepts of material determinism hold that thought is shaped by what people must do to make a living. The evolution of arithmetic and geometry, for instance, is explained almost exclusively in terms of the need for accurate astronomical knowledge and for the irrigational technology that was indispensable in maintaining the great "hydraulic civilizations" located along the course of large rivers like the Tigris, the Euphrates, the Indus, the Chang Jiang (Yangtze), and the Nile. For these historians, every creative step is interpreted as the product of extrinsic forces, whether they be wars, demographic pressures, territorial ambitions, market conditions, technological necessity, or the struggle for class supremacy.

External forces are very important in determining which new ideas will be *selected* from among the many available; but they cannot explain their *production*. It is perfectly true, for instance, that the development and application of the knowledge of atomic energy were expedited enormously by the life-and-death struggle over the bomb between Germany on the one hand, and England and the United States on the other. But the science that formed the basis of nuclear fission owed very little to the war; it was made possible through knowledge laid down in more peaceful circumstances—for example, in the friendly exchange of ideas European physicists had over the years in the beer garden turned over to Niels Bohr and his scientific colleagues by a brewery in Copenhagen.

Great thinkers have always been motivated by the enjoyment of thinking rather than by the material rewards that could be gained by it. Democritus, one of the most original minds of antiquity, was highly respected by his countrymen, the Abderites. However, they had no idea what Democritus was about. Watching him sit for days immersed in thought, they assumed he was acting unnaturally, and must be ill. So they sent for Hippocrates, the great doctor, to see what ailed their sage. After Hippocrates, who was not only a good medical man but also wise, discussed with Democritus the absurdities of life, he reassured the townspeople that their philosopher was, if anything, only too sane. He was not losing his mind; he was lost in the flow of thought.

The surviving fragments of Democritus's writing illustrate how

rewarding he found the practice of thinking to be: "It is godlike ever to think on something beautiful and on something new"; "Happiness does not reside in strength or money; it lies in rightness and many-sidedness"; "I would rather discover one true cause than gain the kingdom of Persia." Not surprisingly, some of his more enlightened contemporaries concluded that Democritus had a cheerful disposition, and said that he "called Cheerfulness, and often Confidence, that is a mind devoid of fear, the highest good." In other words, he enjoyed life because he had learned to control his consciousness.

Democritus was neither the first nor the last thinker to be lost in the flow of the mind. Philosophers have frequently been regarded as being "absentminded," which of course means not that their minds were lost, but that they had temporarily tuned out of everyday reality to dwell among the symbolic forms of their favorite domain of knowledge. When Kant supposedly placed his watch in a pot of boiling water while holding an egg in his hand to time its cooking, all his psychic energy was probably invested in bringing abstract thoughts into harmony, leaving no attention free to meet the incidental demands of the concrete world.

The point is that playing with ideas is extremely exhilarating. Not only philosophy but the emergence of new scientific ideas is fueled by the enjoyment one obtains from creating a new way to describe reality. The tools that make the flow of thought possible are common property, and consist of the knowledge recorded in books available in schools and libraries. A person who becomes familiar with the conventions of poetry, or the rules of calculus, can subsequently grow independent of external stimulation. She can generate ordered trains of thought regardless of what is happening in external reality. When a person has learned a symbolic system well enough to use it, she has established a portable, self-contained world within the mind.

Sometimes having control over such an internalized symbol system can save one's life. It has been claimed, for instance, that the reason there are more poets per capita in Iceland than in any other country of the world is that reciting the sagas became a way for the Icelanders to keep their consciousness ordered in an environment exceedingly hostile to human existence. For centuries the Icelanders have not only preserved in memory but also added new verses to the epics chronicling the deeds of their ancestors. Isolated in the freezing night, they used to chant their poems huddled around fires in precarious huts, while outside the winds of the interminable arctic winters howled. If the Icelanders had spent all those nights in silence listening to the mocking wind, their

minds would have soon filled with dread and despair. By mastering the orderly cadence of meter and rhyme, and encasing the events of their own lives in verbal images, they succeeded instead in taking control of their experiences. In the face of chaotic snowstorms they created songs with form and meaning. To what extent did the sagas help the Icelanders endure? Would they have survived without them? There is no way to answer these questions with certainty. But who would dare to try the experiment?

Similar conditions hold true when individuals are suddenly wrenched from civilization, and find themselves in those extreme situations we described earlier, such as concentration camps or polar expeditions. Whenever the outside world offers no mercy, an internal symbolic system can become a salvation. Anyone in possession of portable rules for the mind has a great advantage. In conditions of extreme deprivation poets, mathematicians, musicians, historians, and biblical experts have stood out as islands of sanity surrounded by the waves of chaos. To a certain extent, farmers who know the life of the fields or lumbermen who understand the forest have a similar support system, but because their knowledge is less abstractly coded, they have more need to interact with the actual environment to be in control.

Let us hope none of us will be forced to call upon symbolic skills to survive concentration camps or arctic ordeals. But having a portable set of rules that the mind can work with is of great benefit even in normal life. People without an internalized symbolic system can all too easily become captives of the media. They are easily manipulated by demagogues, pacified by entertainers, and exploited by anyone who has something to sell. If we have become dependent on television, on drugs, and on facile calls to political or religious salvation, it is because we have so little to fall back on, so few internal rules to keep our mind from being taken over by those who claim to have the answers. Without the capacity to provide its own information, the mind drifts into randomness. It is within each person's power to decide whether its order will be restored from the outside, in ways over which we have no control, or whether the order will be the result of an internal pattern that grows organically from our skills and knowledge.

THE PLAY OF WORDS

How does one start mastering a symbolic system? It depends, of course, on what domain of thought one is interested in exploring. We have seen that the most ancient and perhaps basic set of rules governs the usage

of words. And today words still offer many opportunities to enter flow, at various levels of complexity. A somewhat trivial but nevertheless illuminating example concerns working crossword puzzles. There is much to be said in favor of this popular pastime, which in its best form resembles the ancient riddle contests. It is inexpensive and portable, its challenges can be finely graduated so that both novices and experts can enjoy it, and its solution produces a sense of pleasing order that gives one a satisfying feeling of accomplishment. It provides opportunities to experience a mild state of flow to many people who are stranded in airport lounges, who travel on commuter trains, or who are simply whiling away Sunday mornings. But if one is confined to simply *solving* crosswords, one remains dependent on an external stimulus: the challenge provided by an expert in the Sunday supplement or puzzle magazine. To be really autonomous in this domain, a better alternative is to make up one's own crosswords. Then there is no longer need for a pattern to be imposed from the outside; one is completely free. And the enjoyment is more profound. It is not very difficult to learn to write crossword puzzles; I know a child of eight who, after trying his hand at a few Sunday puzzles in the *New York Times*, began writing his own quite creditable crosswords. Of course, as with any skill worth developing, this one, too, requires that one invest psychic energy in it at the beginning.

A more substantive potential use of words to enhance our lives is the lost art of conversation. Utilitarian ideologies in the past two centuries or so have convinced us that the main purpose of talking is to convey useful information. Thus we now value terse communication that conveys practical knowledge, and consider anything else a frivolous waste of time. As a result, people have become almost unable to talk to each other outside of narrow topics of immediate interest and specialization. Few of us can understand any longer the enthusiasm of Caliph Ali Ben Ali, who wrote: "A subtle conversation, that is the Garden of Eden." This is a pity, because it could be argued that the main function of conversation is not to get things accomplished, but to improve the quality of experience.

Peter Berger and Thomas Luckmann, the influential phenomenological sociologists, have written that our sense of the universe in which we live is held together by conversation. When I say to an acquaintance whom I meet in the morning, "Nice day," I do not convey primarily meteorological information—which would be redundant anyway, since he has the same data as I do—but achieve a great variety of other unvoiced goals. For instance, by addressing him I recognize his existence, and express my willingness to be friendly. Second, I reaffirm one

of the basic rules for interaction in our culture, which holds that talking about the weather is a safe way to establish contact between people. Finally, by emphasizing that the weather is "nice" I imply the shared value that "niceness" is a desirable attribute. So the offhand remark becomes a message that helps keep the content of my acquaintance's mind in its accustomed order. His answer "Yeah, it's great, isn't it?" will help to keep order in mine. Without such constant restatements of the obvious, Berger and Luckmann claim, people would soon begin to have doubts about the reality of the world in which they live. The obvious phrases we exchange with each other, the trivial talk dribbling from radios and TV sets, reassure us that everything is all right, that the usual conditions of existence prevail.

The pity is that so many conversations end right there. Yet when words are well chosen, well arranged, they generate gratifying experiences for the listener. It is not for utilitarian reasons alone that breadth of vocabulary and verbal fluency are among the most important qualifications for success as a business executive. Talking well enriches every interaction, and it is a skill that can be learned by everyone.

One way to teach children the potential of words is by starting to expose them to wordplay quite early. Puns and double meanings may be the lowest form of humor for sophisticated adults, but they provide children with a good training ground in the control of language. All one has to do is pay attention during a conversation with a child, and as soon as the opportunity presents itself—that is, whenever an innocent word or expression can be interpreted in an alternative way—one switches frames, and pretends to understand the word in that different sense.

The first time children realize that the expression "having Grandma for dinner" could mean either as a guest or as a dish, it will be somewhat puzzling, as will a phrase like "a frog in the throat." In fact, breaking the ordered expectations about the meaning of words can be mildly traumatic at first, but in no time at all children catch on and give as good as they are getting, learning to twist conversation into pretzels. By doing so they learn how to enjoy controlling words; as adults, they might help revive the lost art of conversation.

The major creative use of language, already mentioned several times in earlier contexts, is poetry. Because verse enables the mind to preserve experiences in condensed and transformed form, it is ideal for giving shape to consciousness. Reading from a book of poems each night is to the mind as working out on a Nautilus is to the body—a way for staying in shape. It doesn't have to be "great" poetry, at least not at first. And it is not necessary to read an entire poem. What's important is to

find at least a line, or a verse, that starts to sing. Sometimes even one word is enough to open a window on a new view of the world, to start the mind on an inner journey.

And again, there is no reason to stop at being a passive consumer. Everyone can learn, with a little discipline and perseverance, to order personal experience in verse. As Kenneth Koch, the New York poet and social reformer, has shown, even ghetto children and semiliterate elderly women in retirement homes are able to write beautifully moving poetry if they are given a minimum of training. There is no question that mastering this skill improves the quality of their lives. Not only do they enjoy the experience, but in the process they considerably increase their self-esteem as well.

Writing prose provides similar benefits, and although it lacks the obvious order imposed by meter and rhyme, it is a more easily accessible skill. (To write *great* prose, however, is probably just as difficult as writing great poetry.)

In today's world we have come to neglect the habit of writing because so many other media of communication have taken its place. Telephones and tape recorders, computers and fax machines are more efficient in conveying news. If the only point to writing were to *transmit* information, then it would deserve to become obsolete. But the point of writing is to *create* information, not simply to pass it along. In the past, educated persons used journals and personal correspondence to put their experiences into words, which allowed them to reflect on what had happened during the day. The prodigiously detailed letters so many Victorians wrote are an example of how people created patterns of order out of the mainly random events impinging on their consciousness. The kind of material we write in diaries and letters does not exist before it is written down. It is the slow, organically growing process of thought involved in writing that lets the ideas emerge in the first place.

Not so long ago, it was acceptable to be an amateur poet or essayist. Nowadays if one does not make some money (however pitifully little) out of writing, it's considered to be a waste of time. It is taken as downright shameful for a man past twenty to indulge in versification unless he receives a check to show for it. And unless one has great talent, it is indeed useless to write hoping to achieve great profit or fame. But it is never a waste to write for intrinsic reasons. First of all, writing gives the mind a disciplined means of expression. It allows one to record events and experiences so that they can be easily recalled, and relived in the future. It is a way to analyze and understand experiences, a self-communication that brings order to them.

Many have commented lately about the fact that poets and play-wrights as a group show unusually severe symptoms of depression and other affective disorders. Perhaps one reason they become full-time writers is that their consciousness is beset by entropy to an unusual degree; writing becomes a therapy for shaping some order among the confusion of feelings. It is possible that the only way writers can experience flow is by creating worlds of words in which they can act with abandon, erasing from the mind the existence of a troubling reality. Like any other flow activity, however, writing that becomes addictive becomes dangerous: it forces the writer to commit himself to a limited range of experiences, and forecloses other options for dealing with events. But when writing is used to control experience, without letting it control the mind, it is a tool of infinite subtlety and rich rewards.

BEFRIENDING CLIO

As Memory was the mother of culture, Clio, "The Proclaimer," was her eldest daughter. In Greek mythology she was the patroness of history, responsible for keeping orderly accounts of past events. Although history lacks the clear rules that make other mental activities like logic, poetry, or mathematics so enjoyable, it has its own unambiguous structure established by the irreversible sequence of events in time. Observing, recording, and preserving the memory of both the large and small events of life is one of the oldest and most satisfying ways to bring order to consciousness.

In a sense, every individual is a historian of his or her own personal existence. Because of their emotional power, memories of childhood become crucial elements in determining the kind of adults we grow up to be, and how our minds will function. Psychoanalysis is to a large extent an attempt to bring order to people's garbled histories of their childhood. This task of making sense of the past again becomes important in old age. Erik Erikson has held that the last stage of the human life cycle involves the task of achieving "integrity," or bringing together what one has accomplished and what one has failed to accomplish in the course of one's life into a meaningful story that can be claimed as one's own. "History," wrote Thomas Carlyle, "is the essence of innumerable biographies."

Remembering the past is not only instrumental in the creation and preservation of a personal identity, but it can also be a very enjoyable process. People keep diaries, save snapshots, make slides and home movies, and collect souvenirs and mementos to store in their houses to

build what is in effect a museum of the life of the family, even though a chance visitor might be unaware of most of the historical references. He might not know that the painting on the living-room wall is important because it was bought by the owners during their honeymoon in Mexico, that the rug in the hall is valuable because it was the gift of a favorite grandmother, and that the scruffy sofa in the den is kept because it was where the children were fed when they were babies.

Having a record of the past can make a great contribution to the quality of life. It frees us from the tyranny of the present, and makes it possible for consciousness to revisit former times. It makes it possible to select and preserve in memory events that are especially pleasant and meaningful, and so to "create" a past that will help us deal with the future. Of course such a past might not be literally true. But then the past can never be literally true in memory: it must be continuously edited, and the question is only whether we take creative control of the editing or not.

Most of us don't think of ourselves as having been amateur historians all along. But once we become aware that ordering events in time is a necessary part of being a conscious being, and moreover, that it is an enjoyable task, then we can do a much better job of it. There are several levels at which history as a flow activity can be practiced. The most personal involves simply keeping a journal. The next is to write a family chronicle, going as far into the past as possible. But there is no reason to stop there. Some people expand their interest to the ethnic group to which they belong, and start collecting relevant books and memorabilia. With an extra effort, they can begin to record their own impressions of the past, thus becoming "real" amateur historians.

Others develop an interest in the history of the community in which they live, whether it is the neighborhood or the state, by reading books, visiting museums, and joining historical associations. Or they may focus on a particular aspect of that past: for instance, a friend who lives in the wilder reaches of western Canada has been fascinated by "early industrial architecture" in that part of the world, and has gradually learned enough about it to enjoy trips to out-of-the-way sawmills, foundries, and decaying railway depots, where his knowledge enables him to evaluate and appreciate the fine points of what anyone else would dismiss as piles of weedy junk.

All too often we are inclined to view history as a dreary list of dates to memorize, a chronicle established by ancient scholars for their own amusement. It is a field we might tolerate, but not love; it is a subject we learn about so as to be considered educated, but it will be learned

unwillingly. If this is the case, history can do little to improve the quality of life. Knowledge that is seen to be controlled from the outside is acquired with reluctance, and it brings no joy. But as soon as a person decides which aspects of the past are compelling, and decides to pursue them, focusing on the sources and the details that are personally meaningful, and recording findings in a personal style, then learning history can become a full-fledged flow experience.

THE DELIGHTS OF SCIENCE

After reading the preceding section, you may find it just barely plausible that anyone could become an amateur historian. But if we take the argument to another field, can we really conceive of a layperson's becoming an amateur scientist? After all, we have been told many times that in this century science has become a highly institutionalized activity, with the main action confined to the big leagues. It takes extravagantly equipped laboratories, huge budgets, and large teams of investigators to survive on the frontiers of biology, chemistry, or physics. It is true that, if the goal of science is to win Nobel prizes, or to attract the recognition of professional colleagues in the highly competitive arena of a given discipline, then the extremely specialized and expensive ways of doing science may be the only alternatives.

In fact, this highly capital-intensive scenario, based on the model of the assembly line, happens to be an inaccurate description of what leads to success in "professional" science. It is not true, despite what the advocates of technocracy would like us to believe, that breakthroughs in science arise exclusively from teams in which each researcher is trained in a very narrow field, and where the most sophisticated state-of-the-art equipment is available to test out new ideas. Neither is it true that great discoveries are made only by centers with the highest levels of funding. These conditions may help in testing novel theories, but they are largely irrelevant to whether creative ideas will flourish. New discoveries still come to people as they did to Democritus, sitting lost in thought in the market square of his city. They come to people who so enjoy playing with ideas that eventually they stray beyond the limits of what is known, and find themselves exploring an uncharted territory.

Even the pursuit of "normal" (as opposed to "revolutionary" or creative) science would be next to impossible if it did not provide enjoyment to the scientist. In his book *The Structure of Scientific Revolutions*, Thomas Kuhn suggests several reasons why science is "fascinating." First, "By focusing attention upon a small range of relatively

esoteric problems, the paradigm [or theoretical approach] forces scientists to investigate some part of nature in a detail and depth that would otherwise be unimaginable." This concentration is made possible by "rules that limit both the nature of acceptable solutions and the steps by which they are obtained." And, Kuhn claims, a scientist engaged in "normal" science is not motivated by the hope of transforming knowledge, or finding truth, or improving the conditions of life. Instead, "what then challenges him is the conviction that, if only he is skillful enough, he will succeed in solving a puzzle that no one before has solved or solved so well." He also states, "The fascination of the normal research paradigm . . . [is that] though its outcome can be anticipated . . . the way to achieve that outcome remains very much in doubt. . . . The man who succeeds proves himself an expert puzzle-solver, and the challenge of the puzzle is an important part of what usually drives him on." It is no wonder that scientists often feel like P. A. M. Dirac, the physicist who described the development of quantum mechanics in the 1920s by saying, "It was a game, a very interesting game one could play." Kuhn's description of the appeal of science clearly resembles reports describing why riddling, or rock climbing, or sailing, or chess, or any other flow activity is rewarding.

If "normal" scientists are motivated in their work by the challenging intellectual puzzles they confront in their work, "revolutionary" scientists—the ones who break away from existing theoretical paradigms to forge new ones—are even more driven by enjoyment. A lovely example concerns Subrahhmanyan Chandrasekhar, the astrophysicist whose life has already acquired mythical dimensions. When he left India as a young man in 1933, on a slow boat from Calcutta to England, he wrote out a model of stellar evolution that with time became the basis of the theory of black holes. But his ideas were so strange that for a long time they were not accepted by the scientific community. He eventually was hired by the University of Chicago, where he continued his studies in relative obscurity. There is one anecdote told about him that best typifies his commitment to his work. In the 1950s Chandrasekhar was staying in Williams Bay, Wisconsin, where the main astronomical observatory of the university is located, about eighty miles away from the main campus. That winter he was scheduled to teach one advanced seminar in astrophysics. Only two students signed up for it, and Chandrasekhar was expected to cancel the seminar, rather than go through the inconvenience of commuting. But he did not, and instead drove back to Chicago twice a week, along back-country roads, to teach the class. A few years later first one, then the other of those two former students

won the Nobel prize for physics. Whenever this story used to be told, the narrator concluded with sympathetic regrets that it was a shame the professor himself never won the prize. That regret is no longer necessary, because in 1983 Chandrasekhar himself was awarded the Nobel for physics.

It is often under such unassuming circumstances, with people dedicated to playing with ideas, that breakthroughs in the way we think occur. One of the most glamorous discoveries of the last few years involves the theory of superconductivity. Two of the protagonists, K. Alex Muller and J. Georg Bednorz, worked out the principles and the first experiments in the IBM laboratory in Zurich, Switzerland, not exactly a scientific backwater, but not one of its hot spots, either. For several years the researchers did not let anyone else in on their work, not because they were afraid it would be stolen, but because they were afraid that their colleagues would laugh at their seemingly crazy ideas. They received their Nobel prizes for physics in 1987. Susumu Tonegawa, who that same year received the Nobel prize for biology, was described by his wife as a "going-his-own-way kind of a person" who likes sumo wrestling because it takes individual effort and not team performance to win in that sport, just as in his own work. Clearly the necessity of sophisticated laboratories and enormous research teams has been somewhat exaggerated. Breakthroughs in science still depend primarily on the resources of a single mind.

But we should not be concerned primarily with what happens in the professional world of scientists. "Big Science" can take care of itself, or at least it should, given all the support it has been given since the experiments with splitting the atomic nucleus turned out to be such a hit. What concerns us here is amateur science, the delight that ordinary people can take in observing and recording laws of natural phenomena. It is important to realize that for centuries great scientists did their work as a hobby, because they were fascinated with the methods they had invented, rather than because they had jobs to do and fat government grants to spend.

Nicolaus Copernicus perfected his epochal description of planetary motions while he was a canon at the cathedral of Frauenburg, in Poland. Astronomical work certainly didn't help his career in the Church, and for much of his life the main rewards he had were aesthetic, derived from the simple beauty of his system compared to the more cumbersome Ptolemaic model. Galileo had been trained in medicine, and what drove him into increasingly dangerous experimentation was the delight he took in figuring out such things as the location of the center of gravity of various solid objects. Isaac Newton formulated his

major discoveries soon after he received his B.A. at Cambridge, in 1665, when the university was closed because of the plague. Newton had to spend two years in the safety and boredom of a country retreat, and he filled the time playing with his ideas about a universal theory of gravitation. Antoine Laurent Lavoisier, held to be the founder of modern chemistry, was a public servant working for the Ferme Generale, the equivalent of the IRS in prerevolutionary France. He was also involved in agricultural reform and social planning, but his elegant and classic experiments are what he enjoyed doing most. Luigi Galvani, who did the basic research on how muscles and nerves conduct electricity, which in turn led to the invention of the electric battery, was a practicing physician until the end of his life. Gregor Mendel was another clergyman, and his experiments that set the foundations of genetics were the results of a gardening hobby. When Albert A. Michelson, the first person in the United States to win a Nobel prize in science, was asked at the end of his life why he had devoted so much of his time to measuring the velocity of light, he is said to have replied, "It was so much fun." And, lest we forget, Einstein wrote his most influential papers while working as a clerk in the Swiss Patent Office. These and the many other great scientists one could easily mention were not handicapped in their thinking because they were not "professionals" in their field, recognized figures with sources of legitimate support. They simply did what they enjoyed doing.

Is the situation really that different these days? Is it really true that a person without a Ph.D., who is not working at one of the major research centers, no longer has any chance of contributing to the advancement of science? Or is this just one of those largely unconscious efforts at mystification to which all successful institutions inevitably succumb? It is difficult to answer these questions, partly because what constitutes "science" is of course defined by those very institutions that are in line to benefit from their monopoly.

There is no doubt that a layman cannot contribute, as a hobby, to the kind of research that depends on multibillion-dollar supercolliders, or on nuclear magnetic resonance spectroscopy. But then, such fields do not represent the only science there is. The mental framework that makes science enjoyable is accessible to everyone. It involves curiosity, careful observation, a disciplined way of recording events, and finding ways to tease out the underlying regularities in what one learns. It also requires the humility to be willing to learn from the results of past investigators, coupled with enough skepticism and openness of mind to reject beliefs that are not supported by facts.

Defined in this broad sense, there are more practicing amateur

scientists than one would think. Some focus their interest on health, and try to find out everything they can about a disease that threatens them or their families. Following in Mendel's footsteps, some learn whatever they can about breeding domestic animals, or creating new hybrid flowers. Others diligently replicate the observations of early astronomers with their backyard telescopes. There are closet geologists who roam the wilderness in search of minerals, cactus collectors who scour the desert mesas for new specimens, and probably hundreds of thousands of individuals who have pushed their mechanical skills to the point that they are verging on true scientific understanding.

What keeps many of these people from developing their skills further is the belief that they will never be able to become genuine, "professional" scientists, and therefore that their hobby should not be taken seriously. But there is no better reason for doing science than the sense of order it brings to the mind of the seeker. If flow, rather than success and recognition, is the measure by which to judge its value, science can contribute immensely to the quality of life.

LOVING WISDOM

"Philosophy" used to mean "love of wisdom," and people devoted their lives to it for that reason. Nowadays professional philosophers would be embarrassed to acknowledge so naive a conception of their craft. Today a philosopher may be a specialist in deconstructionism or logical positivism, an expert in early Kant or late Hegel, an epistemologist or an existentialist, but don't bother him with wisdom. It is a common fate of many human institutions to begin as a response to some universal problem until, after many generations, the problems peculiar to the institutions themselves will take precedence over the original goal. For example, modern nations create armed forces as a defense against enemies. Soon, however, an army develops its own needs, its own politics, to the point that the most successful soldier is not necessarily the one who defends the country best, but the one who obtains the most money for the army.

Amateur philosophers, unlike their professional counterparts at universities, need not worry about historical struggles for prominence among competing schools, the politics of journals, and the personal jealousies of scholars. They can keep their minds on the basic questions. What these are is the first task for the amateur philosopher to decide. Is he interested in what the best thinkers of the past have believed about what it means to "be"? Or is he more interested in what constitutes the "good" or the "beautiful"?

As in all other branches of learning, the first step after deciding what area one wants to pursue is to learn what others have thought about the matter. By reading, talking, and listening selectively one can form an idea of what the "state of the art" in the field is. Again, the importance of personally taking control of the direction of learning from the very first steps cannot be stressed enough. If a person feels coerced to read a certain book, to follow a given course because that is supposed to be the way to do it, learning will go against the grain. But if the decision is to take that same route because of an inner feeling of rightness, the learning will be relatively effortless and enjoyable.

When his predilections in philosophy become clear, even the amateur may feel compelled to specialize. Someone interested in the basic characteristics of reality may drift toward ontology and read Wolff, Kant, Husserl, and Heidegger. Another person more puzzled by questions of right and wrong would take up ethics and learn about the moral philosophy of Aristotle, Aquinas, Spinoza, and Nietzsche. An interest in what is beautiful may lead to reviewing the ideas of aesthetic philosophers like Baumgarten, Croce, Santayana, and Collingwood. While specialization is necessary to develop the complexity of any pattern of thought, the goals-ends relationship must always be kept clear: specialization is for the sake of thinking better, and not an end in itself. Unfortunately many serious thinkers devote all their mental effort to becoming well-known scholars, but in the meantime they forget their initial purpose in scholarship.

In philosophy as in other disciplines there comes a point where a person is ready to pass from the status of passive consumer to that of active producer. To write down one's insights expecting that someday they will be read with awe by posterity would be in most cases an act of hubris, that "overweening presumption" that has caused so much mischief in human affairs. But if one records ideas in response to an inner challenge to express clearly the major questions by which one feels confronted, and tries to sketch out answers that will help make sense of one's experiences, then the amateur philosopher will have learned to derive enjoyment from one of the most difficult and rewarding tasks of life.

AMATEURS AND PROFESSIONALS

Some individuals prefer to specialize and devote all their energy to one activity, aiming to reach almost professional levels of performance in it. They tend to look down on anyone who is not as skillful and devoted to their specialty as they themselves are. Others prefer to dabble in a

variety of activities, taking as much enjoyment as possible from each without necessarily becoming an expert in any one.

There are two words whose meanings reflect our somewhat warped attitudes toward levels of commitment to physical or mental activities. These are the terms *amateur* and *dilettante*. Nowadays these labels are slightly derogatory. An amateur or a dilettante is someone not quite up to par, a person not to be taken very seriously, one whose performance falls short of professional standards. But originally, "amateur," from the Latin verb *amare*, "to love," referred to a person who loved what he was doing. Similarly a "dilettante," from the Latin *delectare*, "to find delight in," was someone who enjoyed a given activity. The earliest meanings of these words therefore drew attention to experiences rather than accomplishments; they described the subjective rewards individuals gained from doing things, instead of focusing on how well they were achieving. Nothing illustrates as clearly our changing attitudes toward the value of experience as the fate of these two words. There was a time when it was admirable to be an amateur poet or a dilettante scientist, because it meant that the quality of life could be improved by engaging in such activities. But increasingly the emphasis has been to value behavior over subjective states; what is admired is success, achievement, the quality of performance rather than the quality of experience. Consequently it has become embarrassing to be called a dilettante, even though to be a dilettante is to achieve what counts most—the enjoyment one's actions provide.

It is true that the sort of dilettantish learning encouraged here can be undermined even more readily than professional scholarship, if the learners lose sight of the goal that motivates them. Laypersons with an ax to grind sometimes turn to pseudoscience to advance their interests, and often their efforts are almost indistinguishable from those of intrinsically motivated amateurs.

An interest in the history of ethnic origins, for instance, can become easily perverted into a search for proofs of one's own superiority over members of other groups. The Nazi movement in Germany turned to anthropology, history, anatomy, language, biology, and philosophy and concocted from them its theory of Aryan racial supremacy. Professional scholars were also caught up in this dubious enterprise, but it was inspired by amateurs, and the rules by which it was played belonged to politics, not science.

Soviet biology was set back a generation when the authorities decided to apply the rules of communist ideology to growing corn, instead of following experimental evidence. Lysenko's ideas about how

grains planted in a cold climate would grow more hardy, and produce even hardier progeny, sounded good to the layperson, especially within the context of Leninist dogma. Unfortunately the ways of politics and the ways of corn are not always the same, and Lysenko's efforts culminated in decades of hunger.

The bad connotations that the terms *amateur* and *dilettante* have earned for themselves over the years are due largely to the blurring of the distinction between intrinsic and extrinsic goals. An amateur who pretends to know as much as a professional is probably wrong, and up to some mischief. The point of becoming an amateur scientist is not to compete with professionals on their own turf, but to use a symbolic discipline to extend mental skills, and to create order in consciousness. On that level, amateur scholarship can hold its own, and can be even more effective than its professional counterpart. But the moment that amateurs lose sight of this goal, and use knowledge mainly to bolster their egos or to achieve a material advantage, then they become caricatures of the scholar. Without training in the discipline of skepticism and reciprocal criticism that underlies the scientific method, laypersons who venture into the fields of knowledge with prejudiced goals can become more ruthless, more egregiously unconcerned with truth, than even the most corrupt scholar.

THE CHALLENGE OF LIFELONG LEARNING

The aim of this chapter has been to review the ways in which mental activity can produce enjoyment. We have seen that the mind offers at least as many and as intense opportunities for action as does the body. Just as the use of the limbs and of the senses is available to everyone without regard to sex, race, education, or social class, so too the uses of memory, of language, of logic, of the rules of causation are also accessible to anyone who desires to take control of the mind.

Many people give up on learning after they leave school because thirteen or twenty years of extrinsically motivated education is still a source of unpleasant memories. Their attention has been manipulated long enough from the outside by textbooks and teachers, and they have counted graduation as the first day of freedom.

But a person who forgoes the use of his symbolic skills is never really free. His thinking will be directed by the opinions of his neighbors, by the editorials in the papers, and by the appeals of television. He will be at the mercy of "experts." Ideally, the end of extrinsically applied education should be the start of an education that is motivated intrinsi-

cally. At that point the goal of studying is no longer to make the grade, earn a diploma, and find a good job. Rather, it is to understand what is happening around one, to develop a personally meaningful sense of what one's experience is all about. From that will come the profound joy of the thinker, like that experienced by the disciples of Socrates that Plato describes in *Philebus*: "The young man who has drunk for the first time from that spring is as happy as if he had found a treasure of wisdom; he is positively enraptured. He will pick up any discourse, draw all its ideas together to make them into one, then take them apart and pull them to pieces. He will puzzle first himself, then also others, badger whoever comes near him, young and old, sparing not even his parents, nor anyone who is willing to listen. . . ."

The quotation is about twenty-four centuries old, but a contemporary observer could not describe more vividly what happens when a person first discovers the flow of the mind.

WORK AS FLOW

LIKE OTHER ANIMALS, we must spend a large part of our existence making a living: calories needed to fuel the body don't appear magically on the table, and houses and cars don't assemble themselves spontaneously. There are no strict formulas, however, for how much time people actually have to work. It seems, for instance, that the early hunter-gatherers, like their present-day descendants living in the inhospitable deserts of Africa and Australia, spent only three to five hours each day on what we would call working—providing for food, shelter, clothing, and tools. They spent the rest of the day in conversation, resting, or dancing. At the opposite extreme were the industrial workers of the nineteenth century, who were often forced to spend twelve-hour days, six days a week, toiling in grim factories or dangerous mines.

Not only the quantity of work, but its quality has been highly variable. There is an old Italian saying: *"Il lavoro nobilita l'uomo, e lo rende simile alle bestie"*; or, "Work gives man nobility, and turns him into an animal." This ironic trope may be a comment on the nature of all work, but it can also be interpreted to mean that work requiring great skills and that is done freely refines the complexity of the self; and, on the other hand, that there are few things as entropic as unskilled work done under compulsion. The brain surgeon operating in a shining hospital and the slave laborer who staggers under a heavy load as he wades through the mud are both working. But the surgeon has a chance to

learn new things every day, and every day he learns that he is in control and that he can perform difficult tasks. The laborer is forced to repeat the same exhausting motions, and what he learns is mostly about his own helplessness.

Because work is so universal, yet so varied, it makes a tremendous difference to one's overall contentment whether what one does for a living is enjoyable or not. Thomas Carlyle was not far wrong when he wrote, "Blessed is he who has found his work; let him ask no other blessedness." Sigmund Freud amplified somewhat on this simple advice. When asked for his recipe for happiness, he gave a very short but sensible answer: "Work and love." It is true that if one finds flow in work, and in relations with other people, one is well on the way toward improving the quality of life as a whole. In this chapter we shall explore how jobs can provide flow, and in the following one we shall take up Freud's other main theme—enjoying the company of others.

AUTOTELIC WORKERS

As punishment for his ambition, Adam was sentenced by the Lord to work the earth with the sweat of his brow. The passage of Genesis (3:17) that relates this event reflects the way most cultures, and especially those that have reached the complexity of "civilization," conceive of work—as a curse to be avoided at all costs. It is true that, because of the inefficient way the universe operates, it requires a lot of energy to realize our basic needs and aspirations. As long as we didn't care how much we ate, whether or not we lived in solid and well-decorated homes, or whether we could afford the latest fruits of technology, the necessity of working would rest lightly on our shoulders, as it does for the nomads of the Kalahari desert. But the more psychic energy we invest in material goals, and the more improbable the goals grow to be, the more difficult it becomes to make them come true. Then we need increasingly high inputs of labor, mental and physical, as well as inputs of natural resources, to satisfy escalating expectations. For much of history, the great majority of people who lived at the periphery of "civilized" societies had to give up any hope of enjoying life in order to make the dreams of the few who had found a way of exploiting them come true. The achievements that set civilized nations apart from the more primitive—such as the Pyramids, the Great Wall of China, the Taj Mahal, and the temples, palaces, and dams of antiquity—were usually built with the energy of slaves forced to realize their rulers' ambitions. Not surprisingly, work acquired a rather poor reputation.

With all due respect to the Bible, however, it does not seem to be true that work necessarily needs to be unpleasant. It may always have to be hard, or at least harder than doing nothing at all. But there is ample evidence that work can be enjoyable, and that indeed, it is often the most enjoyable part of life.

Occasionally cultures evolve in such a way as to make everyday productive chores as close to flow activities as possible. There are groups in which both work and family life are challenging yet harmoniously integrated. In the high mountain valleys of Europe, in Alpine villages spared by the Industrial Revolution, communities of this type still exist. Curious to see how work is experienced in a "traditional" setting representative of farming life-styles that were prevalent everywhere up to a few generations ago, a team of Italian psychologists led by Professor Fausto Massimini and Dr. Antonella Delle Fave recently interviewed some of their inhabitants, and have generously shared their exhaustive transcripts.

The most striking feature of such places is that those who live there can seldom distinguish work from free time. It could be said that they work sixteen hours a day each day, but then it could also be argued that they never work. One of the inhabitants, Serafina Vinon, a seventy-six-year-old woman from the tiny hamlet of Pont Trentaz, in the Val d'Aosta region of the Italian Alps, still gets up at five in the morning to milk her cows. Afterward she cooks a huge breakfast, cleans the house, and, depending on the weather and time of year, either takes the herd to the meadows just below the glaciers, tends the orchard, or cards some wool. In summer she spends weeks on the high pastures cutting hay, and then carries huge bales of it on her head the several miles down to the barn. She could reach the barn in half the time if she took a direct route; but she prefers following invisible winding trails to save the slopes from erosion. In the evening she may read, or tell stories to her great-grandchildren, or play the accordion for one of the parties of friends and relatives that assemble at her house a few times a week.

Serafina knows every tree, every boulder, every feature of the mountains as if they were old friends. Family legends going back many centuries are linked to the landscape: On this old stone bridge, when the plague of 1473 had exhausted itself, one night the last surviving woman of Serafina's village, with a torch in her hand, met the last surviving man of the village further down the valley. They helped each other, got married, and became the ancestors of her family. It was in that field of raspberries that her grandmother was lost when she was a little girl. On this rock, standing with a pitchfork in his hand, the Devil

threatened Uncle Andrew during the freak snowstorm of '24.

When Serafina was asked what she enjoys doing most in life, she had no trouble answering: milking the cows, taking them to the pasture, pruning the orchard, carding wool . . . in effect, what she enjoys most is what she has been doing for a living all along. In her own words: "It gives me a great satisfaction. To be outdoors, to talk with people, to be with my animals . . . I talk to everybody—plants, birds, flowers, and animals. Everything in nature keeps you company; you see nature progress every day. You feel clean and happy: too bad that you get tired and have to go home. . . . even when you have to work a lot it is very beautiful."

When she was asked what she would do if she had all the time and money in the world, Serafina laughed—and repeated the same list of activities: she would milk the cows, take them to pasture, tend the orchard, card wool. It is not that Serafina is ignorant of the alternatives offered by urban life: she watches television occasionally and reads newsmagazines, and many of her younger relatives live in large cities and have comfortable life-styles, with cars, appliances, and exotic vacations. But their more fashionable and modern way of life does not attract Serafina; she is perfectly content and serene with the role she plays in the universe.

Ten of the oldest residents of Pont Trentaz, ranging from sixty-six to eighty-two years of age, were interviewed; all of them gave responses similar to Serafina's. None of them drew a sharp distinction between work and free time, all mentioned work as the major source of optimal experiences, and none would want to work less if given a chance.

Most of their children, who were also interviewed, expressed the same attitude toward life. However, among the grandchildren (aged between twenty and thirty-three years), more typical attitudes toward work prevailed: given a chance they would have worked less, and spent more time instead in leisure—reading, sports, traveling, seeing the latest shows. Partly this difference between the generations is a matter of age; young people are usually less contented with their lot, more eager for change, and more intolerant of the constraints of routine. But in this case the divergence also reflects the erosion of a traditional way of life, in which work was meaningfully related to people's identities and to their ultimate goals. Some of the young people of Pont Trentaz might in their old age come to feel about their work as Serafina does; probably the majority will not. Instead, they will keep widening the gap between jobs that are necessary but unpleasant, and leisure pursuits that are enjoyable but have little complexity.

Life in this Alpine village has never been easy. To survive from day to day each person had to master a very broad range of difficult challenges ranging from plain hard work, to skillful crafts, to the preservation and elaboration of a distinctive language, of songs, of artworks, of complex traditions. Yet somehow the culture has evolved in such a way that the people living in it find these tasks enjoyable. Instead of feeling oppressed by the necessity to work hard, they share the opinion of Giuliana B., a seventy-four-year-old lady: "I am free, free in my work, because I do whatever I want. If I don't do something today I will do it tomorrow. I don't have a boss, I am the boss of my own life. I have kept my freedom and I have fought for my freedom."

Certainly, not all preindustrial cultures were this idyllic. In many hunting or farming societies life was harsh, brutish, and short. In fact, some of the Alpine communities not far from Pont Trentaz were described by foreign travelers of the last century as riddled with hunger, disease, and ignorance. To perfect a life-style capable of balancing harmoniously human goals with the resources of the environment is as rare a feat as building one of the great cathedrals that fill visitors with awe. We can't generalize from one successful example to all preindustrial cultures. But by the same token even one exception is sufficient to disprove the notion that work must always be less enjoyable than freely chosen leisure.

But what about the case of an urban laborer, whose work is not so clearly tied to his subsistence? Serafina's attitude, as it happens, is not unique to traditional farming villages. We can occasionally find it around us in the midst of the turmoils of the industrial age. A good example is the case of Joe Kramer, a man we interviewed in one of our early studies of the flow experience. Joe was in his early sixties, a welder in a South Chicago plant where railroad cars are assembled. About two hundred people worked with Joe in three huge, dark, hangarlike structures where steel plates weighing several tons move around suspended from overhead tracks, and are welded amid showers of sparks to the wheelbases of freight cars. In summer it is an oven, in winter the icy winds of the prairie howl through. The clanging of metal is always so intense that one must shout into a person's ear to make oneself understood.

Joe came to the United States when he was five years old, and he left school after fourth grade. He had been working at this plant for over thirty years, but never wanted to become a foreman. He declined several promotions, claiming that he liked being a simple welder, and felt uncomfortable being anyone's boss. Although he stood on the lowest rung

of the hierarchy in the plant, everyone knew Joe, and everyone agreed that he was the most important person in the entire factory. The manager stated that if he had five more people like Joe, his plant would be the most efficient in the business. His fellow workers said that without Joe they might as well shut down the shop right now.

The reason for his fame was simple: Joe had apparently mastered every phase of the plant's operation, and he was now able to take anyone's place if the necessity arose. Moreover, he could fix any broken-down piece of machinery, ranging from huge mechanical cranes to tiny electronic monitors. But what astounded people most was that Joe not only could perform these tasks, but actually enjoyed it when he was called upon to do them. When asked how he had learned to deal with complex engines and instruments without having had any formal training, Joe gave a very disarming answer. Since childhood he had been fascinated with machinery of every kind. He was especially drawn to anything that wasn't working properly: "Like when my mother's toaster went on the fritz, I asked myself: 'If I were that toaster and I didn't work, what would be wrong with me?' " Then he disassembled the toaster, found the defect, and fixed it. Ever since, he has used this method of empathic identification to learn about and restore increasingly complex mechanical systems. And the fascination of discovery has never left him; now close to retirement, Joe still enjoys work every day.

Joe has never been a workaholic, completely dependent on the challenges of the factory to feel good about himself. What he did at home was perhaps even more remarkable than his transformation of a mindless, routine job into a complex, flow-producing activity. Joe and his wife live in a modest bungalow on the outskirts of the city. Over the years they bought up the two vacant lots on either side of their house. On these lots Joe built an intricate rock garden, with terraces, paths, and several hundred flowers and shrubs. While he was installing underground sprinklers, Joe had an idea: What if he had them make rainbows? He looked for sprinkler heads that would produce a fine enough mist for this purpose, but none satisfied him; so he designed one himself, and built it on his basement lathe. Now after work he could sit on the back porch, and by touching one switch he could activate a dozen sprays that turned into as many small rainbows.

But there was one problem with Joe's little Garden of Eden. Since he worked most days, by the time he got home the sun was usually too far down the horizon to help paint the water with strong colors. So Joe went back to the drawing board, and came back with an admirable solution. He found floodlights that contained enough of the sun's spec-

trum to form rainbows, and installed them inconspicuously around the sprinklers. Now he was really ready. Even in the middle of the night, just by touching two switches, he could surround his house with fans of water, light, and color.

Joe is a rare example of what it means to have an "autotelic personality," or the ability to create flow experiences even in the most barren environment—an almost inhumane workplace, a weed-infested urban neighborhood. In the entire railroad plant, Joe appeared to be the only man who had the vision to perceive challenging opportunities for action. The rest of the welders we interviewed regarded their jobs as burdens to be escaped as promptly as possible, and each evening as soon as work stopped they fanned out for the saloons that were strategically placed on every third corner of the grid of streets surrounding the factory, there to forget the dullness of the day with beer and camaraderie. Then home for more beer in front of the TV, a brief skirmish with the wife, and the day—in all respects similar to each previous one—was over.

One might argue here that endorsing Joe's life-style over that of his fellow workers is reprehensibly "elitist." After all, the guys in the saloon are having a good time, and who is to say that grubbing away in the backyard making rainbows is a better way to spend one's time? By the tenets of cultural relativism the criticism would be justifiable, of course. But when one understands that enjoyment depends on increasing complexity, it is no longer possible to take such radical relativism seriously. The quality of experience of people who play with and transform the opportunities in their surroundings, as Joe did, is clearly more developed as well as more enjoyable than that of people who resign themselves to live within the constraints of the barren reality they feel they cannot alter.

The view that work undertaken as a flow activity is the best way to fulfill human potentialities has been proposed often enough in the past, by various religious and philosophical systems. To people imbued with the Christian worldview of the Middle Ages it made sense to say that peeling potatoes was just as important as building a cathedral, provided they were both done for the greater glory of God. For Karl Marx, men and women constructed their being through productive activities; there is no "human nature," he held, except that which we create through work. Work not only transforms the environment by building bridges across rivers and cultivating barren plains; it also transforms the worker from an animal guided by instincts into a conscious, goal-directed, skillful person.

One of the most interesting examples of how the phenomenon of flow appeared to thinkers of earlier times is the concept of *Yu* referred to about 2,300 years ago in the writings of the Taoist scholar Chuang Tzu. *Yu* is a synonym for the right way of following the path, or *Tao*: it has been translated into English as "wandering"; as "walking without touching the ground"; or as "swimming," "flying," and *"flowing."* Chuang Tzu believed that to *Yu* was the proper way to live—without concern for external rewards, spontaneously, with total commitment—in short, as a total autotelic experience.

As an example of how to live by *Yu*—or how to flow—Chuang Tzu presents, in the Inner Chapters of the work which has come down to us bearing his name, a parable of a humble worker. This character is Ting, a cook whose task was to butcher the meat at the court of Lord Hui of Wei. Schoolchildren in Hong Kong and Taiwan still have to memorize Chuang Tzu's description: "Ting was cutting up an ox for Lord Wen-hui. At every touch of his hand, every heave of his shoulder, every move of his feet, every thrust of his knee—zip! zoop! He slithered the knife along with a zing, and all was in perfect rhythm, as though he were performing the dance of the Mulberry Grove or keeping time to the Ching-shou music."

Lord Wen-hui was fascinated by how much flow (or *Yu*) his cook found in his work, and so he complimented Ting on his great skill. But Ting denied that it was a matter of skill: "What I care about is the Way, which goes beyond skill." Then he described how he had achieved his superb performance: a sort of mystical, intuitive understanding of the anatomy of the ox, which allowed him to slice it to pieces with what appeared to be automatic ease: "Perception and understanding have come to a stop and spirit moves where it wants."

Ting's explanation may seem to imply that *Yu* and flow are the result of different kinds of processes. In fact, some critics have emphasized the differences: while flow is the result of a conscious attempt to master challenges, *Yu* occurs when the individual gives up conscious mastery. In this sense they see flow as an example of the "Western" search for optimal experience, which according to them is based on changing objective conditions (e.g., by confronting challenges with skills), whereas *Yu* is an example of the "Eastern" approach, which disregards objective conditions entirely in favor of spiritual playfulness and the transcendence of actuality.

But how is a person to achieve this transcendental experience and spiritual playfulness? In the same parable, Chuang Tzu offers a valuable

insight to answer this question, an insight that has given rise to diametrically opposite interpretations. In Watson's translation, it reads as follows: "However, whenever I come to a complicated place, I size up the difficulties, tell myself to watch out and be careful, keep my eyes on what I'm doing, work very slowly, and move my knife with the greatest of subtlety, until—flop! the whole thing comes apart like a clod of earth crumbling to the ground. I stand there holding the knife and look all around me, completely satisfied and reluctant to move on, and then I wipe off the knife and put it away."

Now some earlier scholars have taken this passage to refer to the working methods of a mediocre carver who does not know how to *Yu.* More recent ones such as Watson and Graham believe that it refers to Ting's own working methods. Based on my knowledge of the flow experience, I believe the latter reading must be the correct one. It demonstrates, even after all the obvious levels of skill and craft (*chi*) have been mastered, the *Yu* still depends on the discovery of new challenges (the "complicated place" or "difficulties" in the above quotation), and on the development of new skills ("watch out and be careful, keep my eyes on what I'm doing . . . move my knife with the greatest of subtlety").

In other words, the mystical heights of the *Yu* are not attained by some superhuman quantum jump, but simply by the gradual focusing of attention on the opportunities for action in one's environment, which results in a perfection of skills that with time becomes so thoroughly automatic as to seem spontaneous and otherworldly. The performances of a great violinist or a great mathematician seem equally uncanny, even though they can be explained by the incremental honing of challenges and skills. If my interpretation is true, in the flow experience (or *Yu*) East and West meet: in both cultures ecstasy arises from the same sources. Lord Wen-hui's cook is an excellent example of how one can find flow in the most unlikely places, in the most humble jobs of daily life. And it is also remarkable that over twenty-three centuries ago the dynamics of this experience were already so well known.

The old woman who farms in the Alps, the welder in South Chicago, and the mythical cook from ancient China have this in common: their work is hard and unglamorous, and most people would find it boring, repetitive, and meaningless. Yet these individuals transformed the jobs they had to do into complex activities. They did this by recognizing opportunities for action where others did not, by developing skills, by focusing on the activity at hand, and allowing themselves to be lost in the interaction so that their selves could emerge stronger

afterward. Thus transformed, work becomes enjoyable, and as the result of a personal investment of psychic energy, it feels as if it were freely chosen, as well.

AUTOTELIC JOBS

Serafina, Joe, and Ting are examples of people who have developed an autotelic personality. Despite the severe limitations of their environment they were able to change constraints into opportunities for expressing their freedom and creativity. Their method represents one way to enjoy one's job while making it richer. The other is to change the job itself, until its conditions are more conducive to flow, even for people who lack autotelic personalities. The more a job inherently resembles a game—with variety, appropriate and flexible challenges, clear goals, and immediate feedback—the more enjoyable it will be regardless of the worker's level of development.

Hunting, for instance, is a good example of "work" that by its very nature had all the characteristics of flow. For hundreds of thousands of years chasing down game was the main productive activity in which humans were involved. Yet hunting has proven to be so enjoyable that many people are still doing it as a hobby, after all practical need for it has disappeared. The same is true of fishing. The pastoral mode of existence also has some of the freedom and flowlike structure of earliest "work." Many contemporary young Navajos in Arizona claim that following their sheep on horseback over the mesas is the most enjoyable thing they ever do. Compared to hunting or herding, farming is more difficult to enjoy. It is a more settled, more repetitive activity, and the results take much longer to appear. The seeds planted in spring need months to bear fruit. To enjoy agriculture one must play within a much longer time frame than in hunting: while the hunter may choose his quarry and method of attack several times each day, the farmer decides what crops to plant, where, and in what quantity only a few times each year. In order to succeed, the farmer must make lengthy preparations, and endure chancy periods of waiting helplessly for the weather to cooperate. It is not surprising to learn that populations of nomads or hunters, when forced to become farmers, appear to have died out rather than submitting themselves to that ostensibly boring existence. Yet many farmers also eventually learned to enjoy the more subtle opportunities of their occupation.

The crafts and cottage industries that before the eighteenth century occupied most of the time left free from farming were reasonably

well designed in terms of providing flow. English weavers, for example, had their looms at home, and worked with their entire family according to self-imposed schedules. They set their own goals for production, and modified them according to what they thought they could accomplish. If the weather was good, they quit so they could work in the orchard or the vegetable garden. When they felt like it they would sing a few ballads, and when a piece of cloth was finished they all celebrated with a wee drink.

This arrangement still functions in some parts of the world that have been able to maintain a more humane pace of production, despite all the benefits of modernization. For instance, Professor Massimini and his team have interviewed weavers in the province of Biella, in northern Italy, whose pattern of working resembles that of the fabled English weavers of over two centuries ago. Each of these families owns two to ten mechanical looms that can be supervised by a single person. The father may watch the looms early in the morning, then call in his son to take over while he goes looking for mushrooms in the forest or stops by the creek to fish for trout. The son runs the machines until he gets bored, at which point the mother takes over.

In their interviews, every member of the families listed weaving as the most enjoyable activity they did—more than traveling, more than going to discos, more than fishing, and certainly more than watching TV. The reason that working was so much fun is that it was continually challenging. Family members designed their own patterns, and when they had had enough of one kind they would switch to another. Each family decided what type of cloth to weave, where to buy the materials, how much to produce, and where to sell it. Some families had customers as far away as Japan and Australia. Family members were always traveling to manufacturing centers to keep abreast of new technical developments, or to buy necessary equipment as cheaply as possible.

But throughout most of the Western world such cozy arrangements conducive to flow were brutally disrupted by the invention of the first power looms, and the centralized factory system they spawned. By the middle of the eighteenth century family crafts in England were generally unable to compete with mass production. Families were broken up, workers had to leave their cottages and move en masse into ugly and unwholesome plants, rigid schedules lasting from dawn to dusk were enforced. Children as young as seven years of age had to work themselves to exhaustion among indifferent or exploitive strangers. If the enjoyment of work had any credibility before, it was effectively destroyed in that first frenzy of industrialization.

Now we have entered a new, postindustrial age, and work is said to be becoming benign again: the typical laborer now sits in front of a bank of dials, supervising a computer screen in a pleasant control room, while a band of savvy robots down the line do whatever "real" work needs to be done. In fact, most people are not engaged in production any longer; they work in the so-called "service sector," at jobs that would surely appear like pampered leisure to the farmers and factory workers of only a few generations ago. Above them are the managers and professionals, who have great leeway in making whatever they want to of their jobs.

So work can be either brutal and boring, or enjoyable and exciting. In just a few decades, as happened in England in the 1740s, the average working conditions can change from being relatively pleasant to a nightmare. Technological innovations such as the waterwheel, the plow, the steam engine, electricity, or the silicon chip can make a tremendous difference in whether work will be enjoyable or not. Laws regulating the enclosure of the commons, the abolition of slavery, the abolition of apprentices, or the institution of the forty-hour week and of minimum wages can also have a great impact. The sooner we realize that the quality of the work experience can be transformed at will, the sooner we can improve this enormously important dimension of life. Yet most people still believe that work is forever destined to remain "the curse of Adam."

In theory, any job could be changed so as to make it more enjoyable by following the prescriptions of the flow model. At present, however, whether work is enjoyable or not ranks quite low among the concerns of those who have the power to influence the nature of a given job. Management has to care for productivity first and foremost, and union bosses have to keep safety, security, and compensations uppermost in their minds. In the short run these priorities might well conflict with flow-producing conditions. This is regrettable, because if workers really enjoyed their jobs they would not only benefit personally, but sooner or later they would almost certainly produce more efficiently and reach all the other goals that now take precedence.

At the same time, it would be erroneous to expect that if all jobs were constructed like games, everyone would enjoy them. Even the most favorable external conditions do not guarantee that a person will be in flow. Because optimal experience depends on a subjective evaluation of what the possibilities for action are, and of one's own capacities, it happens quite often that an individual will be discontented even with a potentially great job.

Let us take as an example the profession of surgery. Few jobs involve so much responsibility, or bestow so much status on its practitioners. Certainly if challenges and skills are significant factors, then surgeons must find their job exhilarating. And in fact many surgeons say that they are addicted to their work, that nothing else in their lives compares with it in terms of enjoyment, that anything that takes them away from the hospital—a Caribbean vacation, a night at the opera— feels like a waste of time.

But not every surgeon is as enthusiastic about his job. Some grow so bored by it that they take up drinking, gambling, or a fast life-style to forget its drudgery. How can such widely diverging views of the same profession be possible? One reason is that surgeons who settle down for well-paid but repetitive routines soon begin to feel their tedium. There are surgeons who only cut out appendices, or tonsils; a few even specialize in piercing earlobes. Such specialization can be lucrative, but it makes enjoying the job more difficult. At the other extreme, there are competitive supersurgeons who go off the deep end in the other direction, constantly needing new challenges, wanting to perform spectacular new surgical procedures until they finally can't meet the expectations they have set for themselves. Surgical pioneers burn out for the opposite reason of the routine specialist: they have accomplished the impossible once, but they haven't found a way to do it again.

Those surgeons who enjoy their work usually practice in hospitals that allow variety and a certain amount of experimentation with the latest techniques, and that make research and teaching part of the job. The surgeons who like what they do mention money, prestige, and saving lives as being important to them, but they state that their greatest enthusiasm is for the intrinsic aspects of the job. What makes surgery so special for them is the feeling one gets from the activity itself. And the way they describe that feeling is in almost every detail similar to the flow experiences reported by athletes, artists, or the cook who butchered the meat for the Lord of Wei.

The explanation for this is that surgical operations have all the characteristics that a flow activity should have. Surgeons mention, for instance, how well defined their goals are. An internist deals with problems that are less specific and localized, and a psychiatrist with even more vague and ephemeral symptoms and solutions. By contrast the surgeon's task is crystal-clear: to cut out the tumor, or set the bone, or get some organ pumping away again. Once that task is accomplished he can sew up the incision, and turn to the next patient with the sense of a job well done.

Similarly surgery provides immediate and continuous feedback. If there is no blood in the cavity, the operation is going well; then the diseased tissue comes out, or the bone is set; the stitches take (or not, if that is the case), but throughout the process one knows exactly how successful one is, and if not, why not. For this reason alone, most surgeons believe that what they are doing is so much more enjoyable than any other branch of medicine, or any other job on earth.

At another level, there is no lack of challenges in surgery. In the words of one surgeon: "I get intellectual enjoyment—like the chess player or the academic who studies ancient Mesopotamian toothpicks. . . . The craft is enjoyable, like carpentry is fun. . . . The gratification of taking an extremely difficult problem and making it go." And another: "It's very satisfying and if it is somewhat difficult it is also exciting. It's very nice to make things work again, to put things in their right place so that it looks like it should, and fits neatly. This is very pleasant, particularly when the group works together in a smooth and efficient manner: then the aesthetics of the whole situation can be appreciated."

This second quote indicates that the challenges of an operation are not limited to what the surgeon must do personally, but include coordinating an event that involves a number of additional players. Many surgeons comment on how exhilarating it is to be part of a well-trained team that functions smoothly and efficiently. And of course there is always the possibility of doing things better, of improving one's skills. An eye surgeon commented, "You use fine and precise instruments. It is an exercise in art. . . . It all rests on how precisely and artistically you do the operation." Remarked another surgeon, "It is important to watch for details, to be neat and technically efficient. I don't like to waste motion and so try to make the operation as well planned and thought out as possible. I'm particular about how the needle is held, where the stitches are placed, the type of suture, and so on—things should look the best and seem easy."

The way surgery is practiced helps block out distractions, and concentrates all one's attention on the procedure. The operating theater is indeed like a stage, with spotlights illuminating the action and the actors. Before an operation surgeons go through steps of preparation, purification, and dressing up in special garments—like athletes before a contest, or priests before a ceremony. These rituals have a practical purpose, but they also serve to separate celebrants from the concerns of everyday life, and focus their minds on the event to be enacted. Some surgeons say that on the mornings before an important operation they put themselves on "automatic pilot" by eating the same breakfast, wear-

ing the same clothes, and driving to the hospital by the same route. They do so not because they are superstitious, but because they sense that this habitual behavior makes it easier for them to devote their undivided attention to the challenge ahead.

Surgeons are lucky. Not only are they paid well, not only do they bask in respect and admiration, but they also have a job built according to the blueprint of flow activities. Notwithstanding all these advantages, there are surgeons who go out of their minds because of boredom, or because they are reaching after unattainable power and fame. What this indicates is that important as the structure of a job is, by itself it won't determine whether or not a person performing that job will find enjoyment in it. Satisfaction in a job will also depend on whether or not a worker has an autotelic personality. Joe the welder enjoyed tasks that few would regard as providing opportunities for flow. At the same time some surgeons manage to hate a job that seems to have been intentionally created to provide enjoyment.

To improve the quality of life through work, two complementary strategies are necessary. On the one hand jobs should be redesigned so that they resemble as closely as possible flow activities—as do hunting, cottage weaving, and surgery. But it will also be necessary to help people develop autotelic personalities like those of Serafina, Joe, and Ting, by training them to recognize opportunities for action, to hone their skills, to set reachable goals. Neither one of these strategies is likely to make work much more enjoyable by itself; in combination, they should contribute enormously to optimal experience.

THE PARADOX OF WORK

It is easier to understand the way work affects the quality of life when we take the long view, and compare ourselves with people from different times and cultures. But eventually we have to look more closely at what is happening here and now. Ancient Chinese cooks, Alpine farmers, surgeons, and welders help illuminate the potential inherent in work, but they are not, after all, very typical of the kind of job most people do nowadays. What is work like for average American adults today?

In our studies we have often encountered a strange inner conflict in the way people relate to the way they make their living. On the one hand, our subjects usually report that they have had some of their most positive experiences while on the job. From this response it would follow that they would wish to be working, that their motivation on the job would be high. Instead, even when they feel good, people generally say

that they would prefer not to be working, that their motivation on the job is low. The converse is also true: when supposedly enjoying their hard-earned leisure, people generally report surprisingly low moods; yet they keep on wishing for more leisure.

For example, in one study we used the Experience Sampling Method to answer the question: Do people report more instances of flow at work or in leisure? The respondents, over a hundred men and women working full-time at a variety of occupations, wore an electronic pager for one week, and whenever the pager beeped in response to signals sent at eight random times each day for a week, they filled out two pages of a booklet to record what they were doing and how they felt at the moment they were signaled. Among other things, they were asked to indicate, on ten-point scales, how many challenges they saw at the moment, and how many skills they felt they were using.

A person was counted as being in flow every time he or she marked both the level of challenges and the level of skills to be above the mean level for the week. In this particular study over 4,800 responses were collected—an average of about 44 per person per week. In terms of the criterion we had adopted, 33 percent of these responses were "in flow"—that is, above the mean personal weekly level of challenges and skills. Of course, this method of defining flow is rather liberal. If one only wished to include extremely complex flow experiences—say, those with the highest levels of challenges and skills—perhaps fewer than 1 percent of the responses would qualify as flow. The methodological convention adopted here to define flow functions somewhat like a microscope: depending on the level of magnification used, very different detail will be visible.

As expected, the more time a person spent in flow during the week, the better was the overall quality of his or her reported experience. People who were more often in flow were especially likely to feel "strong," "active," "creative," "concentrated," and "motivated." What was unexpected, however, is how frequently people reported flow situations at work, and how rarely in leisure.

When people were signaled while they were actually working at their jobs (which happened only about three-fourths of the time, because, as it turned out, the remaining one-fourth of the time on the job these average workers were daydreaming, gossiping, or engaged in personal business), the proportion of responses in flow was a high 54 percent. In other words, about half the time that people are working they feel they are confronting above-average challenges, and using above-average skills. In contrast, when engaged in leisure activities such

as reading, watching TV, having friends over, or going to a restaurant, only 18 percent of the responses ended up in flow. The leisure responses were typically in the range we have come to call *apathy*, characterized by below-average levels of both challenges and skills. In this condition, people tend to say that they feel passive, weak, dull, and dissatisfied. When people were working, 16 percent of the responses were in the apathy region; in leisure, over half (52 percent).

As one would expect, managers and supervisors were significantly more often in flow at work (64 percent) than were clerical workers (51 percent) and blue-collar workers (47 percent). Blue-collar workers reported more flow in leisure (20 percent) than clerical workers (16 percent) and managers (15 percent) did. But even workers on the assembly lines reported they were in flow more than twice as often at work as in leisure (47 percent versus 20 percent). Conversely, apathy was reported at work more often by blue-collar workers than by managers (23 percent versus 11 percent), and in leisure more often by managers than by blue-collar workers (61 percent versus 46 percent).

Whenever people were in flow, either at work or in leisure, they reported it as a much more positive experience than the times they were not in flow. When challenges and skills were both high they felt happier, more cheerful, stronger, more active; they concentrated more; they felt more creative and satisfied. All these differences in the quality of experience were very significant statistically, and they were more or less the same for every kind of worker.

There was only a single exception to this general trend. One of the questions in the response booklet asked respondents to indicate, again on a ten-point scale from no to yes, their answer to the following question: "Did you wish you had been doing something else?" The extent to which a person answers this with a no is generally a reliable indication of how motivated he or she is at the moment of the signal. The results showed that people wished to be doing something else to a much greater extent when working than when at leisure, and this regardless of whether they were in flow. In other words, motivation was low at work even when it provided flow, and it was high in leisure even when the quality of experience was low.

Thus we have the paradoxical situation: On the job people feel skillful and challenged, and therefore feel more happy, strong, creative, and satisfied. In their free time people feel that there is generally not much to do and their skills are not being used, and therefore they tend to feel more sad, weak, dull, and dissatisfied. Yet they would like to work less and spend more time in leisure.

What does this contradictory pattern mean? There are several possible explanations, but one conclusion seems inevitable: when it comes to work, people do not heed the evidence of their senses. They disregard the quality of immediate experience, and base their motivation instead on the strongly rooted cultural stereotype of what work is *supposed* to be like. They think of it as an imposition, a constraint, an infringement of their freedom, and therefore something to be avoided as much as possible.

It could be argued that although flow at work is enjoyable, people cannot stand high levels of challenge all the time. They need to recover at home, to turn into couch potatoes for a few hours each day even though they don't enjoy it. But comparative examples seem to contradict this argument. For instance the farmers of Pont Trentaz work much harder, and for longer hours, than the average American, and the challenges they face in their daily round require at least as high levels of concentration and involvement. Yet they don't wish to be doing something else while working, and afterward, instead of relaxing, they fill their free time with demanding leisure activities.

As these findings suggest, the apathy of many of the people around us is not due to their being physically or mentally exhausted. The problem seems to lie more in the modern worker's relation to his job, with the way he perceives his goals in relation to it.

When we feel that we are investing attention in a task against our will, it is as if our psychic energy is being wasted. Instead of helping us reach our own goals, it is called upon to make someone else's come true. The time channeled into such a task is perceived as time subtracted from the total available for our life. Many people consider their jobs as something they have to do, a burden imposed from the outside, an effort that takes life away from the ledger of their existence. So even though the momentary on-the-job experience may be positive, they tend to discount it, because it does not contribute to their own long-range goals.

It should be stressed, however, that "dissatisfaction" is a relative term. According to large-scale national surveys conducted between 1972 and 1978, only 3 percent of American workers said they were very dissatisfied with their jobs, while 52 percent said they were very satisfied—one of the highest rates in industrialized nations. But one can love one's job and still be displeased with some aspects of it, and try to improve what is not perfect. In our studies we find that American workers tend to mention three main reasons for their dissatisfaction with their jobs, all of which are related to the quality of experience typically available to them at work—even though, as we have just seen,

their experience at work tends to be better than it is at home. (Contrary to popular opinion, salary and other material concerns are generally not among their most pressing concerns.) The first and perhaps most important complaint concerns the lack of variety and challenge. This can be a problem for everyone, but especially for those in lower-level occupations in which routine plays a major role. The second has to do with conflicts with other people on the job, especially bosses. The third reason involves burnout: too much pressure, too much stress, too little time to think for oneself, too little time to spend with the family. This is a factor that particularly troubles the higher echelons—executives and managers.

Such complaints are real enough, as they refer to objective conditions, yet they can be addressed by a subjective shift in one's consciousness. Variety and challenge, for instance, are in one sense inherent characteristics of jobs, but they also depend on how one perceives opportunities. Ting, Serafina, and Joe saw challenges in tasks that most people would find dull and meaningless. Whether a job has variety or not ultimately depends more on a person's approach to it than on actual working conditions.

The same is true of the other causes of dissatisfaction. Getting along with co-workers and supervisors might be difficult, but generally can be managed if one makes the attempt. Conflict at work is often due to a person's feeling defensive out of a fear of losing face. To prove himself he sets certain goals for how others should treat him, and then expects rigidly that others will fulfill those expectations. This rarely happens as planned, however, because others also have an agenda for their own rigid goals to be achieved. Perhaps the best way to avoid this impasse is to set the challenge of reaching one's goals while helping the boss and colleagues reach theirs; it is less direct and more time-consuming than forging ahead to satisfy one's interests regardless of what happens to others, but in the long run it seldom fails.

Finally, stresses and pressures are clearly the most subjective aspects of a job, and therefore the ones that should be most amenable to the control of consciousness. Stress exists only if we experience it; it takes the most extreme objective conditions to cause it directly. The same amount of pressure will wilt one person and be a welcome challenge to another. There are hundreds of ways to relieve stress, some based on better organization, delegation of responsibility, better communication with co-workers and supervisors; others are based on factors external to the job, such as improved home life, leisure patterns, or inner disciplines like transcendental meditation.

These piecemeal solutions may help, but the only real answer to coping with work stress is to consider it part of a general strategy to improve the overall quality of experience. Of course this is easier said than done. To do so involves mobilizing psychic energy and keeping it focused on personally forged goals, despite inevitable distractions. Various ways of coping with external stress will be discussed later, in chapter 9. Now it may be useful to consider how the use of leisure time contributes—or fails to contribute—to the overall quality of life.

THE WASTE OF FREE TIME

Although, as we have seen, people generally long to leave their places of work and get home, ready to put their hard-earned free time to good use, all too often they have no idea what to do there. Ironically, jobs are actually easier to enjoy than free time, because like flow activities they have built-in goals, feedback, rules, and challenges, all of which encourage one to become involved in one's work, to concentrate and lose oneself in it. Free time, on the other hand, is unstructured, and requires much greater effort to be shaped into something that can be enjoyed. Hobbies that demand skill, habits that set goals and limits, personal interests, and especially inner discipline help to make leisure what it is supposed to be—a chance for *re-creation*. But on the whole people miss the opportunity to enjoy leisure even more thoroughly than they do with working time. Over sixty years ago, the great American sociologist Robert Park already noted: "It is in the improvident use of our leisure, I suspect, that the greatest wastes of American life occur."

The tremendous leisure industry that has arisen in the last few generations has been designed to help fill free time with enjoyable experiences. Nevertheless, instead of using our physical and mental resources to experience flow, most of us spend many hours each week watching celebrated athletes playing in enormous stadiums. Instead of making music, we listen to platinum records cut by millionaire musicians. Instead of making art, we go to admire paintings that brought in the highest bids at the latest auction. We do not run risks acting on our beliefs, but occupy hours each day watching actors who pretend to have adventures, engaged in mock-meaningful action.

This vicarious participation is able to mask, at least temporarily, the underlying emptiness of wasted time. But it is a very pale substitute for attention invested in real challenges. The flow experience that results from the use of skills leads to growth; passive entertainment leads nowhere. Collectively we are wasting each year the equivalent of millions

of years of human consciousness. The energy that could be used to focus on complex goals, to provide for enjoyable growth, is squandered on patterns of stimulation that only mimic reality. Mass leisure, mass culture, and even high culture when only attended to passively and for extrinsic reasons—such as the wish to flaunt one's status—are parasites of the mind. They absorb psychic energy without providing substantive strength in return. They leave us more exhausted, more disheartened than we were before.

Unless a person takes charge of them, both work and free time are likely to be disappointing. Most jobs and many leisure activities—especially those involving the passive consumption of mass media—are not designed to make us happy and strong. Their purpose is to make money for someone else. If we allow them to, they can suck out the marrow of our lives, leaving only feeble husks. But like everything else, work and leisure can be appropriated for our needs. People who learn to enjoy their work, who do not waste their free time, end up feeling that their lives as a whole have become much more worthwhile. "The future," wrote C. K. Brightbill, "will belong not only to the educated man, but to the man who is educated to use his leisure wisely."

□ 8

ENJOYING SOLITUDE
AND OTHER PEOPLE

STUDIES ON FLOW have demonstrated repeatedly that more than any-
thing else, the quality of life depends on two factors: how we experience
work, and our relations with other people. The most detailed informa-
tion about who we are as individuals comes from those we communicate
with, and from the way we accomplish our jobs. Our self is largely
defined by what happens in those two contexts, as Freud recognized in
his prescription of "love and work" for happiness. The last chapter
reviewed some of the flow potentials of work; here we will explore
relationships with family and friends, to determine how they can
become the source of enjoyable experiences.

Whether we are in the company of other people or not makes a
great difference to the quality of experience. We are biologically pro-
grammed to find other human beings the most important objects in the
world. Because they can make life either very interesting and fulfilling
or utterly miserable, how we manage relationships with them makes an
enormous difference to our happiness. If we learn to make our relations
with others more like flow experiences, our quality of life as a whole is
going to be much improved.

On the other hand, we also value privacy and often wish to be left
alone. Yet it frequently turns out that as soon as we are, we begin to
grow depressed. It is typical for people in this situation to feel lonely,
to feel that there is no challenge, there is nothing to do. For some,

solitude brings about in milder form the disorienting symptoms of sensory deprivation. Yet unless one learns to tolerate and even enjoy being alone, it is very difficult to accomplish any task that requires undivided concentration. For this reason, it is essential to find ways to control consciousness even when we are left to our own devices.

THE CONFLICT BETWEEN BEING ALONE AND BEING WITH OTHERS

Of the things that frighten us, the fear of being left out of the flow of human interaction is certainly one of the worst. There is no question that we are social animals; only in the company of other people do we feel complete. In many preliterate cultures solitude is thought to be so intolerable that a person makes a great effort never to be alone; only witches and shamans feel comfortable spending time by themselves. In many different human societies—Australian Aborigines, Amish farmers, West Point cadets—the worst sanction the community can issue is shunning. The person ignored grows gradually depressed, and soon begins to doubt his or her very existence. In some societies the final outcome of being ostracized is death: the person who is left alone comes to accept the fact that he must be already dead, since no one pays attention to him any longer; little by little he stops taking care of his body, and eventually passes away. The Latin locution for "being alive" was *inter hominem esse*, which literally meant "to be among men"; whereas "to be dead" was *inter hominem esse desinere*, or "to cease to be among men." Exile from the city was, next to being killed outright, the most severe punishment for a Roman citizen; no matter how luxurious his country estate, if banished from the company of his peers the urban Roman became an invisible man. The same bitter fate is well known to contemporary New Yorkers whenever for some reason they have to leave their city.

The density of human contacts that great cities afford is like a soothing balm; people in such centers relish it even when the interactions it provides may be unpleasant or dangerous. The crowds streaming along Fifth Avenue may contain an abundance of muggers and weirdos; nevertheless, they are exciting and reassuring. Everyone feels more alive when surrounded with other people.

Social science surveys have universally concluded that people claim to be most happy with friends and family, or just in the company of others. When they are asked to list pleasant activities that improve their mood for the entire day, the kind of events most often mentioned

are "Being with happy people," "Having people show interest in what I say," "Being with friends," and "Being noticed as sexually attractive." One of the major symptoms that sets depressed and unhappy people apart is that they rarely report such events occurring to them. A supportive social network also mitigates stress: an illness or other misfortune is less likely to break a person down if he or she can rely on the emotional support of others.

There is no question that we are programmed to seek out the company of peers. It is likely that sooner or later behavioral geneticists will find in our chromosomes the chemical instructions that make us feel so uncomfortable whenever we happen to be alone. There are good reasons why, during the course of evolution, such instructions should have been added to our genes. Animals that develop a competitive edge against other species through cooperation survive much better if they are constantly within sight of one another. Baboons, for instance, who need help from peers to protect themselves against the leopards and hyenas roaming the savannah, have a slim chance of reaching maturity if they leave their troop. The same conditions must have selected for gregariousness as a positive survival trait among our ancestors. Of course, as human adaptation began to rely increasingly on culture, additional reasons for sticking together became important. For instance, the more people grew to depend for survival on knowledge instead of instinct, the more they benefited from sharing their learning mutually; a solitary individual under such conditions became an *idiot*, which in Greek originally meant a "private person"—someone who is unable to learn from others.

At the same time, paradoxically, there is a long tradition of wisdom warning us that "Hell is other people." The Hindu sage and the Christian hermit sought peace away from the madding crowd. And when we examine the most negative experiences in the life of average people, we find the other side of the glittering coin of gregariousness: the most painful events are also those that involve relationships. Unfair bosses and rude customers make us unhappy on the job. At home an uncaring spouse, an ungrateful child, and interfering in-laws are the prime sources of the blues. How is it possible to reconcile the fact that people cause both the best and the worst times?

This apparent contradiction is actually not that difficult to resolve. Like anything else that really matters, relationships make us extremely happy when they go well, and very depressed when they don't work out. People are the most flexible, the most changeable aspect of the environment we have to deal with. The same person can make the morning

wonderful and the evening miserable. Because we depend so much on the affection and approval of others, we are extremely vulnerable to how we are treated by them.

Therefore a person who learns to get along with others is going to make a tremendous change for the better in the quality of life as a whole. This fact is well known to those who write and those who read books with titles such as *How to Win Friends and Influence People*. Business executives yearn to communicate better so that they can be more effective managers, and debutantes read books on etiquette to be accepted and admired by the "in" crowd. Much of this concern reflects an extrinsically motivated desire to manipulate others. But people are not important only because they can help make our goals come true; when they are treated as valuable in their own right, people are the most fulfilling source of happiness.

It is the very flexibility of relationships that makes it possible to transform unpleasant interactions into tolerable, or even exciting ones. How we define and interpret a social situation makes a great difference to how people will treat one another, and to how they will feel while doing it. For instance, when our son Mark was twelve years old, he took a shortcut across a rather deserted park one afternoon as he walked home from school. In the middle of the park he was suddenly confronted by three large young men from the neighboring ghetto. "Don't make a move or he'll shoot you," one of them said, nodding toward the third man, who had his hand in his pocket. The three took away everything Mark had—some change and a worn Timex. "Now keep on going. Don't run, don't even turn around."

So Mark started walking again toward home, and the three went in the other direction. After a few steps, however, Mark turned around and tried to catch up with them. "Listen," he called, "I want to talk to you." "Keep going," they shouted back. But he caught up with the trio, and asked if they would reconsider giving him back the watch they had taken. He explained that it was very cheap, and of no possible value to anyone except him: "You see, it was given to me on my birthday by my parents." The three were furious, but finally decided to take a vote on whether to give back the watch. The vote went two to one in favor of returning it, so Mark walked proudly home without change but with the old watch in his pocket. Of course it took his parents a lot longer to recover from the experience.

From an adult perspective, Mark was foolish to possibly risk his life for an old watch, no matter how sentimentally valued it was. But this episode illustrates an important general point: that a social situation has

the potential to be transformed by redefining its rules. By not taking on the role of the "victim" that had been imposed on him, and by not treating his assailants as "robbers," but as reasonable people who might be expected to empathize with a son's attachment to a family keepsake, Mark was able to change the encounter from a holdup to one that involved, at least to some degree, a rational democratic decision. In this case his success was largely dependent on luck: the robbers could have been drunk, or alienated beyond the reach of reason, and then he might have been seriously hurt. But the point is still valid: human relations are malleable, and if a person has the appropriate skills their rules can be transformed.

But before considering in more depth how relationships can be reshaped to provide optimal experiences, it is necessary to take a detour through the realms of solitude. Only after understanding a bit better how being alone affects the mind can we see more clearly why companionship is so indispensable to well-being. The average adult spends about one-third of his or her waking time alone, yet we know very little about this huge slice of our lives, except that we heartily dislike it.

THE PAIN OF LONELINESS

Most people feel a nearly intolerable sense of emptiness when they are alone, especially with nothing specific to do. Adolescents, adults, and old people all report that their worst experiences have taken place in solitude. Almost every activity is more enjoyable with another person around, and less so when one does it alone. People are more happy, alert, and cheerful if there are others present, compared to how they feel alone, whether they are working on an assembly line or watching television. But the most depressing condition is not that of working or watching TV alone; the worst moods are reported when one is alone and there is nothing that *needs* to be done. For people in our studies who live by themselves and do not attend church, Sunday mornings are the lowest part of the week, because with no demands on attention, they are unable to decide what to do. The rest of the week psychic energy is directed by external routines: work, shopping, favorite TV shows, and so on. But what is one to do Sunday morning after breakfast, after having browsed through the papers? For many, the lack of structure of those hours is devastating. Generally by noon a decision is made: I'll mow the lawn, visit relatives, or watch the football game. A sense of purpose then returns, and attention is focused on the next goal.

Why is solitude such a negative experience? The bottom-line an-

swer is that keeping order in the mind from within is very difficult. We need external goals, external stimulation, external feedback to keep attention directed. And when external input is lacking, attention begins to wander, and thoughts become chaotic—resulting in the state we have called "psychic entropy" in chapter 2.

When left alone, the typical teenager begins to wonder: "What is my girlfriend doing now? Am I getting zits? Will I get to finish the math assignment on time? Are those dudes I had a fight with yesterday going to beat me up?" In other words, with nothing to do, the mind is unable to prevent negative thoughts from elbowing their way to center stage. And unless one learns to control consciousness, the same situation confronts adults. Worries about one's love life, health, investments, family, and job are always hovering at the periphery of attention, waiting until there is nothing pressing that demands concentration. As soon as the mind is ready to relax, *zap!* the potential problems that were waiting in the wings take over.

It is for this reason that television proves such a boon to so many people. Although watching TV is far from being a positive experience— generally people report feeling passive, weak, rather irritable, and sad when doing it—at least the flickering screen brings a certain amount of order to consciousness. The predictable plots, familiar characters, and even the redundant commercials provide a reassuring pattern of stimulation. The screen invites attention to itself as a manageable, restricted aspect of the environment. While interacting with television, the mind is protected from personal worries. The information passing across the screen keeps unpleasant concerns out of the mind. Of course, avoiding depression this way is rather spendthrift, because one expends a great deal of attention without having much to show for it afterward.

More drastic ways of coping with the dread of solitude include the regular use of drugs, or the recourse to obsessive practices, which may range from cleaning the house incessantly to compulsive sexual behavior. While under the influence of chemicals, the self is relieved from the responsibility of directing its psychic energy; we can sit back and watch the patterns of thought that the drug is providing for—whatever happens, it's out of our hands. And like television, the drug keeps the mind from having to face depressing thoughts. While alcohol and other drugs are capable of producing optimal experiences, they are usually at a very low level of complexity. Unless consumed in highly skilled ritual contexts, as is practiced in many traditional societies, what drugs in fact do is *reduce* our perception of both what can be accomplished and what we as individuals are able to accomplish, until the two are in balance. This

is a pleasant state of affairs, but it is only a misleading simulation of that enjoyment that comes from *increasing* opportunities for actions and the abilities to act.

Some people will disagree strongly with this description of how drugs affect the mind. After all, for the past quarter-century we have been told with increasing confidence that drugs are "consciousness-expanding," and that using them enhances creativity. But the evidence suggests that while chemicals do alter the content and the organization of consciousness, they do not expand or increase the self's control over its function. Yet to accomplish anything creative, one must achieve just such control. Therefore, while psychotropic drugs do provide a wider variety of mental experiences than one would encounter under normal sensory conditions, they do so without adding to our ability to order them effectively.

Many contemporary artists experiment with hallucinogens in the hope of creating work as mysteriously haunting as those verses of the *Kubla Khan* that Samuel Coleridge allegedly composed under the influence of laudanum. Sooner or later, however, they realize that the *composition* of any work of art requires a sober mind. Work that is carried out under the influence of drugs lacks the complexity we expect from good art—it tends to be obvious and self-indulgent. A chemically altered consciousness may bring forth unusual images, thoughts, and feelings that later, when clarity returns, the artist can use. The danger is that in becoming dependent on chemicals for patterning the mind, he risks losing the ability to control it by himself.

Much of what passes for sexuality is also just a way of imposing an external order on our thoughts, of "killing time" without having to confront the perils of solitude. Not surprisingly, watching TV and having sex can become roughly interchangeable activities. The habits of pornography and depersonalized sex build on the genetically programmed attraction of images and activities related to reproduction. They focus attention naturally and pleasurably, and in so doing help to exclude unwanted contents from the mind. What they fail to do is develop any of the attentional habits that might lead to a greater complexity of consciousness.

The same argument holds for what might at first sight seem the opposite of pleasure: masochistic behavior, risk taking, gambling. These ways that people find to hurt or frighten themselves do not require a great deal of skill, but they do help one to achieve the sensation of direct experience. Even pain is better than the chaos that seeps into an unfocused mind. Hurting oneself, whether physically or emotionally, en-

sures that attention can be focused on something that, although painful, is at least controllable—since we are the ones causing it.

The ultimate test for the ability to control the quality of experience is what a person does in solitude, with no external demands to give structure to attention. It is relatively easy to become involved with a job, to enjoy the company of friends, to be entertained in a theater or at a concert. But what happens when we are left to our own devices? Alone, when the dark night of the soul descends, are we forced into frantic attempts to distract the mind from its coming? Or are we able to take on activities that are not only enjoyable, but make the self grow?

To fill free time with activities that require concentration, that increase skills, that lead to a development of the self, is not the same as killing time by watching television or taking recreational drugs. Although both strategies might be seen as different ways of coping with the same threat of chaos, as defenses against ontological anxiety, the former leads to growth, while the latter merely serves to keep the mind from unraveling. A person who rarely gets bored, who does not constantly need a favorable external environment to enjoy the moment, has passed the test for having achieved a creative life.

Learning to use time alone, instead of escaping from it, is especially important in our early years. Teenagers who can't bear solitude disqualify themselves from later carrying out adult tasks that require serious mental preparation. A typical scenario familiar to many parents involves a teenager who comes back from school, drops the books in his bedroom, and after taking a snack from the refrigerator immediately heads for the phone to get in touch with his friends. If there is nothing going on there, he will turn on the stereo or the TV. If by any chance he is tempted to open a book, the resolve is unlikely to last long. To study means to concentrate on difficult patterns of information, and sooner or later even the most disciplined mind drifts away from the relentless templates on the page to pursue more pleasant thoughts. But it is difficult to summon up pleasant thoughts at will. Instead, one's mind typically is besieged by the usual visitors: the shadowy phantoms that intrude on the unstructured mind. The teenager begins to worry about his looks, his popularity, his chances in life. To repel these intrusions he must find something else to occupy his consciousness. Studying won't do, because it is too difficult. The adolescent is ready to do almost anything to take his mind off this situation—provided it does not take too much psychic energy. The usual solution is to turn back to the familiar routine of music, TV, or a friend with whom to while the time away.

With every passing decade our culture becomes more dependent on information technology. To survive in such an environment, a person must become familiar with abstract symbolic languages. A few generations ago someone who did not know how to read and write could still have found a job that provided a good income and reasonable dignity. A farmer, a blacksmith, a small merchant could learn the skills required for his vocation as an apprentice to older experts and do well without mastering a symbolic system. Nowadays even the simplest jobs rely on written instructions, and more complex occupations require specialized knowledge that one must learn the hard way—alone.

Adolescents who never learn to control their consciousness grow up to be adults without a "discipline." They lack the complex skills that will help them survive in a competitive, information-intensive environment. And what is even more important, they never learn how to enjoy living. They do not acquire the habit of finding challenges that bring out hidden potentials for growth.

But the teenage years are not the only time when it is crucial to learn how to exploit the opportunities of solitude. Unfortunately, too many adults feel that once they have hit twenty or thirty—or certainly forty—they are entitled to relax in whatever habitual grooves they have established. They have paid their dues, they have learned the tricks it takes to survive, and from now on they can proceed on cruise control. Equipped with the bare minimum of inner discipline, such people inevitably accumulate entropy with each passing year. Career disappointments, the failure of physical health, the usual slings and arrows of fate build up a mass of negative information that increasingly threatens their peace of mind. How does one keep these problems away? If a person does not know how to control attention in solitude, he will inevitably turn to the easy external solutions: drugs, entertainment, excitement—whatever dulls or distracts the mind.

But such responses are regressive—they do not lead forward. The way to grow while enjoying life is to create a higher form of order out of the entropy that is an inevitable condition of living. This means taking each new challenge not as something to be repressed or avoided, but as an opportunity for learning and for improving skills. When physical vigor fails with age, for example, it means that one will be ready to turn one's energies from the mastery of the external world to a deeper exploration of inner reality. It means that one can finally read Proust, take up chess, grow orchids, help one's neighbors, and think about God—if these are the things one has decided are worth pursuing. But it is difficult to accomplish any of them unless one has earlier acquired the habit of using solitude to good advantage.

It is best to develop this habit early, but it is never too late to do so. In the previous chapters we have reviewed some of the ways the body and the mind can make flow happen. When a person is able to call upon such activities at will, regardless of what is happening externally, then one has learned how to shape the quality of life.

TAMING SOLITUDE

Every rule has its exceptions, and even though most people dread solitude, there are some individuals who live alone by choice. "Whosoever is delighted in solitude," goes the old saying that Francis Bacon repeated, "is either a wild beast or a god." One does not actually have to be a god, but it is true that to enjoy being alone a person must build his own mental routines, so that he can achieve flow without the supports of civilized life—without other people, without jobs, TV, theaters, restaurants, or libraries to help channel his attention. One interesting example of this type of person is a woman named Dorothy, who lives on a tiny island in the lonely region of lakes and forests of northern Minnesota, along the Canadian border. Originally a nurse in a large city, Dorothy moved to the wilderness after her husband died and their children grew up. During the three summer months fishermen canoeing across her lake stop at the island to have a chat, but during the long winters she is completely alone for months on end. Dorothy has had to hang heavy drapes on the windows of her cabin, because it used to unnerve her to see packs of wolves, their noses flattened against the windowpanes, looking at her longingly when she woke up in the mornings.

Like other people who live alone in the wilderness, Dorothy has tried to personalize her surroundings to an uncommon degree. There are flower tubs, garden gnomes, discarded tools all over the grounds. Most trees have signs nailed to them, filled with doggerel rhymes, corny jokes, or hoary cartoons pointing to the sheds and outhouses. To an urban visitor, the island is the epitome of kitsch. But as extensions of Dorothy's taste, this "junk" creates a familiar environment where her mind can be at ease. In the midst of untamed nature, she has introduced her own idiosyncratic style, her own civilization. Inside, her favorite objects recall Dorothy's goals. She has stamped her preferences on chaos.

More important than structuring space, perhaps, is structuring time. Dorothy has strict routines for every day of the year: up by five, check the hens for eggs, milk the goat, split some wood, make breakfast, wash, sew, fish, and so on. Like the colonial Englishmen who shaved and

dressed impeccably every evening in their lonely outposts, Dorothy also has learned that to keep control in an alien environment one must impose one's own order on the wilderness. The long evenings are taken up by reading and writing. Books on every imaginable subject line the walls of her two cabins. Then there are the occasional trips for supplies, and in the summer some variety is introduced by the visits of fishermen passing through. Dorothy seems to like people, but she likes being in control of her own world even more.

One can survive solitude, but only if one finds ways of ordering attention that will prevent entropy from destructuring the mind. Susan Butcher, the dog breeder and trainer who races sleds in the Arctic for up to eleven days on end while trying to elude the attacks of rogue moose and wolves, moved years ago from Massachusetts to live in a cabin twenty-five miles from the nearest village of Manley, Alaska (population sixty-two). Before her marriage, she lived alone with her hundred and fifty huskies. She doesn't have the time to feel lonely: hunting for food and caring for her dogs, who require her attention sixteen hours a day, seven days a week, prevent that. She knows each dog by name, and the name of each dog's parents and grandparents. She knows their temperaments, preferences, eating habits, and current health. Susan claims she would rather live this way than do anything else. The routines she has built demand that her consciousness be focused on manageable tasks all of the time—thereby making life a continuous flow experience.

A friend who likes to cross oceans alone on a sailboat once told an anecdote that illustrates the lengths to which solitary cruisers sometimes have to go in order to keep their minds focused. Approaching the Azores on an eastward crossing of the Atlantic, about eight hundred miles short of the Portuguese coast, and after many days without sighting a sail, he saw another small craft heading the opposite way. It was a welcome opportunity to visit with a fellow cruiser, and the two boats set course to meet in the open sea, side by side. The man in the other boat had been scrubbing his deck, which was partly covered by a foul-smelling, sticky yellow substance. "How did you get your boat so dirty?" asked my friend to break the ice. "Well, you see," shrugged the other, "it's just a mess of rotten eggs." My friend admitted that it wasn't obvious to him how so many rotten eggs happened to get smeared over a boat in the middle of the ocean. "Well," said the man, "the fridge gave out, and the eggs spoiled. There hasn't been any wind for days, and I was getting really bored. So I thought that instead of tossing the eggs overboard, I would break them over the deck, so that I would get to clean them off afterward. I let them set for a while so it would be harder to clean them off, but I didn't figure on them smelling so bad." In

ordinary circumstances, solo sailors have plenty to keep their minds occupied. Their survival depends on being ever alert to the conditions of the boat and of the sea. It is this constant concentration on a workable goal that makes sailing so enjoyable. But when the doldrums set in, they might have to go to heroic lengths to find any challenge at all.

Is coping with loneliness by letting unnecessary yet demanding rituals give shape to the mind any different from taking drugs or watching TV constantly? It could be argued that Dorothy and the other hermits are escaping from "reality" just as effectively as addicts are. In both cases, psychic entropy is avoided by taking the mind off unpleasant thoughts and feelings. Yet *how* one copes with solitude makes all the difference. If being alone is seen as a chance to accomplish goals that cannot be reached in the company of others, then instead of feeling lonely, a person will enjoy solitude and might be able to learn new skills in the process. On the other hand, if solitude is seen as a condition to be avoided at all costs instead of as a challenge, the person will panic and resort to distractions that cannot lead to higher levels of complexity. Breeding furry dogs and racing sleds through arctic forests might seem like a rather primitive endeavor, compared to the glamorous antics of playboys or cocaine users. Yet in terms of psychic organization the former is infinitely more complex than the latter. Life-styles built on pleasure survive only in symbiosis with complex cultures based on hard work and enjoyment. But when the culture is no longer able or willing to support unproductive hedonists, those addicted to pleasure, lacking skills and discipline and therefore unable to fend for themselves, find themselves lost and helpless.

This is not to imply that the only way to achieve control over consciousness is to move to Alaska and hunt moose. A person can master flow activities in almost any environment. A few will need to live in the wilderness, or to spend long periods of time alone at sea. Most people will prefer to be surrounded by the reassuring hustle and bustle of human interaction. However, solitude is a problem that must be confronted whether one lives in southern Manhattan or the northern reaches of Alaska. Unless a person learns to enjoy it, much of life will be spent desperately trying to avoid its ill effects.

FLOW AND THE FAMILY

Some of the most intense and meaningful experiences in people's lives are the result of family relationships. Many successful men and women would second Lee Iacocca's statement: "I've had a wonderful and successful career. But next to my family, it really hasn't mattered at all."

Throughout history, people have been born into and have spent their entire lives in kinship groups. Families have varied greatly in size and composition, but everywhere individuals feel a special intimacy toward relatives, with whom they interact more often than with people outside the family. Sociobiologists claim that this familial loyalty is proportional to the amount of genes that any two persons share: for instance, a brother and a sister will have half their genes in common, while two cousins only half as many again. In this scenario siblings will, on the average, help each other out twice as much as cousins. Thus the special feelings we have for our relatives are simply a mechanism designed to ensure that the genes' own kind will be preserved and replicated.

There are certainly strong biological reasons for our having a particular attachment to relatives. No slowly maturing mammalian species could have survived without some built-in mechanism that made most adults feel responsible for their young, and the young feel dependent on the old; for that reason the bond of the newborn human infant to its caretakers, and vice versa, is especially strong. But the actual kinds of relationships families have supported have been astonishingly diverse in various cultures, and at various times.

For instance, whether marriage is polygamous or monogamous, or whether it is patrilineal or matrilineal, has a rather strong influence on the kind of daily experiences husbands, wives, and children have with one another. So do less obvious features of family structure, such as specific patterns of inheritance. The many small principalities into which Germany had been divided until about a century ago each had laws of inheritance that were based either on primogeniture, where the oldest son was left the entire family estate, or on an equal division of the estate among all sons. Which of these methods for transmitting property was adopted seems to have been due almost entirely to chance, yet the choice had profound economic implications. (Primogeniture led to concentration of capital in the lands that used this method, which in turn led to industrialization; whereas equal sharing led to the fragmentation of property and industrial underdevelopment.) More pertinent to our story, the relationship between siblings in a culture that had adopted primogeniture must have been substantially different from one in which equal economic benefits accrued to all children. The feelings brothers and sisters had for one another, what they expected from one another, their reciprocal rights and responsibilities, were to a large extent "built into" the peculiar form of the family system. As this example demonstrates, while genetic programming may predispose us to

attachment to family members, the cultural context will have a great deal to do with the strength and direction of that attachment.

Because the family is our first and in many ways our most important social environment, quality of life depends to a large extent on how well a person succeeds in making the interaction with his or her relatives enjoyable. For no matter how strong the ties biology and culture have forged between family members, it is no secret that there is great variety in how people feel about their relatives. Some families are warm and supportive, some are challenging and demanding, others threaten the self of their members at every turn, still others are just insufferably boring. The frequency of murder is much higher among family members than among unrelated people. Child abuse and incestuous sexual molestation, once thought to be rare deviations from the norm, apparently occur much more often than anyone had previously suspected. In John Fletcher's words, "Those have most power to hurt us that we love." It is clear that the family can make one very happy, or be an unbearable burden. Which one it will be depends, to a great extent, on how much psychic energy family members invest in the mutual relationship, and especially in each other's goals.

Every relationship requires a reorienting of attention, a repositioning of goals. When two people begin to go out together, they must accept certain constraints that each person alone did not have: schedules have to be coordinated, plans modified. Even something as simple as a dinner date imposes compromises as to time, place, type of food, and so on. To some degree the couple will have to respond with similar emotions to the stimuli they encounter—the relationship will probably not last long if the man loves a movie that the woman hates, and vice versa. When two people choose to focus their attention on each other, both will have to change their habits; as a result, the pattern of their consciousness will also have to change. Getting married requires a radical and permanent reorientation of attentional habits. When a child is added to the pair, both parents have to readapt again to accommodate the needs of the infant: their sleep cycle must change, they will go out less often, the wife may give up her job, they may have to start saving for the child's education.

All this can be very hard work, and it can also be very frustrating. If a person is unwilling to adjust personal goals when starting a relationship, then a lot of what subsequently happens in that relationship will produce disorder in the person's consciousness, because novel patterns of interaction will conflict with old patterns of expectation. A bachelor may have, on his list of priorities, to drive a sleek sports car and to spend

a few weeks each winter in the Caribbean. Later he decides to marry and have a child. As he realizes these latter goals, however, he discovers that they are incompatible with the prior ones. He can't afford a Maserati any longer, and the Bahamas are out of reach. Unless he revises the old goals, they will be frustrated, producing that sense of inner conflict known as psychic entropy. And if he changes goals, his self will change as a consequence—the self being the sum and organization of goals. In this manner entering any relationship entails a transformation of the self.

Until a few decades ago, families tended to stay together because parents and children were forced to continue the relationship for extrinsic reasons. If divorces were rare in the past, it wasn't because husbands and wives loved each other more in the old times, but because husbands needed someone to cook and keep house, wives needed someone to bring home the bacon, and children needed both parents in order to eat, sleep, and get a start in the world. The "family values" that the elders spent so much effort inculcating in the young were a reflection of this simple necessity, even when it was cloaked in religious and moral considerations. Of course, once family values were taught as being important, people learned to take them seriously, and they helped keep families from disintegrating. All too often, however, the moral rules were seen as an outside imposition, an external constraint under which husbands, wives, and children chafed. In such cases the family may have remained intact physically, but it was internally riven with conflicts and hatred. The current "disintegration" of the family is the result of the slow disappearance of external reasons for staying married. The increase in the divorce rate is probably more affected by changes in the labor market that have increased women's employment opportunities, and by the diffusion of labor-saving home appliances, than it is by a lessening of love or of moral fiber.

But extrinsic reasons are not the only ones for staying married and for living together in families. There are great opportunities for joy and for growth that can only be experienced in family life, and these intrinsic rewards are no less present now than they were in the past; in fact, they are probably much more readily available today than they have been at any previous time. If the trend of traditional families keeping together mainly as a convenience is on the wane, the number of families that endure because their members enjoy each other may be increasing. Of course, because external forces are still much more powerful than internal ones, the net effect is likely to be a further fragmentation of family life for some time to come. But the families that do persevere will be in

a better position to help their members develop a rich self than families held together against their will are able to do.

There have been endless discussions about whether humans are naturally promiscuous, polygamous, or monogamous; and whether in terms of cultural evolution monogamy is the highest form of family organization. It is important to realize that these questions deal only with the extrinsic conditions shaping marriage relationships. And on that count, the bottom line seems to be that marriages will take the form that most efficiently ensures survival. Even members of the same animal species will vary their patterns of relationship so as to adapt best in a given environment. For instance the male long-billed marsh wren (*Cistothorus palustris*) is polygamous in Washington, where swamps vary in quality and females are attracted to those few males who have rich territories, leaving the less lucky ones to a life of enforced bachelorhood. The same wrens are monogamous in Georgia, not so much because that state is part of the Bible Belt, but because the marshes all have roughly the same amount of food and cover, and so each male can attract a doting spouse to an equally comfortable nesting site.

The form the human family takes is a response to similar kinds of environmental pressures. In terms of extrinsic reasons, we are monogamous because in technological societies based on a money economy, time has proven this to be a more convenient arrangement. But the issue we have to confront as individuals is not whether humans are "naturally" monogamous or not, but whether we *want* to be monogamous or not. And in answering that question, we need to weigh all the consequences of our choice.

It is customary to think of marriage as the end of freedom, and some refer to their spouses as "old ball-and-chain." The notion of family life typically implies constraints, responsibilities that interfere with one's goals and freedom of action. While this is true, especially when the marriage is one of convenience, what we tend to forget is that these rules and obligations are no different, in principle, than those rules that constrain behavior in a game. Like all rules, they exclude a wide range of possibilities so that we might concentrate fully on a selected set of options.

Cicero once wrote that to be completely free one must become a slave to a set of laws. In other words, accepting limitations is liberating. For example, by making up one's mind to invest psychic energy exclusively in a monogamous marriage, regardless of any problems, obstacles, or more attractive options that may come along later, one is freed of the constant pressure of trying to maximize emotional returns. Having made

the commitment that an old-fashioned marriage demands, and having made it willingly instead of being compelled by tradition, a person no longer needs to worry whether she has made the right choice, or whether the grass might be greener somewhere else. As a result a great deal of energy gets freed up for living, instead of being spent on wondering about how to live.

If one decides to accept the traditional form of the family, complete with a monogamous marriage, and with a close involvement with children, with relatives, and with the community, it is important to consider beforehand how family life can be turned into a flow activity. Because if it is not, boredom and frustration will inevitably set in, and then the relationship is likely to break up unless there are strong external factors keeping it together.

To provide flow, a family has to have a goal for its existence. Extrinsic reasons are not sufficient: it is not enough to feel that, well, "Everybody else is married," "It is natural to have children," or "Two can live as cheaply as one." These attitudes may encourage one to start a family, and may even be strong enough to keep it going, but they cannot make family life enjoyable. Positive goals are necessary to focus the psychic energies of parents and children on common tasks.

Some of these goals might be very general and long-term, such as planning a particular life-style—to build an ideal home, to provide the best possible education for the children, or to implement a religious way of living in a modern secularized society. For such goals to result in interactions that will help increase the complexity of its members, the family must be both *differentiated* and *integrated*. Differentiation means that each person is encouraged to develop his or her unique traits, maximize personal skills, set individual goals. Integration, in contrast, guarantees that what happens to one person will affect all others. If a child is proud of what she accomplished in school, the rest of the family will pay attention and will be proud of her, too. If the mother is tired and depressed, the family will try to help and cheer her up. In an integrated family, each person's goals matter to all others.

In addition to long-term goals, it is imperative to have a constant supply of short-term objectives. These may include simple tasks like buying a new sofa, going on a picnic, planning for a vacation, or playing a game of Scrabble together on Sunday afternoon. Unless there are goals that the whole family is willing to share, it is almost impossible for its members to be physically together, let alone involved in an enjoyable joint activity. Here again, differentiation and integration are important: the common goals should reflect the goals of individual members as

much as possible. If Rick wants to go to a motocross race, and Erica would like to go to the aquarium, it should be possible for everyone to watch the race one weekend, and then visit the aquarium the next. The beauty of such an arrangement is that Erica is likely to enjoy some of the aspects of bike racing, and Rick might actually get to appreciate looking at fish, even though neither would have discovered as much if left to his or her own prejudices.

As with any other flow activity, family activities should also provide clear feedback. In this case, it is simply a matter of keeping open channels of communication. If a husband does not know what bothers his wife, and vice versa, neither has the opportunity to reduce the inevitable tensions that will arise. In this context it is worth stressing that entropy is the basic condition of group life, just as it is of personal experience. Unless the partners invest psychic energy in the relationship, conflicts are inevitable, simply because each individual has goals that are to a certain extent divergent from those of all other members of the family. Without good lines of communication the distortions will become amplified, until the relationship falls apart.

Feedback is also crucial to determine whether family goals are being achieved. My wife and I used to think that taking our children to the zoo on a Sunday every few months was a splendid educational activity, and one that we could all enjoy. But when our oldest child turned ten, we stopped going because he had become seriously distressed with the idea of animals being confined in restricted spaces. It is a fact of life that sooner or later all children will express the opinion that common family activities are "dumb." At this point, forcing them to do things together tends to be counterproductive. So most parents just give up, and abandon their teenagers to the peer culture. The more fruitful, if more difficult, strategy is to find a new set of activities that will continue to keep the family group involved.

The balancing of challenges and skills is another factor as necessary in enjoying social relationships in general, and family life in particular, as it is for any other flow activity. When a man and a woman are first attracted to each other, the opportunities for action are usually clear enough. Ever since the dawn of time, the most basic challenge for the swain has been "Can I make her?" and for the maid, "Can I catch him?" Usually, and depending on the partners' level of skill, a host of more complex challenges are also perceived: to find out what sort of a person the other really is, what movies she likes, what he thinks about South Africa, and whether the encounter is likely to develop into a "meaningful relationship." Then there are fun things to do together, places to

visit, parties to go to and talk about afterward, and so on.

With time one gets to know the other person well, and the obvious challenges have been exhausted. All the usual gambits have been tried; the other person's reactions have become predictable. Sexual play has lost its first excitement. At this point, the relationship is in danger of becoming a boring routine that might be kept alive by mutual convenience, but is unlikely to provide further enjoyment, or spark a new growth in complexity. The only way to restore flow to the relationship is by finding new challenges in it.

These might involve steps as simple as varying the routines of eating, sleeping, or shopping. They might involve making an effort to talk together about new topics of conversation, visiting new places, making new friends. More than anything else they involve paying attention to the partner's own complexity, getting to know her at deeper levels than were necessary in the earlier days of the relationship, supporting him with sympathy and compassion during the inevitable changes that the years bring. A complex relationship sooner or later faces the big question: whether the two partners are ready to make a lifelong commitment. At that point, a whole new set of challenges presents itself: raising a family together, getting involved in broader community affairs when the children have grown up, working alongside one another. Of course, these things cannot happen without extensive inputs of energy and time; but the payoff in terms of the quality of experience is usually more than worth it.

The same need to constantly increase challenges and skills applies to one's relationship with children. During the course of infancy and early childhood most parents spontaneously enjoy the unfolding of their babies' growth: the first smile, the first word, the first few steps, the first scribbles. Each of these quantum jumps in the child's skills becomes a new joyful challenge, to which parents respond by enriching the child's opportunities to act. From the cradle to the playpen to the playground to kindergarten, the parents keep adjusting the balance of challenges and skills between the child and her environment. But by early adolescence, many teenagers get to be too much to handle. What most parents do at that point is to politely ignore their children's lives, pretending that everything is all right, hoping against hope that it will be.

Teenagers are physiologically mature beings, ripe for sexual reproduction; in most societies (and in ours too, a century or so ago) they are considered ready for adult responsibilities and appropriate recognition. Because our present social arrangements, however, do not provide adequate challenges for the skills teenagers have, they must discover oppor-

tunities for action outside those sanctioned by adults. The only outlets they find, all too often, are vandalism, delinquency, drugs, and recreational sex. Under existing conditions, it is very difficult for parents to compensate for the poverty of opportunities in the culture at large. In this respect, families living in the richest suburbs are barely better off than families living in the slums. What can a strong, vital, intelligent fifteen-year-old do in your typical suburb? If you consider that question you will probably conclude that what is available is either too artificial, or too simple, or not exciting enough to catch a teenager's imagination. It is not surprising that athletics are so important in suburban schools; compared to the alternatives, they provide some of the most concrete chances to exercise and display one's skills.

But there are some steps that families can take to partially alleviate this wasteland of opportunities. In older times, young men left home for a while as apprentices and traveled to distant towns to be exposed to new challenges. Today something similar exists in America for late teens: the custom of leaving home for college. The problem remains with the period of puberty, roughly the five years between twelve and seventeen: What meaningful challenges can be found for young people that age? The situation is much easier when the parents themselves are involved in understandable and complex activities at home. If the parents enjoy playing music, cooking, reading, gardening, carpentry, or fixing engines in the garage, then it is more likely that their children will find similar activities challenging, and invest enough attention in them to begin enjoy doing something that will help them grow. If parents just talked more about their ideals and dreams—even if these had been frustrated—the children might develop the ambition needed to break through the complacency of their present selves. If nothing else, discussing one's job or the thoughts and events of the day, and treating children as young adults, as friends, help to socialize them into thoughtful adults. But if the father spends all his free time at home vegetating in front of the TV set with a glass of alcohol in his hand, children will naturally assume that adults are boring people who don't know how to have fun, and will turn to the peer group for enjoyment.

In poorer communities youth gangs provide plenty of real challenges for boys. Fights, acts of bravado, and ritual displays such as motorcycle gang parades match the youths' skills with concrete opportunities. In affluent suburbs not even this arena for action is available to teenagers. Most activities, including school, recreation, and employment, are under adult control and leave little room for the youths' initiative. Lacking any meaningful outlet for their skills and creativity,

they may turn to redundant partying, joyriding, malicious gossiping, or drugs and narcissistic introspection to prove to themselves that they are alive. Consciously or not, many young girls feel that becoming pregnant is the only really adult thing they can do, despite its dangers and unpleasant consequences. How to restructure such an environment so as to make it sufficiently challenging is certainly one of the most pressing tasks parents of teenagers face. And it is of no value simply to tell one's strapping adolescent children to shape up and do something useful. What does help are living examples and concrete opportunities. If these are not available, one cannot blame the young for taking their own counsel.

Some of the tensions of teenage life can be eased if the family provides a sense of acceptance, control, and self-confidence to the adolescent. A relationship that has these dimensions is one in which people trust one another, and feel totally accepted. One does not have to worry constantly about being liked, being popular, or living up to others' expectations. As the popular sayings go, "Love means never having to say 'I'm sorry,'" "Home is where you're always welcome." Being assured of one's worth in the eyes of one's kin gives a person the strength to take chances; excessive conformity is usually caused by fear of disapproval. It is much easier for a person to try developing her potential if she knows that no matter what happens, she has a safe emotional base in the family.

Unconditional acceptance is especially important to children. If parents threaten to withdraw their love from a child when he fails to measure up, the child's natural playfulness will be gradually replaced by chronic anxiety. However, if the child feels that his parents are unconditionally committed to his welfare, he can then relax and explore the world without fear; otherwise he has to allocate psychic energy to his own protection, thereby reducing the amount he can freely dispose of. Early emotional security may well be one of the conditions that helps develop an autotelic personality in children. Without this, it is difficult to let go of the self long enough to experience flow.

Love without strings attached does not mean, of course, that relationships should have no standards, no punishment for breaking the rules. When there is no risk attached to transgressing rules they become meaningless, and without meaningful rules an activity cannot be enjoyable. Children must know that parents expect certain things from them, and that specific consequences will follow if they don't obey. But they must also recognize that no matter what happens, the parents' concern for them is not in question.

When a family has a common purpose and open channels of communication, when it provides gradually expanding opportunities for action in a setting of trust, then life in it becomes an enjoyable flow activity. Its members will spontaneously focus their attention on the group relationship, and to a certain extent forget their individual selves, their divergent goals, for the sake of experiencing the joy of belonging to a more complex system that joins separate consciousnesses in a unified goal.

One of the most basic delusions of our time is that home life takes care of itself naturally, and that the best strategy for dealing with it is to relax and let it take its course. Men especially like to comfort themselves with this notion. They know how hard it is to succeed on the job, how much effort they have to put into their careers. So at home they just want to unwind, and feel that any serious demand from the family is unwarranted. They often have an almost superstitious faith in the integrity of the home. Only when it is too late—when the wife has become dependent on alcohol, when the children have turned into cold strangers—do many men wake up to the fact that the family, like any other joint enterprise, needs constant investments of psychic energy to assure its existence.

To play the trumpet well, a musician cannot let more than a few days pass without practicing. An athlete who does not run regularly will soon be out of shape, and will no longer enjoy running. Any manager knows that his company will start falling apart if his attention wanders. In each case, without concentration, a complex activity breaks down into chaos. Why should the family be different? Unconditional acceptance, the complete trust family members ought to have for one another, is meaningful only when it is accompanied by an unstinting investment of attention. Otherwise it is just an empty gesture, a hypocritical pretense indistinguishable from disinterest.

ENJOYING FRIENDS

"The worst solitude," wrote Sir Francis Bacon, "is to be destitute of sincere friendship." Compared to familial relationships, friendships are much easier to enjoy. We can choose our friends, and usually do so, on the basis of common interests and complementary goals. We need not change ourselves to be with friends; they reinforce our sense of self instead of trying to transform it. While at home there are many boring things we have to accept, like taking out the garbage and raking up leaves, with friends we can concentrate on things that are "fun."

It is not surprising that in our studies of the quality of daily experience it has been demonstrated again and again that people report the most positive moods overall when they are with friends. This is not only true of teenagers: young adults also are happier with friends than with anyone else, including their spouses. Even retirees are happier when they are with friends than when they are with their spouses or families.

Because a friendship usually involves common goals and common activities, it is "naturally" enjoyable. But like any other activity, this relationship can take a variety of forms, ranging from the destructive to the highly complex. When a friendship is primarily a way of validating one's own insecure sense of self, it will give pleasure, but it will not be enjoyable in our sense—that of fostering growth. For instance, the institution of "drinking buddies," so prevalent in small communities all over the world, is a pleasant way for adult males to get together with men they have known all their lives. In the congenial atmosphere of tavern, pub, *osteria,* beer hall, tearoom, or coffee shop, they grind the day away playing cards, darts, or checkers while arguing and teasing one another. Meanwhile everyone feels his existence validated by the reciprocal attention paid to one another's ideas and idiosyncrasies. This type of interaction keeps at bay the disorganization that solitude brings to the passive mind, but without stimulating much growth. It is rather like a collective form of television watching, and although it is more complex in that it requires participation, its actions and phrases tend to be rigidly scripted and highly predictable.

Socializing of this kind mimics friendship relations, but it provides few of the benefits of the real thing. Everyone takes pleasure in occasionally passing the time of day chatting, but many people become extremely dependent on a daily "fix" of superficial contacts. This is especially true for individuals who cannot tolerate solitude, and who have little emotional support at home.

Teenagers without strong family ties can become so dependent on their peer group that they will do anything to be accepted by it. About twenty years ago in Tucson, Arizona, the entire senior class of a large high school knew for several months that an older dropout from the school, who had kept up a "friendship" with the younger students, had been killing their classmates, and burying their corpses in the desert. Yet none of them reported the crimes to the authorities, who discovered them by chance. The students, all nice middle-class suburban kids, claimed that they could not divulge the murders for fear of being cut by their friends. If those Tucson teenagers had had warm family ties, or

strong links to other adults in the community, ostracization by their peers would not have been so intolerable. But apparently only the peer group stood between them and solitude. Unfortunately, this is not an unusual story; now and then one very much like it appears in the media.

If the young person feels accepted and cared for at home, however, dependence on the group is lessened, and the teenager can learn to be in control of his relationships with peers. Christopher, who at fifteen was a rather shy, quiet boy with glasses and few friends, felt close enough to his parents to explain that he was tired of being left out of the cliques in school, and had decided to become more popular. To do so, Chris outlined a carefully planned strategy: he was to buy contact lenses, wear only fashionable (i.e., funky) clothes, learn about the latest music and teenage fads, and highlight his hair with a blond dye. "I want to see if I can change my personality," he said, and spent many days in front of the mirror practicing a laid-back demeanor and a goofy smile.

This methodical approach, supported by his parents' collusion, worked well. By the end of the year he was being invited into the best cliques, and the following year he won the part of Conrad Birdie in the school musical. Because he identified with the part of the rock star so well, he became the heartthrob of middle-school girls, who taped his picture inside their lockers. The senior yearbook showed him involved in all sorts of successful ventures, such as winning a prize in the "Sexy Legs" contest. He had indeed succeeded in changing his outward personality, and achieved control of the way his peers saw him. At the same time, the inner organization of his self remained the same: he continued to be a sensitive, generous young man who did not think less of his peers because he learned to manage their opinions or think too highly of himself for having succeeded at it.

One of the reasons Chris was able to become popular while many others do not is that he approached his goal with the same detached discipline that an athlete would use to make the football team, or a scientist would apply to an experiment. He was not overwhelmed by the task, but chose realistic challenges he could master on his own. In other words, he transformed the daunting, vague monster of popularity into a feasible flow activity that he ended up enjoying while it gave him a sense of pride and self-esteem. The company of peers, like every other activity, can be experienced at various levels: at the lowest level of complexity it is a pleasurable way to ward off chaos temporarily; at the highest it provides a strong sense of enjoyment and growth.

It is in the context of intimate friendships, however, that the most intense experiences occur. These are the kinds of ties about which

Aristotle wrote, "For without friends no one would choose to live, though he had all other goods." To enjoy such one-to-one relationships requires the same conditions that are present in other flow activities. It is necessary not only to have common goals and to provide reciprocal feedback, which even interactions in taverns or at cocktail parties provide, but also to find new challenges in each other's company. These may amount simply to learning more and more about the friend, discovering new facets of his or her unique individuality, and disclosing more of one's own individuality in the process. There are few things as enjoyable as freely sharing one's most secret feelings and thoughts with another person. Even though this sounds like a commonplace, it in fact requires concentrated attention, openness, and sensitivity. In practice, this degree of investment of psychic energy in a friendship is unfortunately rare. Few are willing to commit the energy or the time for it.

Friendships allow us to express parts of our beings that we seldom have the opportunity to act out otherwise. One way to describe the skills that every man and woman has is to divide them in two classes: the *instrumental* and the *expressive*. Instrumental skills are the ones we learn so that we can cope effectively with the environment. They are basic survival tools, like the cunning of the hunter or the craft of the workman, or intellectual tools, like reading and writing and the specialized knowledge of the professional in our technological society. People who have not learned to find flow in most of the things they undertake generally experience instrumental tasks as extrinsic—because they do not reflect their own choices, but are requirements imposed from the outside. Expressive skills, on the other hand, refer to actions that attempt to externalize our subjective experiences. Singing a song that reflects how we feel, translating our moods into a dance, painting a picture that represents our feelings, telling a joke we like, and going bowling if that is what makes us feel good are forms of expression in this sense. When involved in an expressive activity we feel in touch with our real self. A person who lives only by instrumental actions without experiencing the spontaneous flow of expressivity eventually becomes indistinguishable from a robot who has been programmed by aliens to mimic human behavior.

In the course of normal life there are few opportunities to experience the feeling of wholeness expressivity provides. At work one must behave according to the expectations for one's role, and be a competent mechanic, a sober judge, a deferent waiter. At home one has to be a caring mother or a respectful son. And in between, on the bus or the subway, one has to turn an impassive face to the world. It is only with

friends that most people feel they can let their hair down and be themselves. Because we choose friends who share our ultimate goals, these are the people with whom we can sing, dance, share jokes, or go bowling. It is in the company of friends that we can most clearly experience the freedom of the self and learn who we really are. The ideal of a modern marriage is to have one's spouse as a friend. In previous times, when marriages were arranged for the mutual convenience of families, this was considered an impossibility. But now that there are fewer extrinsic pressures to get married, many people claim that their best friend is their spouse.

Friendship is not enjoyable unless we take up its expressive challenges. If a person surrounds himself with "friends" who simply reaffirm his public persona, who never question his dreams and desires, who never force him to try out new ways of being, he misses out on the opportunities friendship presents. A true friend is someone we can occasionally be crazy with, someone who does not expect us to be always true to form. It is someone who shares our goal of self-realization, and therefore is willing to share the risks that any increase in complexity entails.

While families provide primarily emotional protection, friendships usually involve mysterious novelty. When people are asked about their warmest memories, they usually remember holidays and vacations spent with relatives. Friends are mentioned more often in contexts of excitement, discovery, and adventure.

Unfortunately, few people nowadays are able to maintain friendships into adulthood. We are too mobile, too specialized and narrow in our professional interests to cultivate enduring relationships. We are lucky if we can hold a family together, let alone maintain a circle of friends. It is a constant surprise to hear successful adults, especially men—managers of large companies, brilliant lawyers and doctors—speak about how isolated and lonely their lives have become. They recall with tears in their eyes the good buddies they used to have in middle school, even in high school, sometimes in college. All those friends have been left behind, and even should they now meet again, they would probably have very little in common, other than a few bittersweet memories.

Just as with the family, people believe that friendships happen naturally, and if they fail, there is nothing to be done about it but feel sorry for oneself. In adolescence, when so many interests are shared with others and one has great stretches of free time to invest in a relationship, making friends might seem like a spontaneous process. But later in life

friendships rarely happen by chance: one must cultivate them as assiduously as one must cultivate a job or a family.

THE WIDER COMMUNITY

A person is part of a family or a friendship to the extent he invests psychic energy in goals shared with other people. In the same way, one can belong to larger interpersonal systems by subscribing to the aspirations of a community, an ethnic group, a political party, or a nation. Some individuals, like the Mahatma Gandhi or Mother Teresa, invest all their psychic energy in what they construe to be the goals of humanity as a whole.

In the ancient Greek usage, "politics" referred to whatever involved people in affairs that went beyond personal and family welfare. In this broad sense, politics can be one of the most enjoyable and most complex activities available to the individual, for the larger the social arena one moves in, the greater the challenges it presents. A person can deal with very intricate problems in solitude, and family and friends can take up a lot of attention. But trying to optimize the goals of unrelated individuals involves complexities an order of magnitude higher.

Unfortunately, many people who move in the public arena do not act at very high levels of complexity. Politicians tend to seek power, philanthropists fame, and would-be saints often seek to prove how righteous they are. These goals are not so hard to achieve, provided one invests enough energy in them. The greater challenge is not only to benefit oneself, but to help others in the process. It is more difficult, but much more fulfilling, for the politician to actually improve social conditions, for the philanthropist to help out the destitute, and for the saint to provide a viable model of life to others.

If we consider only material consequences, we might regard selfish politicians as canny because they try to achieve wealth and power for themselves. But if we accept the fact that optimal experience is what gives real value to life, then we must conclude that politicians who strive to realize the common good are actually smarter, because they are taking on the higher challenges, and thus have a better chance to experience real enjoyment.

Any involvement in the public realm can be enjoyable, provided one structures it according to the flow parameters. It does not matter whether one starts to work with the Cub Scouts or with a group exploring the Great Books, or trying to preserve a clean environment, or supporting the local union. What counts is to set a goal, to concentrate one's psychic energy, to pay attention to the feedback, and to make

certain that the challenge is appropriate to one's skill. Sooner or later the interaction will begin to hum, and the flow experience follows.

Of course, given the fact that psychic energy is in limited supply, one cannot expect that everyone will be able to become involved in public goals. Some people have to devote all their attention just to survive in a hostile environment. Others get so involved with a certain set of challenges—with art, for instance, or mathematics—that they can't bear to shift any attention away from it. But life would be harsh indeed if some people did not enjoy investing psychic energy in common concerns, thereby creating synergy in the social system.

The concept of flow is useful not only in helping individuals improve the quality of their lives, but also in pointing out how public action should be directed. Perhaps the most powerful effect flow theory could have in the public sector is in providing a blueprint for how institutions may be reformed so as to make them more conducive to optimal experience. In the past few centuries economic rationality has been so successful that we have come to take for granted that the "bottom line" of any human effort is to be measured in dollars and cents. But an exclusively economic approach to life is profoundly irrational; the true bottom line consists in the quality and complexity of experience.

A community should be judged good not because it is technologically advanced, or swimming in material riches; it is good if it offers people a chance to enjoy as many aspects of their lives as possible, while allowing them to develop their potential in the pursuit of ever greater challenges. Similarly the value of a school does not depend on its prestige, or its ability to train students to face up to the necessities of life, but rather on the degree of the enjoyment of lifelong learning it can transmit. A good factory is not necessarily the one that makes the most money, but the one that is most responsible for improving the quality of life for its workers and its customers. And the true function of politics is not to make people more affluent, safe, or powerful, but to let as many as possible enjoy an increasingly complex existence.

But no social change can come about until the consciousness of individuals is changed first. When a young man asked Carlyle how he should go about reforming the world, Carlyle answered, "Reform yourself. That way there will be one less rascal in the world." The advice is still valid. Those who try to make life better for everyone without having learned to control their own lives first usually end up making things worse all around.

CHEATING
CHAOS

DESPITE EVERYTHING that has been said so far, some people may still think
that it must be easy to be happy as long as one is lucky enough to be
healthy, rich, and handsome. But how can the quality of life be im-
proved when things are not going our way, when fortune deals us an
unfair hand? One can afford to ponder the difference between enjoy-
ment and pleasure if one doesn't have to worry about running out of
money before the end of the month. For most people, such distinctions
are too much of a luxury to be indulged in. It is okay to think of
challenges and complexity if you have an interesting, well-paying profes-
sion, but why try to improve a job that is basically dumb and dehumaniz-
ing? And how can we expect people who are ill, impoverished, or
stricken by adversity to control their consciousness? Surely they would
need to improve concrete material conditions before flow could add
anything appreciable to the quality of existence. Optimal experience, in
other words, should be regarded as the frosting on a cake made with
solid ingredients like health and wealth; by itself it is a flimsy decoration.
Only with a solid base of these more real advantages does it help make
the subjective aspects of life satisfying.

Needless to say, the whole thesis of this book argues against such
a conclusion. Subjective experience is not just one of the dimensions of
life, it is life itself. Material conditions are secondary: they only affect us
indirectly, by way of experience. Flow, and even pleasure, on the other

hand, benefit the quality of life directly. Health, money, and other material advantages may or may not improve life. Unless a person has learned to control psychic energy, chances are such advantages will be useless.

Conversely, many individuals who have suffered harshly end up not only surviving, but also thoroughly enjoying their lives. How is it possible that people are able to achieve harmony of mind, and grow in complexity, even when some of the worst things imaginable happen to them? That is the outwardly simple question this chapter will explore. In the process, we shall examine some of the strategies people use to cope with stressful events, and review how an autotelic self can manage to create order out of chaos.

TRAGEDIES TRANSFORMED

It would be naively idealistic to claim that no matter what happens to him, a person in control of consciousness will be happy. There are certainly limits to how much pain, or hunger, or deprivation a body can endure. Yet it is also true, as Dr. Franz Alexander has so well stated: "The fact that the mind rules the body is, in spite of its neglect by biology and medicine, the most fundamental fact which we know about the process of life." Holistic medicine and such books as Norman Cousins's account of his successful fight against terminal illness and Dr. Bernie Siegel's descriptions of self-healing are beginning to redress the abstractly materialist view of health that has become so prevalent in this century. The relevant point to be made here is that a person who knows how to find flow from life is able to enjoy even situations that seem to allow only despair.

Rather incredible examples of how people achieve flow despite extreme handicaps have been collected by Professor Fausto Massimini of the psychology department of the University of Milan. One group he and his team studied was composed of paraplegics, generally young people who at some point in the past, usually as a result of an accident, have lost the use of their limbs. The unexpected finding of this study was that a large proportion of the victims mentioned the accident that caused paraplegia as both one of the most negative and one of the most *positive* events in their lives. The reason tragic events were seen as positive was that they presented the victim with very clear goals while reducing contradictory and inessential choices. The patients who learned to master the new challenges of their impaired situation felt a clarity of purpose they had lacked before. Learning to live again was in

itself a matter of enjoyment and pride, and they were able to turn the accident from a source of entropy into an occasion of inner order.

Lucio, one of the members of this group, was a twenty-year-old happy-go-lucky gas station attendant when a motorcycle accident paralyzed him below the waist. He had previously liked playing rugby and listening to music, but basically he remembers his life as purposeless and uneventful. After the accident his enjoyable experiences have increased both in number and complexity. Upon recovery from the tragedy he enrolled in college, graduated in languages, and now works as a freelance tax consultant. Both study and work are intense sources of flow; so are fishing and shooting with a bow and arrow. He is currently a regional archery champion—competing from a wheelchair.

These are some of the comments Lucio made in his interview: "When I became paraplegic, it was like being born again. I had to learn from scratch everything I used to know, but in a different way. I had to learn to dress myself, to use my head better. I had to become part of the environment, and use it without trying to control it. . . . it took commitment, willpower, and patience. As far as the future is concerned, I hope to keep improving, to keep breaking through the limitations of my handicap. . . . Everybody must have a purpose. After becoming a paraplegic, these improvements have become my life goal."

Franco is another person in this group. His legs were immobilized five years ago, and he also developed severe urological problems, requiring several surgical operations. Before his accident he was an electrician, and he often enjoyed his work. But his most intense flow experience came from acrobatic dancing on Saturday nights, so the paralysis of his legs was an especially bitter blow. Franco now works as a counselor to other paraplegics. In this case, too, the almost inconceivable setback has led to an enrichment, rather than a diminution, of the complexity of experience. Franco sees his main challenge now as that of helping other victims avoid despair, and assisting their physical rehabilitation. He says the most important goal in his life is to "feel that I can be of use to others, help recent victims accept their situation." Franco is engaged to a paraplegic girl who had been resigned to a life of passivity after her accident. On their first date together, he drove his car (adapted for the handicapped) on a trip to the nearby hills. Unfortunately, the car broke down, and the two of them were left stranded on a deserted patch of road. His fiancée panicked; even Franco admits to having lost his nerve. But eventually they managed to get help, and as is usual after small victories of this kind, they both emerged afterward feeling much more confident of themselves.

Another sample studied by the Milan group was made up of several dozen individuals who were either congenitally blind or had lost their sight sometime after birth. Again, what is so remarkable about these interviews is the number of people who describe the loss of their sight as a *positive* event that has enriched their lives. Pilar, for instance, is a thirty-three-year-old woman whose retinas became detached from both eyes when she was twelve, and who has been unable to see ever since. Blindness freed her from a painfully violent and poor family situation, and made her life more purposeful and rewarding than it probably would have been had she stayed home with her sight intact. Like many other blind people, she now works as an operator at a manual telephone exchange. Among her current flow experiences she mentions working, listening to music, cleaning friends' cars, and "anything else I happen to be doing." At work what she enjoys most is knowing that the calls she has to manage are clicking along smoothly, and the entire traffic of conversation meshing like the instruments of an orchestra. At such times she feels "like I'm God, or something. It is very fulfilling." Among the positive influences in her life Pilar mentions having lost her sight, because "it made me mature in ways that I could never have become even with a college degree . . . for instance, problems no longer affect me with the pathos they used to, and the way that they affect so many of my peers."

Paolo, who is now thirty, lost the use of his eyes entirely six years ago. He does not list blindness among the positive influences, but he mentions four positive outcomes of this tragic event: "First, although I realize and accept my limitations, I am going to keep attempting to overcome them. Second, I have decided to always try changing those situations I don't like. Third, I am very careful not to repeat any of the mistakes I make. And finally, now I have no illusions, but I try to be tolerant with myself so I can be tolerant with others also." It is astonishing how for Paolo, as for most of the people with handicaps, the control of consciousness has emerged in its stark simplicity as the foremost goal. But this does not mean that the challenges are purely intrapsychic. Paolo belongs to the national chess federation; he participates in athletic competitions for the blind; he makes his living by teaching music. He lists playing the guitar, playing chess, sports, and listening to music among his current flow experiences. Recently he finished seventh in a swim meet for the handicapped in Sweden, and he won a chess championship in Spain. His wife is also blind, and coaches a blind women's athletic team. He is presently planning to write a Braille text for learning how to play the classical guitar. Yet none of these astonishing achieve-

ments would matter much if Paolo did not feel in control of his inner life.

And then there is Antonio, who teaches high school and who is married to a woman who is also blind; their current challenge is to adopt a blind child, the first time such an adoption has been considered possible in the entire country . . . Anita, who reports very intense flow experiences sculpting in clay, making love, and reading Braille . . . Dino, eighty-five years old and blind from birth, married with two children, who describes his work, which consists in restoring old chairs, as an intricate and always available flow experience: "When I take a broken chair I use natural rich cane, not the synthetic fibers they use in factories . . . it feels so great when the 'pull' is right, the tension elastic—especially when it happens at the first try . . . When I get through, the seat will last twenty years." . . . and so many others like them.

Another group Professor Massimini and his team has studied included homeless vagrants, "street people," who are just as frequent in the great European cities as they are in Manhattan. We tend to feel sorry for these destitutes, and not so long ago many of them, who seem unable to adapt to "normal" life, would have been diagnosed as psychopaths or worse. In fact, many of them have proven to be unfortunate, helpless individuals whose strength has been exhausted by catastrophes of various kinds. Nevertheless, it is again astonishing to learn how many of them have been able to transform bleak conditions into an existence that has the characteristics of a satisfying flow experience. Of the many examples, we shall quote extensively from one interview that can stand for many others.

Reyad is a thirty-three-year-old Egyptian who currently sleeps in the parks of Milan, eats in charity kitchens, and occasionally washes dishes for restaurants whenever he needs some cash. When during the interview he was read a description of the flow experience, and was asked if this ever happened to him, he answered,

> Yes. It describes my entire life from 1967 up to now. After the War of 1967 I decided to leave Egypt and start hitchhiking toward Europe. Ever since I have been living with my mind concentrated within myself. It has not been just a trip, it has been a search for identity. Every man has something to discover within himself. The people in my town were sure I was crazy when I decided to start walking to Europe. But the best thing in life is to know oneself. . . . My idea from 1967 on has remained the same: to find myself. I had to struggle against many things. I passed through Lebanon and its war, through Syria, Jordan, Turkey, Yugo-

slavia, before getting here. I had to confront all sorts of natural disasters; I slept in ditches near the road in thunderstorms, I was involved in accidents, I have seen friends die next to me, but my concentration has never flagged. . . . It has been an adventure that so far has lasted twenty years, but it will keep going on for the rest of my life. . . .

Through these experiences I have come to see that the world is not worth much. The only thing that counts for me now, first and last, is God. I am most concentrated when I pray with my prayer beads. Then I am able to put my feelings to sleep, to calm myself and avoid becoming crazy. I believe that destiny rules life, and it makes no sense to struggle too hard. . . . During my journey I have seen hunger, war, death, and poverty. Now through prayer I have begun to hear myself, I have returned toward my center, I have achieved concentration and I have understood that the world has no value. Man was born to be tested on this earth. Cars, television sets, clothes are secondary. The main thing is that we were born to praise the Lord. Everyone has his own fate, and we should be like the lion in the proverb. The lion, when he runs after a pack of gazelles, can only catch them one at a time. I try to be like that, and not like Westerners who go crazy working even though they cannot eat more than their daily bread. . . . If I am to live twenty more years, I will try to live enjoying each moment, instead of killing myself to get more. . . . If I am to live like a free man who does not depend on anyone, I can afford to go slowly; if I don't earn anything today, it does not matter. It means that this happens to be my fate. Next day I may earn 100 million—or get a terminal illness. Like Jesus Christ said, What does it benefit to man if he gains the entire world, but loses himself? I have tried first to conquer myself; I don't care if I lose the world.

I set out on this journey like a baby bird hatching from its egg; ever since I have been walking in freedom. Every man should get to know himself and experience life in all its forms. I could have gone on sleeping soundly in my bed, and found work in my town, because a job was ready for me, but I decided to sleep with the poor, because one must suffer to become a man. One does not get to be a man by getting married, by having sex: to be a man means to be responsible, to know when it is time to speak, to know what has to be said, to know when one must stay silent.

Reyad spoke at much greater length, and all his remarks were consistent with the unwavering purpose of his spiritual quest. Like the disheveled prophets who roamed the deserts in search of enlightenment two thousand years ago, this traveler has distilled everyday life into a goal of hallucinatory clarity: to control his consciousness in order to establish a connection between his self and God. What were the causes that led him to give up the "good things in life" and pursue such a

chimera? Was he born with a hormonal imbalance? Did his parents traumatize him? These questions, which are the ones that usually interest psychologists, shall not concern us here. The point is not to explain what accounts for Reyad's strangeness, but to recognize that, given the fact he is who he is, Reyad has transformed living conditions most people would find unbearable into a meaningful, enjoyable existence. And that is more than many people living in comfort and luxury can claim.

COPING WITH STRESS

"When a man knows he is to be hanged in a fortnight, it concentrates his mind wonderfully," remarked Samuel Johnson, in a saying whose truth applies to the cases just presented. A major catastrophe that frustrates a central goal of life will either destroy the self, forcing a person to use all his psychic energy to erect a barrier around remaining goals, defending them against further onslaughts of fate; or it will provide a new, more clear, and more urgent goal: to overcome the challenges created by the defeat. If the second road is taken, the tragedy is not necessarily a detriment to the quality of life. Indeed, as in the cases of Lucio, Paolo, and innumerable others like them, what objectively seems a devastating event may come to enrich the victims' lives in new and unexpected ways. Even the loss of one of the most basic human faculties, like that of sight, does not mean that a person's consciousness need become impoverished; the opposite is often what happens. But what makes the difference? How does it come about that the same blow will destroy one person, while another will transform it into inner order?

Psychologists usually study the answers to such questions under the heading of *coping with stress.* It is obvious that certain events cause more psychological strain than others: for example, the death of a spouse is several orders of magnitude more stressful than taking out a mortgage on a house, which in turn causes more strain than being given a traffic ticket. But it is also clear that the same stressful event might make one person utterly miserable, while another will bite the bullet and make the best of it. This difference in how a person responds to stressful events has been called "coping ability" or "coping style."

In trying to sort out what accounts for a person's ability to cope with stress, it is useful to distinguish three different kinds of resources. The first is the external support available, and especially the network of social supports. A major illness, for instance, will be mitigated to a certain extent if one has good insurance and a loving family. The second

bulwark against stress includes a person's psychological resources, such as intelligence, education, and relevant personality factors. Moving to a new city and having to establish new friendships will be more stressful to an introvert than to an extrovert. And finally, the third type of resource refers to the coping strategies that a person uses to confront the stress.

Of these three factors, the third one is the most relevant to our purposes. External supports by themselves are not that effective in mitigating stress. They tend to help only those who can help themselves. And psychological resources are largely outside our control. It is difficult to become much smarter, or much more outgoing, than one was at birth. But how we cope is both the most important factor in determining what effects stress will have and the most flexible resource, the one most under our personal control.

There are two main ways people respond to stress. The positive response is called a "mature defense" by George Vaillant, a psychiatrist who has studied the lives of successful and relatively unsuccessful Harvard graduates over a period of about thirty years; others call it "transformational coping." The negative response to stress would be a "neurotic defense" or "regressive coping," according to these models.

To illustrate the difference between them, let us take the example of Jim, a fictitious financial analyst who has just been fired from a comfortable job at age forty. Losing one's job is reckoned to be about midpoint in the severity of life stresses; its impact varies, of course, with a person's age and skills, the amount of his savings, and the conditions of the labor market. Confronted with this unpleasant event, Jim can take one of two opposite courses of action. He can withdraw into himself, sleep late, deny what has happened, and avoid thinking about it. He can also discharge his frustration by turning against his family and friends, or disguise it by starting to drink more than usual. All these would be examples of regressive coping, or immature defenses.

Or Jim can keep his cool by suppressing temporarily his feelings of anger and fear, analyzing the problem logically, and reassessing his priorities. Afterward he might redefine what the problem is, so that he can solve it more easily—for instance, by deciding to move to a place where his skills are more in demand, or by retraining himself and acquiring the skills for a new job. If he takes this course, he would be using mature defenses, or transformational coping.

Few people rely on only one or the other strategy exclusively. It is more likely that Jim would get drunk the first night; have a fight with his wife, who had been telling him for years that his job was lousy; and

then the following morning, or the week after, he would simmer down and start figuring out what to do next. But people do differ in their abilities to use one or the other strategy. The paraplegic who became a champion archer, or the blind chess master, visited by misfortunes so intense that they are off the scale of stressful life events, are examples of individuals who have mastered transformational coping. Others, however, when confronted by much less intense levels of stress, might give up and respond by scaling down the complexity of their lives forever.

The ability to take misfortune and make something good come of it is a very rare gift. Those who possess it are called "survivors," and are said to have "resilience," or "courage." Whatever we call them, it is generally understood that they are exceptional people who have overcome great hardships, and have surmounted obstacles that would daunt most men and women. In fact, when average people are asked to name the individuals they admire the most, and to explain why these men and women are admired, courage and the ability to overcome hardship are the qualities most often mentioned as a reason for admiration. As Francis Bacon remarked, quoting from a speech by the Stoic philosopher Seneca, "The good things which belong to prosperity are to be wished, but the good things that belong to adversity are to be admired."

In one of our studies the list of admired persons included an old lady who, despite her paralysis, was always cheerful and ready to listen to other people's troubles; a teenage camp counselor who, when a swimmer was missing and everybody else panicked, kept his head and organized a successful rescue effort; a female executive who, despite ridicule and sexist pressures, prevailed in a difficult working environment; and Ignaz Semmelweis, the Hungarian physician who in the last century insisted that the lives of many mothers could be saved at childbirth if obstetricians would only wash their hands, even though the rest of the doctors ignored and mocked him. These and the many hundreds of others mentioned were respected for the same reasons: They stood firm for what they believed in, and didn't let opposition daunt them. They had courage, or what in earlier time was known simply as "virtue"—a term derived from the Latin word *vir*, or man.

It makes sense, of course, that people should look up to this one quality more than to any other. Of all the virtues we can learn no trait is more useful, more essential for survival, and more likely to improve the quality of life than the ability to transform adversity into an enjoyable challenge. To admire this quality means that we pay attention to those who embody it, and we thereby have a chance to emulate them if the need arises. Therefore admiring courage is in itself a positive

adaptive trait; those who do so may be better prepared to ward off the blows of misfortune.

But simply calling the ability to cheat chaos "transformational coping," and people who are good at it "courageous," falls short of explaining this remarkable gift. Like the character in Moliere who said that sleep was caused by "dormitive power," we fail to illuminate matters if we say that effective coping is caused by the virtue of courage. What we need is not only names and descriptions, but an understanding of how the process works. Unfortunately our ignorance in this matter is still very great.

THE POWER OF DISSIPATIVE STRUCTURES

One fact that does seem clear, however, is that the ability to make order out of chaos is not unique to psychological processes. In fact, according to some views of evolution, complex life forms depend for their existence on a capacity to extract energy out of entropy—to recycle waste into structured order. The Nobel prize–winning chemist Ilya Prigogine calls physical systems that harness energy which otherwise would be dispersed and lost in random motion "dissipative structures." For example, the entire vegetable kingdom on our planet is a huge dissipative structure because it feeds on light, which normally would be a useless by-product of the sun's combustion. Plants have found a way to transform this wasted energy into the building blocks out of which leaves, flowers, fruit, bark, and timber are fashioned. And because without plants there would be no animals, all life on earth is ultimately made possible by dissipative structures that capture chaos and shape it into a more complex order.

Human beings have also managed to utilize waste energy to serve their goals. The first major technological invention, that of fire, is a good example. In the beginning, fires started at random: volcanoes, lightning, and spontaneous combustion ignited fuel here and there, and the energy of the decomposing timber was dispersed without purpose. As they learned to take control over fire people used the dissipating energy to warm their caves, cook their food, and finally to smelt and forge objects made of metal. Engines run by steam, electricity, gasoline, and nuclear fusion are also based on the same principle: to take advantage of energy that otherwise would be lost, or opposed to our goals. Unless men learned various tricks for transforming the forces of disorder into something they could use, we would not have survived as successfully as we have.

The psyche, as we have seen, operates according to similar princi-

ples. The integrity of the self depends on the ability to take neutral or destructive events and turn them into positive ones. Getting fired could be a godsend, if one took the opportunity to find something else to do that was more in tune with one's desires. In each person's life, the chances of only good things happening are extremely slim. The likelihood that our desires will be always fulfilled is so minute as to be negligible. Sooner or later everyone will have to confront events that contradict his goals: disappointments, severe illness, financial reversal, and eventually the inevitability of one's death. Each event of this kind is negative feedback that produces disorder in the mind. Each threatens the self and impairs its functioning. If the trauma is severe enough, a person may lose the capacity to concentrate on necessary goals. If that happens, the self is no longer in control. If the impairment is very severe, consciousness becomes random, and the person "loses his mind"—the various symptoms of mental disease take over. In less severe cases the threatened self survives, but stops growing; cowering under attack, it retreats behind massive defenses and vegetates in a state of continuous suspicion.

It is for this reason that courage, resilience, perseverance, mature defense, or transformational coping—the dissipative structures of the mind—are so essential. Without them we would be constantly suffering through the random bombardment of stray psychological meteorites. On the other hand, if we do develop such positive strategies, most negative events can be at least neutralized, and possibly even used as challenges that will help make the self stronger and more complex.

Transformational skills usually develop by late adolescence. Young children and early teens still depend to a large extent on a supportive social network to buffer them against things that go wrong. When a blow falls on a young teenager—even something as trivial as a bad grade, a pimple erupting on the chin, or a friend ignoring him at school—it seems to him as if the world is about to end, and there is no longer any purpose in life. Positive feedback from other people usually picks his mood up in a matter of minutes; a smile, a phone call, a good song captures his attention, distracting him from worries and restoring order in the mind. We have learned from the Experience Sampling Method studies that a healthy adolescent stays depressed on the average for only half an hour. (An adult takes, on the average, twice as long to recover from bad moods.)

In a few years, however—by the time they are seventeen or eighteen—teenagers are generally able to place negative events in perspective, and they are no longer destroyed by things that don't work out as

desired. It is at this age that for most people the ability to control consciousness begins. Partly this ability is a product of the mere passage of time: having been disappointed before, and having survived the disappointment, the older teen knows that a situation is not as bad as it may seem at the moment. Partly it is knowing that other people also have been going through the same problems, and have been able to resolve them. The knowledge that one's sufferings are shared adds an important perspective to the egocentrism of youth.

The peak in the development of coping skills is reached when a young man or woman has achieved a strong enough sense of self, based on personally selected goals, that no external disappointment can entirely undermine who he or she is. For some people the strength derives from a goal that involves identification with the family, with the country, or with a religion or an ideology. For others, it depends on mastery of a harmonious system of symbols, such as art, music, or physics. Srinivasa Ramanujan, the young mathematical genius from India, had so much of his psychic energy invested in number theory that poverty, sickness, pain, and even rapidly approaching death, although tiresome, had no chance of distracting his mind from calculations—in fact, they just spurred him on to greater creativity. On his deathbed he kept on marveling at the beauty of the equations he was discovering, and the serenity of his mind reflected the order of the symbols he used.

Why are some people weakened by stress, while others gain strength from it? Basically the answer is simple: those who know how to transform a hopeless situation into a new flow activity that can be controlled will be able to enjoy themselves, and emerge stronger from the ordeal. There are three main steps that seem to be involved in such transformations:

1. *Unselfconscious self-assurance.* As Richard Logan found in his study of individuals who survived severe physical ordeals—polar explorers wandering alone in the Arctic, concentration camp inmates—one common attitude shared by such people was the implicit belief that their destiny was in their hands. They did not doubt their own resources would be sufficient to allow them to determine their fate. In that sense one would call them self-assured, yet at the same time, their egos seem curiously absent: they are not self-centered; their energy is typically not bent on dominating their environment as much as on finding a way to function within it harmoniously.

This attitude occurs when a person no longer sees himself in opposition to the environment, as an individual who insists that *his*

goals, *his* intentions take precedence over everything else. Instead, he feels a part of whatever goes on around him, and tries to do his best within the system in which he must operate. Paradoxically, this sense of humility—the recognition that one's goals may have to be subordinated to a greater entity, and that to succeed one may have to play by a different set of rules from what one would prefer—is a hallmark of strong people.

To take a trivial but common example, suppose that one cold morning, when you are in a hurry to get to the office, the car engine won't start when you try the ignition. In such circumstances many people become so increasingly obsessed with their goal—getting to the office—that they cannot formulate any other plans. They may curse the car, turn the ignition key more frantically, slam the dashboard in exasperation—usually to no avail. Their ego involvement prevents them from coping effectively with frustration and from realizing their goal. A more sensible approach would be to recognize that it makes no difference to the car that you have to be downtown in a hurry. The car follows its own laws, and the only way to get it moving is by taking them into account. If you have no idea what may be wrong with the starter, it makes more sense to call a cab or form an alternative goal: cancel the appointment and find something useful to do at home instead.

Basically, to arrive at this level of self-assurance one must trust oneself, one's environment, and one's place in it. A good pilot knows her skills, has confidence in the machine she is flying, and is aware of what actions are required in case of a hurricane, or in case the wings ice over. Therefore she is confident in her ability to cope with whatever weather conditions may arise—not because she will force the plane to obey her will, but because she will be the instrument for matching the properties of the plane to the conditions of the air. As such she is an indispensable link for the safety of the plane, but it is only as a link—as a catalyst, as a component of the air-plane-person system, obeying the rules of that system—that she can achieve her goal.

2. *Focusing attention on the world.* It is difficult to notice the environment as long as attention is mainly focused inward, as long as most of one's psychic energy is absorbed by the concerns and desires of the ego. People who know how to transform stress into enjoyable challenge spend very little time thinking about themselves. They are not expending all their energy trying to satisfy what they believe to be their needs, or worrying about socially conditioned desires. Instead their attention is alert, constantly processing information from their surroundings. The focus is still set by the person's goal, but it is open enough to notice and

adapt to external events even if they are not directly relevant to what he wants to accomplish.

An open stance makes it possible for a person to be objective, to be aware of alternative possibilities, to feel a part of the surrounding world. This total involvement with the environment is well expressed by the rock climber Yvon Chouinard, describing one of his ascents on the fearsome El Capitan in Yosemite: "Each individual crystal in the granite stood out in bold relief. The varied shapes of the clouds never ceased to attract our attention. For the first time, we noticed tiny bugs that were all over the walls, so tiny that they were barely noticeable. I stared at one for fifteen minutes, watching him move and admiring his brilliant red color.

"How could one ever be bored with so many good things to see and feel! This unity with our joyous surroundings, this ultra-penetrating perception, gave us a feeling that we had not had for years."

Achieving this unity with one's surroundings is not only an important component of enjoyable flow experiences but is also a central mechanism by which adversity is conquered. In the first place, when attention is focused away from the self, frustrations of one's desires have less of a chance to disrupt consciousness. To experience psychic entropy one must concentrate on the internal disorder; but by paying attention to what is happening around oneself instead, the destructive effects of stress are lessened. Second, the person whose attention is immersed in the environment becomes part of it—she participates in the system by linking herself to it through psychic energy. This, in turn, makes it possible for her to understand the properties of the system, so that she can find a better way to adapt to a problematic situation.

Returning again to the example of the car that wouldn't start: if your attention is completely absorbed by the goal of making it to the office in time, your mind might be full of images about what will happen if you are late, and of hostile thoughts about your uncooperative vehicle. Then you are less likely to notice what the car is trying to tell you: that the engine is flooded or that the battery is dead. Similarly the pilot who spends too much energy contemplating what she wants the plane to do might miss the information that will enable her to navigate safely. A sense of complete openness to the environment is well described by Charles Lindbergh, who experienced it during his epoch-making solo crossing of the Atlantic:

> My cockpit is small, and its walls are thin: but inside this cocoon I feel
> secure, despite the speculations of my mind. . . . I become minutely
> conscious of details in my cockpit—of the instruments, the levers, the

angles of construction. Each item takes on a new value. I study weld marks on the tubing (frozen ripples of steel through which pass invisible hundredweights of strain), a dot of radiolite paint on the altimeter's face . . . the battery of fuel valves . . .—all such things, which I never considered much before, are now obvious and important. . . . I may be flying a complicated airplane, rushing through space, but in this cabin I'm surrounded by simplicity and thoughts set free of time.

A former colleague of mine, G., used to tell a gruesome story from his air force years that illustrates how dangerous excessive concern with safety can be, when it demands so much attention that it makes us oblivious to the rest of reality. During the Korean War, G.'s unit was involved in routine parachute training. One day, as the group was preparing for a drop, it was discovered that there were not enough regular parachutes to go around, and one of the right-handed men was forced to take a left-handed chute. "It is the same as the others," the ordnance sergeant assured him, "but the rip cord hangs on the left side of the harness. You can release the chute with either hand, but it is easier to do it with the left." The team boarded the plane, went up to eight thousand feet, and over the target area one after the other they jumped out. Everything went well, except for one of the men: his parachute never opened, and he fell straight to his death on the desert below.

G. was part of the investigating team sent to determine why the chute didn't open. The dead soldier was the one who had been given the left-handed release latch. The uniform on the right side of his chest, where the rip cord for a regular parachute would have been, had been completely torn off; even the flesh of his chest had been gouged out in long gashes by his bloody right hand. A few inches to the left was the actual rip cord, apparently untouched. There had been nothing wrong with the parachute. The problem had been that, while falling through that awful eternity, the man had become fixated on the idea that to open the chute he had to find the release in the accustomed place. His fear was so intense that it blinded him to the fact that safety was literally at his fingertips.

In a threatening situation it is natural to mobilize psychic energy, draw it inward, and use it as a defense against the threat. But this innate reaction more often than not compromises the ability to cope. It exacerbates the experience of inner turmoil, reduces the flexibility of response, and, perhaps worse than anything else, it isolates a person from the rest of the world, leaving him alone with his frustrations. On the other hand, if one continues to stay in touch with what is going on, new possibilities

are likely to emerge, which in turn might suggest new responses, and one is less likely to be entirely cut off from the stream of life.

3. *The discovery of new solutions.* There are basically two ways to cope with a situation that creates psychic entropy. One is to focus attention on the obstacles to achieving one's goals and then to move them out of the way, thereby restoring harmony in consciousness. This is the direct approach. The other is to focus on the entire situation, including oneself, to discover whether alternative goals may not be more appropriate, and thus different solutions possible.

Let us suppose, for instance, that Phil, who is due to be promoted to a vice presidency within his company, sees that the appointment might go instead to a colleague who gets along better with the CEO. At this point he has two basic options: to find ways to change the CEO's mind about who is the better person for the job (the first approach), or to consider another set of goals, like moving to another division of the company, changing careers altogether, or scaling down his career objectives and investing his energies in the family, the community, or his own self-development (the second approach). Neither solution is "better" in an absolute sense; what matters is whether it makes sense in terms of Phil's overall goals, and whether it allows him to maximize enjoyment in his life.

Whatever solution he adopts, if Phil takes himself, his needs, and his desires too seriously, he is going to be in trouble as soon as things do not go his way. He will not have enough disposable attention available to seek out realistic options, and instead of finding enjoyable new challenges, he will be surrounded instead by stressful threats.

Almost every situation we encounter in life presents possibilities for growth. As we have seen, even terrible disasters like blindness and paraplegia can be turned into conditions for enjoyment and greater complexity. Even the approach of death itself can serve to create harmony in consciousness, rather than despair.

But these transformations require that a person be prepared to perceive unexpected opportunities. Most of us become so rigidly fixed in the ruts carved out by genetic programming and social conditioning that we ignore the options of choosing any other course of action. Living exclusively by genetic and social instructions is fine as long as everything goes well. But the moment biological or social goals are frustrated— which in the long run is inevitable—a person must formulate new goals, and create a new flow activity for himself, or else he will waste his energies in inner turmoil.

But how does one go about discovering these alternative strategies? The answer is basically simple: if one operates with unselfconscious assurance, and remains open to the environment and involved in it, a solution is likely to emerge. The process of discovering new goals in life is in many respects similar to that by which an artist goes about creating an original work of art. Whereas a conventional artist starts painting a canvas knowing what she wants to paint, and holds to her original intention until the work is finished, an original artist with equal technical training commences with a deeply felt but undefined goal in mind, keeps modifying the picture in response to the unexpected colors and shapes emerging on the canvas, and ends up with a finished work that probably will not resemble anything she started out with. If the artist is responsive to her inner feelings, knows what she likes and does not like, and pays attention to what is happening on the canvas, a good painting is bound to emerge. On the other hand, if she holds on to a preconceived notion of what the painting should look like, without responding to the possibilities suggested by the forms developing before her, the painting is likely to be trite.

We all start with preconceived notions of what we want from life. These include the basic needs programmed by our genes to ensure survival—the need for food, comfort, sex, dominance over other beings. They also include the desires that our specific culture has inculcated in us—to be slim, rich, educated, and well liked. If we embrace these goals and are lucky, we may replicate the ideal physical and social image for our historical time and place. But is this the best use of our psychic energy? And what if we cannot realize these ends? We will never become aware of other possibilities unless, like the painter who watches with care what is happening on the canvas, we pay attention to what is happening around us, and evaluate events on the basis of their direct impact on how we feel, rather than evaluating them exclusively in terms of preconceived notions. If we do so we may discover that, contrary to what we were led to believe, it is more satisfying to help another person than to beat him down, or that it is more enjoyable to talk with one's two-year-old than to play golf with the company president.

THE AUTOTELIC SELF: A SUMMARY

In this chapter we have seen it demonstrated repeatedly that outside forces do not determine whether adversity will be able to be turned into enjoyment. A person who is healthy, rich, strong, and powerful has no greater odds of being in control of his consciousness than one who is

sickly, poor, weak, and oppressed. The difference between someone who enjoys life and someone who is overwhelmed by it is a product of a combination of such external factors and the way a person has come to interpret them—that is, whether he sees challenges as threats or as opportunities for action.

The "autotelic self" is one that easily translates potential threats into enjoyable challenges, and therefore maintains its inner harmony. A person who is never bored, seldom anxious, involved with what goes on, and in flow most of the time may be said to have an autotelic self. The term literally means "a self that has self-contained goals," and it reflects the idea that such an individual has relatively few goals that do not originate from within the self. For most people, goals are shaped directly by biological needs and social conventions, and therefore their origin is outside the self. For an autotelic person, the primary goals emerge from experience evaluated in consciousness, and therefore from the self proper.

The autotelic self transforms potentially entropic experience into flow. Therefore the rules for developing such a self are simple, and they derive directly from the flow model. Briefly, they can be summarized as follows:

1. *Setting goals.* To be able to experience flow, one must have clear goals to strive for. A person with an autotelic self learns to make choices—ranging from lifelong commitments, such as getting married and settling on a vocation, to trivial decisions like what to do on the weekend or how to spend the time waiting in the dentist's office—without much fuss and the minimum of panic.

Selecting a goal is related to the recognition of challenges. If I decide to learn tennis, it follows that I will have to learn to serve, to use my backhand and forehand, to develop my endurance and my reflexes. Or the causal sequence may be reversed: because I enjoyed hitting the ball over the net, I may develop the goal of learning how to play tennis. In any case goals and challenges imply each other.

As soon as the goals and challenges define a system of action, they in turn suggest the skills necessary to operate within it. If I decide to quit my job and become a resort operator, it follows that I should learn about hotel management, financing, commercial locations, and so on. Of course, the sequence may also start in reverse order: what I perceive my skills to be could lead to the development of a particular goal that builds on those strengths—I may decide to become a resort operator because I see myself as having the right qualifications for it.

And to develop skills, one needs to pay attention to the results of one's actions—to monitor the feedback. To become a good resort operator, I have to interpret correctly what the bankers who might lend me money think about my business proposal. I need to know what features of the operation are attractive to customers and what features they dislike. Without constant attention to feedback I would soon become detached from the system of action, cease to develop skills, and become less effective.

One of the basic differences between a person with an autotelic self and one without it is that the former knows that it is she who has chosen whatever goal she is pursuing. What she does is not random, nor is it the result of outside determining forces. This fact results in two seemingly opposite outcomes. On the one hand, having a feeling of ownership of her decisions, the person is more strongly dedicated to her goals. Her actions are reliable and internally controlled. On the other hand, knowing them to be her own, she can more easily modify her goals whenever the reasons for preserving them no longer make sense. In that respect, an autotelic person's behavior is both more consistent and more flexible.

2. *Becoming immersed in the activity.* After choosing a system of action, a person with an autotelic personality grows deeply involved with whatever he is doing. Whether flying a plane nonstop around the world or washing dishes after dinner, he invests attention in the task at hand.

To do so successfully one must learn to balance the opportunities for action with the skills one possesses. Some people begin with unrealistic expectations, such as trying to save the world or to become millionaires before the age of twenty. When their hopes are dashed, most become despondent, and their selves wither from the loss of psychic energy expended in fruitless attempts. At the other extreme, many people stagnate because they do not trust their own potential. They choose the safety of trivial goals, and arrest the growth of complexity at the lowest level available. To achieve involvement with an action system, one must find a relatively close mesh between the demands of the environment and one's capacity to act.

For instance, suppose a person walks into a room full of people and decides to "join the party," that is, to get acquainted with as many people as possible while having a good time. If the person lacks an autotelic self he might be incapable of starting an interaction by himself, and withdraw into a corner, hoping that someone will notice him. Or he may try to be boisterous and overly slick, turning people off with

inappropriate and superficial friendliness. Neither strategy would be very successful or likely to provide a good time. A person with an autotelic self, upon entering the room, would shift his attention away from himself to the party—the "action system" he wishes to join. He would observe the guests, try to guess which of them might have matching interests and compatible temperament, and start talking to that person about topics he suspects will be mutually agreeable. If the feedback is negative—if the conversation turns out to be boring, or above one partner's head—he will try a different topic or a different partner. Only when a person's actions are appropriately matched with the opportunities of the action system does he truly become involved.

Involvement is greatly facilitated by the ability to concentrate. People who suffer from attentional disorders, who cannot keep their minds from wandering, always feel left out of the flow of life. They are at the mercy of whatever stray stimulus happens to flash by. To be distracted against one's will is the surest sign that one is not in control. Yet it is amazing how little effort most people make to improve control of their attention. If reading a book seems too difficult, instead of sharpening concentration we tend to set it aside and instead turn on the television, which not only requires minimal attention, but in fact tends to diffuse what little it commands with choppy editing, commercial interruptions, and generally inane content.

3. *Paying attention to what is happening.* Concentration leads to involvement, which can only be maintained by constant inputs of attention. Athletes are aware that in a race even a momentary lapse can spell complete defeat. A heavyweight champion may be knocked out if he does not see his opponent's uppercut coming. The basketball player will miss the net if he allows himself to be distracted by the roaring of the crowd. The same pitfalls threaten anyone who participates in a complex system: to stay in it, he must keep investing psychic energy. The parent who does not listen closely to his child undermines the interaction, the lawyer whose attention lapses may forfeit the case, and the surgeon whose mind wanders may lose the patient.

Having an autotelic self implies the ability to sustain involvement. Self-consciousness, which is the most common source of distraction, is not a problem for such a person. Instead of worrying about how he is doing, how he looks from the outside, he is wholeheartedly committed to his goals. In some cases it is the depth of involvement that pushes self-consciousness out of awareness, while sometimes it is the other way around: it is the very lack of self-consciousness that makes deep involve-

ment possible. The elements of the autotelic personality are related to one another by links of mutual causation. It does not matter where one starts—whether one chooses goals first, develops skills, cultivates the ability to concentrate, or gets rid of self-consciousness. One can start anywhere, because once the flow experience is in motion the other elements will be much easier to attain.

A person who pays attention to an interaction instead of worrying about the self obtains a paradoxical result. She no longer feels like a separate individual, yet her self becomes stronger. The autotelic individual grows beyond the limits of individuality by investing psychic energy in a system in which she is included. Because of this union of the person and the system, the self emerges at a higher level of complexity. This is why 'tis better to have loved and lost than never to have loved at all.

The self of a person who regards everything from an egocentric perspective may be more secure, but it is certain to be an impoverished one relative to that of a person who is willing to be committed, to be involved, and who is willing to pay attention to what is happening for the sake of the interaction rather than purely out of self-interest.

During the ceremony celebrating the unveiling of Chicago's huge outdoor Picasso sculpture in the plaza across from City Hall, I happened to be standing next to a personal-injury lawyer with whom I was acquainted. As the inaugural speech droned on, I noticed a look of intense concentration on his face, and that his lips were moving. Asked what he was thinking, he answered that he was trying to estimate the amount of money the city was going to have to pay to settle suits involving children who got hurt climbing the sculpture.

Was this lawyer lucky, because he could transform everything he saw into a professional problem his skills could master, and thus live in constant flow? Or was he depriving himself of an opportunity to grow by paying attention only to what he was already familiar with, and ignoring the aesthetic, civic, and social dimensions of the event? Perhaps both interpretations are accurate. In the long run, however, looking at the world exclusively from the little window that one's self affords is always limiting. Even the most highly respected physicist, artist, or politician becomes a hollow bore and ceases to enjoy life if all he can interest himself in is his limited role in the universe.

4. *Learning to enjoy immediate experience.* The outcome of having an autotelic self—of learning to set goals, to develop skills, to be sensitive to feedback, to know how to concentrate and get involved—is that one can enjoy life even when objective circumstances are brutish and

nasty. Being in control of the mind means that literally anything that happens can be a source of joy. Feeling a breeze on a hot day, seeing a cloud reflected on the glass facade of a high-rise, working on a business deal, watching a child play with a puppy, drinking a glass of water can all be felt as deeply satisfying experiences that enrich one's life.

To achieve this control, however, requires determination and discipline. Optimal experience is not the result of a hedonistic, lotus-eating approach to life. A relaxed, laissez-faire attitude is not a sufficient defense against chaos. As we have seen from the very beginning of this book, to be able to transform random events into flow, one must develop skills that stretch capacities, that make one become more than what one is. Flow drives individuals to creativity and outstanding achievement. The necessity to develop increasingly refined skills to sustain enjoyment is what lies behind the evolution of culture. It motivates both individuals and cultures to change into more complex entities. The rewards of creating order in experience provide the energy that propels evolution—they pave the way for those dimly imagined descendants of ours, more complex and wise than we are, who will soon take our place.

But to change all existence into a flow experience, it is not sufficient to learn merely how to control moment-by-moment states of consciousness. It is also necessary to have an overall context of goals for the events of everyday life to make sense. If a person moves from one flow activity to another without a connecting order, it will be difficult at the end of one's life to look back on the years past and find meaning in what has happened. To create harmony in whatever one does is the last task that the flow theory presents to those who wish to attain optimal experience; it is a task that involves transforming the entirety of life into a single flow activity, with unified goals that provide constant purpose.

THE MAKING
OF MEANING

IT IS NOT UNUSUAL for famous tennis players to be deeply committed to their game, to take pleasure in playing, but off the court to be morose and hostile. Picasso enjoyed painting, but as soon as he lay down his brushes he turned into a rather unpleasant man. Bobby Fischer, the chess genius, appeared to be helplessly inept except when his mind was on chess. These and countless similar examples are a reminder that having achieved flow in one activity does not necessarily guarantee that it will be carried over to the rest of life.

If we enjoyed work and friendships, and faced every challenge as an opportunity to develop new skills, we would be getting rewards out of living that are outside the realm of ordinary life. Yet even this would not be enough to assure us of optimal experience. As long as enjoyment follows piecemeal from activities not linked to one another in a meaningful way, one is still vulnerable to the vagaries of chaos. Even the most successful career, the most rewarding family relationship eventually runs dry. Sooner or later involvement in work must be reduced. Spouses die, children grow up and move away. To approach optimal experience as closely as is humanly possible, a last step in the control of consciousness is necessary.

What this involves is turning all life into a unified flow experience. If a person sets out to achieve a difficult enough goal, from which all other goals logically follow, and if he or she invests all energy in developing skills to reach that goal, then actions and feelings will be in harmony,

and the separate parts of life will fit together—and each activity will "make sense" in the present, as well as in view of the past and of the future. In such a way, it is possible to give meaning to one's entire life.

But isn't it incredibly naive to expect life to have a coherent overall meaning? After all, at least since Nietzsche concluded that God was dead, philosophers and social scientists have been busy demonstrating that existence has no purpose, that chance and impersonal forces rule our fate, and that all values are relative and hence arbitrary. It *is* true that life has no meaning, if by that we mean a supreme goal built into the fabric of nature and human experience, a goal that is valid for every individual. But it does not follow that life cannot be *given* meaning. Much of what we call culture and civilization consists in efforts people have made, generally against overwhelming odds, to create a sense of purpose for themselves and their descendants. It is one thing to recognize that life is, by itself, meaningless. It is another thing entirely to accept this with resignation. The first fact does not entail the second any more than the fact that we lack wings prevents us from flying.

From the point of view of an individual, it does not matter what the ultimate goal is—provided it is compelling enough to order a lifetime's worth of psychic energy. The challenge might involve the desire to have the best beer-bottle collection in the neighborhood, the resolution to find a cure for cancer, or simply the biological imperative to have children who will survive and prosper. As long as it provides clear objectives, clear rules for action, and a way to concentrate and become involved, any goal can serve to give meaning to a person's life.

In the past few years I have come to be quite well acquainted with several Muslim professionals—electronics engineers, pilots, businessmen, and teachers, mostly from Saudi Arabia and from the other Gulf states. In talking to them, I was struck with how relaxed most of them seemed to be even under strong pressure. "There is nothing to it," those I asked about it told me, in different words, but with the same message: "We don't get upset because we believe that our life is in God's hands, and whatever He decides will be fine with us." Such implicit faith used to be widespread in our culture as well, but it is not easy to find it now. Many of us have to discover a goal that will give meaning to life on our own, without the help of a traditional faith.

WHAT MEANING MEANS

Meaning is a concept difficult to define, since any definition runs the risk of being circular. How do we talk about the meaning of meaning itself? There are three ways in which unpacking the sense of this word helps

illuminate the last step in achieving optimal experience. Its first usage points toward the end, purpose, significance of something, as in: *What is the meaning of life?* This sense of the word reflects the assumption that events are linked to each other in terms of an ultimate goal; that there is a temporal order, a causal connection between them. It assumes that phenomena are not random, but fall into recognizable patterns directed by a final purpose. The second usage of the word refers to a person's intentions: *She usually means well.* What this sense of *meaning* implies is that people reveal their purposes in action; that their goals are expressed in predictable, consistent, and orderly ways. Finally, the third sense in which the word is used refers to ordering information, as when one says: *Otorhinolaryngology means the study of ear, nose, and throat,* or: *Red sky in the evening means good weather in the morning.* This sense of *meaning* points to the identity of different words, the relationship between events, and thus it helps to clarify, to establish order among unrelated or conflicting information.

Creating meaning involves bringing order to the contents of the mind by integrating one's actions into a unified flow experience. The three senses of the word *meaning* noted above make it clearer how this is accomplished. People who find their lives meaningful usually have a goal that is challenging enough to take up all their energies, a goal that can give significance to their lives. We may refer to this process as achieving *purpose.* To experience flow one must set goals for one's actions: to win a game, to make friends with a person, to accomplish something in a certain way. The goal in itself is usually not important; what matters is that it focuses a person's attention and involves it in an achievable, enjoyable activity. In a similar way, some people are able to bring the same sharp focus to their psychic energy throughout the entirety of their lives. The unrelated goals of the separate flow activities merge into an all-encompassing set of challenges that gives purpose to everything a person does. There are very different ways to establish this directionality. Napoleon devoted his life, and in the process gladly led to death hundreds of thousands of French soldiers, to the single-minded pursuit of power. Mother Teresa has invested all her energies to help the helpless, because her life has been given purpose by an unconditional love based on the belief in God, in a spiritual order beyond the reach of her senses.

From a purely psychological point of view, Napoleon and Mother Teresa may both have achieved equal levels of inner purpose, and therefore of optimal experience. The obvious differences between them prompt a broader ethical question: What have the consequences of

these two ways of giving meaning to life been? We might conclude that Napoleon brought chaos to thousands of lives, whereas Mother Teresa reduced the entropy in the consciousness of many. But here we will not try to pass judgment on the objective value of actions; we will be concerned instead with the more modest task of describing the subjective order that a unified purpose brings to individual consciousness. In this sense the answer to the old riddle "What is the meaning of life?" turns out to be astonishingly simple. The meaning of life *is* meaning: whatever it is, wherever it comes from, a unified purpose is what gives meaning to life.

The second sense of the word *meaning* refers to the expression of intentionality. And this sense also is appropriate to the issue of how to create meaning by transforming all life into a flow activity. It is not enough to find a purpose that unifies one's goals; one must also carry through and meet its challenges. The purpose must result in strivings; intent has to be translated into action. We may call this *resolution* in the pursuit of one's goals. What counts is not so much whether a person actually achieves what she has set out to do; rather, it matters whether effort has been expended to reach the goal, instead of being diffused or wasted. When "the native hue of resolution is sicklied o'er with the pale cast of thought," Hamlet observed, ". . . enterprises of great pith and moment . . . lose the name of action." Few things are sadder than encountering a person who knows exactly what he should do, yet cannot muster enough energy to do it. "He who desires but acts not," wrote Blake with his accustomed vigor, "breeds pestilence."

The third and final way in which life acquires meaning is the result of the previous two steps. When an important goal is pursued with resolution, and all one's varied activities fit together into a unified flow experience, the result is that *harmony* is brought to consciousness. Someone who knows his desires and works with purpose to achieve them is a person whose feelings, thoughts, and actions are congruent with one another, and is therefore a person who has achieved inner harmony. In the 1960s this process was called "getting your head together," but in practically every other historical period a similar concept has been used to describe this necessary step toward living a good life. Someone who is in harmony no matter what he does, no matter what is happening to him, knows that his psychic energy is not being wasted on doubt, regret, guilt, and fear, but is always usefully employed. Inner congruence ultimately leads to that inner strength and serenity we admire in people who seem to have come to terms with themselves.

Purpose, resolution, and harmony unify life and give it meaning

by transforming it into a seamless flow experience. Whoever achieves this state will never really lack anything else. A person whose consciousness is so ordered need not fear unexpected events, or even death. Every living moment will make sense, and most of it will be enjoyable. This certainly sounds desirable. So how does one attain it?

CULTIVATING PURPOSE

In the lives of many people it is possible to find a unifying purpose that justifies the things they do day in, day out—a goal that like a magnetic field attracts their psychic energy, a goal upon which all lesser goals depend. This goal will define the challenges that a person needs to face in order to transform his or her life into a flow activity. Without such a purpose, even the best-ordered consciousness lacks meaning.

Throughout human history innumerable attempts have been made to discover ultimate goals that would give meaning to experience. These attempts have often been very different from one another. For instance, in the ancient Greek civilization, according to the social philosopher Hannah Arendt, men sought to achieve immortality through heroic deeds, whereas in the Christian world men and women hoped to reach eternal life through saintly deeds. Ultimate goals, in Arendt's opinion, must accommodate the issue of mortality: they must give men and women a purpose that extends beyond the grave. Both immortality and eternity accomplish this, but in very different ways. The Greek heroes performed noble deeds so as to attract the admiration of their peers, expecting that their highly personal acts of bravery would be passed on in songs and stories from generation to generation. Their identity, therefore, would continue to exist in the memory of their descendants. Saints, on the contrary, surrendered individuality so as to merge their thoughts and actions with the will of God, expecting to live forever after in union with Him. The hero and the saint, to the extent that they dedicated the totality of their psychic energy to an all-encompassing goal that prescribed a coherent pattern of behavior to follow until death, turned their lives into unified flow experiences. Other members of society ordered their own less exalted actions on these outstanding models, providing a less clear, but more or less adequate, meaning to their own lives.

Every human culture, by definition, contains meaning systems that can serve as the encompassing purpose by which individuals can order their goals. For instance, Pitrim Sorokin divided the various epochs of Western civilization into three types, which he believed have

alternated with one another for over twenty-five centuries, sometimes lasting hundreds of years, sometimes just a few decades. He called these the *sensate*, the *ideational*, and the *idealistic* phases of culture, and he attempted to demonstrate that in each one a different set of priorities justified the goals of existence.

Sensate cultures are integrated around views of reality designed to satisfy the senses. They tend to be epicurean, utilitarian, concerned primarily with concrete needs. In such cultures art, religion, philosophy, and everyday behavior glorify and justify goals in terms of tangible experience. According to Sorokin, sensate culture predominated in Europe from about 440 to about 200 B.C., with a peak between 420 and 400 B.C.; it has become dominant once again in the past century or so, at least in the advanced capitalist democracies. People in a sensate culture are not necessarily more materialistic, but they organize their goals and justify their behavior with reference primarily to pleasure and practicality rather than to more abstract principles. The challenges they see are almost exclusively concerned with making life more easy, more comfortable, more pleasant. They tend to identify the good with what feels good and mistrust idealized values.

Ideational cultures are organized on a principle opposite from the sensate: they look down on the tangible and strive for nonmaterial, supernatural ends. They emphasize abstract principles, asceticism, and transcendence of material concerns. Art, religion, philosophy, and the justification of everyday behavior tend to be subordinated to the realization of this spiritual order. People turn their attention to religion or ideology, and view their challenges not in terms of making life easier, but of reaching inner clarity and conviction. Greece from 600 to 500 B.C., and Western Europe from 200 B.C. to A.D. 400 are the high points of this worldview, according to Sorokin. More recent and disturbing examples might include the Nazi interlude in Germany, the communist regimes in Russia and China, and the Islamic revival in Iran.

A simple example may illustrate the difference between cultures organized around sensate and ideational principles. In our own as well as in fascist societies physical fitness is cherished and the beauty of the human body worshiped. But the reasons for doing so are very different. In our sensate culture, the body is cultivated in order to achieve health and pleasure. In an ideational culture, the body is valued primarily as a symbol of some abstract principle of metaphysical perfection associated with the idea of the "Aryan race," or "Roman valor." In a sensate culture, a poster of a handsome youth might produce a sexual response to be used for commercial ends. In an ideational culture, the

same poster would make an ideological statement, and be used for political ends.

Of course, at no time does any group of people shape its purpose through only one of these two ways of ordering experience to the exclusion of the other. At any given moment, various subtypes and combinations of the sensate and the ideational worldview may coexist in the same culture, and even in the consciousness of the same individual. The so-called yuppie life-style, for instance, is based primarily on sensate principles, while Bible Belt fundamentalism rests on ideational premises. These two forms, in their many variants, coexist somewhat uneasily in our current social system. And either one, functioning as a system of goals, can help to organize life into a coherent flow activity.

Not only cultures but individuals as well embody these meaning systems in their behavior. Business leaders like Lee Iacocca or H. Ross Perot, whose lives are ordered by concrete entrepreneurial challenges, often display the best features of the sensate approach to life. The more primitive aspects of the sensate worldview are represented by someone like Hugh Hefner, whose "playboy philosophy" celebrates the simpleminded pursuit of pleasure. Representatives of an unreflective ideational approach include ideologues and mystics who advocate simple transcendental solutions, such as blind faith in divine providence. There are, of course, many different permutations and combinations: televangelists like the Bakkers or Jimmy Swaggart publicly exhort their audience to value ideational goals, while in private indulging in luxury and sensuality.

Occasionally a culture succeeds in integrating these two dialectically opposed principles into a convincing whole that preserves the advantages of both, while neutralizing the disadvantages of each. Sorokin calls these cultures "idealistic." They combine an acceptance of concrete sensory experience with a reverence for spiritual ends. In Western Europe the late Middle Ages and the Renaissance were classified by Sorokin as being relatively most idealistic, with the highest points reached in the first two decades of the fourteenth century. Needless to say, the idealistic solution seems to be the preferable one, as it avoids the listlessness that is often the keynote of purely materialistic worldviews and the fanatical asceticism that bedevils many ideational systems.

Sorokin's simple trichotomy is a debatable method of categorizing cultures, but it is useful in illustrating some of the principles by which men and women end up ordering their ultimate goals. The sensate option is always quite popular. It involves responding to concrete challenges, and shaping one's life in terms of a flow activity that tends toward

material ends. Among its advantages is the fact that the rules are comprehended by everyone and that feedback tends to be clear—the desirability of health, money, power, and sexual satisfaction is seldom controversial. But the ideational option also has its advantages: metaphysical goals may never be achieved, but then failure is almost impossible to prove: the true believer can always distort feedback to use it as a proof that he has been right, that he is among the chosen. Probably the most satisfying way to unify life into an all-embracing flow activity is through the idealistic mode. But setting challenges that involve the improvement of material conditions while at the same time pursuing spiritual ends is not easy, especially when the culture as a whole is predominantly sensate in character.

Another way to describe how individuals order their actions is to focus on the complexity of the challenges they set for themselves rather than on their content. Perhaps what matters most is not whether a person is materialist or ideational, but how differentiated and integrated are the goals he or she pursues in those areas. As was discussed in the final section of chapter 2, complexity depends on how well a system develops its unique traits and potentialities and on how well related these traits are to each other. In that respect, a well-thought-out sensate approach to life, one that was responsive to a great variety of concrete human experiences and was internally consistent, would be preferable to an unreflective idealism, and vice versa.

There is a consensus among psychologists who study such subjects that people develop their concept of who they are, and of what they want to achieve in life, according to a sequence of steps. Each man or woman starts with a need to preserve the self, to keep the body and its basic goals from disintegrating. At this point the meaning of life is simple; it is tantamount to survival, comfort, and pleasure. When the safety of the physical self is no longer in doubt, the person may expand the horizon of his or her meaning system to embrace the values of a community—the family, the neighborhood, a religious or ethnic group. This step leads to a greater complexity of the self, even though it usually implies conformity to conventional norms and standards. The next step in development involves reflective individualism. The person again turns inward, finding new grounds for authority and value within the self. He or she is no longer blindly conforming, but develops an autonomous conscience. At this point the main goal in life becomes the desire for growth, improvement, the actualization of potential. The fourth step, which builds on all the previous ones, is a final turning away from the self, back toward an integration with other people and with universal

values. In this final stage the extremely individualized person—like Siddhartha letting the river take control of his boat—willingly merges his interests with those of a larger whole.

In this scenario building a complex meaning system seems to involve focusing attention alternately on the self and on the Other. First, psychic energy is invested in the needs of the organism, and psychic order is equivalent to pleasure. When this level is temporarily achieved, and the person can begin to invest attention in the goals of a community, what is meaningful corresponds to group values—religion, patriotism, and the acceptance and respect of other people provide the parameters of inner order. The next movement of the dialectic brings attention back to the self: having achieved a sense of belonging to a larger human system, the person now feels the challenge of discerning the limits of personal potential. This leads to attempts at self-actualization, to experimentation with different skills, different ideas and disciplines. At this stage enjoyment, rather than pleasure, becomes the main source of rewards. But because this phase involves becoming a seeker, the person may also encounter a midlife crisis, a career change, and an increasingly desperate straining against the limitations of individual capability. From this point on the person is ready for the last shift in the redirection of energy: having discovered what one can and, more important, cannot do alone, the ultimate goal merges with a system larger than the person—a cause, an idea, a transcendental entity.

Not everyone moves through the stages of this spiral of ascending complexity. A few never have the opportunity to go beyond the first step. When survival demands are so insistent that a person cannot devote much attention to anything else, he or she will not have enough psychic energy left to invest in the goals of the family or of the wider community. Self-interest alone will give meaning to life. The majority of people are probably ensconced comfortably in the second stage of development, where the welfare of the family, or the company, the community, or the nation are the sources of meaning. Many fewer reach the third level of reflective individualism, and only a precious few emerge once again to forge a unity with universal values. So these stages do not necessarily reflect what does happen, or what will happen; they characterize what *can* happen if a person is lucky and succeeds in controlling consciousness.

The four stages outlined above are the simplest of the models for describing the emergence of meaning along a gradient of complexity; other models detail six, or even eight, stages. The number of steps is irrelevant; what counts is that most theories recognize the importance

of this dialectic tension, this alternation between differentiation on the one hand and integration on the other. From this point of view, individual life appears to consist of a series of different "games," with different goals and challenges, that change with time as a person matures. Complexity requires that we invest energy in developing whatever skills we were born with, in becoming autonomous, self-reliant, conscious of our uniqueness and of its limitations. At the same time we must invest energy in recognizing, understanding, and finding ways to adapt to the forces beyond the boundaries of our own individuality. Of course we don't *have* to undertake any of these plans. But if we don't, chances are, sooner or later, we will regret it.

FORGING RESOLVE

Purpose gives direction to one's efforts, but it does not necessarily make life easier. Goals can lead into all sorts of trouble, at which point one gets tempted to give them up and find some less demanding script by which to order one's actions. The price one pays for changing goals whenever opposition threatens is that while one may achieve a more pleasant and comfortable life, it is likely that it will end up empty and void of meaning.

The Pilgrims who first settled this country decided that the freedom to worship according to their conscience was necessary to maintain the integrity of their selves. They believed that nothing mattered more than maintaining control over their relationship with the supreme being. Theirs was not a novel choice for an ultimate goal by which to order one's life—many other people had done so previously. What distinguished the Pilgrims was that—like the Jews of Masada, the Christian martyrs, the Cathars of southern France in the late Middle Ages who had chosen similarly—they did not allow persecution and hardship to blunt their resolve. Instead they followed the logic of their convictions wherever it led, acting *as if* their values were worth giving up comfort, and even life itself, for. And because they acted thus, their goals in fact *became* worthwhile regardless of whether they had been originally valuable. Because their goals had become valuable through commitment, they helped give meaning to the Pilgrims' existence.

No goal can have much effect unless taken seriously. Each goal prescribes a set of consequences, and if one isn't prepared to reckon with them, the goal becomes meaningless. The mountaineer who decides to scale a difficult peak knows that he will be exhausted and endangered for most of the climb. But if he gives up too easily, his quest will be

revealed as having little value. The same is true of all flow experiences: there is a mutual relationship between goals and the effort they require. Goals justify the effort they demand at the outset, but later it is the effort that justifies the goal. One gets married because the spouse seems worthy of sharing one's life with, but unless one then behaves as if this is true, the partnership will appear to lose value with time.

All things considered, it cannot be said that humankind has lacked the courage to back its resolutions. Billions of parents, in every age and in every culture, have sacrificed themselves for their children, and thereby made life more meaningful for themselves. Probably as many have devoted all their energies to preserving their fields and their flocks. Millions more have surrendered everything for the sake of their religion, their country, or their art. For those who have done so consistently, despite pain and failure, life as a whole had a chance to become like an extended episode of flow: a focused, concentrated, internally coherent, logically ordered set of experiences, which, because of its inner order, was felt to be meaningful and enjoyable.

But as the complexity of culture evolves, it becomes more difficult to achieve this degree of total resolve. There are simply too many goals competing for prominence, and who is to say which one is worth the dedication of an entire life? Just a few decades ago a woman felt perfectly justified in placing the welfare of her family as her ultimate goal. Partly this was due to the fact that she did not have many other options. Today, now that she can be a businessperson, a scholar, an artist, or even a soldier, it is no longer "obvious" that being a wife and mother should be a woman's first priority. The same embarrassment of riches affects us all. Mobility has freed us from ties to our birthplaces: there is no longer any reason to become involved in one's native community, to identify with one's place of birth. If the grass looks greener across the fence, we simply move to the other field—How about opening that little restaurant in Australia? Life-styles and religions are choices that are easily switched. In the past a hunter was a hunter until he died, a blacksmith spent his life perfecting his craft. We can now shed our occupational identities at will: no one needs to remain an accountant forever.

The wealth of options we face today has extended personal freedom to an extent that would have been inconceivable even a hundred years ago. But the inevitable consequence of equally attractive choices is uncertainty of purpose; uncertainty, in turn, saps resolution, and lack of resolve ends up devaluing choice. Therefore freedom does not necessarily help develop meaning in life—on the contrary. If the rules of a

game become too flexible, concentration flags, and it is more difficult to attain a flow experience. Commitment to a goal and to the rules it entails is much easier when the choices are few and clear.

This is not to imply that a return to the rigid values and limited choices of the past would be preferable—even if that were a possibility, which it is not. The complexity and freedom that have been thrust upon us, and that our ancestors had fought so hard to achieve, are a challenge we must find ways to master. If we do, the lives of our descendants will be infinitely more enriched than anything previously experienced on this planet. If we do not, we run the risk of frittering away our energies on contradictory, meaningless goals.

But in the meantime how do we know where to invest psychic energy? There is no one *out there* to tell us, "Here is a goal worth spending your life on." Because there is no absolute certainty to which to turn, each person must discover ultimate purpose on his or her own. Through trial and error, through intense cultivation, we can straighten out the tangled skein of conflicting goals, and choose the one that will give purpose to action.

Self-knowledge—an ancient remedy so old that its value is easily forgotten—is the process through which one may organize conflicting options. "Know thyself" was carved over the entrance to the Delphic oracle, and ever since untold pious epigrams have extolled its virtue. The reason the advice is so often repeated is that it works. We need, however, to rediscover afresh every generation what these words mean, what the advice actually implies for each individual. And to do that it is useful to express it in terms of current knowledge, and envision a contemporary method for its application.

Inner conflict is the result of competing claims on attention. Too many desires, too many incompatible goals struggle to marshal psychic energy toward their own ends. It follows that the only way to reduce conflict is by sorting out the essential claims from those that are not, and by arbitrating priorities among those that remain. There are basically two ways to accomplish this: what the ancients called the *vita activa,* a life of action, and the *vita contemplativa,* or the path of reflection.

Immersed in the *vita activa,* a person achieves flow through total involvement in concrete external challenges. Many great leaders like Winston Churchill or Andrew Carnegie set for themselves lifelong goals that they pursued with great resolve, without any apparent internal struggle or questioning of priorities. Successful executives, experienced professionals, and talented craftspeople learn to trust their judgment and competence so that they again begin to act with the unselfconscious

spontaneity of children. If the arena for action is challenging enough, a person may experience flow continuously in his or her calling, thus leaving as little room as possible for noticing the entropy of normal life. In this way harmony is restored to consciousness indirectly—not by facing up to contradictions and trying to resolve conflicting goals and desires, but by pursuing chosen goals with such intensity that all potential competition is preempted.

Action helps create inner order, but it has its drawbacks. A person strongly dedicated to achieving pragmatic ends might eliminate internal conflict, but often at the price of excessively restricting options. The young engineer who aims to become plant manager at age forty-five and bends all his energies to that end may sail through several years successfully and without hesitation. Sooner or later, however, postponed alternatives may reappear again as intolerable doubts and regrets. Was it worth sacrificing my health for the promotion? What happened to those lovely children who have suddenly turned into sullen adolescents? Now that I have achieved power and financial security, what do I do with it? In other words, the goals that have sustained action over a period turn out not to have enough power to give meaning to the entirety of life.

This is where the presumed advantage of a contemplative life comes in. Detached reflection upon experience, a realistic weighing of options and their consequences, have long been held to be the best approach to a good life. Whether it is played out on the psychoanalyst's couch, where repressed desires are laboriously reintegrated with the rest of consciousness, or whether it is performed as methodically as the Jesuits' test of conscience, which involves reviewing one's actions one or more times each day to check whether what one has been doing in the past few hours has been consistent with long-term goals, self-knowledge can be pursued in innumerable ways, each leading potentially to greater inner harmony.

Activity and reflection should ideally complement and support each other. Action by itself is blind, reflection impotent. Before investing great amounts of energy in a goal, it pays to raise the fundamental questions: Is this something I really want to do? Is it something I enjoy doing? Am I likely to enjoy it in the foreseeable future? Is the price that I—and others—will have to pay worth it? Will I be able to live with myself if I accomplish it?

These seemingly easy questions are almost impossible to answer for someone who has lost touch with his own experience. If a man has not bothered to find out what he wants, if his attention is so wrapped up in external goals that he fails to notice his own feelings, then he

cannot plan action meaningfully. On the other hand, if the habit of reflection is well developed, a person need not go through a lot of soul-searching to decide whether a course of action is entropic or not. He will know, almost intuitively, that this promotion will produce more stress than it is worth, or that this particular friendship, attractive as it is, would lead to unacceptable tensions in the context of marriage.

It is relatively easy to bring order to the mind for short stretches of time; any realistic goal can accomplish this. A good game, an emergency at work, a happy interlude at home will focus attention and produce the harmonious experience of flow. But it is much more difficult to extend this state of being through the entirety of life. For this it is necessary to invest energy in goals that are so persuasive that they justify effort even when our resources are exhausted and when fate is merciless in refusing us a chance at having a comfortable life. If goals are well chosen, and if we have the courage to abide by them despite opposition, we shall be so focused on the actions and events around us that we won't have the time to be unhappy. And then we shall directly feel a sense of order in the warp and the woof of life that fits every thought and emotion into a harmonious whole.

RECOVERING HARMONY

The consequence of forging life by purpose and resolution is a sense of inner harmony, a dynamic order in the contents of consciousness. But, it may be argued, why should it be so difficult to achieve this inner order? Why should one strive so hard to make life into a coherent flow experience? Aren't people born at peace with themselves—isn't human nature naturally ordered?

The original condition of human beings, prior to the development of self-reflective consciousness, must have been a state of inner peace disturbed only now and again by tides of hunger, sexuality, pain, and danger. The forms of psychic entropy that currently cause us so much anguish—unfulfilled wants, dashed expectations, loneliness, frustration, anxiety, guilt—are all likely to have been recent invaders of the mind. They are by-products of the tremendous increase in complexity of the cerebral cortex and of the symbolic enrichment of culture. They are the dark side of the emergence of consciousness.

If we were to interpret the lives of animals with a human eye, we would conclude that they are in flow most of the time because their perception of what has to be done generally coincides with what they are prepared to do. When a lion feels hungry, it will start grumbling and

looking for prey until its hunger is satisfied; afterward it lies down to basking in the sun, dreaming the dreams lions dream. There is no reason to believe that it suffers from unfulfilled ambition, or that it is overwhelmed by pressing responsibilities. Animals' skills are always matched to concrete demands because their minds, such as they are, only contain information about what is actually present in the environment *in relation to* their bodily states, as determined by instinct. So a hungry lion only perceives what will help it to find a gazelle, while a sated lion concentrates fully on the warmth of the sun. Its mind does not weigh possibilities unavailable at the moment; it neither imagines pleasant alternatives, nor is it disturbed by fears of failure.

Animals suffer just as we do when their biologically programmed goals are frustrated. They feel the pangs of hunger, pain, and unsatisfied sexual urges. Dogs bred to be friends to man grow distraught when left alone by their masters. But animals other than man are not in a position to be the cause of their own suffering; they are not evolved enough to be able to feel confusion and despair even after all their needs are satisfied. When free of externally induced conflicts, they are in harmony with themselves and experience the seamless concentration that in people we call flow.

The psychic entropy peculiar to the human condition involves seeing more to do than one can actually accomplish and feeling able to accomplish more than what conditions allow. But this becomes possible only if one keeps in mind more than one goal at a time, being aware at the same time of conflicting desires. It can happen only when the mind knows not only what *is* but also what *could be.* The more complex any system, the more room it leaves open for alternatives, and the more things can go wrong with it. This is certainly applicable to the evolution of the mind: as it has increased its power to handle information, the potential for inner conflict has increased as well. When there are too many demands, options, challenges, we become anxious; when too few, we get bored.

To pursue the evolutionary analogy, and to extend it from biological to social evolution, it is probably true that in less developed cultures, where the number and complexity of social roles, of alternative goals and courses of action, are negligible, the chances for experiencing flow are greater. The myth of the "happy savage" is based on the observation that when free of external threats, preliterate people often display a serenity that seems enviable to the visitor from more differentiated cultures. But the myth tells only half the story: when hungry or hurting, the "savage" is no more happy than we would be; and he may be in that

condition more often than we are. The inner harmony of technologically less advanced people is the positive side of their limited choices and of their stable repertory of skills, just as the confusion in our soul is the necessary consequence of unlimited opportunities and constant perfectibility. Goethe represented this dilemma in the bargain Doctor Faustus, the archetype of modern man, made with Mephistopheles: the good doctor gained knowledge and power, but at the price of introducing disharmony in his soul.

There is no need to visit far-off lands to see how flow can be a natural part of living. Every child, before self-consciousness begins to interfere, acts spontaneously with total abandon and complete involvement. Boredom is something children have to learn the hard way, in response to artificially restricted choices. Again, this does not mean that children are always happy. Cruel or neglectful parents, poverty and sickness, the inevitable accidents of living make children suffer intensely. But a child is rarely unhappy without good reason. It is understandable that people tend to be so nostalgic about their early years; like Tolstoy's Ivan Ilyich, many feel that the wholehearted serenity of childhood, the undivided participation in the here and now, becomes increasingly difficult to recapture as the years go by.

When we can imagine only few opportunities and few possibilities, it is relatively easy to achieve harmony. Desires are simple, choices clear. There is little room for conflict and no need to compromise. This is the order of simple systems—order by default, as it were. It is a fragile harmony; step by step with the increase of complexity, the chances of entropy generated internally by the system increase as well.

We can isolate many factors to account for why consciousness gets to be more complex. At the level of the species, the biological evolution of the central nervous system is one cause. No longer ruled entirely by instincts and reflexes, the mind is endowed with the dubious blessing of choice. At the level of human history, the development of culture—of languages, belief systems, technologies—is another reason why the contents of the mind become differentiated. As social systems move from dispersed hunting tribes to crowded cities, they give rise to more specialized roles that often require conflicting thoughts and actions from the same person. No longer is every man a hunter, sharing skills and interests with every other man. The farmer and the miller, the priest and the soldier now see the world differently from one another. There is no one right way to behave, and each role requires different skills. Within the individual life span as well, each person becomes exposed with age to increasingly contradictory goals, to incompatible opportunities for ac-

tion. A child's options are usually few and coherent; with each year, they become less so. The earlier clarity that made spontaneous flow possible is obscured by a cacophony of disparate values, beliefs, choices, and behaviors.

Few would argue that a simpler consciousness, no matter how harmonious, is preferable to a more complex one. While we might admire the serenity of the lion in repose, the tribesman's untroubled acceptance of his fate, or the child's wholehearted involvement in the present, they cannot offer a model for resolving our predicament. The order based on innocence is now beyond our grasp. Once the fruit is plucked from the tree of knowledge, the way back to Eden is barred forever.

THE UNIFICATION OF MEANING IN LIFE THEMES

Instead of accepting the unity of purpose provided by genetic instructions or by the rules of society, the challenge for us is to create harmony based on reason and choice. Philosophers like Heidegger, Sartre, and Merleau-Ponty have recognized this task of modern man by calling it the *project,* which is their term for the goal-directed actions that provide shape and meaning to an individual's life. Psychologists have used terms like *propriate strivings* or *life themes.* In each case, these concepts identify a set of goals linked to an ultimate goal that gives significance to whatever a person does.

The life theme, like a game that prescribes the rules and actions one must follow to experience flow, identifies what will make existence enjoyable. With a life theme, everything that happens will have a meaning—not necessarily a positive one, but a meaning nevertheless. If a person bends all her energies to making a million dollars before age thirty, whatever happens is a step either toward or away from that goal. The clear feedback will keep her involved with her actions. Even if she loses all her money, her thoughts and actions are tied by a common purpose, and they will be experienced as worthwhile. Similarly a person who decides that finding a cure for cancer is what she wants to accomplish above all else will usually know whether she is getting closer to her goal or not—in either case, what must be done is clear, and whatever she does will make sense.

When a person's psychic energy coalesces into a life theme, consciousness achieves harmony. But not all life themes are equally productive. Existential philosophers distinguish between *authentic* and *inau-*

thentic projects. The first describes the theme of a person who realizes that choices are free, and makes a personal decision based on a rational evaluation of his experience. It does not matter what the choice is, as long as it is an expression of what the person genuinely feels and believes. Inauthentic projects are those a person chooses because they are what she feels ought to be done, because they are what everybody else is doing, and therefore there is no alternative. Authentic projects tend to be intrinsically motivated, chosen for what they are worth in themselves; inauthentic ones are motivated by external forces. A similar distinction is that between *discovered* life themes, when a person writes the script for her actions out of personal experience and awareness of choice; and *accepted* life themes, when a person simply takes on a predetermined role from a script written long ago by others.

Both types of life themes help give meaning to life, but each has drawbacks. The accepted life theme works well as long as the social system is sound; if it is not, it can trap the person into perverted goals. Adolf Eichmann, the Nazi who calmly shipped tens of thousands to the gas chambers, was a man for whom the rules of bureaucracy were sacred. He probably experienced flow as he shuffled the intricate schedules of trains, making certain that the scarce rolling stock was available where needed, and that the bodies were transported at the least expense. He never seemed to question whether what he was asked to do was right or wrong. As long as he followed orders, his consciousness was in harmony. For him the meaning of life was to be part of a strong, organized institution; nothing else mattered. In peaceful, well-ordered times a man like Adolf Eichmann might have been an esteemed pillar of the community. But the vulnerability of his life theme becomes apparent when unscrupulous and demented people seize control of society; then such an upright citizen turns into an accessory to crimes without having to change his goals, and without even realizing the inhumanity of his actions.

Discovered life themes are fragile for a different reason: because they are products of a personal struggle to define the purpose of life, they have less social legitimacy; because they are often novel and idiosyncratic, they may be regarded by others as crazy or destructive. Some of the most powerful life themes are based on ancient human goals, but freshly discovered and freely chosen by the individual. Malcolm X, who in his early life followed the behavioral script for young men in the slum, fighting and dealing drugs, discovered in jail, through reading and reflection, a different set of goals through which to achieve dignity and self-respect. In essence he invented an entirely new identity, although

one that was made up of bits and pieces of earlier human achievements. Instead of continuing to play the game of hustlers and pimps, he created a more complex purpose that could help order the lives of many other marginal men, black or white.

A man interviewed in one of our studies whom we shall designate as E. provides another example of how a life theme can be discovered, even though the purpose underlying it is a very ancient one. E. grew up the son of a poor immigrant family in the early part of this century. His parents knew only a few words of English, and were barely able to read and write. They were intimidated by the frenetic pace of life in New York, but they worshiped and admired America and the authorities who represented it. When he was seven, E.'s parents spent a good chunk of their savings to buy him a bicycle for his birthday. A few days later, as he was riding in the neighborhood, he was hit by a car that had ignored a stop sign. E. suffered serious wounds, and his bike was wrecked. The driver of the car was a wealthy doctor; he drove E. to a hospital, asking him not to report what had happened, but promising in return to pay for all expenses and to buy him a new bike. E. and his parents were convinced, and they went along with the deal. Unfortunately the doctor never showed up again, and E.'s father had to borrow money to pay the expensive hospital bill; the bike was never replaced.

This event could have been a trauma that left its scar on E. forever, turning him into a cynic who would from now on look out for his own self-interest no matter what. Instead E. drew a curious lesson from his experience. He used it to create a life theme that not only gave meaning to his own life but helped reduce entropy in the experience of many other people. For many years after the accident, E. and his parents were bitter, suspicious, and confused about the intentions of strangers. E.'s father, feeling that he was a failure, took to drinking and became morose and withdrawn. It looked as though poverty and helplessness were having their expected effects. But when he was fourteen or fifteen years old, E. had to read in school the U.S. Constitution and the Bill of Rights. He connected the principles in those documents with his own experience. Gradually he became convinced that his family's poverty and alienation were not their fault, but were the result of not being aware of their rights, of not knowing the rules of the game, of not having effective representation among those who had power.

He decided to become a lawyer, not only to better his own life, but to make certain that injustices such as he had suffered would not occur so easily again to others in his position. Once he had set this goal for himself, his resolution was unwavering. He was accepted into law

school, clerked for a famous justice, became a judge himself, and at the zenith of his career spent years in the cabinet helping the president develop stronger civil rights policies and legislation to help the disadvantaged. Until the end of his life his thoughts, actions, and feelings were unified by the theme he had chosen as a teenager. Whatever he did to the end of his days was part of one great game, held together by goals and rules he had agreed to abide by. He felt his life had meaning, and enjoyed confronting the challenges that came his way.

E.'s example illustrates several common characteristics of how people forge discovered life themes. In the first place, the theme is in many cases a *reaction to a great personal hurt suffered in early life*—to being orphaned, abandoned, or treated unjustly. But what matters is not the trauma per se; the external event never determines what the theme will be. What matters is the interpretation that one places on the suffering. If a father is a violent alcoholic, his children have several options for explaining what is wrong: they can tell themselves that the father is a bastard who deserves to die; that he is a man, and all men are weak and violent; that poverty is the cause of the father's affliction, and the only way to avoid his fate is to become rich; that a large part of his behavior is due to helplessness and lack of education. Only the last of these equally likely explanations leads in the direction of a life theme such as E. was able to develop.

So the next question is, What kinds of explanations for one's suffering lead to negentropic life themes? If a child abused by a violent father concluded that the problem was inherent in human nature, that all men were weak and violent, there would not be much he or she could do about it. How could a child change human nature? To find purpose in suffering one must interpret it as a *possible challenge*. In this case, by formulating his problem as being due to the helplessness of disenfranchised minorities, and not to his father's faults, E. was able *to develop appropriate skills*—his legal training—to confront the challenges he saw at the root of what had been wrong in his personal life. What transforms the consequences of a traumatic event into a challenge that gives meaning to life is what in the previous chapter was called a *dissipative structure*, or the ability to draw order from disorder.

Finally, a complex, negentropic life theme is rarely formulated as the response to just a personal problem. Instead, *the challenge becomes generalized to other people, or to mankind as a whole.* For example, in E.'s case, he attributed the problem of helplessness not only to himself or to his own family but to all poor immigrants in the same situation as his parents had been. Thus whatever solution he found to his own

problems would benefit not only himself, but many others besides. This altruistic way of generalizing solutions is typical of negentropic life themes; it brings harmony to the lives of many.

Gottfried, another one of the men interviewed by our University of Chicago team, provides a similar example. As a child Gottfried was very close to his mother, and his memories of those early years are sunny and warm. But before he turned ten, his mother developed cancer, and died in great pain. The young boy could have felt sorry for himself and become depressed, or he could have adopted hardened cynicism as a defense. Instead he began to think of the disease as his personal enemy, and swore to defeat it. In time he earned a medical degree and became a research oncologist, and the results of his work have become part of the pattern of knowledge that eventually will free mankind of this scourge. In this case, again, a personal tragedy became transformed into a challenge that can be met. In developing skills to meet that challenge, the individual improves the lives of other people.

Ever since Freud, psychologists have been interested in explaining how early childhood trauma leads to adult psychic dysfunction. This line of causation is fairly easy to understand. More difficult to explain, and more interesting, is the opposite outcome: the instances when suffering gives a person the incentive to become a great artist, a wise statesman, or a scientist. If one assumes that external events must determine psychic outcomes, then it makes sense to see the neurotic response to suffering as normal, and the constructive response as "defense" or "sublimation." But if one assumes that people have a choice in how they respond to external events, in what meaning they attribute to suffering, then one can interpret the constructive response as normal and the neurotic one as a failure to rise to the challenge, as a breakdown in the ability to flow.

What makes some people able to develop a coherent purpose, while others struggle through an empty or meaningless life? There is no simple answer, of course, because whether a person will discover a harmonious theme in the apparent chaos of experience is influenced by many factors, both internal and external. It is easier to doubt that life makes sense if one is born deformed, poor, and oppressed. But even here, this is not inevitably the case: Antonio Gramsci, the philosopher of humane socialism and a man who left a profound mark on recent European thought, was born a hunchback in a miserable peasant hovel. As he was growing up, his father was jailed for many years (unjustly, as it turned out), and the family could barely survive from day to day. Antonio was so sickly as a child that for years his mother is said to have dressed him in his best clothes every evening and laid him out to sleep

in a coffin, expecting him to be dead by morning. Altogether, it was not a very promising start. Yet despite these and many other handicaps Gramsci struggled to survive and even succeeded in getting himself an education. And he did not stop when he achieved a modest security as a teacher, for he had decided that what he really wanted from life was to struggle against the social conditions that broke his mother's health and destroyed his father's honor. He ended up being a university professor, a deputy in parliament, and one of the most fearless leaders against fascism. Until the very end, before he finally died in one of Mussolini's prisons, he wrote beautiful essays about the wonderful world that could be ours if we stopped being fearful and greedy.

There are so many examples of this type of personality that one certainly cannot assume a direct causal relation between external disorder in childhood and internal lack of meaning later in life: Thomas Edison as a child was sickly, poor, and believed to be retarded by his teacher; Eleanor Roosevelt was a lonely, neurotic young girl; Albert Einstein's early years were filled with anxieties and disappointments— yet they all ended up inventing powerful and useful lives for themselves.

If there is a strategy shared by these and by other people who succeed in building meaning into their experience, it is one so simple and obvious that it is almost embarrassing to mention. Yet because it is so often overlooked, especially nowadays, it will be valuable to review it. The strategy consists in extracting from the order achieved by past generations patterns that will help avoid disorder in one's own mind. There is much knowledge—or well-ordered information—accumulated in culture, ready for this use. Great music, architecture, art, poetry, drama, dance, philosophy, and religion are there for anyone to see as examples of how harmony can be imposed on chaos. Yet so many people ignore them, expecting to create meaning in their lives by their own devices.

To do so is like trying to build up material culture from scratch in each generation. No one in his right mind would want to start reinventing the wheel, fire, electricity, and the million objects and processes that we now take for granted as part of the human environment. Instead we learn how to make these things by receiving ordered information from teachers, from books, from models, so as to benefit from the knowledge of the past and eventually surpass it. To discard the hard-won information on how to live accumulated by our ancestors, or to expect to discover a viable set of goals all by oneself, is misguided hubris. The chances of success are about as good as in trying to build an electron microscope without the tools and knowledge of physics.

People who as adults develop coherent life themes often recall that

when they were very young, their parents told them stories and read from books. When told by a loving adult whom one trusts, fairy tales, biblical stories, heroic historical deeds, and poignant family events are often the first intimations of meaningful order a person gleans from the experience of the past. In contrast, we found in our studies that individuals who never focus on any goal, or accept one unquestioningly from the society around them, tend not to remember their parents having read or told stories to them as children. Saturday morning kiddie shows on television, with their pointless sensationalism, are unlikely to achieve the same purpose.

Whatever one's background, there are still many opportunities later on in life to draw meaning from the past. Most people who discover complex life themes remember either an older person or a historical figure whom they greatly admired and who served as a model, or they recall having read a book that revealed new possibilities for action. For instance, a now famous social scientist, widely respected for his integrity, tells how when he was in his early teens he read *A Tale of Two Cities*, and was so impressed by the social and political chaos Dickens described—which echoed the turmoil his parents had experienced in Europe after World War I—that he decided then and there that he would spend his life trying to understand why people made life miserable for one another. Another young boy, reared in a harsh orphanage, thought to himself, after reading by chance a Horatio Alger story in which a similarly poor and lonely youth makes his way in life by dint of hard work and good luck, "If he could do it, why not me?" Today this person is a retired banker well known for his philanthropy. Others remember being changed forever by the rational order of the Platonic *Dialogues* or by the courageous acts of characters in a science fiction story.

At its best, literature contains ordered information about behavior, models of purpose, and examples of lives successfully patterned around meaningful goals. Many people confronted with the randomness of existence have drawn hope from the knowledge that others before them had faced similar problems, and had been able to prevail. And this is just literature; what about music, art, philosophy, and religion?

Occasionally I run a seminar for business managers on the topic of how to handle the midlife crisis. Many of these successful executives, having risen as far as they are likely to advance in their organizations, and often with their family and private lives in disarray, welcome the opportunity to spend some time thinking about what they want to do next. For years I have relied on the best theories and research results

in developmental psychology for the lectures and discussions. I was reasonably content with how these seminars worked out, and the participants usually felt that they had learned something useful. But I was never quite satisfied that the material made enough sense.

Finally it occurred to me to try something more unusual. I would begin the seminar with a quick review of Dante's *Divina Commedia*. After all, written over six hundred years ago, this was the earliest description I knew of a midlife crisis and its resolution. "In the middle of the journey of our life," writes Dante in the first line of his enormously long and rich poem, "I found myself inside a dark forest, for the right way I had completely lost." What happens afterward is a gripping and in many ways still relevant account of the difficulties to be encountered in middle age.

First of all, wandering in the dark forest, Dante realizes that three fierce beasts are stalking him, licking their chops in anticipation. They are a lion, a lynx, and a she-wolf—representing, among other things, ambition, lust, and greed. As for the contemporary protagonist of one of the bestsellers of 1988, the middle-aged New York bond trader in Tom Wolfe's *Bonfire of the Vanities*, Dante's nemesis turns out to be the desire for power, sex, and money. To avoid being destroyed by them, Dante tries to escape by climbing a hill. But the beasts keep drawing nearer, and in desperation Dante calls for divine help. His prayer is answered by an apparition: it is the ghost of Virgil, a poet who died more than a thousand years before Dante was born, but whose wise and majestic verse Dante admired so much that he thought of the poet as his mentor. Virgil tries to reassure Dante: The good news is that there is a way out of the dark forest. The bad news is that the way leads through hell. And through hell they slowly wend their way, witnessing as they go the sufferings of those who had never chosen a goal, and the even worse fate of those whose purpose in life had been to increase entropy—the so-called "sinners."

I was rather concerned about how the harried business executives would take to this centuries-old parable. Chances were, I feared, that they would regard it as a waste of their precious time. I need not have worried. We never had as open and as serious a discussion of the pitfalls of midlife, and of the options for enriching the years that would follow, as we had after talking about the *Commedia*. Later, several participants told me privately that starting the seminar with Dante had been a great idea. His story focused the issues so clearly that it became much easier to think and to talk about them afterward.

Dante is an important model for another reason as well. Although

his poem is informed by a deep religious ethic, it is very clear to anyone who reads it that Dante's Christianity is not an *accepted* but a *discovered* belief. In other words, the religious life theme he created was made up of the best insights of Christianity combined with the best of Greek philosophy and Islamic wisdom that had filtered into Europe. At the same time, his Inferno is densely populated with popes, cardinals, and clerics suffering eternal damnation. Even his first guide, Virgil, is not a Christian saint but a heathen poet. Dante recognized that every system of spiritual order, when it becomes incorporated into a worldly structure like an organized church, begins to suffer the effects of entropy. So to extract meaning from a system of beliefs a person must first compare the information contained in it with his or her concrete experience, retain what makes sense, and then reject the rest.

These days we occasionally still meet people whose lives reveal an inner order based on the spiritual insights of the great religions of the past. Despite what we read every day about the amorality of the stock market, the corruption of defense contractors, and the lack of principles in politicians, examples to the contrary do exist. Thus there are also successful businessmen who spend some of their free time in hospitals keeping company with dying patients because they believe that reaching out to people who suffer is a necessary part of a meaningful life. And many people continue to derive strength and serenity from prayer, people for whom a personally meaningful belief system provides goals and rules for intense flow experiences.

But it seems clear that an increasing majority are not being helped by traditional religions and belief systems. Many are unable to separate the truth in the old doctrines from the distortions and degradations that time has added, and since they cannot accept error, they reject the truth as well. Others are so desperate for some order that they cling rigidly to whatever belief happens to be at hand—warts and all—and become fundamentalist Christians, or Muslims, or communists.

Is there any possibility that a new system of goals and means will arise to help give meaning to the lives of our children in the next century? Some people are confident that Christianity restored to its former glory will answer that need. Some still believe that communism will solve the problem of chaos in human experience and that its order will spread across the world. At present, neither of these outcomes seems likely.

If a new faith is to capture our imagination, it must be one that will account rationally for the things we know, the things we feel, the things we hope for, and the ones we dread. It must be a system of beliefs

that will marshal our psychic energy toward meaningful goals, a system that provides rules for a way of life that can provide flow.

It is difficult to imagine that a system of beliefs such as this will not be based, at least to some degree, on what science has revealed about humanity and about the universe. Without such a foundation, our consciousness would remain split between faith and knowledge. But if science is to be of real help, it will have to transform itself. In addition to the various specialized disciplines aimed at describing and controlling isolated aspects of reality, it will have to develop an integrated interpretation of all that is known, and relate it to humankind and its destiny.

One way to accomplish this is through the concept of evolution. Everything that matters most to us—such questions as: Where did we come from? Where are we going? What powers shape our lives? What is good and bad? How are we related to one another, and to the rest of the universe? What are the consequences of our actions?—could be discussed in a systematic way in terms of what we now know about evolution and even more in terms of what we are going to know about it in the future.

The obvious critique of this scenario is that science in general, and the science of evolution in particular, deals with what *is*, not with what *ought to be*. Faiths and beliefs, on the other hand, are not limited by actuality; they deal with what is right, what is desirable. But one of the consequences of an evolutionary faith might be precisely a closer integration between the *is* and the *ought*. When we understand better why we are as we are, when we appreciate more fully the origins of instinctual drives, social controls, cultural expressions—all the elements that contribute to the formation of consciousness—it will become easier to direct our energies where they ought to go.

And the evolutionary perspective also points to a goal worthy of our energies. There seems to be no question about the fact that over the billions of years of activity on the earth, more and more complex life forms have made their appearance, culminating in the intricacies of the human nervous system. In turn, the cerebral cortex has evolved consciousness, which now envelops the earth as thoroughly as the atmosphere does. The reality of complexification is both an *is* and an *ought*: it has happened—given the conditions ruling the earth, it was bound to happen—but it might not continue unless we wish it to go on. The future of evolution is now in our hands.

In the past few thousand years—a mere split second in evolutionary time—humanity has achieved incredible advances in the *differentiation* of consciousness. We have developed a realization that mankind is

separate from other forms of life. We have conceived of individual human beings as separate from one another. We have invented abstraction and analysis—the ability to separate dimensions of objects and processes from each other, such as the velocity of a falling object from its weight and its mass. It is this differentiation that has produced science, technology, and the unprecedented power of mankind to build up and to destroy its environment.

But complexity consists of *integration* as well as differentiation. The task of the next decades and centuries is to realize this underdeveloped component of the mind. Just as we have learned to separate ourselves from each other and from the environment, we now need to learn how to reunite ourselves with other entities around us without losing our hard-won individuality. The most promising faith for the future might be based on the realization that the entire universe is a system related by common laws and that it makes no sense to impose our dreams and desires on nature without taking them into account. Recognizing the limitations of human will, accepting a cooperative rather than a ruling role in the universe, we should feel the relief of the exile who is finally returning home. The problem of meaning will then be resolved as the individual's purpose merges with the universal flow.

NOTES

CHAPTER 1

PAGE
1 **Happiness.** Aristotle's views of happiness are most clearly developed in the *Nicomachean Ethics,* book 1, and book 9, chapters 9 and 10. Contemporary research on happiness by psychologists and other social scientists started relatively late, but has recently begun to catch up with this important topic in earnest. One of the first, and still very influential, works in this field has been Norman Bradburn's *The Structure of Psychological Well-Being* (Bradburn 1969), which pointed out that happiness and unhappiness were independent of each other; in other words, just because a person is happy it does not mean he can't also be unhappy at the same time. Dr. Ruut Veenhoven at the Erasmus University in Rotterdam, the Netherlands, has recently published a *Databook of Happiness* which summarizes 245 surveys conducted in 32 countries between 1911 and 1975 (Veenhoven 1984); a second volume is in preparation. The Archimedes Foundation of Toronto, Canada, has also set as its task the keeping track of investigations of human happiness and well-being; its first directory appeared in 1988. *The Psychology of Happiness,* by the Oxford social psychologist Michael Argyle, was published in 1987. Another comprehensive collection of ideas and research in this area is the volume by Strack, Argyle, & Schwartz (1990).

Undreamed-of material luxuries. Good recent accounts of the conditions of everyday life in past centuries can be found in a series under the general editorship of Philippe Aries and Georges Duby, entitled *A History of Private Life.* The first volume, *From Pagan Rome to Byzantium,* edited by Paul Veyne, was published here in 1987. Another magisterial series on the same topic is Fernand Braudel's *The Structures of Everyday Life,* whose first volume appeared in English in 1981. For the changes in home furnishings, see also Le Roy Ladurie (1979) and Csikszentmihalyi & Rochberg-Halton (1981).

242 • NOTES

4 **Flow.** My work on optimal experience began with my doctoral dissertation, which involved a study of how young artists went about creating a painting. Some of the results were reported in the book *The Creative Vision* (Getzels & Csikszentmihalyi 1976). Since then several dozen scholarly articles have appeared on the subject. The first book that described the flow experience directly was *Beyond Boredom and Anxiety* (Csikszentmihalyi 1975). The latest summary of the academic research on the flow experience was collected in the edited volume *Optimal Experience: Psychological Studies of Flow in Consciousness* (Csikszentmihalyi & Csikszentmihalyi 1988).

 Experience Sampling Method. I first used this technique in a study of adult workers in 1976; the first publication concerned a study of adolescents (Csikszentmihalyi, Larson, & Prescott 1977). Detailed descriptions of the method are available in Csikszentmihalyi & Larson (1984, 1987).

5 **Applications of the flow concept.** These are described in the first chapter of *Optimal Experience* (Csikszentmihalyi & Csikszentmihalyi 1988).

6 **Goals.** The earliest explanations of human behavior, starting with Aristotle, assumed that actions were motivated by goals. Modern psychology, however, has shown that much of what people do can be explained more parsimoniously by simpler, often unconscious, causes. As a result, the importance of goals in directing behavior has been greatly discredited. Some exceptions include Alfred Adler (1956), who believed that people develop goal hierarchies that inform their decisions throughout life; and the American psychologists Gordon Allport (1955) and Abraham Maslow (1968), who believed that after more basic needs are satisfied, goals may begin to be effective in directing actions. Goals have also regained some credibility in cognitive psychology, where researchers such as Miller, Galanter, & Pribram (1960), Mandler (1975), Neisser (1976), and Emde (1980) have used the concept to explain decision-making sequences and the regulation of behavior. I do not claim that most people most of the time act the way they do because they are trying to achieve goals; but only that when they do so, they experience a sense of control which is absent when behavior is not motivated by consciously chosen goals (see Csikszentmihalyi 1989).

9 **Chaos.** It might seem strange that a book which deals with optimal experience should be concerned with the chaos of the universe. The reason for this is that the value of life cannot be understood except against the background of its problems and dangers. Ever since the first known work of literature, the *Gilgamesh*, was written 35 centuries ago (Mason 1971), it has been customary to start with a review of the Fall

before venturing to suggest ways to improve the human condition. Perhaps the best prototype is Dante's *Divina Commedia*, where the reader first has to pass through the gates of Hell (*"per me si va nell'eterno dolore . . ."*) before he or she can contemplate a solution to the predicaments of life. In this context we are following these illustrious exemplars not because of a sense of tradition, but because it makes good sense psychologically.

10 **Hierarchy of needs.** The best-known formulation of the relationship between "lower order" needs such as survival and safety and "higher" goals like self-actualization is the one by Abraham Maslow (1968, 1971).

Escalating expectations. According to many authors, chronic dissatisfaction with the status quo is a feature of modernity. The quintessential modern man, Goethe's Faust, was given power by the Devil on condition that he never be satisfied with what he has. A good recent treatment of this theme can be found in Berman (1982). It is more likely, however, that hankering for more than what one has is a fairly universal human trait, probably connected with the development of consciousness.

That happiness and satisfaction with life depend on how small a gap one perceives between what one wishes for and what one possesses, and that expectations tend to rise, have been often observed. For instance, in a poll conducted in 1987 and reported in the *Chicago Tribune* (Sept. 24, sect. 1, p. 3), Americans making more than $100,000 a year (who constitute 2 percent of the population) believe that to live in comfort they would need $88,000 a year; those who earn less think $30,000 would be sufficient. The more affluent also said that they would need a quarter-million to fulfill their dreams, while the price tag on the average American's dream was only one-fifth that sum.

Of the scholars who have been studying the quality of life, many have reported similar findings: e.g., Campbell, Converse, & Rodgers (1976), Davis (1959), Lewin et al. (1944 [1962]), Martin (1981), Michalos (1985), and Williams (1975). These approaches, however, tend to focus on the *extrinsic* conditions of happiness, such as health, financial affluence, and so on. The approach of this book is concerned instead with happiness that results from a person's actions.

Controlling one's life. The effort to achieve self-control is one of the oldest goals of human psychology. In a lucid summary of several hundred writings of different intellectual traditions aimed at increasing self-control (e.g., Yoga, various philosophies, psychoanalysis, personality psychology, self-help), Klausner (1965) found that the objects to which control was directed could be summarized in four categories: (1) control of performance or behavior; (2) control of underlying physiological drives; (3) control of intellectual functions, i.e., thinking; (4) control of emotions, i.e., feeling.

11 **Culture as defense** against chaos. See, for instance, Nelson's (1965) summary on this point. Interesting treatments of the positive integrative effects of culture are Ruth Benedict's concept of "synergy" (Maslow & Honigmann 1970), and Laszlo's (1970) general systems perspective. (See also Redfield 1942; von Bertalanffy 1960, 1968; and Polanyi 1968, 1969.) For an example of how meaning is created by individuals in a cultural context, see Csikszentmihalyi & Rochberg-Halton (1981).

 Cultures believe themselves to be at the center of the universe. Ethnocentrism tends to be one of the basic tenets of every culture; see for instance LeVine & Campbell (1972), Csikszentmihalyi (1973).

12 **Ontological anxiety.** The experts on ontological (or existential) anxiety have been, at least in the past few centuries, the poets, the painters, the playwrights, and other sundry artists. Among philosophers one must mention Kierkegaard (1944, 1954), Heidegger (1962), Sartre (1956), and Jaspers (1923, 1955); among psychiatrists, Sullivan (1953) and Laing (1960, 1961).

 Meaning. An experience is *meaningful* when it is related positively to a person's goals. Life has meaning when we have a purpose that justifies our strivings, and when experience is ordered. To achieve this order in experience it is often necessary to posit some supernatural force, or providential plan, without which life might make no sense. See also Csikszentmihalyi & Rochberg-Halton (1981). The problem of meaning will be discussed in more depth in chapter 10.

14 **Religion and the loss of meaning.** That religion still helps as a shield against chaos is shown by several studies that report higher satisfaction with life among adults who report themselves as being religious (Bee 1987, p. 373). But there have been several claims made recently to the effect that the cultural values which sustained our society are no longer as effective as they once were; for example, see Daniel Bell (1976) on the decline of capitalistic values, and Robert Bellah (1975) on the decline of religion. At the same time, it is clear that even the so-called "Age of Faith" in Europe, during the entire Middle Ages, was beset by doubt and confusion. For the spiritual turmoil of those times see the excellent accounts of Johann Huizinga (1954) and Le Roy Ladurie (1979).

15 **Trends in social pathology.** For the statistics on energy use, see *Statistical Abstracts of the U.S.* (U.S. Dept. of Commerce 1985, p. 199); for those on poverty, see ibid., p. 457. Violent crime trends are drawn from the *U.S. Dept. of Justice's Uniform Crime Reports* (July 25, 1987, p. 41), the *Statistical Abstracts* (1985, p. 166), and the Commerce Department's *U.S. Social Indicators* (1980, pp. 235, 241). Venereal disease statistics are from the *Statistical Abstracts of the U.S.* (1985, p. 115); for divorce see ibid., p. 88.

Mental health figures are from the *U.S. Social Indicators*, p. 93. The budget figures are from the *U.S. Statistical Abstracts* (1985, p. 332).

For information on the number of **adolescents living in two-parent families** see Brandwein (1977), Cooper (1970), Glick (1979), and Weitzman (1978). For crime statistics, see *U.S. Statistical Abstracts* (1985, p. 189).

Adolescent pathology. For suicide and homicide among teenagers, see *Vital Statistics of the United States, 1985* (U.S. Dept. of Health and Human Services, 1988), table 8.5. Changes in SAT scores are reported in the *U.S. Statistical Abstracts* (1985, p. 147). According to reliable estimates, teenage suicide increased by about 300 percent between 1950 and 1980, with the heaviest losses among the privileged cohorts of white, middle-class, male adolescents (*Social Indicators*, 1981). The same patterns are shown for crime, homicide, illegitimate pregnancies, venereal diseases, and psychosomatic complaints (Wynne 1978, Yankelovich 1981). By 1980 one out of ten high school seniors was using psychotropic drugs daily (Johnston, Bachman, & O'Malley 1981). To qualify this picture of gloom, it should be mentioned that in most cultures, as far as it is possible to ascertain, adolescents have been seen as troublesome (Fox 1977). "The great internal turmoil and external disorder of adolescence are universal and only moderately affected by cultural determinants" (Kiell 1969, p. 9). According to Offer, Ostrov, & Howard (1981), only about 20 percent of contemporary U.S. adolescents are to be considered "troubled," but even this conservative estimate represents, of course, quite a huge number of young people.

17 **Socialization.** The necessity to postpone gratification in order to function in society was discussed by Freud in *Civilization and Its Discontents* (1930). Brown (1959) provided a spirited rebuttal of Freud's arguments. For standard works on socialization see Clausen (1968) and Zigler & Child (1973). A recent extended study of socialization in adolescence can be found in Csikszentmihalyi & Larson (1984).

Social controls. Some good examples of how social controls are enforced by creating chemical dependencies are the case of the Spaniards' introduction of rum and brandy into Central America (Braudel 1981, pp. 248–49); the use of whiskey in the expropriation of American Indian territories; and the Chinese Opium Wars. Herbert Marcuse (1955, 1964) has discussed extensively how dominant social groups coopt sexuality and pornography to enforce social controls. As Aristotle said long ago, "The study of pleasure and pain belongs to the province of the political philosopher" (*Nicomachean Ethics*, book 7, chapter 11).

Genes and personal advantage. The argument that genes were programmed for their own benefit, and not to make life better for their

carriers, was first formulated in a coherent way by Dawkins (1976), although the saying "The chicken is only an egg's way for making another egg," which encapsulates Dawkins's idea very well, is much older. For another view of this matter, see Csikszentmihalyi & Massimini (1985) and Csikszentmihalyi (1988).

20 **Paths of liberation.** The history of this quest is so rich and long that it is impossible to do it justice in a short space. For the *mystical* traditions see Behanan (1937) and Wood (1954) on Yoga, and Scholem (1969) on Jewish mysticism. In *philosophy* one might single out Hadas (1960) on Greek humanism; Arnold (1911) and Murray (1940) on the Stoics; and MacVannel (1896) on Hegel. For more contemporary philosophers see Tillich (1952) and Sartre (1956). A recent reinterpretation of Aristotle's notion of virtue that is very similar in some ways to the concept of autotelic activity, or flow, presented here can be found in the work of Alasdair MacIntyre (1984). In *history* Croce (1962), Toynbee (1934), and Berdyaev (1952) stand out; in *sociology* Marx (1844 [1956]), Durkheim (1897, 1912), Sorokin (1956, 1967), and Gouldner (1968); in *psychology* Angyal (1941, 1965), Maslow (1968, 1970), and Rogers (1951); in *anthropology* see Benedict (1934), Mead (1964), and Geertz (1973). This is just an idiosyncratic selection among a huge array of possible choices.

Control of consciousness. Control of consciousness as developed in this chapter includes all four manifestations of self-control reviewed by Klausner (1965) and listed in the note to page 10. One of the oldest known techniques for achieving such controls are the various yogi disciplines developed in India roughly fifteen hundred years ago; these will be discussed more amply in chapter 5. Followers of holistic medicine believe that the mental state of the patient is extremely important in determining the course of physical health; see also Cousins (1979) and Siegel (1986). Eugene Gendlin (1981), a colleague at the University of Chicago, has developed a contemporary technique for controlling attention called "focusing." In this volume I am not proposing any one technique, but instead will present a conceptual analysis of what control and enjoyment involve as well as give practical examples, so that the reader can develop a method best suited to his or her inclinations and conditions.

21 **Routinization.** The argument here is of course reminiscent of Weber's (1922) notion of routinization of charisma, developed in his work *The Social Psychology of World Religions,* and of the even earlier Hegelian idea that the "world of the spirit" eventually turns into the "world of nature" (e.g., Sorokin 1950). The same concept is developed from a sociological viewpoint by Berger & Luckmann (1967).

CHAPTER 2

PAGE
23–
24

Consciousness. This concept has been central to many religious and philosophical systems, e.g., those of Kant and Hegel. Early psychologists like Ach (1905) have tried to define it in modern scientific terms, with little success. For several decades, behavioral sciences had abandoned the notion of consciousness altogether, because self-reports of internal states were held to lack scientific validity. Some recent renewal of interest in the topic can be discerned (Pope & Singer 1978). Historical summaries of the concept can be found in Boring (1953) and Klausner (1965). Smith (1969), who coined the term "introspective behaviorism," gives a definition which is very close to the one used in this volume: "conscious experience is an internal event about which one does do, directly, what one wants to do" (Smith 1969, p. 108). Otherwise, however, there is little overlap between the concept as developed here and that of either Smith or any other behaviorally oriented psychologist. The main difference is that my emphasis is on the subjective dynamics of experience, and on its phenomenological primacy. A fuller definition of consciousness will be provided in the later sections of this chapter.

25–
26

Phenomenology. The term "phenomenological" is not used here to denote adherence to the tenets or methods of any particular thinker or school. It only means that the approach to the problem of studying experience is heavily influenced by the insights of Husserl (1962), Heidegger (1962, 1967), Sartre (1956), Merleau-Ponty (1962, 1964), and some of their translators into the social sciences, e.g., Natanson (1963), Gendlin (1962), Fisher (1969), Wann (1964), and Schutz (1962). Clear, short introductions to the phenomenology of Husserl are the books by Kohak (1978) and Kolakowski (1987). To follow this volume, however, there is no need to keep in mind any phenomenological assumption. The argument must stand on its own merits and be understood on its own terms. The same is true for **information theory** (see Wiener 1948 [1961]).

26

Dreaming. Stewart (1972) reports that the Sinoi of Malaysia learn to control their dreams, and thereby achieve unusual mastery over waking consciousness as well. If this is true (which seems doubtful), it is an interesting exception that goes toward proving the general rule—in other words, it means that by training attention one can control consciousness even in sleep (Csikszentmihalyi 1982a). One recent consciousness-expansion method has been trying to do just this. "Lucid dreaming" is an attempt to control thought processes in sleep (La Berge 1985).

28

Limits of consciousness. The first general statement about the number of bits that can be processed simultaneously was by Miller (1956). Orme

(1969), on the basis of von Uexkull's (1957) calculations, has figured that 1/18 of a second is the threshold of discrimination. Cognitive scientists who have treated the limitations of attention include Simon (1969, 1978), Kahneman (1973), Hasher & Zacks (1979), Eysenck (1982), and Hoffman, Nelson, & Houck (1983). Attentional demands made by cognitive processes are discussed by Neisser (1967, 1976), Treisman & Gelade (1980), and Treisman & Schmidt (1982). The attentional requirements of storing and recalling information from memory have been dealt with by Atkinson & Shiffrin (1968) and Hasher & Zacks (1979). But the importance of attention and its limitations was already well known to William James (1890).

29 **Limits for processing speech.** For the 40-bit-per-second requirement see Liberman, Mattingly, & Turvey (1972) and Nusbaum & Schwab (1986).

The uses of time. The first comprehensive tabulation of how people spend their time was the cross-national project reported in Szalai (1965). The figures reported here are based on my studies with the Experience Sampling Method (ESM), e.g., Csikszentmihalyi, Larson, & Prescott (1977), Csikszentmihalyi & Graef (1980), Csikszentmihalyi & Larson (1984), Csikszentmihalyi & Csikszentmihalyi (1988).

30 **Television watching.** The feelings people report while watching television are compared to experiences in other activities in ESM studies by Csikszentmihalyi, Larson, & Prescott (1977), Csikszentmihalyi & Kubey (1981), Larson & Kubey (1983), and Kubey & Csikszentmihalyi (in press).

Psychic energy. The processes taking place in consciousness— thoughts, emotions, will, and memory—have been described by philosophers since the earliest times, and by some of the earliest psychologists (e.g., Ach 1905). For a review, see Hilgard (1980). Energistic approaches to consciousness include Wundt (1902), Lipps (1899), Ribot (1890), Binet (1890), and Jung (1928 [1960]). Some contemporary approaches are represented by Kahneman (1973), Csikszentmihalyi (1978, 1987), and Hoffman, Nelson, & Houck (1983).

33 **Attention and culture.** The Melanesians' ability to remember precise locations by floating on the surface of the sea is described by Gladwin (1970). Reference to the many names for snow used by Eskimos can be found in Bourguignon (1979).

The self. Psychologists have thought of innumerable ways of describing the self, from the social-psychological approaches of George Herbert Mead (1934 [1970]) and Sullivan (1953) to the analytic psychology of Carl Gustav Jung (1933 [1961]). Currently, however, psychologists try to avoid speaking of the "self"; instead they limit themselves to describ-

ing the "self concept." A good account of how this concept develops is given by Damon & Hart (1982). Another approach uses the term "self-efficacy" (see Bandura 1982). The model of the self developed in these pages has been influenced by many sources, and is described in Csikszentmihalyi (1985a) and Csikszentmihalyi & Csikszentmihalyi (1988).

36 **Disorder in consciousness.** Psychologists have studied negative emotions, such as anger, distress, sadness, fear, shame, contempt, or disgust, very extensively: Ekman (1972), Frijda (1986), Izard, Kagan, & Zajonc (1984), and Tomkins (1962). But these investigators generally assume that each emotion is separately "wired" in the central nervous system as a response to a specific set of stimuli, instead of being an integrated response of the self system. Clinical psychologists and psychiatrists are familiar with "disphoric moods" such as anxiety and depression which interfere with concentration and normal functioning (Beck 1976, Blumberg & Izard 1985, Hamilton 1982, Lewinsohn & Libet 1972, Seligman et al. 1984).

39 **Order.** What order—or psychic negentropy—implies will be discussed in the pages below; see also Csikszentmihalyi (1982a) and Csikszentmihalyi & Larson (1984). Basically, it refers to the lack of conflict among the bits of information present in an individual's consciousness. When the information is in harmony with a person's goals, the consciousness of that person is "ordered." The same concept applies also to lack of conflict between individuals, when their goals are in harmony with each other.

40 **Flow.** The original research and the theoretical model of the flow experience were first fully reported in *Beyond Boredom and Anxiety* (Csikszentmihalyi 1975). Since then a great number of works have used the flow concept, and extensive new research has been accumulating. A few examples are Victor Turner's (1974) application of the concept to anthropology, Mitchell's (1983) to sociology, and Crook's (1980) to evolution. Eckblad (1981), Amabile (1983), and Deci & Ryan (1985) have used it in developing motivational theories. For summaries of the various research findings, see Massimini & Inghilleri (1986) and Csikszentmihalyi & Csikszentmihalyi (1988).

 "It's exhilarating . . ." The quote is from Csikszentmihalyi (1975), p. 95.

41 **Complexity.** Complexity is a function of how well the information in a person's consciousness is differentiated and integrated. A complex person is one who is able to access precise, discrete information, and yet is able to relate the various pieces to each other; for example, a person whose desires, emotions, thoughts, values, and actions are strongly individuated yet do not contradict each other. See, for instance, Csikszent-

250 • NOTES

mihalyi (1970), Csikszentmihalyi & Csikszentmihalyi (1988), and Csik-szentmihalyi & Larson (1984). The notion of complexity used here is related to the same concept as used by some evolutionary biologists (e.g., Dobzhansky 1962, 1967), and it has been influenced by the poetic insights of Teilhard de Chardin (1965). A very promising definition of complexity in physical systems, defined as "thermodynamic depth," was being worked on by Heinz Pagels (1988) before his recent untimely death. By his definition, the complexity of a system is the difference between the amount of information needed to describe the system in its present state and the amount needed to describe all the states it might have been in at the point at which it changed from the last previous state. Applying this to the psychology of the self, one might say that a complex person was one whose behavior and ideas could not be easily explained, and whose development was not obviously predictable.

"[There's] no place . . ." The quote is from Csikszentmihalyi 1975, p. 94.

CHAPTER 3

PAGE
44 **For research on the relationship between happiness and wealth,** see Diener, Horwitz, & Emmons (1985), Bradburn (1969), and Camp-bell, Converse, & Rodgers (1976).

45 **Pleasure and enjoyment.** Aristotle's entire *Nicomachean Ethics* deals with this issue, especially book 3, chapter 11, and book 7. See also Csikszentmihalyi & Csikszentmihalyi (1988, pp. 24–25).

47 **Children's pleasure in activity.** Early German psychologists posited the existence of *Funktionlust,* or the pleasure derived from using one's body in such activities as running, hitting, swinging, and so on (Groos 1901, Buhler 1930). Later Jean Piaget (1952) declared that one of the sensory-motor stages of an infant's physical development was character-ized by the "pleasure of being the cause." In the U.S., Murphy (1947) posited the existence of sensory and activity drives to account for the feeling of pleasure that sight, sound, or muscle sense occasionally gives. These insights were incorporated into a theory of optimal stimulation or optimal arousal mainly through the work of Hebb (1955) and Berlyne (1960), who assumed pleasure was the consequence of an optimal bal-ance between the incoming stimulation and the nervous system's ability to assimilate it. The extension of these basically neurological explana-tions for why one finds pleasure in action was provided by White (1959), deCharms (1968), and Deci & Ryan (1985), who looked at the same phenomenon but from the point of view of the self, or conscious orga-nism. Their explanations hinge on the fact that action provides pleasure because it gives the person a feeling of competence, efficacy, or auton-omy.

Learning in adulthood. The importance of learning in later life has received much needed attention lately. For some of the basic ideas in this field see Mortimer Adler's early statement (Adler 1956), Tough (1978), and Gross (1982).

48 **Interviews.** Most of the interviews mentioned here were collected in the course of studies reported in Csikszentmihalyi (1975) and Csikszentmihalyi & Csikszentmihalyi (1988). Over 600 additional interviews were collected by Professor Fausto Massimini and his collaborators in Europe, Asia, and the southwestern United States.

49 **Ecstasy.** Extensive case studies of ecstatic religious experiences were collected by Marghanita Laski (1962). Abraham Maslow (1971), who coined the term "peak experience" to describe such events, played a very important role in helping give legitimacy to the consideration of such phenomena by psychologists. It is fair to say, however, that Laski and Maslow looked at ecstasy as a fortuitous epiphany that happened more or less by itself, rather than a natural process which could be controlled and cultivated. For a comparison between Maslow's concept of peak experience and flow, see Privette (1983). Ecstatic experiences are apparently more common than one might think. As of March 1989, over 30 percent of a national representative sample of 1,000 U.S. respondents answered affirmatively to the item: "You felt as though you were very close to a powerful spiritual force that seemed to lift you out of your self." A full 12 percent claimed that they had experienced this feeling often or on several occasions (*General Social Survey* 1989).

49– **Reading** as a favorite flow activity. This finding is reported in Mas-
50 simini, Csikszentmihalyi, & Delle Fave (1988). A recent book that describes in detail how reading provides enjoyment is by Nell (1988).

50 **Socializing as a flow activity.** All the studies conducted with the Experience Sampling Method confirm the fact that simply being with other people generally improves a person's mood significantly, regardless of what else is happening. This seems to be as true of teenagers (Csikszentmihalyi & Larson 1984) as of adults (Larson, Csikszentmihalyi, & Graef 1980) and of older people (Larson, Mannell, & Zuzanek 1986). But to really enjoy the company of other people requires interpersonal skills.

51 **"A lot of pieces . . ."** The quote is from a study of how fine-art museum curators describe the aesthetic experience (Csikszentmihalyi & Robinson, in press, p. 51).

Professor Maier-Leibnitz described his ingenious way of keeping track of time by tapping his fingers in a personal communication (1986).

52 The importance of **microflow** activities was examined in *Beyond Boredom and Anxiety* (Csikszentmihalyi 1975, pp. 140–78). Those studies

showed that if people were asked to do without their usual routines, such as tapping their fingers, doodling, whistling, or joking with friends, within a matter of hours they would become irritable. Frequently they would report loss of control and disruption of behavior after only a day of microflow deprivation. Few people were able or willing to do without these small routines for more than 24 hours.

52–53 The balanced **ratio between challenges and skills** was recognized from the very beginning as one of the central conditions of the flow experience (e.g., Csikszentmihalyi 1975, pp. 49–54). The original model assumed that enjoyment would occur along the entire diagonal, that is, when challenges and skills were both very low, as well as when they were both very high. Empirical research findings later led to a modification of the model. People did not enjoy situations in which their skills and the outside challenges were both lower than their accustomed levels. The new model predicts flow only when challenges and skills are relatively in balance, and above the individual's mean level—and this prediction is confirmed by the studies conducted with the Experience Sampling Method (Carli 1986, Csikszentmihalyi & Nakamura 1989, Massimini, Csikszentmihalyi, & Carli 1987). In addition, these studies have shown that the condition of anxiety (high challenge, low skills) is relatively rare in everyday life, and it is experienced as much more negative than the condition of boredom (low challenge, high skills).

53 **"Your concentration . . . ," "You are so involved . . . ,"** and **". . . the concentration . . ."** are from Csikszentmihalyi (1975, p. 39). **"Her reading . . ."** is from Allison and Duncan (1988, p. 129). The relationship between focused attention and enjoyment was clearly perceived four centuries ago by Montaigne (1580 [1958], p. 853): "I enjoy . . . [life] twice as much as others, for the measure of enjoyment depends on the greater or lesser attention that we lend it."

54 **"The mystique of rock climbing . . ."** is from Csikszentmihalyi (1975, pp. 47–48).

55 **"I find special satisfaction . . ."** is from Delle Fave & Massimini (1988, p. 197). **"I . . . experienced a sense of satisfaction . . ."** is from Hiscock (1968, p. 45), and **"Each time . . ."** is from Moitessier (1971, p. 159); the last two are cited in Macbeth (1988, p. 228).

55–56 **Painting.** The distinction between more and less original artists is that the former start painting with a general and often vague idea of what they want to accomplish, while the latter tend to start with a clearly visualized picture in mind. Thus original artists must discover as they go along what it is that they will do, using feedback from the developing work to suggest new approaches. The less original artists end up painting

the picture in their heads, which has no chance to grow and develop. But to be successful in his open-ended process of creation, the original artist must have well-internalized criteria for what is good art, so that he can choose or discard the right elements in the developing painting (Getzels & Csikszentmihalyi 1976).

56 **Surgery** as a flow experience is described in Csikszentmihalyi (1975, 1985b).

57 **Exceptional sensitivities.** The commonsense impression that different children have a facility for developing different talents, some having an affinity for physical movement, others for music, or languages, or for getting along with other people, has recently been formalized in a theory of "multiple intelligences" by Howard Gardner (1983). Gardner and his collaborators at Harvard are now at work developing a comprehensive testing battery for each of the seven major dimensions of intelligence he has identified.

The importance of **feedback for the blind** is reported in Massimini, Csikszentmihalyi, & Delle Fave (1988, pp. 79–80).

58 **"It is as if . . ."** is from Csikszentmihalyi (1975, p. 40).

58– **"The court . . ."** and **"Kids my age . . ."** are from Csikszentmihalyi
59 (1975, pp. 40–41); **"When you're [climbing] . . ."** is from ibid., p. 81, and **"I get a feeling . . ."** from ibid., p. 41. **"But no matter how many . . ."** is from Crealock (1951, pp. 99–100), quoted in Macbeth (1988, pp. 221–22). The quotation from Edwin Moses is in Johnson (1988, p. 6).

59– **"A strong relaxation . . ."** and **". . . I have a general feeling . . ."**
60 are from Csikszentmihalyi (1975, pp. 44, 45).

60 **The attraction of risk** and danger has been extensively studied by Marvin Zuckerman (1979), who identified the "sensation seeking" personality trait. A more popular treatment of the subject is the recent book by Ralph Keyes (1985).

61 One of the earliest psychological studies of **gambling** is the one by Kusyszyn (1977). That games of chance have developed from the divinatory aspects of religious ceremonials has been argued by Culin (1906, pp. 32, 37, 43), David (1962), and Huizinga (1939 [1970]).

62 **Morphy and Fischer.** The similarity between the careers of these two chess champions who lived a century apart is indeed striking. Paul Charles Morphy (1837–84) became a chess master in his early teens; when he was 22 years old he traveled to Europe, where he beat everyone who dared to play against him. After he returned to New York potential competitors thought he was too good, and were afraid to play him even at favorable odds. Deprived of his only source of flow, Morphy became

a recluse displaying eccentric and paranoid behavior. For parallels with Bobby Fischer's career, see Waitzkin (1988). There are two lines of explanation for such coincidences. One is that people with fragile psychic organization are disproportionately attracted to chess. The other is that chess, at highly competitive levels, requires a complete commitment of psychic energy and can become addictive. When a player becomes a champion, and exhausts all the challenges of the activity into which so much of his attention has been invested, he runs a serious risk of becoming disoriented because the goal that has given order to his consciousness is no longer meaningful.

Gambling among American Indians is described by Culin (1906), Cushing (1896), and Kohl (1860). Carver (1796, p. 238) describes Iroquois playing until they have lost everything they owned, including their moccasins, and then walking back to their home camp in snow three feet deep. An observer of the Tarahumara in Mexico reported that "he . . . may go on playing [stick-dice] for a fortnight to a month, until he has lost everything he has in the world except his wife and children; he draws the line at that" (Lumholtz 1902 [1987], p. 278).

Surgeons who claim that performing operations can be "addictive" are quoted in Csikszentmihalyi (1975, pp. 138–39).

"It's a Zen feeling . . ." is from ibid., p. 87.

63 **"So one forgets oneself . . ."** is from Moitessier (1971, p. 52) cited in Macbeth (1988, p. 22). **"I understand something . . ."** is from Sato (1988, p. 113).

64 For the **sense of self-transcendence** while involved in rock climbing see Robinson (1969); while involved in chess, see Steiner (1974).

65 The **danger of losing self** as a result of "transcendent" experience has been extensively written about. One of the earliest treatments of this possibility is by Le Bon (1895 [1960]), whose work influenced that of McDougall (1920) and Freud (1921). Some recent studies dealing with the relationship of self-awareness and behavior are by Diener (1979), Wicklund (1979), and Scheier & Carver (1980). In terms of our model of complexity a deindividuated person who loses his or her self in a group is *integrated,* but not *differentiated.* Such a person yields the control of consciousness to the group, and may easily engage in dangerous behavior. To benefit from transcendence one must also have a strongly differentiated, or individuated self. Describing the dialectical relationship between the **I,** or the active part of the self, and the **me,** or the reflected self-concept, was the very influential contribution of George Herbert Mead (1934 [1970]).

66 **"Two things happen . . ."** is from Csikszentmihalyi (1975, p. 116).

67 The essential connection between something like happiness, enjoyment, and even virtue, on the one hand, and **intrinsic or autotelic rewards** on the other has been generally recognized by thinkers in a variety of cultural traditions. It is essential to the Taoist concept of *Yu*, or right living (e.g., the basic writings of Chuang Tzu, translated by Watson 1964); to the Aristotelian concept of virtue (MacIntyre 1984); and to the Hindu attitude toward life that infuses the *Bhagavad Gita*.

68 The generalizations about people being **dissatisfied with work** and with **leisure time** are based on our studies with the Experience Sampling Method (e.g., Csikszentmihalyi & Graef 1979, 1980; Graef, Csikszentmihalyi, & Gianinno, 1983; Csikszentmihalyi & LeFevre 1987, 1989; and LeFevre 1988). The conclusions are based on the momentary responses adult workers wrote down whenever they were paged at random times on their jobs. When workers respond to large-scale surveys, however, they often tend to give much more favorable global responses. A compilation of 15 studies of job satisfaction carried out between 1972 and 1978 concluded that 3 percent of U.S. workers are "very dissatisfied" with their jobs, 9 percent are "somewhat dissatisfied," 36 percent are "somewhat satisfied," and 52 percent are "very satisfied" (Argyle 1987, pp. 31–63). A more recent national survey conducted by Robert Half International and reported in the *Chicago Tribune* (Oct. 18, 1987, sect. 8) arrives at much less rosy results. According to this study, 24 percent of the U.S. work force, or one worker in four, is quite dissatisfied with his or her job. Our methods of measuring satisfaction may be too stringent, whereas the survey methods are likely to give results that are too optimistic. It should be easy to find out whether a group of people are "satisfied" or "dissatisfied" with work. In reality, because satisfaction is such a relative concept, it is very difficult to give an objective answer to this simple question. It is rather like whether one should say "half full" or "half empty" when asked to describe a glass with water halfway up (or down) the container. In a recent book by two outstanding German social scientists, the authors came to diametrically opposed conclusions about German workers' attitudes toward work, one claiming they loved it, the other that they hated it, even though they were both arguing from the same exhaustive and detailed survey data base (Noelle-Neumann & Strumpel 1984). The counterintuitive finding that people tend to rate work as more satisfying than leisure has been noticed by several investigators (e.g., Andrews & Withey 1976, Robinson 1977). For example, Veroff, Douvan, & Kulka (1981) report that 49 percent of employed men claim work is more satisfying for them than leisure, whereas only 19 percent say that leisure is more satisfying than work.

69 **The dangers of addiction to flow** have been dealt with in more detail by Csikszentmihalyi (1985b).

Crime as flow. A description of how juvenile delinquency can provide flow experiences is given in Csikszentmihalyi & Larson (1978).

The **Oppenheimer** quote is from Weyden (1984).

70 **"Water can be both good and bad . . ."** This fragment from Democritus was cited by de Santillana (1961 [1970], p. 157).

CHAPTER 4

PAGE
72
Play. After Huizinga's *Homo Ludens*, which first appeared in 1939, perhaps the most seminal book about play and playfulness has been Roger Caillois's *Les Jeux et les Hommes* (1958).

73 **Mimicry.** An excellent example of how a ritual disguise can help one to step out of ordinary experience is given by Monti (1969, pp. 9–15), in his discussion of the use of West African ceremonial masks:

"From a psychological point of view the origin of the mask can also be explained by the more atavistic *aspiration of the human being to escape from himself in order to be enriched by the experience of different existences*—a desire which obviously cannot be fulfilled on the physical level—and in order to increase its own power by identifying with universal, divine, or demonic forces, whichever they may be. It is a desire to break out of the human constriction of individuals shaped in a specific and immutable mould and closed in a birth-death cycle which leaves no possibility of *consciously chosen existential adventures*" (italics added).

74 **Flow and discovery.** When asked to rank 16 very different activities as being more or less similar to flow, the groups of highly skilled rock climbers, composers of music, chess players, and so on studied by Csikszentmihalyi (1975, p. 29) listed the item "Designing or discovering something new" as being the most similar to their flow activity.

75 **Flow and growth.** The issue of how flow experiences lead to growth of the self are discussed in Deci & Ryan (1985) and Csikszentmihalyi (1982b, 1985a). Anne Wells (1988) has shown that women who spend more time in flow have a more positive self-concept.

76 **Flow and ritual.** The anthropologist Victor Turner (1974) saw the ubiquity of the ritual processes in preliterate societies as an indication that they were socially sanctioned opportunities to experience flow. Religious rituals in general are usually conducive to the flow experience (see Carrington 1977; Csikszentmihalyi 1987; I. Csikszentmihalyi 1988; and Wilson 1985 and in press). A good introduction to the historical relationship between the sacred and the secular dimensions of leisure can be found in John R. Kelly's textbook *Leisure* (1982, pp. 53–68).

Flow and art. A description of how passive visual aesthetic experiences can produce flow is given in Csikszentmihalyi & Robinson (in press).

The religious significance of **Mayan ball games** is described in Blom (1932) and Gilpin (1948). *Pok-ta-pok*, as this game similar to basketball was called, took place in a stone courtyard, and the aim was for one team to throw the ball through the opponents' stone hoop placed about 28 feet above the playing field—*without touching it with their hands*. Father Diego Duran, an early Spanish missionary, gives a vivid description: ". . . It was a game of much recreation to them and enjoyment among which were some who played it with such dexterity and skill that they during one hour succeeded in not stopping the flight of the ball from one end to the other without missing a single hit with their buttocks, not being allowed to reach it with hands nor feet, nor with the calf of their legs, nor with their arms . . ." (quoted in Blom 1932). Apparently such games sometimes ended in human sacrifices or the killing of the members of the losing team (Pina Chan 1969).

77 **Flow and society.** The idea that the kind of flow activities a society made available to its people could reflect something essential about the society itself was first suggested in Csikszentmihalyi (1981a, 1981b). See also Argyle (1987, p. 65).

78 The issue of **cultural relativism** is too complex to be given an unbiased evaluation here. An excellent (but not impartial) review of the concept is given by the anthropologist Melford Spiro (1987), who in a recent autobiographical account describes why he changed his mind from an uncritical acceptance of the equal value of cultural practices to a much more qualified recognition of the pathological forms that cultures can occasionally assume. Philosophers and other humanists have often accused social scientists, sometimes with justification, of "debunking" absolute values that are important for the survival of culture (e.g., Arendt 1958, Bloom 1987). The early Italian-Swiss sociologist Vilfredo Pareto (1917, 1919) has been one of the scholars most keenly aware of the dangers of relativity inherent in his discipline.

78– **English workers.** The classic story of how the free English workers were
79 transformed into highly regimented industrial laborers is told by the historian E. P. Thompson (1963).

79 The suspicious **Dobuans** were studied by the anthropologist Reo Fortune (1932 [1963]). For the tragic plight of the **Ik** of Uganda see Turnbull (1972).

Yonomamo. This fierce tribe was immortalized by the writings of the anthropologist Napoleon Chagnon (1979). The **sad Nigerian tribe** was described by Laura Bohannan, under the pseudonym E. S. Bowen (1954). Colin Turnbull (1961) gave a loving description of the pygmies of the **Ituri** forest. The quote concerning the **Shushwap** was contained in a 1986 letter from Richard Kool to the author.

80 The information about the **Great Isé Shrine** was provided in a personal communication by Mark Csikszentmihalyi.

82 For the percentages of **happy people in different nations,** see George Gallup (1976). The study that showed U.S. respondents to be about as happy as Cubans and Egyptians was conducted by Easterlin (1974). For a general discussion of happiness and cross-cultural differences, see Argyle (1987, pp. 102–11).

 Affluence and happiness. Both Argyle (1987) and Veenhoven (1984) agree, on the basis of their evaluation of practically every study in the field conducted so far, that there is conclusive evidence for a positive but very modest correlation between material well-being and happiness or satisfaction with life.

 The **time budgets** for U.S. workers are based on our ESM studies (e.g., Csikszentmihalyi & Graef 1980; Graef, Csikszentmihalyi, & Gianinno 1983; Csikszentmihalyi & LeFevre 1987, 1989). These estimates are very similar to those obtained with much more extensive surveys (e.g., Robinson 1977).

84 **Stimulus overinclusion in schizophrenia.** The concept of anhedonia was originally developed by the psychiatrist Roy Grinker. Overinclusion and the symptomatology of attentional disorders have been studied by, among others, Harrow, Grinker, Holzman, & Kayton (1977) and Harrow, Tucker, Hanover, & Shield (1972). The quotations are from McGhie & Chapman (1961, pp. 109, 114). I have argued the continuity between lack of flow experiences due to severe psychopathologies and milder attentional disorders often caused by social deprivation in Csikszentmihalyi (1978, 1982a).

85– Among the studies of the **Eskimo** that are worth reading are those of
86 Carpenter (1970, 1973). The destruction of **Caribbean** cultures is described by Mintz (1985). The concept of **anomie** was originally developed by Emile Durkheim in his work *Suicide* (1897 [1951]). The best introduction to the concept of **alienation** is in the early manuscripts of Karl Marx, especially his *Economic and Philosophic Manuscripts of 1844* (see Tucker 1972). The sociologist Richard Mitchell (1983, 1988) has argued that anomie and alienation are the societal counterparts of anxiety and boredom, respectively, and that they occur when people cannot find flow because the conditions of everyday life are either too chaotic or too predictable.

86 **The neurophysiological hypothesis** concerning attention and flow is based on the following research: Hamilton (1976, 1981), Hamilton, Holcomb, & De la Pena (1977), and Hamilton, Haier, & Buchsbaum (1984). This line of research is now continuing with the use of more sophisticated brain-scanning equipment.

87 **Cortical activation** is the amount of electrical activity in the cerebral cortex at a given moment in time; its amplitude (in microvolts) has been used to indicate the general effort taking place in the brain at that time. When people concentrate their attention, their cortical activation is generally found to increase, indicating an increase in mental effort.

89 The study of **autotelic families** is reported in Rathunde (1988). His findings are in line with many previous investigations, for instance that securely attached infants engage more in exploratory behavior (Ainsworth, Bell, & Stayton 1971, Matas, Arend, & Sroufe 1978), or that an optimal balance between love and discipline is the best child-rearing context (Bronfenbrenner 1970, Devereux 1970, Baumrind 1977). The systems approach to family studies, which is very congenial with the one developed here, was pioneered in clinical settings by Bowen (1978).

90 **The people of flow.** This is the term Richard Logan (1985, 1988) used to describe individuals who are able to transform trying ordeals into flow experiences. The quote **"If the reach of experience . . ."** is from Burney (1952, pp. 16–18).

91 **Eva Zeisel**'s imprisonment is described in a *New Yorker* profile (Lessard 1987). How a **Chinese lady** survived the brutalities of the Cultural Revolution is the subject of *Life and Death in Shanghai* (Cheng 1987). **Solzhenitsyn**'s accounts of prison are from *The Gulag Archipelago* (1976).

The account by **Tollas Tibor** is reconstructed from personal conversations we had in the summer of 1957, when he was released from jail after the Hungarian revolution.

92 The quote from **Solzhenitsyn** is cited in Logan (1985). **Bettelheim** presents his generalizations about imprisonment based on his concentration camp experiences in the article "Individual and Mass Behavior in Extreme Situations" (1943); for **Frankl** see *Man's Search for Meaning* and *The Unheard Cry for Meaning* (1963, 1978).

93 The quotation from **Russell** was cited in an article in *Self* magazine (Merser 1987, p. 147).

CHAPTER 5

PAGE The **Tarahumara** festivals that include ritual footraces up and down the
95 mountains of northern Mexico for hundreds of miles are described in Lumholtz (1902 [1987]) and Nabokov (1981). An account of the ritual elements involved in modern sports is given by MacAloon's (1981) study of the modern Olympics.

97 The **Icarus complex** was explored by Henry A. Murray (1955).
 At this point it might be appropriate to confront squarely the

Freudian concept of *sublimation,* a topic that, if bypassed, might leave us with the nagging feeling of an unresolved problem. Superficial applications of Freud's thought have led many people to interpret any action that is not directed to the satisfaction of basic sexual desires either as a defense, when it aims to hold back an unacceptable wish that otherwise might be expressed, or as a sublimation, when an acceptable goal is substituted for a desire that could not be safely expressed in its original form. At best, sublimation is a poor substitute for the unsatisfied pleasure it helps to disguise. For example, Bergler (1970) has argued that games involving risk provide a release from guilt about sexuality and aggression. According to the "Icarus complex" a high jumper is trying to escape from the ties of an Oedipal tangle in a socially acceptable way, but without really resolving the basic conflict that motivates his actions. Similarly, Jones (1931) and Fine (1956) have explained chess as a way of coping with castration anxiety (to mate the opponent's king with the help of one's queen is a sublimated enactment of the father's castration with the collusion of the mother); and mountain climbing has been explained as sublimated penis envy. Nobody seems to do anything, according to this point of view, except to resolve a festering childhood anxiety.

The logical consequence of reducing motivation to a search for pleasure that is instigated by a few basic genetically programmed desires, however, is a failure to account for much of the behavior that differentiates humans from other animal species. To illustrate this, it is useful to examine the role of enjoyment in an evolutionary perspective.

Life is shaped as much by the future as it is by the past. The first fish to leave the sea for dry land were not programmed to do so, but exploited unused potentials in their makeup to take advantage of the opportunities of an entirely new environment. The monkeys who use sticks to fish for ants at the mouth of anthills are not following a destiny carved in their genes, but are experimenting with possibilities that in the future may lead to the conscious use of tools, and hence to what we call progress. And certainly human history can only be understood as the action of people striving to realize indistinct dreams. It is not a question of teleology—the belief that our actions are the unfolding of a preordained destiny—because teleology is also a mechanistic concept. The goals we pursue are not determined in advance or built into our makeup. They are discovered in the process of enjoying the extension of our skills in novel settings, in new environments.

Enjoyment seems to be the mechanism that natural selection has provided to ensure that we will evolve and become more complex. (This argument has been made in Csikszentmihalyi and Massimini [1985]; I. Csikszentmihalyi [1988]; and M. Csikszentmihalyi [1988]. The evolutionary implications of flow were also perceived by Crook [1980].) Just as pleasure from eating makes us want to eat more, and pleasure from

physical love makes us want to have sex, both of which we need to do in order to survive and reproduce, enjoyment motivates us to do things that push us beyond the present and into the future. It makes no sense to assume that only the pursuit of pleasure is the source of "natural" desires, and any other motivation must be its pale derivative. The rewards of reaching new goals are just as genuine as the rewards of satisfying old needs.

99 The study of the relationship between **happiness and energy consumption** was reported in Graef, Gianinno, & Csikszentmihalyi (1981).

100 The U.S. **dancers'** quotations are from Csikszentmihalyi (1975, p. 104). The Italian dancer's is from Delle Fave & Massimini (1988, p. 212).

The cultivation of **sexuality**. An excellent historical review of Western ideas about love, and of the behaviors that accompanied it, is given in the three volumes of *The Nature of Love* by Irving Singer (1981). A compendium of contemporary psychologists' views on love was collected by Kenneth Pope (1980). A very recent statement on the subject is by the Yale psychologist Robert Sternberg (1988), who expands the classical description of love as *eros* or as *agape* to three components: intimacy, passion, and commitment. Liza Dalby (1983), an American anthropologist who spent a few years training as a geisha in Kyoto, gives a good description of the refinements involved in the Far Eastern approach to sexuality. For the lack of romance in antiquity, see Veyne (1987, esp. pp. 202–5).

104 The way in which the rules of the Jesuit order developed by Saint Ignatius of **Loyola** helped organize life as a unified activity, potentially suited to provide flow experience for those who followed them, is described in I. Csikszentmihalyi (1986, 1988) and Toscano (1986).

A brief introduction to Patanjali's **Yoga** can be found in the *Encyclopaedia Britannica* (1985, vol. 12, p. 846). Eliade (1969) provides a more thorough immersion in the subject.

107 Some of the most powerful contemporary insights on the psychology of **aesthetics** are in the works of Arnheim (1954, 1971, 1982) and Gombrich (1954, 1979), who stress the role of order (or negative entropy) in art. For more psychoanalytically oriented approaches, see the three volumes edited by Mary Gedo, *Psychoanalytic Perspectives on Art* (1986, 1987, 1988).

"There is that wonderful . . ." is from Csikszentmihalyi & Robinson (in press).

107– **"When I see works . . ."** and **"On a day like this . . ."** are from
108 Csikszentmihalyi & Robinson (in press).

109 The **use of music by the pygmies** is described in Turnbull (1961).

The **importance of music** in the lives of Americans is mentioned in *The Meaning of Things* (Csikszentmihalyi & Rochberg-Halton 1981), where it was found that for teenagers the most important object in the home tended to be the stereo set. The **policeman**'s interview is also from the same source. How music helps teenagers recover their good moods and its role in providing a matrix of peer solidarity are discussed in Csikszentmihalyi & Larson (1984) and Larson & Kubey (1983).

Recorded music makes life richer. I heard this argument propounded most forcefully (but, I think, quite erroneously) by the aesthetic philosopher Eliseo Vivas at a public lecture in Lake Forest College, Illinois, sometime in the late 1960s.

110 **Durkheim** developed his concept of "collective effervescence" as a precursor of religiosity in his *Elementary Forms of Religious Life* (1912 [1967]). Victor Turner's "communitas" provides a contemporary perspective on the importance of spontaneous social interaction (1969, 1974).

The writings of **Carlos Castaneda** (e.g., 1971, 1974), so influential even a decade ago, now barely produce a ripple on the collective consciousness. Much has been said to discredit the authenticity of his accounts. The last few volumes of the enduring saga of his sorcerer's apprenticeship seem indeed confused and pointless. But the first four volumes contained many important ideas, intriguingly presented; for these the old Italian saying applies: *Se non è vero, è ben trovato*—or, "It may not be true, but it is well conceived."

110– **The stages of musical listening** were described in an unpublished
111 empirical study by Michael Heifetz at the University of Chicago. A similar developmental trajectory was postulated earlier by the musicologist Leonard Meyer (1956).

111 **Plato** expresses his views on music in the *Republic*, book 3, in the dialogue between Glaucon and Socrates about the aims of education. The idea is that children should not be exposed to either "plaintive" or "relaxed" music, because both will undermine their character—thus Ionian and Lydian harmonies should be eliminated from the curriculum. The only acceptable harmonies are the Dorian and the Phrygian, because these are the "strains of necessity and the strains of freedom," inculcating courage and temperance in the young. Whatever one may think of Plato's taste, it is clear that he took music very seriously. Here is what Socrates says (book 3, p. 401): "And therefore I said, Glaucon, musical training is a more potent instrument than any other, because rhythm and harmony find their way into the inward place of the soul, on which they mightily fasten, imparting grace, and making the soul of him who is rightly educated graceful. . . ."

Alan Bloom (1987, esp. pp. 68–81) provides a spirited defense of Plato and an indictment of modern music, presumably because it has an affinity for Ionian and Lydian harmonies.

112 **Lorin Hollander**'s story is based on conversations we had in 1985.

113 **Eating.** For instance, ESM studies show that of the main things adult Americans do during an average day, eating is the most intrinsically motivated (Graef, Csikszentmihalyi, & Giannino 1983). Teenagers report the second highest levels of positive affect when eating (after socializing with peers, which is the most positive), and very high levels of intrinsic motivation—lower only than listening to music, being involved in sports and games, and resting (Csikszentmihalyi & Larson 1984, p. 300).

114 **Cyrus the Great.** The information comes from Xenophon's (431 B.C.– 350 B.C.) *Cyropaedia,* a fictional account of Cyrus's life. But Xenophon is the only contemporary who had actually served in Cyrus's army, and who has left a written record of the man and his exploits (see also his *Anabasis,* translated as *The Persian Expedition,* Warner 1965).

115 **Puritans and enjoyment.** On this topic see the extensive history by Foster Rhea Dulles (1965), Jane Carson's account of recreation in colonial Virginia (1965), and chapter 5 in Kelly (1982).

CHAPTER 6

PAGE
117 **Reading.** In the interviews conducted by Professor Massimini around the world, reading books was the most often mentioned flow activity, especially in traditional groups undergoing modernization (Massimini, Csikszentmihalyi, & Delle Fave 1988, pp. 74–75). See also the study by Nell of how reading provides enjoyment (1988).

Mental puzzles. The Dutch historian Johann Huizinga (1939 [1970]) argued that science and scholarship in general originated in riddling games.

"Works of art . . ." is from Csikszentmihalyi & Robinson (in press).

119 **The normal state of the mind is chaos.** This conclusion is based on various lines of evidence collected with the ESM. For example, of all the things teenagers do, "thinking" is the least intrinsically motivating activity, and one of the highest on negative affect and on passivity (Csikszentmihalyi & Larson 1984, p. 300). This is because people say they are thinking only when they are not doing anything else—when there are no external demands on their mind. The same pattern holds for adults, who are least happy and motivated when their mind is not engaged by an externally structured activity (Kubey & Csikszentmihalyi in press).

The various sensory deprivation experiments also show that without patterned input of information, the organization of consciousness tends to break down. For instance, George Miller writes: "The mind survives by ingesting information" (Miller 1983, p. 111). A more general claim is that organisms survive by ingesting negentropy (Schrödinger 1947).

The negative quality of the **television viewing** experience has been documented by several ESM studies, e.g., Csikszentmihalyi & Kubey (1981), Csikszentmihalyi & Larson (1984), Csikszentmihalyi, Larson, & Prescott (1977), Kubey & Csikszentmihalyi (in press), and Larson & Kubey (1983).

120 **Mental imagery.** For some of Singer's work on daydreaming, see Singer (1966, 1973, 1981) and Singer & Switzer (1980). In the last decade, a widespread "mental imagery" movement has developed in the U.S.

121 The **Buñuel** reference is from Sacks (1970 [1987], p. 23).

 Reciting names of ancestors. Generally, the task of remembering belongs to the elder members of the tribe, and sometimes it is assigned to the chief. For example: "The Melanesian chief . . . has no administrative work, he has no function, properly speaking. . . . But in him . . . are enclosed the clan's myth, tradition, alliances, and strengths. . . . When he delivers from his own lips the clan names and the marvelous phrases which have moved generations, he enlarges time for each one. . . . The chief's authority rests on a simple quality which is his alone: he himself is the Word of the clan" (Leenhardt 1947 [1979], pp. 117–18). One example of how complex kinship reckoning can be is illustrated by Evans-Pritchard's work on the Nuer of the Sudan, who divide their ancestors in maximal, major, minor, and minimal lineages, all connecting to each other for five or six ascending generations (Evans-Pritchard 1940 [1978]).

122 **Riddles.** The rhyme translated by Charlotte Guest, as well as the material on the following page, come from the famous account Robert Graves (1960) gives of the origins of poetry and literacy in *The White Goddess*. Graves belonged to that wonderful period of British academic life when serious scholarship coexisted with unfettered flights of the imagination—the period when C. S. Lewis and R. R. Tolkien taught classics and wrote science fiction at Oxford. Graves's mythopoetic reconstructions are controversial, but they provide the layperson with a feeling for what the quality of thought and experience might have been in the distant past, to an extent that one cannot get from works of more cautious scholarship.

123 **Rote learning.** H. E. Garrett (1941) has reviewed the experimental evidence that contributed to the demise of rote learning in schools; see

also Suppies (1978). This evidence showed that learning nonsense sylla-
bles did not improve a generalized aptitude for remembering. It is diffi-
cult to understand why educators would have thought such results
relevant to making students stop memorizing meaningful texts.

124 **The control of memory.** Remembering, like dreaming, seems not to
be a process under volitional control of the self—we cannot bring into
consciousness information that refuses to be called up. But just as with
dreaming—except even more so—if one is willing to invest energy in it,
memory can be greatly improved. With a little method and discipline,
it is possible to build a whole set of mnemonic devices to help remember
material that otherwise would be forgotten. For a recent review of how
some of these methods were used in antiquity and the Renaissance, see
Spence (1984).

125 The reference to **Archytas** and his thought experiments is from de
Santillana (1961 [1970], p. 63).
The evolution of arithmetic and geometry. Wittfogel (1957) gives a
brilliant materialist account of the development of the sciences (as well
as political forms) on the basis of the prior development of irrigational
techniques.

That **new cultural products** are developed more for the sake of enjoy-
ment than out of necessity is argued in Csikszentmihalyi (1988). This
seems to be true even in the introduction of such basic techniques as
the use of metals: "In several areas of the world it has been noted, in
the case of metallurgical innovation in particular, that the development
of bronze and other metals as useful commodities was a much later
phenomenon than their first utilization as new and attractive materials,
employed in contexts of display. . . . In most cases early metallurgy
appears to have been practiced primarily because products have novel
properties that made them attractive to use as symbols and as personal
adornments and ornaments, in a manner that, by focusing attention,
could attract or enhance prestige" (Renfrew 1986, pp. 144, 146).
Huizinga (1939 [1970]) argued that institutions such as religion,
law, government, and the armed forces originally started as play-forms,
or games, and only gradually did they become rigid and serious. Similarly
Max Weber (1930 [1958]) pointed out that capitalism started as an
adventurous game of entrepreneurs, and only later, when its practices
became rigidified in laws and conventions, did it become an "iron cage."

126 For the anecdotes concerning **Democritus,** see de Santillana (1961
[1970], pp. 142ff.)

127 For an introduction to the **sagas of Iceland,** see Skuli Johnson's (1930)
collection.

129 The argument about how **conversation** helps maintain the symbolic universe is in Berger & Luckmann (1967).

131 How **poetry** can be taught to ghetto children and to old people in retirement homes without formal education is beautifully told by Koch (1970, 1977).

132 **Writing and depression.** At least since the Romantic era, artists of all types have been held to be "tortured" or "demonically impelled." There is reasonably good evidence that many modern artists and writers in fact show a variety of depressive and obsessive symptoms (see, e.g., Alvarez 1973, Berman 1988, Csikszentmihalyi 1988, and Matson 1980). Recently much has been written also about the relationship of manic depression and literary creativity (Andreasen 1987, Richards et al. 1988). It is very likely, however, that this relationship between psychic entropy and artistic creativity is the result of specific cultural expectations, and of the awkward structure of the artistic role, rather than anything necessarily inherent in art or in creativity. In other words, if to survive as an artist in a given social environment a person has to put up with insecurity, neglect, ridicule, and a lack of commonly shared expressive symbols, he or she is likely to show the psychic effects of these adverse conditions. Vasari in 1550 was one of the first to express concern that the personality of the young Italian artists of the time, already influenced by Mannerism, a precursor of Baroque and Romantic styles, displayed a "certain element of savagery and madness" which made them appear "strange and eccentric" in a way that previous artists were not (Vasari 1550 [1959], p. 232). In earlier periods, such as the thousands of years of Egyptian civilization, or the Middle Ages, artists were apparently quite pleasant and well adjusted (Hauser 1951). And of course there are several more recent examples of great artists, like J. S. Bach, Goethe, Dickens, or Verdi, that disprove the existence of a necessary link between creativity and neurosis.

 Remembering the personal past. In part under the influence of Erikson's psychobiographical accounts of the lives of Hitler, Gorki, Luther, and Gandhi (1950, 1958, 1969), a concern for "personal narrative" has become prominent in life-span developmental psychology (see Cohler 1982; Freeman 1989; Gergen & Gergen 1983, 1984; McAdams 1985; Robinson 1988; Sarbin 1986; and Schafer 1980). This perspective claims that knowing how a person sees his or her own past is one of the best ways to predict what he or she will do in the future.

132– **Every home a museum.** Csikszentmihalyi & Rochberg-Halton (1981)
133 studied over 300 members of three-generational families around Chicago, who were asked in their homes to show interviewers their favorite objects, and to explain the reasons for cherishing them.

134– The four quotations from **Thomas Kuhn**'s *The Structure of Scientific*
135 *Revolutions* (1962) are from pages 24, 38, 38, and 36, respectively. One
 of the most exciting promises of flow theory is that it may help explain
 why certain ideas, practices, and products are adopted, while others are
 ignored or forgotten—since at this point the histories of ideas, institu-
 tions, and cultures work almost exclusively within a paradigm informed
 by economic determinism. In addition, it might be revealing to consider
 how history is directed by the enjoyment people derive or anticipate
 from different courses of action. A beginning in that direction is Isabella
 Csikszentmihalyi's analysis of the reasons for the success of the Jesuit
 order in the 16th and 17th centuries (1988).

136 **Breakthroughs.** It would go against the central message of this book
 to claim that the flow experience is "good for you" in the sense that it
 helps people achieve scientific or any other kind of success. It needs to
 be stressed again and again that what counts is the quality of experience
 flow provides, and that this is more important for achieving happiness
 than riches or fame. At the same time, it would be disingenuous to
 ignore the fact that successful people tend to enjoy what they do to an
 unusual extent. This may indicate that people who enjoy what they are
 doing will do a good job of it (although, as we know, correlation does
 not imply causation). A long time ago, Maurice Schlick (1934) pointed
 out how important enjoyment was in sustaining scientific creativity. In
 an interesting recent study, B. Eugene Griessman interviewed a pot-
 pourri of high achievers ranging from Francis H. C. Crick, the codiscov-
 erer of the double helix, to Hank Aaron, Julie Andrews, and Ted
 Turner. Fifteen of these celebrities completed a questionnaire in which
 they rated the importance of thirty-three personal characteristics, such
 as creativity, competence, and breadth of knowledge, in terms of helping
 them achieve success. The item most strongly endorsed (for an average
 of 9.86 on a 10-point scale) was enjoyment of work (Griessman 1987,
 pp. 294–95).

 Another indication of how flow may be linked to success is sug-
 gested by the work of Larson (1985, 1988). In a study of high school
 juniors writing a month-long assignment, he found that the students
 who were bored wrote essays expert English teachers found boring,
 students who were anxious wrote disconnected essays that were confus-
 ing to read, whereas students who enjoyed the writing task created essays
 that were enjoyable to read—this controlling for differences in intelli-
 gence or ability among the students. The obvious suggestion is that a
 person who experiences flow in an activity will end up with a product
 that others will find more valuable.

The interview with the wife of **Susumu Tonegawa** appeared in *USA Today* (Oct. 13, 1987, p. 2A).

137– The amazing variety of **things adults learn** in their free time is de-
138 scribed in the investigations of Allen Tough (1978); see also Gross
 (1982). One of the areas of knowledge to which laypersons continue to
 contribute is that concerning health. One keeps hearing how people
 (often mothers) will notice some peculiarities in the health patterns of
 members of their family, which when communicated to health experts
 turn out to have beneficial consequences. For example Berton Roueché
 (1988) reports how a woman in New England, struck by the fact that
 her son and many of his friends were suffering from arthritic pains in
 the knee, alerted doctors of this suspicious coincidence, and as a result
 of her information researchers "discovered" Lyme disease, a potentially
 serious affliction transmitted by ticks.

139 It may be presumptuous to present a "reading list" of the great **philoso-
 phers,** but to simply name them without a reference would also offend
 professional scruples. So here goes. A few of the most seminal works in
 each area might include the following. As to ontology, there are Chris-
 tian von Wolff's *Vernunftige Gedanken*, Kant's *Critique of Pure Reason*,
 Husserl's *Ideas: General Introduction to Pure Phenomenology*, and Heideg-
 ger's *Being and Time* (1962); for these last two, it might be a good idea
 to start with the introductions to Husserl by Kohak (1978) and by
 Kolakowski (1987), and to Heidegger by George Steiner (1978 [1987]).
 In terms of ethics, one would certainly wish to tackle Aristotle's *Nicoma-
 chean Ethics*; Aquinas's treatises on Human Acts, on Habits, and on the
 Active and Contemplative Life in the *Summa Theologica*; Benedict
 Spinoza's *Ethics*; and from Nietzsche, *Beyond Good and Evil* and *Geneal-
 ogy of Morals*. In aesthetics, Alexander Baumgarten's "Reflections on
 Poetry," Benedetto Croce's *Aesthetics*, Santayana's *The Sense of Beauty*,
 and Collingwood's *The Principles of Art*. The 54-volume series of the
 Great Books of the Western World, now edited by Mortimer Adler and
 published by the Encyclopaedia Britannica, is a good introduction to the
 most influential thinkers of our culture—the first two *Syntopicon*
 volumes, which contain a summary of the main ideas of the books that
 follow, could be especially useful to the amateur philosopher.

140– Medvedev (1971) provides an informed account of how the agricultural
141 policies of **Lysenko,** based on Leninist dogma, resulted in food short-
 ages in Soviet Russia. See also Lecourt (1977).

CHAPTER 7

PAGE For the time budget allocated to **work by preliterate people,** see the
143 excellent volume by Marshall Sahlins (1972) and the estimates of Lee
 (1975). Some glimpses of the working patterns of medieval Europe are
 to be found in Le Goff (1980) and Le Roy Ladurie (1979). The pattern

of the working day of typical English workers before and after the advent of the Industrial Revolution is reconstructed by E. P. Thompson (1963). The changing role of women as workers in the public sector is discussed by, among others, Clark (1919) and Howell (1986).

145 **Serafina Vinon** is one of the respondents in the groups studied by Delle Fave and Massimini (1988). Her quote **"It gives me great satisfaction . . ."** is from p. 203.

147 The quote **"I am free . . ."** is from ibid.

149 **Development and complexity.** While most developmental psychology has remained determinedly value-free (at least in its rhetoric, if not in its substance), the psychology department at Clark University has maintained a relatively strong value orientation in its approach to human development, based on the notion that complexity is the goal of human growth (e.g., Kaplan 1983, Werner 1957, Werner & Kaplan 1956). For recent attempts in the same direction see Robinson (1988) and Freeman & Robinson (in press).

150 **"Ting was cutting up . . ."** is in Watson (1964, p. 46), who translated Chuang Tzu's Inner Chapters.

Some critics. The criticism that flow describes an exclusively Western state of mind was one of the first to be leveled at the flow concept. The specific contrast between flow and *Yu* was brought out by Sun (1987). It is to be hoped that the ample cross-cultural evidence presented in Csikszentmihalyi & Csikszentmihalyi (1988) will reassure skeptics that the flow experience is reported in almost exactly the same terms in vastly different non-Western cultures.

151 **"However . . ."** is from Watson (1964, p. 97). Waley (1939, p. 39) is the scholar who thinks the quotation does not describe *Yu*, but its opposite; whereas Graham (cited in Crandall 1983) and Watson (1964) believe it describes Ting's own way of butchering, and therefore that it refers to *Yu.*

152 **Navajos.** Interviews with Navajo shepherds were conducted by Professor Massimini's group in the summers of 1984 and 1985.

153 The life of 17th- and 18th-century **English weavers** is described by E. P. Thompson (1963).

155 The flow interviews of **surgeons** were conducted by Dr. Jean Hamilton, and written up by her and I. Csikszentmihalyi (M. Csikszentmihalyi 1975, pp. 123–39).

156 The first two quotations are from Csikszentmihalyi (1975), p. 129, the next two from ibid., p. 136.

158 The ESM study that looks at how much flow **American workers** report on their job and in leisure was reported in Csikszentmihalyi & LeFevre (1987, 1989) and LeFevre (1988).

160 **Dissatisfaction.** The low percentages of dissatisfied workers were computed by a meta-analysis performed in 1980 on 15 national surveys between 1972 and 1978; see Argyle (1987, p. 32).

 Our studies of American workers. In addition to the ESM studies, here I am drawing on data I have collected over a period of five years (1984–88) on about 400 managers, from different companies and all parts of the country, who have attended the Vail Management Seminars organized by the Office of Continuing Education of the University of Chicago.

162 **Jobs are easier to enjoy.** That leisure can be a problem for many people has been recognized for a long time by psychologists and psychiatrists. For example, the Group for the Advancement of Psychiatry ended one of its reports in 1958 with the bald statement "For many Americans, leisure is dangerous." The same conclusion was reached by Gussen (1967), who reviewed some of the psychological ills that people who cannot adapt to leisure manifest. The role of television as a way of masking the perils of free time has also been often remarked upon. For instance, Conrad (1982, p. 108) writes: "The original technological revolution was about saving time, shortcutting labor; the consumerism which is the latest installment of that revolution is about wasting the time we've saved, and the institution it deputes to serve that purpose is television. . . ."

 The leisure industry. It is difficult to estimate the economic value of leisure, because the worth of federal land used for recreation and the cost of the space devoted to leisure at home and in public buildings are truly incalculable. Direct spending on leisure in the United States has been estimated at $160 billion for 1980, double the amount for 1970 when adjusted for inflation. The average household spends about 5 percent of its income directly on leisure (Kelly 1982, p. 9).

CHAPTER 8

PAGE **The importance of human interaction.** All the ESM studies show
165 that the quality of experience improves when there are other people around, and deteriorates whenever the person is alone, even if by his or her own choice (Larson & Csikszentmihalyi 1978, 1980; Larson, Csikszentmihalyi, & Graef 1980). A vivid description of how and why people depend on public opinion for their own beliefs is given by Elisabeth Noelle-Neumann (1984). From a philosophical perspective, Martin Heidegger (1962) has analyzed our continuous dependence on

the *they*, or the intrapsychic representation of other people we carry in our minds. Related concepts are Charles Cooley's (1902) "generalized other" and Freud's "superego."

To be among men. This section is indebted to Hannah Arendt's brilliant treatment of the public and private realms in *The Human Condition* (1958).

166 **The company of others.** Here again we refer to the findings of the ESM studies mentioned in the last note. That interactions with other people improve the mood for the entire day has been reported by Lewinsohn & Graf (1973), Lewinsohn & Libet (1972), MacPhillamy & Lewinsohn (1974), and Lewinsohn et al. (1982). Lewinsohn and his group have developed the clinical applications of a psychotherapy based on maximizing pleasant activities and interactions. If one were to develop a therapy based on flow—and steps in that direction have already been taken at the Medical School of the University of Milan, Italy—this would also be the route to follow. That is, one would endeavor to increase the frequency and intensity of optimal experiences, rather than (or in addition to) decreasing the incidence of negative ones.

Baboons. Stuart Altmann (1970) and Jeanne Altmann (1970, 1980) know more about social relations among these primates than possibly anyone else. Their work indicates that the role of sociability for ensuring survival in such primates gives a good clue as to how and why human social "instincts" evolved.

166– **People are flexible.** It was Patrick Mayers's doctoral dissertation
167 (1978), which utilized the Experience Sampling Method for gathering data, that first alerted us to the fact that teenagers listed interactions with their friends as both the most enjoyable and also the most anxiety-producing and boring experiences in their day. This usually did not happen with other categories of activities, which were, in general, either always boring or always enjoyable. Since then the finding has been replicated with adults also.

167 The realization of how important **communication** skills are for effective management was suggested by the data collected in the Vail program (see note to p. 160). For middle managers especially, better communication is the number one strength they wish to develop.

Books on etiquette. For a particularly mind-boggling example of such, see Letitia Baldrige's *Complete Guide to a Great Social Life*, whose advice includes such perfectly true but rather fulsome pearls of wisdom as "Flattery is an immensely useful device. . . ." and "Any host . . . is proud to have well-dressed guests at his or her party. They convey a sweet smell of success." (Compare this last quote with Samuel Johnson's remark recorded in Boswell's *Life*, March 27, 1776: "Fine clothes are good only

as they supply the want of other means of procuring respect.") See review in *Newsweek* (Oct. 5, 1987, p. 90).

168 **Human relations are malleable.** This has been one of the basic tenets of symbolic interactionism in sociology and anthropology (see Goffman 1969, 1974; Suttles 1972). It also underlies the systems approach to family therapy, e.g., Jackson (1957), Bateson (1978), Bowen (1978), and Hoffman (1981).

Intolerable solitude. See notes to p. 165.

Sunday mornings. That people tended to have an unusual number of nervous breakdowns on Sunday mornings was already noted by psychoanalysts in turn-of-the-century Vienna (see Ferenczi 1950). They, however, attributed the fact to more complicated causes than the ones we are postulating here.

169 The literature on **television viewing** is so enormous that even a short summary would probably be too long. A reasonably complete review is given in Kubey & Csikszentmihalyi in press. Given the scale of the phenomenon, and its social and economic implications, it is very difficult to maintain scientific objectivity when dealing with television. Some researchers stoutly defend it, claiming that viewers are perfectly able to use television for their own purposes and turn viewing to their advantage, while others interpret the data to show that it makes the viewers passive and discontented. Needless to say, this writer belongs to the second faction.

170 The conclusion that **drugs are not consciousness-expanding** is based on interviews with about 200 artists whom our team has been studying for the past 25 years (see Getzels & Csikszentmihalyi 1965, 1976; Csikszentmihalyi, Getzels, & Kahn 1984). Although artists have a tendency to glorify drug-induced experiences, I have yet to hear of a creative work (or at least one that the artists themselves thought was a *good* one) produced entirely under the influence of drugs.

Coleridge and *Kubla Khan*. One of the most often-quoted examples of how drugs help creativity is Coleridge's claim that he wrote *Kubla Khan* in a flash of inspiration caused by the ingestion of laudanum—or opium. But Schneider (1953) has cast serious doubts on this story, presenting documentary evidence that Coleridge wrote several drafts of the poem, and made up the opium story to appeal to the romantic tastes of early-19th-century readers. Presumably if he had lived now, he would have done the same.

171 Our current research with **talented teenagers** shows that many fail to develop their skills not because they have cognitive deficits, but because they cannot stand being alone, and are left behind by their peers who

can tolerate the difficult learning and practicing required to perfect a talent (for a first report on this topic, see Nakamura 1988 and Robinson 1986). In the latter study, equally talented high school mathematics students were divided into those who by objective and subjective criteria were still involved in math by senior year, and those who were not. It was found that the involved students spent 15 percent of their waking time outside of school studying, 6 percent in structured leisure activities (e.g., playing a musical instrument, doing sports), and 14 percent in unstructured activities, like hanging out with buddies and socializing. For those no longer involved, the respective percentages were 5 percent, 2 percent, and 26 percent. Since each percentage point corresponds to about one hour spent in the activity each week, the figures mean that students still involved in math spend one hour a week more studying than in unstructured socializing, whereas those no longer involved spend 21 more hours a week socializing than studying. When a teenager becomes exclusively dependent on the company of peers, there is little chance to develop a complex skill.

173 The description of **Dorothy**'s life-style is based on personal experience.

174 For **Susan Butcher,** see *The New Yorker* (Oct. 5, 1987, pp. 34–35).

176 **Kinship groups.** One of the most eloquent essays on the civilizing effects of the family on humankind is Lévi-Strauss's *Les Structures élementaires de la Parenté* (1947 [1969]). The **sociobiological** claim was first articulated by Hamilton (1964), Trivers (1972), Alexander (1974), and E. O. Wilson (1975). For later contributions to this topic see Sahlins (1976), Alexander (1979), Lumdsen & Wilson (1983), and Boyd & Richerson (1985). The attachment literature is now very large; the classics in the area include work by John Bowlby (1969) and Mary D. Ainsworth et al. (1978).

Primogeniture. For the effects of inheritance laws in Europe see Habakuk (1955); in France, see Pitts (1964); in Austria and Germany, see Mitterauer & Sieder (1983).

179 **Monogamy.** According to some sociobiologists, however, monogamy does have an absolute advantage over other mating combinations. If we assume that siblings help each other more in proportion to the genes they share, then children of monogamous marriages will help each other more because they share more genes than children whose parents are not the same. Thus under selective pressures, children of monogamous couples will get more help, and thus might survive more easily, and reproduce proportionately more, than children of polygamous couples growing up in a similar environment. Moving from the biological to the cultural level of explanation, it seems clear that, other things being

equal, stable monogamous couples are able to provide better psychological as well as financial resources for their children. Just from a strictly economic point of view, serial monogamy (or the frequency of divorce) seems to be an inefficient way of redistributing income and property. For the plight of one-parent families, economic and otherwise, see, for instance, Hetherington (1979), McLanahan (1988), and Tessman (1978).

Cistothorus palustris. The marital practices of the marsh wren are described in the *Encyclopaedia Britannica* (1985, vol. 14, p. 701).

Cicero's quote about freedom was printed in my seventh-grade school assignment diary, but despite several attempts I have been unable to find its source. I sincerely hope it is not apocryphal.

180 **Family complexity.** Following the lead of Pagels's (1988) definition of complexity, we could also say that a family whose interactions are more difficult to describe, and whose future interactions are more difficult to predict on the basis of present knowledge, is more complex than a family that is easier to describe and to predict. Such a measure would presumably give very similar results to a measure of complexity based on differentiation and integration.

183 **Suburban teenagers.** The anthropologist Jules Henry (1965) gave a profoundly insightful description of what growing up in suburban communities entailed a generation ago. More recently Schwartz (1987) compared six Midwestern communities in terms of what opportunities they gave adolescents for experiencing freedom and self-respect, and found striking differences from one community to the next, which suggests that sweeping generalizations about what is involved in being a teenager in our society might not be very accurate.

If parents talked more. In one study of adolescents at a very good suburban high school, we found that although teenagers spent 12.7 percent of their waking time with parents, time alone with fathers amounted to an average of only five minutes a day, half of which was spent watching television together (Csikszentmihalyi & Larson 1984, p. 73). It is difficult to imagine how any deep communication of values can occur in such short periods. It might be true that it is "quality time" that counts, but after a certain point quantity has a bearing on quality.

184 **Teenage pregnancy.** The United States now leads other developed countries in teenage pregnancies, abortions, and childbearing. For every 1,000 girls between the ages of 15 and 19, 96 get pregnant in the United States each year. Next is France, with 43 pregnancies per 1,000 (Mall 1985). The number of out-of-wedlock births to teenagers has doubled between 1960 and 1980 (Schiamberg 1988, p. 718). At present rates, it has been estimated that 40 percent of today's 14-year-old

girls will become pregnant at least once before they turn 20 (Wallis et al. 1985).

Families that provide flow. The characteristics of families that facilitate the development of autotelic personalities in children are being studied by Rathunde (1988).

186 **Positive moods with friends.** When teenagers are with friends, they report very significantly higher levels of happiness, self-esteem, strength, and motivation—but lower levels of concentration and cognitive efficiency—than they report in any other social context (Csikszentmihalyi & Larson 1984). The same pattern is true for older people studied with the ESM. For example, married adults and retired couples report more intense positive moods when they are with friends than when they are with their spouses or children—or anyone else.

Drinking patterns. The different patterns of public drinking, and the resultant patterns of social interaction that they make possible, have been described in Csikszentmihalyi (1968).

188 **Instrumental versus expressive.** The distinction between these two functions was introduced into the sociological literature by Talcott Parsons (1942). For a contemporary application, see Schwartz (1987), who argues that one of the main problems with teenagers is that there are too few opportunities for expressive behavior within the boundaries of society, and thus they have to resort to deviance.

190 **Politics.** Hannah Arendt (1958) defines politics as the mode of interaction that allows individuals to get objective feedback about their strengths and weaknesses. In a political situation, where a person is given a chance to argue a point of view and to convince peers of its worth, the hidden capabilities of an individual are allowed to surface. But this kind of impartial feedback can only occur in a "public realm" where each person is willing to listen and evaluate others on their merit. According to Arendt the public realm is the best medium for personal growth, creativity, and self-revelation.

191 **Irrationality of economic approaches.** Max Weber (1930 [1958]), in his famous essay on the Protestant ethic, argued that the apparent rationality of economic calculation was deceptive. Hard work, savings, investment, the entire science of production and consumption are justified because of the belief that they make life happier. But, Weber claimed, after this science was perfected it developed its own goals, based on the logic of production and consumption and not that of human happiness. At that point economic behavior ceases to be rational, because it is no longer guided by the goal that originally justified it. Weber's argument applies to many other activities that after developing clear

goals and rules become autonomous from their original purposes, and begin to be pursued for intrinsic reasons—because they are fun to do. This was recognized by Weber himself, who complained that capitalism, which originated as a religious vocation, had in time become a mere "sport" for entrepreneurs—and an "iron cage" for everyone else. See also Csikszentmihalyi & Rochberg-Halton (1981, chapter 9).

CHAPTER 9

PAGE **This entire section to p. 198** draws heavily on interview transcripts
193 made available to me by Professor Massimini. I translated the Italian answers into English.

The quote by Franz **Alexander** was cited in Siegel (1986, p. 1). Norman Cousins's strategy for controlling his illness is described in his *Anatomy of an Illness* (1979).

198 **"When a man knows . . ."** is from Johnson's *Letters to Boswell,* Sept. 19, 1777.

Stress. Hans Selye, who began studying the physiology of stress in 1934, defined it as the generalized result, whether mental or physical, of any demand on the body (1956 [1978]). An important breakthrough in the investigation of psychological effects of such demands was the development of a scale that attempts to measure their severity (Holmes & Rahe 1967). On this scale the highest stress is caused by "Death of spouse" with a value of 100; "Marriage" has a value of 50, and "Christmas" a value of 12. In other words, the impact of four Christmases is almost equal to the stress of getting married. It is to be noted that both negative and positive events can cause stress, since they both present "demands" one must adapt to.

Supports. Of the various resources that mitigate the effects of stressful events, social supports, or social networks, have been studied the most extensively (Lieberman et al. 1979). Family and friends often provide material help, emotional support, and needed information (Schaefer, Coyne, & Lazarus 1981). But even interest in other people seems to alleviate stress: "Those who have a concern for other people and concerns beyond the self have fewer stressful experiences, and stress has less effect on anxiety, depression, and hostility; they make more active attempts to cope with their problems" (Crandall 1984, p. 172).

199 **Coping styles.** The experience of stress is mediated by a person's coping style. The same event might have positive or negative psychological outcomes, depending on the person's inner resources. *Hardiness* is a term coined by Salvatore Maddi and Suzanne Kobasa to describe the tendency of certain people to respond to threats by transforming them into manageable challenges. The three main components of hardiness

are commitment to one's goals, a sense of being in control, and enjoy-
ment of challenges (Kobasa, Maddi, & Kahn 1982). A similar term is
Vaillant's (1977) concept of "mature defense," Lazarus's concept of
"coping" (Lazarus & Folkman 1984), and the concept of "personality
strength" measured in German surveys by Elisabeth Noelle-Neumann
(1983, 1985). All of these coping styles—hardiness, mature defenses,
and transformational coping—share many characteristics with the auto-
telic personality trait described in this volume.

200 **Courage.** That people consider courage the foremost reason for admir-
ing others emerged from the data of my three-generation family study
when Bert Lyons analyzed it for his Ph.D. dissertation (1988).

201 **Dissipative structures.** For the meaning of this term in the natural
sciences see Prigogine (1980).

202 **Transformational skills in adolescence.** One longitudinal study con-
ducted with the ESM (Freeman, Larson, & Csikszentmihalyi 1986)
suggests that older teenagers have just as many negative experiences with
family, with friends, and alone as younger teenagers do, but that they
interpret them more leniently—that is, the conflicts that at 13 years of
age seemed tragic at 17 are seen to be perfectly manageable.

203 **Unselfconscious self-assurance.** For the development of this concept
see Logan (1985, 1988).

205 **"Each individual crystal . . ."** This quote from Chouinard was re-
ported in Robinson (1969, p. 6).
"My cockpit is small . . ." is from Lindbergh (1953, pp. 227–28).

208 **Discovering new goals.** That a complex self emerges out of various
experiences in the world, just as a creative painting emerges out of the
interaction between the artist and his materials, has been argued in
Csikszentmihalyi (1985a) and Csikszentmihalyi & Beattie (1979).
Artists' discovery. The process of problem finding, or discovery, in art
is described in a variety of papers starting with Csikszentmihalyi (1965)
and ending with Csikszentmihalyi & Getzels (1989). See also Getzels &
Csikszentmihalyi (1976). Very briefly, our findings show that art stu-
dents who in 1964 painted in the manner described here (i.e., who
approached the canvas without a clearly worked out image of the fin-
ished painting) were 18 years later significantly more successful—by the
standards of the artistic community—than their peers who worked out
the finished product in their minds beforehand. Other characteristics,
such as technical competence, did not differentiate the two groups.

209 **Setting realistic goals.** It has been reported that adults who commit
themselves to very long-term goals, with few short-term rewards, are less
satisfied with their lives than people who have easier, short-term goals

(Bee 1987, p. 373). On the other hand, the flow model suggests that having too-easy goals would be equally dissatisfying. Neither extreme allows a person to enjoy life fully.

CHAPTER 10

Hannah Arendt describes the difference between meaning systems built on eternity and immortality in her *The Human Condition* (1958).

219 **Sorokin** worked out his classification of cultures in the four volumes of his *Social and Cultural Dynamics*, which appeared in 1937. (An abridged single volume with the same title was published in 1962.) Sorokin's work has been forgotten almost completely by sociologists, perhaps because of his old-fashioned idealism, perhaps because in the crucial decades of the 1950s and 1960s it was overshadowed by that of his much more theoretically astute colleague at Harvard, Talcott Parsons. It is likely that with time this enormously wide-ranging and methodologically innovative scholar will receive the recognition he deserves.

221 **Sequences in the development of the self.** Very similar theories of stages of development that alternate between attention focused on the self and attention focused primarily on the social environment were developed by Erikson (1950), who believed that adults had to develop a sense of Identity, then Intimacy, then Generativity, and finally reach a stage of Integrity; by Maslow (1954), whose hierarchy of needs led from physiological safety needs to self-actualization through love and belongingness; by Kohlberg (1984), who claimed that moral development started from a sense of right and wrong based on self-interest and ended with ethics based on universal principles; and by Loevinger (1976), who saw ego development proceed from impulsive self-protective action to a sense of integration with the environment. Helen Bee (1987, especially chapters 10 and 13) gives a good summary of these and other "spiraling" models of development.

225 *Vita activa* and *vita contemplativa.* These Aristotelian terms are extensively used by Thomas Aquinas in his analysis of the good life, and by Hannah Arendt (1958).

226 A description of how the **Jesuit** rules helped create order in the consciousness of those who followed them is given in Isabella Csikszentmihalyi (1986, 1988) and Marco Toscano (1986).

227 **Emergence of consciousness.** A stab in the direction of speculating about how consciousness emerged in human beings was made by Jaynes (1977), who ascribes it to the connection between the left and right cerebral hemispheres, which he speculates occurred only about 3,000 years ago. See also Alexander (1987) and Calvin (1986). Of course this

NOTES • 279

fascinating question is likely to remain forever beyond the reach of certainty.

227– **The inner life of animals.** To what extent animals other than humans
228 have feelings that approach ours has been extensively debated; see von
Uexkull (1921). Recent studies of primates who communicate with peo-
ple seem to suggest that some of them do have emotions even in the
absence of concrete stimuli (e.g., that they can feel sad at the memory
of a departed companion), but the evidence on this issue does not yet
appear conclusive.

228 **The consciousness of preliterate people.** Among many others, the
anthropologist Robert Redfield (1955) argued that tribal societies were
too simple and homogeneous for their members to be able to take a
self-reflective stance toward their beliefs and actions. Before the first
urban revolution made cities possible about 5,000 years ago, people
tended to accept the reality their culture presented to them without
much question, and had no alternatives to conformity. Others, such as
the anthropologist Paul Radin (1927), have claimed to find great philo-
sophical sophistication and freedom of conscience among "primitive"
people. It is doubtful that this ancient debate will be resolved soon.

229 **Leo Tolstoy's** novella has been often reprinted; see Tolstoy (1886
[1985]).

That the **complexification of social roles** has resulted in the complex-
ification of consciousness has been argued by De Roberty (1878) and by
Draghicesco (1906), who developed elaborate theoretical models of so-
cial evolution based on the assumption that intelligence is a function of
the frequency and intensity of human interactions; and by many others
ever since, including the Russian psychologists Vygotsky (1978) and
Luria (1976).

Sartre's concept of the project is described in *Being and Nothingness*
(1956). The concept of "propriate strivings" was introduced by Allport
(1955). For the concept of life theme, defined as "a set of problems
which a person wishes to solve above everything else and the means the
person finds to achieve solution," see Csikszentmihalyi & Beattie
(1979).

231 Hannah Arendt (1963) wrote an authoritative analysis of the life of
Adolf **Eichmann.**

The autobiography of Malcolm X (1977) is a classic description of
the development of a life theme.

233 **Blueprint of negentropic life themes.** The counterintuitive notion
that transference of attention from personal problems to the problems
of others helps personal growth underlies the work of the developmental

psychologists mentioned in the note to page 221; see also Crandall (1984), and note to p. 198.

234 The best English-language biography of **Antonio Gramsci** is by Giuseppe Fiore (1973).

235 **Edison, Roosevelt, and Einstein.** Goertzel & Goertzel (1962) detail the early lives of 300 eminent men and women, and show how little predictability there is between the conditions in which children grow up and their later achievements.

Cultural evolution is another concept prematurely discarded by social scientists in the last few decades. Among the attempts to show that the concept is still viable see, for instance, Burhoe (1982), Csikszentmihalyi & Massimini (1985), Lumdsen & Wilson (1981, 1983), Massimini (1982), and White (1975).

235– **Books as socializing agents.** For studies on the effect of books and
236 stories told in childhood on the subsequent life themes of individuals see Csikszentmihalyi & Beattie (1979) and Beattie & Csikszentmihalyi (1981).

238 **Religion and entropy.** See, for instance, Georg Wilhelm Friedrich Hegel's early essay, written in 1798 but not published until 110 years later: *Der Geist der Christentums und sein Schiksal* (The spirit of Christianity and its fate), in which he reflects on the materialization that Christ's teachings underwent after they were embedded into a Church.

239 **Evolution.** A great many scholars and scientists, from a diverse variety of backgrounds, have expressed the belief that a scientific understanding of evolution, taking into account the goals of human beings and the laws of the universe, will provide the basis for a new system of meanings. See, for instance, Burhoe (1976), Campbell (1965, 1975, 1976), Csikszentmihalyi & Massimini (1985), Csikszentmihalyi & Rathunde (1989), Teilhard de Chardin (1965), Huxley (1942), Mead (1964), Medawar (1960), and Waddington (1970). It is on this faith that a new civilization may be built. But evolution does not guarantee progress (Nitecki 1988). Humankind may be left out of the evolutionary process altogether. Whether it will or not depends to a large extent on the choices we are about to make. And these choices are likely to be more intelligent if we understand how evolution works.

REFERENCES

Ach, N. 1905. *Über die Willenstätigkeit und das Denkens*. Göttingen: Vandenhoeck & Ruprecht.

Adler, A. 1956. *The individual psychology of Alfred Adler*. New York: Basic Books.

Adler, M. J. 1956. Why only adults can be educated. In *Great issues in education*. Chicago: Great Books Foundation.

Ainsworth, M. D. S., Bell, S. M., & Stayton, D. J. 1971. Individual differences in strange-situation behavior of one-year-olds. In H. R. Schaffer, ed., *The origins of human social relations*. London: Academic Press.

Ainsworth, M., Blehar, M., Waters, E., & Wall, S. 1978. *Patterns of attachment*. Hillsdale, N.J.: Erlbaum.

Alexander, R. D. 1974. The evolution of social behavior. *Annual Review of Ecology and Systematics* 5:325–83.

———. 1979. Evolution and culture. In N. A. Chagnon & W. Irons, eds., *Evolutionary biology and human social behavior: An anthropological perspective* (pp. 59–78). North Scituate, Mass.: Duxbury Press.

———. 1987. *The biology of moral systems*. New York: Aldine de Guyter.

Allison, M. T., & Duncan, M. C. 1988. Women, work, and flow. In M. Csikszentmihalyi & I. S. Csikszentmihalyi, eds., *Optimal experience: Studies of flow in consciousness* (pp. 118–37). New York: Cambridge University Press.

Allport, G. W. 1955. *Becoming: Basic considerations for a psychology of personality*. New Haven: Yale University Press.

Altmann, J. 1980. *Baboon mothers and infants*. Cambridge: Harvard University Press.

Altmann, S. A., & Altmann, J. 1970. *Baboon ecology: African field research*. Chicago: University of Chicago Press.

Alvarez, A. 1973. *The savage god*. New York: Bantam.

Amabile, T. M. 1983. *The social psychology of creativity*. New York: Springer Verlag.

Andreasen, N. C. 1987. Creativity and mental illness: Prevalence rates in writers and their first-degree relatives. *American Journal of Psychiatry* 144(10):1288–92.

Andrews, F. M., & Withey, S. B. 1976. *Social indicators of well-being.* New York: Plenum.

Angyal, A. 1941. *Foundations for a science of personality.* Cambridge: Harvard University Press.

———. 1965. *Neurosis and treatment: A holistic theory.* New York: Wiley.

Aquinas, T. (1985). *Summa theologica. Aquinas' Summa: An introduction and interpretation* (by E. J. Gratsch). New York: Alba House.

Archimedes Foundation. 1988. *Directory of human happiness and well-being.* Toronto.

Arendt, H. 1958. *The human condition.* Chicago: University of Chicago Press.

———. 1963. *Eichmann in Jerusalem.* New York: Viking Press.

Argyle, M. 1987. *The psychology of happiness.* London: Methuen.

Aries, P., & Duby, G., gen. eds. 1987. *A history of private life.* Cambridge, Mass.: Belknap Press.

Aristotle. (1980). *Nicomachean Ethics.* Book 1; book 3, chapter 11; book 7; book 7, chapter 11; book 9, chapters 9, 10. In *Aristotle's Nicomachean Ethics,* commentary and analysis by F. H. Eterovich. Washington, D.C.: University Press of America.

Arnheim, R. 1954. *Art and visual perception: A psychology of the creative eye.* Berkeley: University of California Press.

———. 1971. *Entropy and art.* Berkeley: University of California Press.

———. 1982. *The power of the center.* Berkeley: University of California Press.

Arnold, E. V. 1911 (1971). *Roman Stoicism.* New York: Books for Libraries Press.

Atkinson, R. C., & Shiffrin, R. M. 1968. Human memory: A proposed system and its control processes. In K. Spence & J. Spence, eds., *The psychology of learning and motivation,* vol. 2. New York: Academic Press.

Baldridge, L. 1987. *Letitia Baldridge's complete guide to a great social life.* New York: Rawson Assocs.

Bandura, A. 1982. Self-efficacy mechanisms in human agency. *American Psychologist* 37:122–47.

Bateson, G. 1978. The birth of a double bind. In M. Berger, ed., *Beyond the double bind* (p. 53). New York: Brunner/Mazel.

Baumgarten, A. 1735 (1936). Reflections on poetry. In B. Croce, ed., *Aesthetica.* Bari: Laterza.

Baumrind, D. 1977. Socialization determinants of personal agency. Paper presented at biennial meeting of the Society for Research in Child Development, New Orleans.

Beattie, O., & Csikszentmihalyi, M. 1981. On the socialization influence of books. *Child Psychology and Human Development* 11(1):3–18.

Beck, A. T. 1976. *Cognitive therapy and emotional disorders.* New York: International Universities Press.

Bee, H. L. 1987. *The journey of adulthood.* New York: Macmillan.

Behanan, K. T. 1937. *Yoga: A scientific evaluation.* New York: Macmillan.

Bell, D. 1976. *The cultural contradictions of capitalism.* New York: Basic Books.

Bellah, R. N. 1975. *The broken covenant: American civil religion in a time of trial.* New York: Seabury Press.

Benedict, R. 1934. *Patterns of culture.* Boston: Houghton Mifflin.

Berdyaev, N. 1952. *The beginning and the end.* London: Geoffrey Bles.

Berger, P. L., & Luckmann, T. 1967. *The social construction of reality.* Garden City, N.Y.: Anchor Books.

Bergler, E. 1970. *The psychology of gambling.* New York: International Universities Press.

Berlyne, D. E. 1960. *Conflict, arousal, and curiosity.* New York: McGraw-Hill.

Berman, Marshall Howard. 1982. *All that is solid melts into air.* New York: Simon & Schuster.

Berman, Morris. 1988. The two faces of creativity. In J. Brockman, ed., *The reality club* (pp. 9–38). New York: Lynx Books.

Bettelheim, B. 1943. Individual and mass behavior in extreme situations. *Journal of Abnormal and Social Psychology* 38:417–52.

Binet, A. 1890. La concurrence des états psychologiques. *Revue Philosophique de la France et de l'Étranger* 24:138–55.

Blom, F. 1932. The Maya ball-game. In M. Ries, ed., *Middle American Research Series, 1.* New Orleans: Tulane University Press.

Bloom, A. 1987. *The closing of the American mind.* New York: Simon & Schuster.

Blumberg, S. H., & Izard, C. E. 1985. Affective and cognitive characteristics of depression in 10- and 11-year-old children. *Journal of Personality and Social Psychology* 49:194–202.

Boring, E. G. 1953. A history of introspection. *Psychological Bulletin* 50(3):169–89.

Boswell, J. 1964. *Life of Samuel Johnson.* New York: McGraw.

Bourguignon, E. 1979. *Psychological anthropology.* New York: Holt, Rinehart & Winston.

Bowen, E. S. (pseud. of Laura Bohannan). 1954. *Return to laughter.* New York: Harper & Bros.

Bowen, M. 1978. *Family therapy in clinical practice.* New York: Aronson.

Bowlby, J. 1969. *Attachment and loss.* Vol. 1: *Attachment.* New York: Basic Books.

Boyd, R., & Richerson, P. J. 1985. *Culture and the evolutionary process.* Chicago: University of Chicago Press.

Bradburn, N. 1969. *The structure of psychological well-being.* Chicago: Aldine.

Brandwein, R. A. 1977. After divorce: A focus on single parent families. *Urban and Social Change Review* 10:21–25.

Braudel, F. 1981. *The structures of everyday life.* Vol. 2: *Civilization and capitalism, 15th–18th century.* New York: Harper & Row.

Bronfenbrenner, U. 1970. *Two worlds of childhood.* New York: Russell Sage.

Brown, N. O. 1959. *Life against death.* Middletown, Conn.: Wesleyan University Press.

Buhler, C. 1930. *Die geistige Entwicklung des Kindes.* Jena: G. Fischer.

Burhoe, R. W. 1976. The source of civilization in the natural selection of coadapted information in genes and cultures. *Zygon* 11(3):263–303.

———. 1982. Pleasure and reason as adaptations to nature's requirements. *Zygon* 17(2):113–31.

Burney, C. 1952. *Solitary confinement.* London: Macmillan.

Caillois, R. 1958. *Les jeux et les hommes.* Paris: Gallimard.

Calvin, W. H. 1986. *The river that flows uphill: A journey from the big bang to the big brain.* New York: Macmillan.

Campbell, A. P. 1972. Aspiration, satisfaction, and fulfillment. In A. P. Campbell & P. E. Converse, eds., *The human meaning of social change* (pp. 441–66). New York: Russell Sage.

Campbell, A. P., Converse, P. E., & Rodgers, W. L. 1976. *The quality of American life.* New York: Russell Sage.

Campbell, D. T. 1965. Variation and selective retention in socio-cultural evolution. In H. R. Barringer, G. I. Blankston, & R. W. Monk, eds., *Social change in developing areas* (pp. 19–42). Cambridge: Schenkman.

———. 1975. On the conflicts between biological and social evolution and between psychology and moral tradition. *American Psychologist* 30:1103–25.

———. 1976. Evolutionary epistemology. In D. A. Schlipp, ed., *The library of living philosophers* (pp. 413–63). LaSalle, Ill.: Open Court.

Carli, M. 1986. Selezione psicologica e qualita dell'esperienza. In F. Massimini & P. Inghilleri, eds., *L'esperienza quotidiana* (pp. 285–304). Milan: Franco Angeli.

Carpenter, E. 1970. *They became what they beheld.* New York: Ballantine.

———. 1973. *Eskimo realities.* New York: Holt.

Carrington, P. 1977. *Freedom in meditation.* New York: Doubleday Anchor.

Carson, J. 1965. *Colonial Virginians at play.* Williamsburg, Va.: Colonial Williamsburg, Inc.

Carver, J. 1796. *Travels through the interior parts of North America.* Philadelphia.

Castaneda, C. 1971. *A separate reality.* New York: Simon & Schuster.

———. 1974. *Tales of power.* New York: Simon & Schuster.

Chagnon, N. 1979. Mate competition, favoring close kin, and village fissioning among the Yanomamo Indians. In N. A. Chagnon & W. Irons, eds., *Evolutionary biology and human social behavior* (pp. 86–132). North Scituate, Mass.: Duxbury Press.

Cheng, N. 1987. *Life and death in Shanghai.* New York: Grove Press.

Chicago Tribune. 24 September 1987.

Chicago Tribune. 18 October 1987.

Clark, A. 1919. *The working life of women in the seventeenth century.* London.

Clausen, J. A., ed. 1968. *Socialization and society.* Boston: Little, Brown.

Cohler, B. J. 1982. Personal narrative and the life course. In P. B. Bates & O. G. Brim, eds., *Life span development and behavior*, vol. 4. New York: Academic Press.

Collingwood, R. G. 1938. *The principles of art*. London: Oxford University Press.

Conrad, P. 1982. *Television: The medium and its manners*. Boston: Routledge & Kegan.

Cooley, C. H. 1902. *Human nature and the social order*. New York: Charles Scribner's Sons.

Cooper, D. 1970. *The death of the family*. New York: Pantheon.

Cousins, N. 1979. *Anatomy of an illness as perceived by the patient*. New York: Norton.

Crandall, J. E. 1984. Social interest as a moderator of life stress. *Journal of Personality and Social Psychology* 47:164–74.

Crandall, M. 1983. On walking without touching the ground: "Play" in the *Inner Chapters* of the *Chuang-Tzu*. In V. H. Muir, ed., *Experimental essays on Chuang-Tzu* (pp. 101–23). Honolulu: University of Hawaii Press.

Crealock, W. I. B. 1951. *Vagabonding under sail*. New York: David McKay.

Croce, B. 1902 (1909). *Aesthetics*. New York: Macmillan.

———. 1962. *History as the story of liberty*. London: Allen & Unwin.

Crook, J. H. 1980. *The evolution of human consciousness*. New York: Oxford University Press.

Csikszentmihalyi, I. 1986. Il flusso di coscienza in un contesto storico: Il caso dei gesuiti. In F. Massimini & P. Inghilleri, eds., *L'esperienza quotidiana* (pp. 181–96). Milan: Franco Angeli.

———. 1988. Flow in a historical context: The case of the Jesuits. In M. Csikszentmihalyi & I. S. Csikszentmihalyi, eds., *Optimal experience: Psychological studies of flow in consciousness* (pp. 232–48). New York: Cambridge University Press.

Csikszentmihalyi, M. 1965. Artistic problems and their solution: An exploration of creativity in the arts. Unpublished doctoral dissertation, University of Chicago.

———. 1968. A cross-cultural comparison of some structural characteristics of group drinking. *Human Development* 11:201–16.

———. 1969. The Americanization of rock climbing. *University of Chicago Magazine* 61(6):20–27.

———. 1970. Sociological implications in the thought of Teilhard de Chardin. *Zygon* 5(2):130–47.

———. 1973. Socio-cultural speciation and human aggression. *Zygon* 8(2):96–112.

———. 1975. *Beyond boredom and anxiety*. San Francisco: Jossey-Bass.

———. 1978. Attention and the wholistic approach to behavior. In K. S. Pope & J. L. Singer, eds., *The stream of consciousness* (pp. 335–58). New York: Plenum.

———. 1981a. Leisure and socialization. *Social Forces* 60:332–40.

———. 1981b. Some paradoxes in the definition of play. In A. Cheska, ed., *Play as context* (pp. 14–26). New York: Leisure Press.

———. 1982a. Towards a psychology of optimal experience. In L. Wheeler, ed., *Review of personality and social psychology,* vol. 2. Beverly Hills, Calif.: Sage.

———. 1982b. Learning, flow, and happiness. In R. Gross, ed., *Invitation to life-long learning* (pp. 167–87). New York: Fowlett.

———. 1985a. Emergent motivation and the evolution of the self. In D. Kleiber & M. H. Maehr, eds., *Motivation in adulthood* (pp. 93–113). Greenwich, Conn.: JAI Press.

———. 1985b. Reflections on enjoyment. *Perspectives in Biology and Medicine* 28(4):469–97.

———. 1987. The flow experience. In M. Eliade, ed., *The encyclopedia of religion,* vol. 5 (pp. 361–63). New York: Macmillan.

———. 1988. The ways of genes and memes. *Reality Club Review* 1(1):107–28.

———. 1989. Consciousness for the 21st century. Paper presented at the ELCA Meeting, *Year 2000 and Beyond,* March 30–April 2, St. Charles, Illinois.

Csikszentmihalyi, M., & Beattie, O. 1979. Life themes: A theoretical and empirical exploration of their origins and effects. *Journal of Humanistic Psychology* 19:45–63.

Csikszentmihalyi, M., & Csikszentmihalyi, I. S., eds. 1988. *Optimal experience: Psychological studies of flow in consciousness.* New York: Cambridge University Press.

Csikszentmihalyi, M., & Getzels, J. W. 1989. Creativity and problem finding. In F. H. Farley & R. W. Neperud, eds., *The foundations of aesthetics* (pp. 91–116). New York: Praeger.

Csikszentmihalyi, M., Getzels, J. W., & Kahn, S. 1984. *Talent and achievement: A longitudinal study of artists.* A report to the Spencer Foundation and to the MacArthur Foundation. Chicago: University of Chicago.

Csikszentmihalyi, M., & Graef, R. 1979. *Flow and the quality of experience in everyday life.* Unpublished manuscript, University of Chicago.

———. 1980. The experience of freedom in daily life. *American Journal of Community Psychology* 8:401–14.

Csikszentmihalyi, M., & Kubey, R. 1981. Television and the rest of life. *Public Opinion Quarterly* 45:317–28.

Csikszentmihalyi, M., & Larson, R. 1978. Intrinsic rewards in school crime. *Crime and Delinquency* 24:322–35.

———. 1984. *Being adolescent: Conflict and growth in the teenage years.* New York: Basic Books.

———. 1987. Validity and reliability of the Experience-Sampling Method. *Journal of Nervous and Mental Disease* 175(9):526–36.

Csikszentmihalyi, M., Larson, R., & Prescott, S. 1977. The ecology of adolescent activity and experience. *Journal of Youth and Adolescence* 6:281–94.

Csikszentmihalyi, M., & LeFevre, J. 1987. The experience of work and leisure. *Third Canadian Leisure Research Conference,* Halifax, N.S., May 22–25.

———. 1989. Optimal experience in work and leisure. *Journal of Personality and Social Psychology* 56(5):815–22.

Csikszentmihalyi, M., & Massimini, F. 1985. On the psychological selection of bio-cultural information. *New Ideas in Psychology* 3(2):115–38.

Csikszentmihalyi, M., & Nakamura, J. 1989. The dynamics of intrinsic motivation. In R. Ames & C. Ames, eds., *Handbook of motivation theory and research,* vol. 3 (pp. 45–71). New York: Academic Press.

Csikszentmihalyi, M., & Rathunde, K. 1989. The psychology of wisdom: An evolutionary interpretation. In R. J. Sternberg, ed., *The psychology of wisdom.* New York: Cambridge University Press.

Csikszentmihalyi, M., & Robinson, R. In press. *The art of seeing.* Malibu, Calif.: J. P. Getty Press.

Csikszentmihalyi, M., & Rochberg-Halton, E. 1981. *The meaning of things: Domestic symbols and the self.* New York: Cambridge University Press.

Culin, S. 1906. Games of North American Indians. *24th Annual Report.* Washington, D.C.: Bureau of American Ethnology.

Cushing, F. H. 1896. Outlines of Zuni creation myths. *13th Annual Report.* Washington, D.C.: Bureau of American Ethnology.

Dalby, L. C. 1983. *Geisha.* Berkeley: University of California Press.

Damon, W., & Hart, D. 1982. The development of self-understanding from infancy through adolescence. *Child Development* 53:831–57.

Dante, A. (1965). *The divine comedy.* Trans. G. L. Bickerstein. Cambridge: Harvard University Press.

David, F. N. 1962. *Games, gods, and gambling.* New York: Hafner.

Davis, J. A. 1959. A formal interpretation of the theory of relative deprivation. *Sociometry* 22:280–96.

Dawkins, R. 1976. *The selfish gene.* New York: Oxford University Press.

deCharms, R. 1968. *Personal causation: The internal affective determinants of behavior.* New York: Academic Press.

Deci, E. L., & Ryan, R. M. 1985. *Intrinsic motivation and self-determination in human behavior.* New York: Plenum Press.

Delle Fave, A., & Massimini, F. 1988. Modernization and the changing contexts of flow in work and leisure. In M. Csikszentmihalyi & I. S. Csikszentmihalyi, eds., *Optimal experience: Studies of flow in consciousness* (pp. 193–213). New York: Cambridge University Press.

De Roberty, E. 1878. *La sociologie.* Paris.

de Santillana, G. 1961 (1970). *The origins of scientific thought.* Chicago: University of Chicago Press.

Devereux, E. 1970. Socialization in cross-cultural perspective: Comparative study of England, Germany, and the United States. In R. Hill & R. Konig, eds., *Families in East and West: Socialization process and kinship ties* (pp. 72–106). Paris: Mouton.

Diener, E. 1979. Deindividuation: The absence of self-awareness and self-regulation in group members. In P. Paulus, ed., *The psychology of group influence.* Hillsdale, N.J.: Erlbaum.

———. 1979. Deindividuation, self-awareness, and disinhibition. *Journal of Personality and Social Psychology* 37:1160–71.

Diener, E., Horwitz, J., & Emmons, R. A. 1985. Happiness of the very wealthy. *Social Indicators Research* 16:263–74.

Dobzhansky, T. 1962. *Mankind evolving: The evolution of the human species.* New Haven: Yale University Press.

———. 1967. *The biology of ultimate concern.* New York: New American Library.

Draghicesco, D. 1906. *Du role de l'individu dans le determinisme social.* Paris.

Dulles, F. R. 1965. *A history of recreation: America learns to play.* 2d ed. Englewood Cliffs, N.J.: Prentice-Hall.

Durkheim, E. 1897 (1951). *Suicide.* New York: Free Press.

———. 1912 (1967). *The elementary forms of religious life.* New York: Free Press.

Easterlin, R. A. 1974. Does economic growth improve the human lot? Some empirical evidence. In P. A. David & M. Abramovitz, eds., *Nations and households in economic growth.* New York: Academic Press.

Eckblad, G. 1981. *Scheme theory: A conceptual framework for cognitive-motivational processes.* London: Academic Press.

Ekman, P. 1972. Universals and cultural differences in facial expressions of emotions. In *Current theory in research on motivation, Nebraska symposium on motivation,* vol. 19 (pp. 207–83). Lincoln: University of Nebraska Press.

Eliade, M. 1969. *Yoga: Immortality and freedom.* Princeton: Princeton University Press.

Emde, R. 1980. Toward a psychoanalytic theory of affect. In S. Greenspan & E. Pollack, eds., *The course of life.* Washington, D.C.: U.S. Government Printing Office.

Encyclopaedia Britannica. 1985. 15th ed. Chicago: Encyclopaedia Britannica, Inc.

Erikson, E. H. 1950. *Childhood and society.* New York: W. W. Norton.

———. 1958. *Young man Luther.* New York: W. W. Norton.

———. 1969. *Gandhi's truth: On the origins of militant nonviolence.* New York: W. W. Norton.

Evans-Pritchard, E. E. 1940 (1978). *The Nuer.* New York: Oxford University Press.

Eysenck, M. W. 1982. *Attention and arousal.* Berlin: Springer Verlag.

Ferenczi, S. 1950. Sunday neuroses. In S. Ferenczi, ed., *Further contributions to the theory and technique of psychoanalysis* (pp. 174–77). London: Hogarth Press.

Fine, R. 1956. Chess and chess masters. *Psychoanalysis* 3:7–77.

Fiore, G. 1973. *Antonio Gramsci: Life of a revolutionary.* New York: Schocken Books.

Fisher, A. L. 1969. *The essential writings of Merleau-Ponty.* New York: Harcourt Brace.

Fortune, R. F. 1932 (1963). *Sorcerers of Dobu.* New York: Dutton.

Fox, V. 1977. Is adolescence a phenomenon of modern times? *Journal of Psychiatry* 1:271–90.

Frankl, V. 1963. *Man's search for meaning.* New York: Washington Square.

———. 1978. *The unheard cry for meaning.* New York: Simon & Schuster.

Freeman, M. 1989. Paul Ricoeur on interpretation: The model of the text and the idea of development. *Human Development* 28:295–312.

Freeman, M., Larson, R., & Csikszentmihalyi, M. 1986. Immediate experience and its recollection. *Merrill Palmer Quarterly* 32(2):167–85.

Freeman, M., & Robinson, R. E. In press. The development within: An alternative approach to the study of lives. *New Ideas in Psychology.*

Freud, S. 1921. Massenpsychologie und Ich-Analyse. *Vienna Gesammelte Schriften* 6:261.

———. 1930 (1961). *Civilization and its discontents.* New York: Norton.

Frijda, N. H. 1986. *The emotions.* New York: Cambridge University Press.

Gallup, G. H. 1976. Human needs and satisfactions: A global survey. *Public Opinion Quarterly* 40:459–67.

Gardner, H. 1983. *Frames of mind.* New York: Basic Books.

Garrett, H. E. 1941. *Great experiments in psychology.* Boston: Appleton Century Crofts.

Gedo, M. M., ed. 1986–88. *Psychoanalytic perspectives on art.* Vol. 1, 1986; vol. 2, 1987; vol. 3, 1988. Hillsdale, N.J.: Analytic Press.

Geertz, C. 1973. *The interpretation of culture.* New York: Basic Books.

Gendlin, E. T. 1962. *Experiencing and the creation of meaning.* Glencoe: Free Press.

———. 1981. *Focusing.* New York: Bantam.

General Social Survey. 1989 (March). Chicago: National Opinion Research Center.

Gergen, K., & Gergen, M. 1983. Narrative of the self. In T. Sarbin & K. Scheibe, eds., *Studies in social identity* (pp. 254–73). New York: Praeger.

———. 1984. The social construction of narrative accounts. In K. Gergen & M. Gergen, eds., *Historical social psychology* (pp. 173–89). Hillsdale, N.J.: Erlbaum.

Getzels, J. W., & Csikszentmihalyi, M. 1965. *Creative thinking in art students: The process of discovery.* HEW Cooperative Research Report S-080, University of Chicago.

———. 1976. *The creative vision: A longitudinal study of problem finding in art.* New York: Wiley Interscience.

Gilpin, L. 1948. *Temples in Yucatan.* New York: Hastings House.

Gladwin, T. 1970. *East is a big bird: Navigation and logic on Puluat atoll.* Cambridge: Harvard University Press.

Glick, P. G. 1979. Children of divorced parents in demographic perspective. *Journal of Social Issues* 35:170–82.

Goertzel, V., & Goertzel, M. G. 1962. *Cradles of eminence.* Boston: Little, Brown.

Goffman, E. 1969. *Strategic interaction.* Philadelphia: University of Pennsylvania Press.

————. 1974. *Frame analysis: An essay on the organization of experience.* New York: Harper & Row.

Gombrich, E. H. 1954. Psychoanalysis and the history of art. *International Journal of Psychoanalysis* 35:1–11.

————. 1979. *The sense of order.* Ithaca, N.Y.: Cornell University Press.

Gouldner, A. W. 1968. The sociologist as partisan: Sociology and the welfare state. *American Sociologist* 3:103–16.

Graef, R. 1978. *An analysis of the person by situation interaction through repeated measures.* Unpublished doctoral dissertation, University of Chicago.

Graef, R., Csikszentmihalyi, M., & Giannino, S. M. 1983. Measuring intrinsic motivation in everyday life. *Leisure Studies* 2:155–68.

Graef, R., McManama Gianinno, S., & Csikszentmihalyi, M. 1981. Energy consumption in leisure and perceived happiness. In J. D. Clayton et al., eds., *Consumers and energy conservation.* New York: Praeger.

Graves, R. 1960. *The white goddess: A historical grammar of poetic myth.* New York: Vintage Books.

Griessman, B. E. 1987. *The achievement factors.* New York: Dodd, Mead.

Groos, K. 1901. *The play of man.* New York: Appleton.

Gross, R., ed. 1982. *Invitation to life-long learning.* New York: Fowlett.

Group for the Advancement of Psychiatry. 1958 (August). *The psychiatrist's interest in leisure-time activities.* Report 39, New York.

Gussen, J. 1967. The psychodynamics of leisure. In P. A. Martin, ed., *Leisure and mental health: A psychiatric viewpoint* (pp. 51–169). Washington, D.C.: American Psychiatric Association.

Habakuk, H. J. 1955. Family structure and economic change in nineteenth century Europe. *Journal of Economic History* 15 (January):1–12.

Hadas, N. 1960 (1972). *Humanism: The Greek ideal and its survival.* Gloucester, Mass.: C. P. Smith.

Hamilton, J. A. 1976. Attention and intrinsic rewards in the control of psycho-physiological states. *Psychotherapy and Psychosomatics* 27:54–61.

————. 1981. Attention, personality, and self-regulation of mood: Absorbing interest and boredom. In B. A. Maher, ed., *Progress in Experimental Personality Research* 10:282–315.

Hamilton, J. A., Haier, R. J., & Buchsbaum, M. S. 1984. Intrinsic enjoyment and boredom coping scales: Validation with personality evoked potential and attentional measures. *Personality and Individual Differences* 5(2):183–93.

Hamilton, J. A., Holcomb, H. H., & De la Pena, A. 1977. Selective attention and eye movements while viewing reversible figures. *Perceptual and Motor Skills* 44:639–44.

Hamilton, M. 1982. Symptoms and assessment of depression. In E. S. Paykel, ed., *Handbook of affective disorders.* New York: Guilford Press.

Hamilton, W. D. 1964. The genetical evolution of social behavior: Parts 1 and 2. *Journal of Theoretical Biology* 7:1–52.

Harrow, M., Grinker, R. R., Holzman, P. S., & Kayton, L. 1977. Anhedonia and schizophrenia. *American Journal of Psychiatry* 134:794–97.

Harrow, M., Tucker, G. J., Hanover, N. H., & Shield, P. 1972. Stimulus overinclusion in schizophrenic disorders. *Archives of General Psychiatry* 27:40–45.

Hasher, L., & Zacks, R. T. 1979. Automatic and effortful processes in memory. *Journal of Experimental Psychology: General* 108:356–88.

Hauser, A. 1951. *The social history of art.* New York: Knopf.

Hebb, D. O. 1955. Drive and the CNS. *Psychological Review* (July) 243–52.

Hegel, G. F. 1798 (1974). *Lectures on the philosophy of religion, together with a work on the proofs of the existence of God.* Trans. E. B. Speirs. New York: Humanities Press.

Heidegger, M. 1962. *Being and time.* London: SCM Press.

———. 1967. *What is a thing?* Chicago: Regnery.

Henry, J. 1965. *Culture against man.* New York: Vintage.

Hetherington, E. M. 1979. Divorce: A child's perspective. *American Psychologist* 34:851–58.

Hilgard, E. 1980. The trilogy of mind: Cognition, affection, and conation. *Journal of the History of the Behavioral Sciences* 16:107–17.

Hiscock, E. C. 1968. *Atlantic cruise in Wanderer III.* London: Oxford University Press.

Hoffman, J. E., Nelson, B., & Houck, M. R. 1983. The role of attentional resources in automatic detection. *Cognitive Psychology* 51:379–410.

Hoffman, L. 1981. *Foundations of family therapy: A conceptual framework for systems change.* New York: Basic Books.

Holmes, T. H., & Rahe, R. H. 1967. The social readjustment rating scale. *Journal of Psychometric Research* 11:213–18.

Howell, M. C. 1986. *Women, production, and patriarchy in late medieval cities.* Chicago: University of Chicago Press.

Huizinga, J. 1939 (1970). *Homo ludens: A study of the play element in culture.* New York: Harper & Row.

———. 1954. *The waning of the Middle Ages.* Garden City, N.Y.: Doubleday.

Husserl, E. 1962. *Ideas: General introduction to pure phenomenology.* New York: Collier.

Huxley, J. S. 1942. *Evolution: The modern synthesis.* London: Allen and Unwin.

Izard, C. E., Kagan, J., & Zajonc, R. B. 1984. *Emotions, cognition, and behavior.* New York: Cambridge University Press.

Jackson, D. D. 1957. The question of family homeostasis. *Psychiatric Quarterly Supplement* 31:79–90.

James, W. 1890. *Principles of psychology: Vol. 1.* New York: Henry Holt.

Jaspers, K. 1923. *Psychopathologie generale.* 3d ed. Paris.

———. 1955. *Reason and Existenz.* New York: Noonday.

Jaynes, J. 1977. *The origin of consciousness in the breakdown of the bicameral mind.* Boston: Houghton Mifflin.

Johnson, R. 1988. Thinking yourself into a win. *American Visions* 3:6–10.

Johnson, Samuel. 1958. *Works of Samuel Johnson.* New Haven: Yale University Press.

Johnson, Skuli. 1930. *Pioneers of freedom: An account of the Icelanders and the Icelandic free state, 879–1262.* Boston: Stratford Co.

Johnston, L., Bachman, J., & O'Malley, P. 1981. *Student drug use in America.* Washington, D.C.: U.S. Department of Health and Human Services, National Institute of Drug Abuse.

Jones, E. 1931. The problem of Paul Morphy. *International Journal of Psychoanalysis* 12:1–23.

Jung, C. G. 1928 (1960). On psychic energy. In C. G. Jung, *collected works,* vol. 8. Princeton: Princeton University Press.

———. 1933 (1961). *Modern man in search of a soul.* New York: Harcourt Brace Jovanovich.

Kahneman, D. 1973. *Attention and effort.* Englewood Cliffs, N.J.: Prentice-Hall.

Kant, I. 1781 (1969). *Critique of pure reason.* Trans. N. Smith. New York: St. Martin's.

Kaplan, B. 1983. A trio of trials. In R. M. Lerner, ed., *Developmental psychology: Historical and philosophical perspectives.* Hillsdale, N.J.: Erlbaum.

Kelly, J. R. 1982. *Leisure.* Englewood Cliffs, N.J.: Prentice-Hall.

Keyes, R. 1985. *Chancing it: Why we take risks.* Boston: Little, Brown.

Kiell, N. 1969. *The universal experience of adolescence.* London: University of London Press.

Kierkegaard, S. 1944. *The concept of dread.* Princeton: Princeton University Press.

———. 1954. *Fear and trembling, and the sickness unto death.* Garden City, N.Y.: Doubleday.

Klausner, S. Z. 1965. *The quest for self-control.* New York: Free Press.

Kobasa, S. C., Maddi, S. R., & Kahn, S. 1982. Hardiness and health: A prospective study. *Journal of Personality and Social Psychology* 42:168–77.

Koch, K. 1970. *Wishes, lies, and dreams: Teaching children to write poetry.* New York: Chelsea House.

———. 1977. *I never told anybody: Teaching poetry writing in a nursing home.* New York: Random House.

Kohak, E. 1978. *Idea & experience: Edmund Husserl's project of phenomenology.* Chicago: University of Chicago Press.

Kohl, J. G. 1860. *Kitchi-Gami: Wanderings round Lake Superior.* London.

Kohlberg, L. 1984. *The psychology of moral development: Essays on moral development,* vol. 2. San Francisco: Harper & Row.

Kolakowski, L. 1987. *Husserl and the search for certitude.* Chicago: University of Chicago Press.

Kubey, R., & Csikszentmihalyi, M. In press. *Television and the quality of life.* Hillsdale, N.J.: Erlbaum.

Kuhn, T. S. 1962. *The structure of scientific revolutions.* Chicago: University of Chicago Press.

Kusyszyn, I. 1977. How gambling saved me from a misspent sabbatical. *Journal of Humanistic Psychology* 17:19–25.

La Berge, S. 1985. *Lucid dreaming: The power of being awake and aware of your dreams.* Los Angeles: Jeremy Tarcher.

Laing, R. D. 1960. *The divided self.* London: Tavistock.

———. 1961. *The self and others.* London: Tavistock.

Larson, R. 1985. Emotional scenarios in the writing process: An examination of young writers' affective experiences. In M. Rose, ed., *When a writer can't write* (pp. 19–42). New York: Guilford Press.

———. 1988. Flow and writing. In M. Csikszentmihalyi & I. S. Csikszentmihalyi, eds., *Optimal experience: Psychological studies of flow in consciousness* (pp. 150–71). New York: Cambridge University Press.

Larson, R., & Csikszentmihalyi, M. 1978. Experiential correlates of solitude in adolescence. *Journal of Personality* 46(4):677–93.

———. 1980. The significance of time alone in adolescents' development. *Journal of Adolescent Medicine* 2 (6):33–40.

———. 1983. The Experience Sampling Method. In H. T. Reis, ed., *Naturalistic approaches to studying social interaction (New Directions for Methodology of Social and Behavioral Science, No. 15).* San Francisco: Jossey-Bass.

Larson, R., Csikszentmihalyi, M., & Graef, R. 1980. Mood variability and the psychosocial adjustment of adolescents. *Journal of Youth and Adolescence* 9:469–90.

Larson, R., & Kubey, R. 1983. Television and music: Contrasting media in adolescent life. *Youth and Society* 15:13–31.

Larson, R., Mannell, R., & Zuzanek, J. 1986. Daily well-being of older adults with family and friends. *Psychology and Aging* 1(2):117–26.

Laski, M. 1962. *Ecstasy: A study of some secular and religious experiences.* Bloomington: Indiana University Press.

Laszlo, E. 1970. *System, structure and experience.* New York: Gordon & Breach.

Lazarus, R. S., & Folkman, S. 1984. *Stress, appraisal, and coping.* New York: Springer.

Le Bon, G. 1895 (1960). *The crowd.* New York: Viking.

Lecourt, D. 1977. *Proletarian science.* London: New Left Books.

Lee, R. B. 1975. What hunters do for a living. In R. B. Lee & I. de Vore, eds., *Man the hunter* (pp. 30–48). Chicago: Aldine.

Leenhardt, M. 1947 (1979). *Do Kamo.* Chicago: University of Chicago Press.

LeFevre, J. 1988. Flow and the quality of experience in work and leisure. In M. Csikszentmihalyi & I. S. Csikszentmihalyi, eds., *Optimal experience: Psychological studies of flow in consciousness* (pp. 317–18). New York: Cambridge University Press.

Le Goff, J. 1980. *Time, work, and culture in the Middle Ages.* Chicago: University of Chicago Press.

Le Roy Ladurie, L. 1979. *Montaillou.* New York: Vintage.

Lessard, S. 1987. Profiles: Eva Zeisel. *New Yorker* April 13, 60–82.

LeVine, R. A., & Campbell, D. T. 1972. *Ethnocentrism: Theories of conflict, ethnic attitudes, and group behavior.* New York: Wiley.

Lévi-Strauss, C. 1947 (1969). *Les structures élementaires de la parenté.* Paris: PUF.

Lewin, K., et al. 1944 (1962). Level of aspiration. In J. McV. Hunt, ed., *Personality and behavioral disorders* (pp. 333–78). New York: Ronald Press.

Lewinsohn, P. M., & Graf, M. 1973. Pleasant activities and depression. *Journal of Consulting and Clinical Psychology* 41:261–68.

Lewinsohn, P. M., & Libet, J. 1972. Pleasant events, activity schedules, and depression. *Journal of Abnormal Psychology* 79:291–95.

Lewinsohn, P. M., et al. 1982. Behavioral therapy: Clinical applications. In A. J. Rush, ed., *Short-term therapies for depression.* New York: Guilford.

Liberman, A. M., Mattingly, I. G., & Turvey, M. T. 1972. Language codes and memory codes. In A. W. Melton & E. Martin, eds., *Coding processes in human memory.* New York: Wiley.

Lieberman, M. A., et al. 1979. *Self-help groups for coping with crisis: Origins, members, processes, and impact.* San Francisco: Jossey-Bass.

Lindbergh, C. 1953. *The Spirit of St. Louis.* New York: Scribner.

Lipps, G. F. 1899. *Grundriss der psychophysik.* Leipzig: G. J. Goschen.

Loevinger, J. 1976. *Ego development.* San Francisco: Jossey-Bass.

Logan, R. 1985. The "flow experience" in solitary ordeals. *Journal of Humanistic Psychology* 25(4):79–89.

———. 1988. Flow in solitary ordeals. In M. Csikszentmihalyi & I. S. Csikszentmihalyi, eds., *Optimal experience: Psychological studies of flow in consciousness* (pp. 172–80). New York: Cambridge University Press.

Lumdsen, C. J., & Wilson, E. O. 1981. *Genes, mind, culture: The coevolutionary process.* Cambridge: Harvard University Press.

———. 1983. *Promethean fire: Reflections on the origin of mind.* Cambridge: Harvard University Press.

Lumholtz, C. 1902 (1987). *Unknown Mexico,* vol. 1. New York: Dover Publications.

Luria, A. R. 1976. *Cognitive development: Its cultural and social foundations.* Cambridge: Harvard University Press.

Lyons, A. W. 1988. *Role models: Criteria for selection and life cycle changes.* Unpublished doctoral dissertation, University of Chicago.

McAdams, D. 1985. *Power, intimacy and the life story.* Homewood, Ill.: Dorsey Press.

MacAloon, J. 1981. *This great symbol.* Chicago: University of Chicago Press.

Macbeth, J. 1988. Ocean cruising. In M. Csikszentmihalyi & I. S. Csikszentmihalyi, eds., *Optimal experience: Psychological studies of flow in consciousness* (pp. 214–31). New York: Cambridge University Press.

McDougall, W. 1920. *The group mind.* Cambridge: Cambridge University Press.

McGhie, A., & Chapman, J. 1961. Disorders of attention and perception in early schizophrenia. *British Journal of Medical Psychology* 34:103–16.

MacIntyre, A. 1984. *After virtue: A study in moral therapy.* Notre Dame: University of Notre Dame Press.

McLanahan, S. 1988. *Single mothers and their children: A new American dilemma.* New York: University Press of America.

MacPhillamy, D. J., & Lewinsohn, P. M. 1974. Depression as a function of levels of desired and obtained pleasure. *Journal of Abnormal Psychology* 83:651–57.

MacVannel, J. A. 1896. *Hegel's doctrine of the will.* New York: Columbia University Press.

Malcolm X. 1977. *The autobiography of Malcolm X.* New York: Ballantine.

Mall, J. 1985. A study of U.S. teen pregnancy rate. *Los Angeles Times,* March 17, p. 27.

Mandler, G. 1975. *Man and emotion.* New York: Wiley.

Marcuse, H. 1955. *Eros and civilization.* Boston: Beacon.

———. 1964. *One-dimensional man.* Boston: Beacon.

Martin, J. 1981. Relative deprivation: A theory of distributive injustice for an era of shrinking resources. *Research in Organizational Behavior* 3:53–107.

Marx, K. 1844 (1956). *Karl Marx: Selected writings in sociology and social philosophy.* Ed. T. B. Bottomore & Maximilien Rubel. London: Watts.

Maslow, A. 1954. *Motivation and personality.* New York: Harper.

———. 1968. *Toward a psychology of being.* New York: Van Nostrand.

———. 1969. *The psychology of science.* Chicago: Regnery.

———, ed. 1970. *New knowledge in human values.* Chicago: Regnery.

———. 1971. *The farther reaches of human nature.* New York: Viking.

Maslow, A., & Honigmann, J. J. 1970. Synergy: Some notes of Ruth Benedict. *American Anthropologist* 72:320–33.

Mason, H., trans. 1971. *Gilgamesh.* Boston: Houghton Mifflin.

Massimini, F. 1982. Individuo e ambiente: I papua Kapauku della Nuova Guinea occidentale. In F. Perussia, ed., *Psicologia ed ecologia* (pp. 27–154). Milan: Franco Angeli.

Massimini, F., Csikszentmihalyi, M., & Carli, M. 1987. The monitoring of optimal experience: A tool for psychiatric rehabilitation. *Journal of Nervous and Mental Disease* 175(9):545–49.

Massimini, F., Csikszentmihalyi, M., & Delle Fave, A. 1988. Flow and biocultural evolution. In M. Csikszentmihalyi & I. S. Csikszentmihalyi, eds., *Optimal experience: Studies of flow in consciousness* (pp. 60–81). New York: Cambridge University Press.

Massimini, F., & Inghilleri, P., eds., 1986. *L'Esperienza quotidiana: Teoria e metodo d'analisi.* Milan: Franco Angeli.

Matas, L., Arend, R. A., & Sroufe, L. A. 1978. Continuity of adaptation in the second year: The relationship between quality of attachment and later competence. *Child Development* 49:547–56.

Matson, K. 1980. *Short lives: Portraits of creativity and self-destruction.* New York: Morrow.

Mayers, P. 1978. *Flow in adolescence and its relation to the school experience.* Unpublished doctoral dissertation, University of Chicago.

Mead, G. H. 1934 (1970). *Mind, self and society.* Ed. C. W. Morris. Chicago: University of Chicago Press.

Mead, M. 1964. *Continuities in cultural evolution.* New Haven: Yale University Press.

Medawar, P. 1960. *The future of man.* New York: Basic Books.

Medvedev, Z. 1971. *The rise and fall of Dr. Lysenko.* Garden City, N.Y.: Doubleday.

Merleau-Ponty, M. 1962. *Phenomenology of perception.* New York: Humanities.

———. 1964. *The primacy of perception.* Ed. J. M. Edie. Evanston, Ill.: Northwestern University Press.

Merser, C. 1987. A throughly modern identity crisis. *Self* October, 147.

Meyer, L. B. 1956. *Emotion and meaning in music.* Chicago: University of Chicago Press.

Michalos, A. C. 1985. Multiple discrepancy theory (MDT). *Social Indicators Research* 16:347–413.

Miller, G. A. 1956. The magical number seven, plus or minus two: Some limits on our capacity to process information. *Psychological Review* 63:81–97.

———. 1983. Informavors. In F. Machlup & U. Mansfield, eds., *The study of information.* New York: Wiley.

Miller, G. A., Galanter, E. H., & Pribram, K. 1960. *Plans and the structure of behavior.* New York: Holt.

Mintz, S. 1985. *Sweetness and power: The place of sugar in modern history.* New York: Viking.

Mitchell, R. G., Jr. 1983. *Mountain experience: The psychology and sociology of adventure.* Chicago: University of Chicago Press.

———. 1988. Sociological implications of the flow experience. In M. Csikszentmihalyi & I. S. Csikszentmihalyi, eds., *Optimal experience: Psychological studies of flow in consciousness* (pp. 36–59). New York: Cambridge University Press.

Mitterauer, M., & Sieder, R. 1983. *The European family: Patriarchy to partnership from the Middle Ages to the present.* Chicago: University of Chicago Press.

Moitessier, B. 1971. *The long way.* Trans. W. Rodarmor. London: Granada.

Montaigne, M. de. 1580 (1958). *The complete essays of Montaigne.* Trans. Donald M. Frame. Stanford: Stanford University Press.

Monti, F. 1969. *African masks.* London: Paul Hamlyn.

Murphy, G. 1947. *Personality: A biosocial approach to origins and structure.* New York: Harper.

Murray, G. 1940. *Stoic, Christian and humanist.* London: S. Allen & Unwin.

Murray, H. A. 1955. American Icarus. *Clinical Studies of Personality,* vol. 2. New York: Harper.

Nabokov, P. 1981. *Indian running.* Santa Barbara: Capra Press.

Nakamura, J. 1988. Optimal experience and the uses of talent. In M. Csikszentmihalyi & I. S. Csikszentmihalyi, eds., *Optimal experience: Psychological*

studies of flow in consciousness (pp. 319–26). New York: Cambridge University Press.

Natanson, M. A., ed. 1963. *Philosophy of the social sciences.* New York: Random House.

Neisser, U. 1967. *Cognitive psychology.* New York: Appleton-Century-Crofts.

———. 1976. *Cognition and reality.* San Francisco: Freeman.

Nell, V. 1988. *Lost in a book: The psychology of reading for pleasure.* New Haven: Yale University Press.

Nelson, A. 1965. Self-images and systems of spiritual direction in the history of European civilization. In S. Z. Klausner, ed., *The quest for self-control* (pp. 49–103). New York: Free Press.

Newsweek. 5 October 1987.

New Yorker. 5 October 1987, pp. 33–35.

Nietzsche, F. 1886 (1989). *Beyond good and evil: Prelude to a philosophy of the future.* Trans. W. Kaufmann. New York: Random House.

———. 1887 (1974). *Genealogy of morals and peoples and countries.* New York: Gordon Press.

Nitecki, M. H., ed. 1988. *Evolutionary progress.* Chicago: University of Chicago Press.

Noelle-Neumann, E. 1983. *Spiegel-Dokumentation: Personlickeitsstarke.* Hamburg: Springer Verlag.

———. 1984. *The spiral of silence: Public opinion—our social skin.* Chicago: University of Chicago Press.

———. 1985. Identifying opinion leaders. Paper presented at the 38th ESOMAR Conference, Wiesbaden, West Germany, Sept. 1–5.

Noelle-Neumann, E., & Strumpel, B. 1984. *Mach Arbeit krank? Macht Arbeit glucklich?* Munich: Pieper Verlag.

Nusbaum, H. C., & Schwab, E. C., eds. 1986. The role of attention and active processing in speech perception. In *Pattern recognition by humans and machines,* vol. 1 (pp. 113–57). New York: Academic Press.

Offer, D., Ostrov, E., & Howard, K. 1981. *The adolescent: A psychological self-portrait.* New York: Basic Books.

Orme, J. E. 1969. *Time, experience, and behavior.* London: Iliffe.

Pagels, H. 1988. *The dreams of reason—the computer and the rise of the sciences of complexity.* New York: Simon & Schuster.

Pareto, V. 1917. *Traite de sociologie generale,* vol. 1. Paris.

———. 1919. *Traite de sociologie generale,* vol. 2. Paris.

Parsons, T. 1942. Age and sex in the social structure. *American Sociological Review* 7:604–16.

Piaget, J. 1952. *The origins of intelligence in children.* New York: International Universities Press.

Pina Chan, R. 1969. *Spiele und Sport in alten Mexico.* Leipzig: Edition Leipzig.

Pitts, Jesse R. 1964. The case of the French bourgeoisie. In R. L. Coser, ed., *The family: Its structure and functions.* New York: St. Martin's Press.

Plato. *Republic,* book 3, 401.

Polanyi, M. 1968. The body-mind relation. In W. R. Coulson & C. R. Rogers, eds., *Man and the science of man* (pp. 84–133). Columbus: Bell & Howell.

———. 1969. *Knowing and being.* Ed. Marjorie Grene. Chicago: University of Chicago Press.

Pope, K. S. 1980. *On love and loving.* San Francisco: Jossey-Bass.

Pope, K. S., & Singer, J. L. 1978. *The stream of consciousness.* New York: Plenum.

Prigogine, I. 1980. *From being to becoming: Time and complexity in the physical sciences.* San Francisco: W. H. Freeman.

Privette, G. 1983. Peak experience, peak performance, and flow: A comparative analysis of positive human experiences. *Journal of Personality and Social Psychology* 83(45):1361–68.

Radin, P. 1927. *Primitive man as philosopher.* New York: D. Appleton & Co.

Rathunde, K. 1988. Optimal experience and the family context. In M. Csikszentmihalyi & I. S. Csikszentmihalyi, eds., *Optimal experience: Psychological studies of flow in consciousness* (pp. 342–63). New York: Cambridge University Press.

Redfield, R., ed. 1942. *Levels of integration in biological and social systems.* Lancaster, Pa.: J. Catell Press.

———. 1955. *The little community: Viewpoints for the study of a human whole.* Chicago: University of Chicago Press.

Renfrew, C. 1986. Varna and the emergence of wealth in prehistoric Europe. In A. Appadurai, ed., *The social life of things* (pp. 141–68). New York: Cambridge University Press.

Ribot, T. A. 1890. *The psychology of attention.* Chicago: Open Court Publishing.

Richards, R., Kinney, D. K., Lunde, I., Benet, M., et al. 1988. Creativity in manic depressives, cyclothymes, their normal relatives, and control subjects. *Journal of Abnormal Psychology* 97(3):281–88.

Robinson, D. 1969. The climber as visionary. *Ascent* 9:4–10.

Robinson, J. P. 1977. *How Americans use time.* New York: Praeger.

Robinson, R. E. 1986. Differenze tra i sessi e rendimento scolastico: Aspetti dell'esperienza quotidiana degli adolescenti dotati in matematica. In F. Massimini & P. Inghilleri, eds., *L'esperienza quotidiana* (pp. 417–36). Milan: Franco Angeli.

———. 1988. Project and prejudice: Past, present, and future in adult development. *Human Development* 31:158–75.

Rogers, C. 1951. *Client-centered therapy.* Boston: Houghton Mifflin.

Roueché, B. 1988. Annals of medicine. *New Yorker* Sept. 12, 83–89.

Sacks, O. 1970 (1987). *The man who mistook his wife for a hat.* New York: Harper & Row.

Sahlins, M.D. 1972. *Stone age economics.* Chicago: Aldine Press.

———. 1976. *The use and abuse of biology: An anthropological critique of sociobiology.* Ann Arbor: University of Michigan Press.

Santayana, G. 1986. *The sense of beauty.* New York: Charles Scribner's Sons.

Sarbin, T., ed. 1986. *Narrative psychology: The storied nature of human conduct.* New York: Praeger.

Sartre, J. P. 1956. *Being and nothingness.* New York: Philosophical Library.

Sato, I. 1988. Bosozoku: Flow in Japanese motorcycle gangs. In M. Csikszent-mihalyi & I. S. Csikszentmihalyi, eds., *Optimal experience: Psychological studies of flow in consciousness* (pp. 92–117). New York: Cambridge University Press.

Schaefer, C., Coyne, J. C., & Lazarus, R. S. 1981. The health-related functions of social support. *Journal of Behavioral Medicine* 4(4):381–406.

Schafer, R. 1980. Narration in the psychoanalytic dialogue. *Critical Inquiry* 7:29–54.

Scheier, M. F., & Carver, C. S. 1980 Private and public self-attention, resistance to change, and dissonance reduction. *Journal of Personality and Social Psychology* 39:390–405.

Schiamberg, L. B. 1988. *Child and adolescent development.* New York: Macmillan.

Schlick, M. 1934. Uber das Fundament der Erkentniss. *Erkenntniss* 4. English translation in A. J. Ayer, ed., 1959, *Logical positivism.* New York: Free Press.

Schneider, E. 1953. *Coleridge, opium, and Kubla Khan.* Chicago: University of Chicago Press.

Scholem, G. 1969. *Major trends in Jewish mysticism.* New York: Schocken Books.

Schrödinger E. 1947. *What is life? The physical aspects of the living cell.* New York: Macmillan.

Schutz, A. 1962. *The problem of social reality.* The Hague: Martinus Nijhoff.

Schwartz, G. 1987. *Beyond conformity and rebellion.* Chicago: University of Chicago Press.

Schwarz, N., & Clore, G. L. 1983. Mood, misattribution, and judgments of well-being: Informative and directive functions of affective states. *Journal of Personality and Social Psychology* 45:513–23.

Seligman, M. E. P. 1975. *Helplessness: On depression, development, and death.* San Francisco: Freeman.

Seligman, M. E. P., Peterson, C., Kaslow, N. J., Tannenbaum, R. L., Alloy, L. B., & Abramson, L. Y. 1984. Attributional style and depressive symptoms among children. *Journal of Abnormal Psychology* 93:235–38.

Selye, H. 1956 (1978). *The stress of life.* Rev. ed. New York: McGraw-Hill.

Siegel, B. S. 1986. *Love, medicine, and miracles.* New York: Harper & Row.

Simon, H. A. 1969. *Sciences of the artificial.* Boston: MIT Press.

———. 1978. Rationality as process and as product of thought. *American Economic Review* 68:1–16.

Singer, I. 1981. *The nature of love* (2d ed.). Vol. 1: Plato to Luther; vol. 2: Courtly and romantic; vol. 3: The modern world. Chicago: University of Chicago Press.

Singer, J. L. 1966. *Daydreaming: An introduction to the experimental study of inner experiences.* New York: Random House.

———. 1973. *The child's world of make-believe.* New York: Academic Press.

———. 1981. *Daydreaming and fantasy.* Oxford: Oxford University Press.

Singer, J. L., & Switzer, E. 1980. *Mind play: The creative uses of fantasy.* Englewood Cliffs, N.J.: Prentice-Hall.

Smith, K. R. 1969. *Behavior and conscious experience: A conceptual analysis.* Athens: Ohio University Press.

Solzhenitsyn, A. 1976. *The gulag archipelago.* New York: Harper & Row.

Sorokin, P. 1950. *Explorations in altruistic love and behavior, a symposium.* Boston: Beacon Press.

————. 1956. *Fads and foibles in modern sociology.* Chicago: Regnery.

————. 1962. *Social and cultural dynamics.* New York: Bedminster.

————. 1967. *The ways and power of love.* Chicago: Regnery.

Spence, J. D. 1984. *The memory palace of Matteo Ricci.* New York: Viking Penguin.

Spinoza, B. de. 1675 (1981). *Ethics.* Trans. G. Eliot. Wolfeboro, N.H.: Longwood Publishing Group.

Spiro, M. E. 1987. *Culture and human nature: Theoretical papers of Melford E. Spiro.* Chicago: University of Chicago Press.

Steiner, G. 1974. *Fields of force.* New York: Viking.

————. 1978 (1987). *Martin Heidegger.* Chicago: University of Chicago Press.

Sternberg, R. J. 1988. *The triangle of love: Intimacy, passion, commitment.* New York: Basic Books.

Stewart, K. 1972. Dream exploration among the Sinoi. In T. Roszak, ed., *Sources.* New York: Harper & Row.

Strack, F., Argyle, M., & Schwarz, N., eds. 1990. *The social psychology of subjective well-being.* New York: Pergamon.

Sullivan, H. S. 1953. *The interpersonal theory of psychiatry.* New York: Norton.

Sun, W. 1987. *Flow and Yu: Comparison of Csikszentmihalyi's theory and Chuang-tzu's philosophy.* Paper presented at the meetings of the Anthropological Association for the Study of Play, Montreal, March.

Suppies, P. 1978. *The impact of research on education.* Washington, D.C.: National Academy of Education.

Suttles, G. 1972. *The social construction of communities.* Chicago: University of Chicago Press.

Szalai, A., ed. 1965. *The use of time: Daily activities of urban and suburban populations in twelve counties.* Paris: Mouton.

Teilhard de Chardin, P. 1965. *The phenomenon of man.* New York: Harper & Row.

Tessman, J. 1978. *Children of parting parents.* New York: Aronson.

Thompson, E. P. 1963. *The making of the English working class.* New York: Viking.

Tillich, P. 1952. *The courage to be.* New Haven: Yale University Press.

Tolstoy, L. 1886 (1985). *The death of Ivan Ilych.* Ed. M. Beresford. Oxford and New York: Basil Blackwell.

Tomkins, S. S. 1962. *Affect, imagery and consciousness.* Vol. 1: *The positive affects.* New York: Springer Verlag.

Toscano, M. 1986. Scuola e vita quotidiana: Un caso di selezione culturale. In F. Massimini & P. Inghilleri, eds., *L'esperienza quotidiana* (pp. 305–18). Milan: Franco Angeli.

Tough, A. 1978. *Adults' learning prospects: A fresh approach to theory and practice in adult learning.* Toronto: Ontario Institute for Studies in Education.

Toynbee, A. J. 1934. *A study of history.* London: Oxford University Press.

Treisman, A. M., & Gelade, G. 1980. A feature integration theory of attention. *Cognitive Psychology* 12:97–136.

Treisman, A. M., & Schmidt, H. 1982. Illusory conjunctions in the perception of objects. *Cognitive Psychology* 14:107–41.

Trivers, R. L. 1972. Parental investment and sexual selection. In B. H. Campbell, ed., *Sexual selection and the descent of man, 1871–1971* (pp. 136–79). Chicago: Aldine.

Tucker, R. C. 1972. *Philosophy and myth in Karl Marx.* 2d ed. Cambridge: Cambridge University Press.

Turnbull, C. M. 1961. *The forest people.* Garden City, N.Y.: Doubleday.

———. 1972. *The mountain people.* New York: Simon & Shuster.

Turner, V. 1969. *The ritual process.* New York: Aldine.

———. 1974. Liminal to liminoid in play, flow, and ritual: An essay in comparative symbology. *Rice University Studies* 60(3):53–92.

USA Today. 1987. An interview with Susumu Tonegawa. Oct. 13, p. 2A.

U.S. Dept. of Commerce. 1980. *Social indicators, III.* Washington, D.C.: Bureau of the Census.

U.S. Dept. of Commerce. 1985. *Statistical abstracts of the U.S., 1986.* 106th ed. Washington, D.C.: Bureau of the Census.

U.S. Dept. of Health & Human Services. 1988. *Vital statistics of the United States, 1985, II.* Hyattsville, Md.: U.S. Dept. of Health.

U.S. Dept. of Justice. 1987. *Uniform Crime Reports* 7:25. Washington, D.C.: Dept. of Justice.

Vaillant, G. E. 1977. *Adaptation to life.* Boston: Little, Brown.

Vasari, G. 1550 (1959). *Lives of the most eminent painters, sculptors, and architects.* New York: Random House.

Veenhoven, R. 1984. *Databook of happiness.* Boston: Dordrecht-Reidel.

Veroff, J., Douvan, E., & Kulka, R. A. 1981. *The inner American.* New York: Basic Books.

Veyne, P., ed. 1987. *From pagan Rome to Byzantium.* Vol. 1 of *A history of private life,* P. Aries and G. Duby, gen. eds. Cambridge, Mass.: Belknap Press.

von Bertalanffy, L. 1960. *Problems of life.* New York: Harper & Row.

———. 1968. *General system theory: Foundations, development, applications.* New York: G. Braziller.

von Uexkull, J. 1921. *Umwelt und Innenwelt der Tiere.* 2d ed. Berlin.

———. 1957. *Instinctive behaviour.* London: Methuen.

von Wolff, C. 1724. *Vernunftige Gedanken von dem Krafften des menschlichen Verstandes.* Halle im Magdeburg: Rengerische Buchhandl. English trans-

302 ▪ REFERENCES

lation (1963) by R. Blackwell, *Preliminary discourse on philosophy in general.* Indianapolis: Bobbs-Merrill.

Vygotsky, L. S. 1978. *Mind in society: The development of higher psychological processes,* M. Cole, V. John-Steiner, S. Scribner, & E. Souberman, eds. Cambridge: Harvard University Press.

Waddington, C. H. 1970. The theory of evolution today. In A. Koestler & J. R. Smythies, eds., *Beyond reductionism.* New York: Macmillan.

Waitzkin, F. 1988. *Searching for Bobby Fischer.* New York: Random House.

Waley, A. 1939. *Three ways of thought in ancient China.* London: G. Allen & Unwin.

Wallis, C., Booth, C., Ludtke, M., & Taylor, E. 1985. Children having children. *Time* Dec. 9, pp. 78–90.

Wann, T. W., ed. 1964. *Behaviorism and phenomenology.* Chicago: University of Chicago Press.

Warner, R., trans. 1965. *The Persian expedition.* Baltimore: Penguin Books.

Watson, B., trans. 1964. *Chuang Tzu, basic writings.* New York: Columbia University Press.

Weber, M. 1922. Die protestantische Ethik und der Geist des Kapitalismus. In I. C. B. Mohr, ed., *Gesammelte Aufsatze zur Religions-Sociologie.* Vol. 1: *Die Wirtschaftsethik der Weltreligionen* (pp. 237–68). Tubingen. English translation (1946) in H. A. Gerth & C. W. Mills, eds., *From Max Weber: Essays in sociology* (pp. 267–301). New York: Oxford University Press.

———. 1930 (1958). *The Protestant ethic and the spirit of capitalism.* London: Allen & Unwin.

Weitzman, M. S. 1978. Finally the family. *Annals of the AAPSS* 435:60–82.

Wells, A. 1988. Self-esteem and optimal experience. In M. Csikszentmihalyi & I. S. Csikszentmihalyi, eds., *Optimal experience: Psychological studies of flow in consciousness* (pp. 327–41). New York: Cambridge University Press.

Werner, H. 1957. *Comparative psychology of mental development.* Rev. ed. New York: International Universities Press.

Werner, H., & Kaplan, B. 1956. The developmental approach to cognition: Its relevance to the psychological interpretation of anthropological and ethnolinguistic data. *American Anthropologist* 58:866–80.

Weyden, P. 1984. *Day one.* New York: Simon & Schuster.

White, L. A. 1975. *The concept of cultural systems.* New York: Columbia University Press.

White, R. W. 1959. Motivation reconsidered: The concept of competence. *Psychological Review* 66:297–333.

Wicklund, R. A. 1979. The influence of self-awareness on human behavior. *American Scientist* 67:182–93.

Wiener, N. 1948 (1961). *Cybernetics, or control and communication in the animal and the machine.* Cambridge: MIT Press.

Williams, R. M., Jr. 1975. Relative deprivation. In L. A. Coser, ed., *The idea of social structure: Papers in honor of Robert K. Merton* (pp. 355–78). New York: Harcourt Brace Jovanovich.

Wilson, E. O. 1975. *Sociobiology: The new synthesis.* Boston: Belknap Press.

Wilson, S. R. 1985. Therapeutic processes in a yoga ashram. *American Journal of Psychotherapy* 39:253–62.

———. In press. Personal growth in a yoga ashram: A social psychological analysis. *The social scientific study of religion,* vol. 2.

Wittfogel, K. 1957. *Oriental despotism.* New Haven: Yale University Press.

Wolfe, T. 1987. *The bonfire of the vanities.* New York: Farrar, Straus.

Wood, E. 1954. *Great system of yoga.* New York: Philosophical Library.

Wundt, W. 1902. *Grundzuge der physiologischen Psychologie,* vol. 3. Leipzig.

Wynne, E. A. 1978. Behind the discipline problem: Youth suicide as a measure of alienation. *Phi Delta Kappan* 59:307–15.

Yankelovich, D. 1981. *New rules: Searching for self-fulfillment in a world turned upside down.* New York: Random House.

Zigler, E. F., & Child, I. L. 1973. *Socialization and personality development.* Reading, Mass.: Addison-Wesley.

Zuckerman, M. 1979. *Sensation seeking.* Hillsdale, N.J.: Erlbaum.

About the author

About the book

Insights,
Interviews
& More . . .

Read on

Meet Mihaly Csikszentmihalyi

© 1990 by Michael P. Weinstein

MIHALY CSIKSZENTMIHALYI is the C. S. and D. J. Davidson Professor of Psychology and Management at Claremont Graduate University's Drucker School of Management in Claremont, California. He is director of the Quality of Life Research Center at the Drucker School. He is a former chairman of the Department of Psychology at the University of Chicago, where he also taught psychology. For more than thirty-five years he has been involved in research on topics related to flow. Funding for these studies has come from the Public Health Service and various private grants, primarily the Spencer Foundation. In addition, a great deal of interest in his work has been building outside academia, spearheaded by substantial articles in *Psychology Today*, the *New York Times*, the *Washington Post*, the *Chicago Tribune*,

Omni, Newsweek, and elsewhere. He
is the author of *Beyond Boredom and
Anxiety, The Evolving Self,* and *Creativity,*
and is coauthor of *The Creative Vision,
The Meaning of Things,* and *Being
Adolescent.*

Dr. Csikszentmihalyi is a member
of the American Academy of Arts and
Sciences, the National Academy of
Education, and the National Academy
of Leisure Sciences. He has been a Senior
Fulbright Fellow and has sat on several
boards, including the Board of Advisers
for the *Encyclopaedia Britannica.* He
has appeared on a number of foreign
television networks, including the BBC
and RAI (Italian television), and has
taken part in several hour-long segments
of *Nova.* ∾

The Flow of Creativity

The following passage is excerpted from Creativity: Flow and the Psychology of Discovery and Invention *by Mihaly Csikszentmihalyi (HarperCollins, 1996).*

CREATIVE PERSONS DIFFER from one another in a variety of ways, but in one respect they are unanimous: They all love what they do. It is not the hope of achieving fame or making money that drives them; rather, it is the opportunity to do the work that they enjoy doing. Jacob Rabinow explains: "You invent for the hell of it. I don't start with the idea 'What will make money?' This is a rough world; money's important. But if I have to trade between what's fun for me and what's money-making, I'll take what's fun." The novelist Naguib Mahfouz concurs in more genteel tones: "I love my work more than I love what it produces. I am dedicated to the work regardless of its consequences." We found the same sentiments in every single interview.

What is extraordinary in this case is that we talked to engineers and chemists, writers and musicians, businesspersons and social reformers, historians and architects, sociologists and physicians— and they all agree that they do what they do primarily because it's fun. Yet many others in the same occupations don't enjoy what they do. So we have to assume that it is not *what* people do that counts but *how* they do it. Being an engineer or a carpenter is not in itself enjoyable. But if one does these things a certain way,

then they become intrinsically rewarding, worth doing for their own sake. What is the secret of transforming activities so that they are rewarding in and of themselves?

Programmed for Creativity

When people are asked to choose from a list the best description of how they feel when doing whatever they enjoy doing most—reading, climbing mountains, playing chess, whatever—the answer most frequently chosen is "designing or discovering something new." At first, it seems strange that dancers, rock climbers, and composers all agree that their most enjoyable experiences resemble a process of discovery. But when we think about it some more, it seems perfectly reasonable that at least some people should enjoy discovering and creating above all else.

To see the logic of this, try a simple thought experiment. Suppose that you want to build an organism, an artificial life form, that will have the best chance of surviving in a complex and unpredictable environment, such as that on Earth. You want to build into this organism some mechanism that will prepare it to confront as many of the sudden dangers and to take advantage of as many of the opportunities that arise as possible. How would you go about doing this? Certainly you would want to design an organism that is basically conservative, one that learns the best solutions from the past and keeps repeating them, trying to save energy, ▶

66 What is the secret of transforming activities so that they are rewarding in and of themselves? 99

to be cautious and go with the tried-and-true patterns of behavior.

But the best solution would also include a relay system in a few organisms that would give a positive reinforcement every time they discovered something new or came up with a novel idea or behavior, whether or not it was immediately useful. It is especially important to make sure that the organism was not rewarded only for useful discoveries, otherwise it would be severely handicapped in meeting the future. For no earthly builder could anticipate the kind of situations the species of new organisms might encounter tomorrow, next year, or in the next decade. So the best program is one that makes the organism feel good whenever something new is discovered, regardless of its present usefulness. And this is what seems to have happened with our race through evolution.

By random mutations, some individuals must have developed a nervous system in which the discovery of novelty stimulates the pleasure centers in the brain. Just as some individuals derive a keener pleasure from sex and others from food, so some must have been born who derived a keener pleasure from learning something new. It is possible that children who were more curious ran more risks and so were more likely to die earlier than their more stolid companions. But it is also probable that those human groups that learned to appreciate the curious children among

> " Just as some individuals derive a keener pleasure from sex and others from food, so some must have been born who derived a keener pleasure from learning something new. "

them, and helped to protect and reward them so that they could grow to maturity and have children of their own, were more successful than groups that ignored the potentially creative in their midst.

If this is true, we are the descendants of ancestors who recognized the importance of novelty, protected those individuals who enjoyed being creative, and learned from them. Because they had among them individuals who enjoyed exploring and inventing, they were better prepared to face the unpredictable conditions that threatened their survival. So we too share this propensity for enjoying whatever we do, provided we can do it in a new way, provided we can discover or design something new in doing it. This is why creativity, no matter in what domain it takes place, is so enjoyable. This is why Brenda Milner, among many others, said: "I would say that I am impartial about what is important or great, because every new little discovery, even a tiny one, is exciting at the moment of discovery."

But this is only part of the story. Another force motivates us, and it is more primitive and more powerful than the urge to create: the force of entropy. This too is a survival mechanism built into our genes by evolution. It gives us pleasure when we are comfortable, when we relax, when we can get away with feeling good without expending energy. If we didn't have this built-in regulator, we could easily kill ourselves by running ragged and then not having ▶

66 Another force motivates us, and it is more primitive and more powerful than the urge to create: the force of entropy. 99

The Flow of Creativity *(continued)*

enough reserves of strength, body fat, or nervous energy to face the unexpected.

This is the reason why the urge to relax, to curl up comfortably on the sofa whenever we can get away with it, is so strong. Because this conservative urge is so powerful, for most people "free time" means a chance to wind down, to park the mind in neutral. When there are no external demands, entropy kicks in, and unless we understand what is happening, it takes over the body and our mind.

We are generally torn between two opposite sets of instructions programmed into the brain: the least-effort imperative on one side, and the claims of creativity on the other.

In most individuals entropy seems to be stronger, and they enjoy comfort more than the challenge of discovery. A few, like the ones who tell their stories in this book, are more responsive to the rewards of discovery. But we all respond to both of these rewards; the tendencies toward conserving energy as well as using it constructively are simultaneously part of our inheritance. Which one wins depends not only on our genetic makeup but also presumably on our early experiences. However, unless enough people are motivated by the enjoyment that comes from confronting challenges, by discovering new ways of being and doing, there is no evolution of culture, no progress in thought or feeling. It is important, therefore, to understand better what enjoyment consists of and how creativity can produce it.

What Is Enjoyment?

In order to answer that question, many years ago I started to study people who seemed to be doing things that they enjoyed but were not rewarded for with money or fame. Chess players, rock climbers, dancers, and composers devoted many hours a week to their avocations. Why were they doing it? It was clear from talking to them that what kept them motivated was the quality of experience they felt when they were involved with the activity. This feeling didn't come when they were relaxing, when they were taking drugs or alcohol, or when they were consuming the expensive privileges of wealth. Rather, it often involved painful, risky, difficult activities that stretched the person's capacity and involved an element of novelty and discovery. This optimal experience is what I have called *flow*, because many of the respondents described the feeling when things were going well as an almost automatic, effortless, yet highly focused state of consciousness.

The flow experience was described in almost identical terms regardless of the activity that produced it. Athletes, artists, religious mystics, scientists, and ordinary working people described their most rewarding experiences with very similar words. And the description did not vary much by culture, gender, or age; old and young, rich and poor, men and women, Americans and Japanese seem to ▶

66 Many years ago I started to study people who seemed to be doing things that they enjoyed but were not rewarded for with money or fame. 99

9

experience enjoyment in the same way, even though they may be doing very different things to attain it. Nine main elements were mentioned over and over again to describe how it feels when an experience is enjoyable.

1. *There are clear goals every step of the way.* In contrast to what happens in everyday life, on the job or at home, where often there are contradictory demands and our purpose is unsure, in flow we always know what needs to be done. The musician knows what notes to play next, the rock climber knows the next moves to make. When a job is enjoyable, it also has clear goals. The surgeon is aware how the incision should proceed moment by moment; the farmer has a plan for how to carry out the planting.

2. *There is immediate feedback to one's actions.* Again, in contrast to the usual state of affairs, in a flow experience we know how well we are doing. The musician hears right away whether the note played is the one. The rock climber finds out immediately whether the move was correct because he or she is still hanging in there and hasn't fallen to the bottom of the valley. The surgeon sees there is no blood in the cavity, and the farmer sees the furrows lining up neatly in the field.

> In flow, we feel that our abilities are well matched to the opportunities for action. In everyday life we sometimes feel that the challenges are too high in relation to our skills, and then we feel frustrated and anxious.

3. *There is a balance between challenges and skills.* In flow, we feel that our abilities are well matched to the opportunities for action. In everyday life we sometimes feel that the challenges are too high in relation to our skills, and then we feel frustrated and anxious. Or we feel that our potential is greater than the opportunities to express it, and then we feel bored. Playing tennis or chess against a much better opponent leads to frustration; against a much weaker opponent, to boredom. In a really enjoyable game, the players are balanced on the fine line between boredom and anxiety. The same is true when work, or a conversation, or a relationship is going well.

4. *Action and awareness are merged.* It is typical of everyday experience that our minds are disjointed from what we do. Sitting in class, students may appear to be paying attention to the teacher, but they are actually thinking about lunch, or last night's date. The worker thinks about the weekend; the mother cleaning house is worried about her child; the golfer's mind is preoccupied with how his swing looks to his friends. In flow, however, our concentration is focused on what we do. One-pointedness of mind is required by the close match between challenges and skills, and it is made possible ▶

by the clarity of goals and the constant availability of feedback.

5. *Dimensions are excluded from consciousness.* Another typical element of flow is that we are aware only of what is relevant here and now. If the musician thinks of his health or tax problems when playing, he is likely to hit a wrong note. If the surgeon's mind wanders during an operation, the patient's life is in danger. Flow is the result of intense concentration on the present, which relieves us of the usual fears that cause depression and anxiety in everyday life.

6. *There is no worry of failure.* While in flow, we are too involved to be concerned with failure. Some people describe it as a feeling of total control; but actually we are not in control, it's just that the issue does not even come up. If it did, we would not be concentrating totally, because our attention would be split between what we did and the feeling of control. The reason that failure is not an issue is that in flow it is clear what has to be done, and our skills are potentially adequate to the challenges.

7. *Self-consciousness disappears.* In everyday life, we are always monitoring how we appear to

other people; we are on the alert to defend ourselves from potential slights and anxious to make a favorable impression. Typically this awareness of self is a burden. In flow we are too involved in what we are doing to care about protecting the ego. Yet after an episode of flow is over, we generally emerge from it with a stronger self-concept; we know that we have succeeded in meeting a difficult challenge. We might even feel that we have stepped out of the boundaries of the ego and have become part, at least temporarily, of a larger entity. The musician feels at one with the harmony of the cosmos, the athlete moves at one with the team, the reader of a novel lives for a few hours in a different reality. Paradoxically, the self expands through acts of self-forgetfulness.

> " Paradoxically, the self expands through acts of self-forgetfulness. "

8. *The sense of time becomes distorted.* Generally in flow we forget time, and hours may pass by in what seem like a few minutes. Or the opposite happens: A figure skater may report that a quick turn that in real time takes only a second seems to stretch out for ten times as long. In other words, clock time no longer marks equal lengths of experienced time; our sense of how much time passes depends on what we are doing.

9. *The activity becomes autotelic.* Whenever most of these conditions are present, we begin to enjoy whatever it is that produces such an experience. I may be scared of using a computer and learn to do it only because my job depends on it. But as my skills increase, and I recognize what the computer allows me to do, I may begin to enjoy using the computer for its own sake as well. At this point the activity becomes *autotelic*, which is Greek for something that is an end in itself. Some activities such as art, music, and sports are usually autotelic: There is no reason for doing them except to feel the experience they provide. Most things in life are *exotelic*: We do them not because we enjoy them but in order to get at some later goal. And some activities are both: The violinist gets paid for playing, and the surgeon gets status and good money for operating, as well as getting enjoyment from doing what they do. In many ways, the secret to a happy life is to learn to get flow from as many of the things we have to do as possible. If work and family life become autotelic, then there is nothing wasted in life, and everything we do is worth doing for its own sake. ❧

Have You Read?
More by Mihaly Csikszentmihalyi

CREATIVITY

Creativity is about capturing those moments that make life worth living. The author's objective is to offer an understanding of what leads to these moments, be it the excitement of the artist at the easel or the scientist in the lab, so that knowledge can be used to enrich people's lives. Drawing on one hundred interviews with exceptional people—from biologists, physicists, and politicians to business leaders, poets, and artists—as well as his thirty years of research on the subject, Csikszentmihalyi investigates the creative process. He explores such ideas as why creative individuals are often seen as selfish and arrogant, and why the tortured genius is largely a myth. Most important, he clearly explains why creativity needs to be cultivated and is necessary for the future of our country, if not the world.

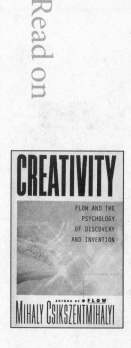

"[T]he rich anecdotal material Csikszentmihalyi has mined and analyzed make this an important study of a vital topic." —*Kirkus Reviews*

THE EVOLVING SELF

His bestselling book, *Flow*, introduced us to a radical new theory of happiness; in this breakthrough sequel, Mihaly Csikszentmihalyi shows us how to understand and overcome our evolutionary heritage in order to re-create ourselves and the world for the twenty-first century.

"[A] wise, humane inquiry."
—*Publishers Weekly*

"Csikszentmihalyi goes beyond the psychobabble and traces human behavior from the beginning of time and shows with great clarity why we do the things we do." —*Library Journal*

Don't miss the next book by your favorite author. Sign up now for AuthorTracker by visiting www.AuthorTracker.com.